Freehand

AN INTIMATE PORTRAIT OF THE
NEW YORK ART SCENE IN ITS GOLDEN YEARS
BY A REMARKABLE WOMAN WHO LIVED,
LOVED AND PAINTED IT

LILY HARMON

SIMON AND SCHUSTER · NEW YORK

PUBLISHED BY SIMON AND SCHUSTER
A DIVISION OF GULF & WESTERN CORPORATION
SIMON & SCHUSTER BUILDING
ROCKEFELLER CENTER
1230 AVENUE OF THE AMERICAS
NEW YORK, NEW YORK 10020
SIMON AND SCHUSTER AND COLOPHON ARE TRADEMARKS OF
SIMON & SCHUSTER
DESIGNED BY EVE METZ
MANUFACTURED IN THE UNITED STATES OF AMERICA

1 3 5 7 9 10 8 6 4 2

LIBRARY OF CONGRESS CATALOGING IN PUBLICATION DATA

HARMON, LILY 1912–
FREEHAND: THE LIFE AND ART OF A LADY
WHO MADE HER OWN RULES.
1. HARMON, LILY, 1912- 2. PAINTERS—UNITED STATES—
BIOGRAPHY. I. TITLE.
ND237.H314A2 1981 759.13 [B] 80-25835

ISBN 0-671-41452-6

*For my daughters, Amy and Jo Ann Hirshhorn,
and my husband, Milton Schachter.*

*With special thanks to Mary-Lou Weisman and the late Maxwell
Geismar for saying I could, and to my editor, Roslyn Siegel, for making
it possible.*

Chapter One
1912–1931

NOBODY CAN FIND ME. I am lost in the attic with a bunch of my bankrupt Uncle Abe's checkbooks. I am drawing mermaids with long wavy hair, tiny breasts and fishtails scribbled with scales and split in two at the bottom. I am six years old. I cannot draw feet. When I have used up all the blank sides I draw over the faces, around "pay to the order of," and the lines leading to "dollars." Then I start on the empty stubs. I am in a world of my own. '

"Lilinyu. Lilinyu," they call but I do not answer. I remember when it was I who called to them and nobody came.

It is my earliest memory.

"Baba," I cry but nobody answers. I am deserted. The family is not there. There are not even mattresses on the floor for the greenhorns or chairs pulled seat to seat to make beds for their children. I stumble down the dark narrow stairway toward the night brightness of Grand Avenue past the painted figures of a man, woman, and child in their Sunday best marching four stories high on the side of the store my father has finally bought after years of peddling: PERELMUTTER'S 763 GRAND AVENUE MENS LADIES AND CHILDRENS FURNISHINGS.

The dressed dummies in the lit windows look down haughtily at me exposing my privates while I draw up the dry end of my nightgown to wipe away my tears. Baba, returning from a mis-

7

sion of mercy to the store with coffee, comes around the corner, scoops me up in her arms and cradles me to her pillow bosom.

"*Veyn nicht. Veyn nicht,* Lilinyu."

But I cannot stop crying, and the memory of my abandonment will cling to me forever like meat to my bones. I do not feel lonely in attics with images and mermaids. They are safer. They will never leave me.

"*Luftmensh,*" they say when they find me.

I know what they mean. Someone like Zayda with his head in the clouds. An air person. Zayda spends only half a day in the store. He walks there early in the morning to open it, wearing his European black broadcloth coat with a kolinsky fur collar and a bowler hat on his distinguished head with its neatly trimmed Vandyke beard. He carries an amber-handled cane and not only looks distinguished but has Old World manners. When he leaves the house he kisses my hand as if I were a duchess.

In the afternoons Zayda reads Spinoza and writes his play in Yiddish, filling up small, lined notebooks.

"*Koheleth . . . Koheleth . . .*" he sometimes mutters when I run to see him after school.

"What does it mean, Zayda?"

"It's from Ecclesiastes. 'Vanity of vanities. All is vanity. Of making books there is no end; and much study is a weariness of the flesh. . . .' "

But Zayda does not stop writing any more than he stops talking when I am delegated to hold a stopwatch and pluck at his sleeve after five minutes of an after-dinner speech. At the broken-down *shul* with its flamelike painted gold letters over the doorway and its iron gate hanging from rusty hinges Zayda is considered a saint by some, a heretic by others. He argues all the time, dares to discuss the virtues of Jesus of Nazareth, and resigns periodically.

Elegant though he is, Zayda hates to cut his toenails. Baba screams that he must. When he does, the nails are so hard and long, they fly everywhere. I run around the room picking them up in unlikely corners because Zayda saves them in a little box.

8

I ask him why and he says that all parts of the body are sacred and must be available for reassembling. Momma saves hair combings, which she puts into the round open hole of an ivory container, but her savings have a purpose, an immediate purpose. She uses them to stuff into her pompadour and calls it a rat. Mom is enamored of herself, sitting in front of her vanity table with the mirrors that show her front, back and side views, powdering herself out of the box in the drawer that holds a fluffy puff and pink dust. I know I am nothing compared to Pop, for whom she adorns herself. *Mein mann,* as she calls him proudly, her man is all.

I hardly see my parents. They are home only on Sundays. The store is their natural habitat and closes when the last customer leaves. It could be midnight. Pop is King of the Men's Side; Mom is Queen of the Ladies'. Her greatest pleasure is outfitting brides. The rack with white satin wedding gowns has a glass door to protect it. I hang around watching Mom drape a veil from a wreath of artificial orange blossoms.

"*Gei avek!*" she yells at me. "Go away. You vant you should step on the train with your dirty shoes?" I withdraw myself from the preening Polish bride. I am unclean.

Inside the store, Sam, the clerk on the Men's Side, folds boxes. "I'll put you in one and ship you to New York." I shudder. Would he really? In the three-way mirror I pirouette, and endless images mimic me going back, back, into infinity. I draw myself small and smaller. I cannot stop drawing on Pop's brown wrapping paper.

A Yankee spinster sits in a cage in the center of the store with a cash book in front of her where she enters the small deposits made weekly by my father's customers. He is one of the first merchants in New Haven to extend credit. The cash register chimes loudly every time its drawer explodes open.

I pick small treasures of fabric to make dolls' clothes from the bin in the back room where Lena, the Italian seamstress, does alterations. She has a black mustache and hairs erupt from a large mole on her face. I love her, and lean over the ornate

Singer sewing machine while the needle bites the cloth with staccato regularity. I watch, fascinated, while she presses pants by putting a damp cloth on them and resting a huge iron that sends out curlicues of steam.

The cellar is spooky with mannequins—half a body here, legs sprawled indecently, and worst of all, a bald severed head with its wig somewhere else. Rows and rows of winter woolen knickers are wedged tightly together. There is an avenue of Melton cloth coats, and fumes of mothballs rise from all the aisles and especially those where the fur coats hang—delicate gray squirrels, hairy raccoons and plushy soft beavers. Under my feet stray mothballs escaped from coat pockets crush into a fine powder.

On Saturday afternoons I munch stale caramels that last through reel upon reel at Dreamland, the nickelodeon, where Pearl White is rescued week after week. In other movies, much dilating of nostrils indicates passion and a half-naked heroine cowers behind a screen while the villain leers at her from the doorway. Later, she has a baby. What happened? I cannot figure it out, but then I decide he has *thought* a baby into her. It is years before a big lummox of a girl tells me all about it and I say, "I'll never get married. Never."

We stumble out of the dark theater like little bats, blinking at reality and daylight, released to the smell of hot chestnuts and sweet potatoes, Italian ices in paper cones, heavy hanging wheels of provolone and Parmesan, dry-goods stores and Jewish delicatessens.

All three of us, my brother Joe, my sister Gert, and I, the youngest, work in the store on Saturdays when we are old enough to be able to divide by four. That is how we translate the figure on the price tag to get the wholesale price, and anything we ask above that is cricket. The customers all bargain. Whole families—aunts, uncles, even grandparents—trail in just to buy one boy's suit with two pairs of pants.

"Call your father. Call the boss. Call Mr. Perelmutter," they say when I quote a price.

Pop walks over gravely, feels the fabric reverently, looks at the tag.

"A beautiful piece of worsted," he proclaims. "It could last ten years. The next son can wear it." It will go down in history.

"Mr. Perelmutter," the little boy's father says, "you know I work at Winchester's. There is talk they are laying off people now the war is over. Not me, yet, but who knows?"

"For you, Mr. Pomerico, the first customer of the day," my father pronounces, "you should bring me luck . . . for you, is six dollars."

The whole family sighs with relief and Pop pats the lucky little boy on the head.

"Why couldn't you have made it less, Pop? They were so poor. And maybe he'll lose his job."

"Not him. He's the best worker they have. Like an ox." And Pop explains he is not a philanthropist. He is in business to make a profit and see that his children have an education. As the Saturdays go on, and I am always a bleeding heart, I am excused from the job. I don't care. I would rather draw.

Reality is the lifeline of a wall telephone that connects the store to the house but not to the outside world. It rings constantly with messages. "I'm coming to eat now. . . . I can't come now. I'll come later. A customer just walked in. . . ." And Baba saying, "The soup is getting cold on the table. . . ."

Baba cooks while Mom works in the store. Sunday is the only day we all eat together because the store is closed. We have kosher chicken that comes from the *shochet.* It is complete. It has everything—a head with beady eyes, feathers, and clawlike yellow feet. Baba plucks and saves the feathers for pillows. When she singes the bird over the gas flame, an acrid smell fills the kitchen. I look inside the fat hens to see if there are coveted golden embryos to be cooked in the rich soup, gelatinous from the bony feet.

The chicken has to be soup before it is anything else. For economy. I hate boiled chicken. Baba knows this and makes a special effort for me. She sprinkles it with paprika to hide its telltale whiteness, but I am not fooled.

"You boiled it!"

"Roasted," Baba assures me.

"You boiled it *first.* I can tell."

"Alles oder garnichts."

All or nothing. She is right. She knows me well.

"Pigeon's tongues," Baba sighs, "she wants I should make her pigeon's tongues, the prin*cess*kela."

"Just don't boil it first, that's all I want."

There are even ways to make sure everything gets eaten. No waste and no arguments.

"Dark meat for the boys," says Pop, carving. "Drumsticks. They have to stand on their feet. Support a household. White meat for girls. Wings. They should fly away from home to be married."

"*Kine-ahora*," Mom adds and I know she is wishing away any evil eye or curse that could keep my sister and me from finding a proper husband someday.

Friday is baking day. I watch the *challah* rising on the back of the stove. Sometimes I am allowed to divide it in three parts and braid it like hair. It comes out of the oven in shiny brown lacquered loaves.

Baba's strudel never grows stale but ages like fruitcake soaked in brandy. It could last till a bride's first anniversary. She rolls the dough out so thin that it hangs over the kitchen table like a cloth. She lets me use her special *hakmesser* to chop the almonds in a wooden bowl for the filling. I sprinkle and strew the cinnamon, nuts, sugar, raisins and citron over the butter-spread dough. Baba rolls it into sausagelike forms and cuts it across, exposing a pattern like a wheel.

The black fry pan that Baba used for blintzes is so well seasoned that it never has to be washed, and it glistens from countless applications of butter on waxed paper. She pours the thin batter quickly and cooks the pancake until it curls at the edge, then flips it onto a stack. Baba makes fillings with whatever she has, from farmer's cheese and eggs to delicate mixtures of ground chicken and veal.

In our house, sour cream flows in thick white streams over the cheese blintzes. It goes over red raspberries or strawberries sprinkled with sugar, over fat blueberries, over a combination of red sliced radishes, sharp green scallions, shredded pale crispy lettuce and cucumbers. Sour cream is plopped on borscht so

magenta-red that the cream dissolves into intense pink rivulets. In the center of the cold soup a hot potato rises steaming like a white island in a wine-dark sea. With this we eat a crusty rye or heavy corn bread filled with caraway seeds and spread thickly with sweet tub butter.

A skinny child is a bad reflection on a Jewish family. Like the witch in *Hansel and Gretel,* Baba runs her fingers down my bony spine to see if I am getting fatter. Despite the *cholupzes,* little bundles of cabbage leaves wrapped around chopped meat and rice, despite *brust,* pot roast, simmered for hours with lima beans, despite bagels stuffed with cream cheese and lox, I stay thin.

"A *gogol-mogol.*"

Baba whips up a rich milk cocktail for extra nourishment. It is laced with eggs, sugar and vanilla, but it is no use. I stay thin.

On Sundays, after our midday dinner, Pop and I go collecting in the new Reo. We drive out to Guilford or Branford to his Polish customers who are farmers and too busy to make their small payments in New Haven.

"Time is money," says Pop on the way out. "The first English words I learned when I came to Winnipeg in Canada." I love the legend of his meeting Mom, of how they came to this country. "My brother Barney sent me the money. A peasant took me over the border at Radzilov, he carried me over a small river, I shouldn't get my new shoes wet. Finally when I got to St. John, I sent a telegram to my brother. But when I got to Winnipeg, nobody was there to meet me. The telegram came a week later. That's what it was like in those days."

"Tell me about Mom."

"She was fifteen years old when I saw her. She came from Drezna. I saw her walking down the street in Rovno with five other girls from the gymnasia. That was high school there. I went to see Zayda and Baba in Drezna to ask if I could marry her. She was so beautiful. She had a tiny waist. . . ."

I nod. I had tried to fit into one of Mom's old shirtwaists and couldn't button it.

"She had a long thick braid. She played the guitar."

I know the guitar. It is inlaid with mother-of-pearl and has seven strings. We still have it, but Mom never plays it now. She only works in the store and once a week goes to New York with Pop on a buying trip.

"Drezna was a *shtetl,* a tiny town. Baba ran a dry goods store, but Zayda was a scholar and a lawyer. She gave him *kest,* a dowry. It was an honor to support a man of learning. They said I could marry your mother because I came from a good family. My grandfather died in Israel; he was a learned man. I remember the Czar confiscated his land for a church in 1890. I was there when they laid the cornerstone. I was seven."

"Tell me how you came to New Haven."

"Well, the streets in Winnipeg were not paved with gold, like they said. The sidewalks were slippery and made of wood. The temperature was fifty below zero. My nose would freeze. I peddled to the French farmers. They would yell on me. *Juif! Juif!"*

"What's that?"

"Jew! Jew! And they would send their dogs to chase me and my horse and buggy away. But just the same, I saved money and I sent for your mother, and Baba and Zayda and your Aunt Emma. And your mother and I were married in Winnipeg. Then I caught typhoid and I was in the hospital and I nearly died. I weighed eighty pounds. When I came home from the hospital Baba tried to fatten me up. My own mother, Gittel, may she rest in peace, died when I was nine years old. The doctor said to give me a little water to drink but Baba thought he said I should eat all day long, and she nearly killed me with *knishes* and kindness. But anyhow, I lived. When I got better, I asked her to see a mirror. *'Ich vil zehen mein ponim.'* I wanted to look at my face, but when I saw it I said to Baba, 'Better-looking faces I've seen in the grave.' And so we decided it was too cold in Canada and we went to New Haven, to the United States."

"Where I was born."

"Where you were all born."

At the first farm, I am offered warm, foamy milk from a dipper put into a pail. I hate it, but I'm ashamed to say no.

"It's fresh from the cow," says Pop.

Politely, not to shame him, I drink it and wipe off the white

mustache left on my upper lip. The farmer's children look at me with surprise, and no wonder. Over my fancy dress of baby-shit-colored chiffon with green ribbons cascading from my shoulders to my hips, I wear a brown-and-white ponyskin fur coat.

"I don't want it," I said sullenly when Mom brought it from a wholesale house in New York.

"Vy not?"

"Nobody else has one."

"That's the beauty part. It's a semple. It's the only vun."

I don't want the beauty part. I just want a mother like Catherine Sisk's who is always home when we come from school. I have Zayda and Baba, but they are old. I envy the Yankee girls with their young mothers and their ordinary cotton gingham dresses and the white gloves they carry in their hands not to get them dirty. I hate my fur coat.

At least I have my father all to myself on Sunday. I sit up straight and proud next to him in the Reo and hold a box with a dozen large eggs carefully in my lap.

"Every one of those eggs has a double yolk. Every one is a twin. The farmer collects them just for us," Pop says. If the farmers have no cash, they pay us off in produce.

In the back of the car there may be a live chicken or a duck or a honking goose. The poultry stalks in the cellar until the day of reckoning. Who kills them? I never know. The *shochet*? The kosher butcher or Pop? Nobody tells me. On Sunday, I burst into tears and run from the table. I named them. They were my friends.

Pop's faith in extending credit to his Polish and Italian customers pays off. The store prospers. We are raised in the social structure when we move from the ghetto of Grand Avenue to our own house on Orange Street. Great elms line the street of two- and three-family houses. Ours, Number 709, is a mirror image of the house next to it. We live on the second and third floors. The first is always rented.

Orange Street leads straight to the glory of East Rock, whose jagged rocks rise like the Acropolis to a plateau overlooking the

city. Down below is the harbor with tiny boats. There are factories puffing smoke, miniature houses, and Mill River twisting affectionately around the base of this glacial miracle.

Discovering the paths up this mountain, I struggle to get up a small incline. A man is watching me.

"Here. Let me help you."

He lifts me up. Oddly, he has put his hand squarely in my crotch to do so. Frightened, I scramble up myself the rest of the way. Looking back, I see him smiling. He waves at me. I run as fast as I can back down the path, back to safety.

Running up the stairs at our house, I pass a standing lamp on the landing. It is made of fake gold plaster and is crowned with a green Venetian glass shade. I pass a crouched Venus with a vase that serves as an umbrella stand and ascend to a hall with a grandfather clock that chimes the hours and has a brass pendulum swinging heavily in its stomach.

We have all these treasures due to the efforts of my Aunt Rose, wife of my Uncle George Wolf, and an interior decorator in New York. Curtains of iridescent rose translucence shimmer at the windows. There are lined green satin drapes which do not draw, but hang in measured folds fastened by a glass flower star. A large sofa, upholstered in a silky antique rose velvet sits in front of the bay windows. Its frame is a whirl of machine-carved mahogany. A tea table has two concealed leaves that pull out at each end. We never use them, but it is nice to know that they are there.

In the dining-room china closet, catching light like diamonds, cut-glass pitchers, bowls and glasses are reflected in mirrors. A fat brass samovar sits on the sideboard, resting on an embroidered runner. There is a large Spanish table and eight high-backed chairs drawn to it, but we eat here only on Sundays. The kitchen, where Baba presides, is the real center of the house, the stove its black heart.

I run to Baba for solace. She is round like an apple. Her cheeks blush with the pink of a fine network of tiny blood vessels like the crackle on old paintings. Her fine hair is drawn sternly back into a snaillike knot at the top of her head. She smells of Ivory Soap and wash on the line. Baba saves everything upstairs

in the attic, a cozy, cluttered world where I love to paint. The window looks out over the backyard rooftops and the strung-out wet wash that makes a pattern of flapping color. Monday, the laundry is rubbed by hand on a washboard in one sink in the cellar, rinsed in another, and wrung in a mangle by our Polish maid, who hauls the wash up the cellar stairs. In winter, the sheets are frozen stiff and have to be thawed out before she irons them with the heavy black irons she has lined up in military precision on the kitchen stove.

"*Es kimt zu nitz,*" it might come in handy, Baba says every spring when my mother seems to want to give everything to the second-hand man. But Mom hates old things as much as Baba loves them. Mom is jealous when I side with Baba about the old things. She is jealous that I sit in Baba's lap on car trips and hug her when she says, "Look, Lilichka, *cowelech!*" And yet, Mom never hugs me. I am a doll she dresses. And the little brown-and-white spotted cows grazing on green grass look like my fur coat. There is constant warfare. I feel as if I have two sets of parents, but Baba and Zayda are the real ones. They are there. They regard me as a *wunderkind.* I speak English. I understand their Yiddish but cannot speak it. The bad words, particularly, are etched in my mind, sometimes with inaccurate meanings. After school, I sit on the back stairs with Zayda.

"*Du herst,* Lilinyu?" he asks. "If I am not for myself, who will be for me? If I am all for myself, what am I? And if not now, when?" He says this all in Yiddish. "Hillel said it. *Du herst?*"

"I hear, Zayda. I hear."

My sister Gert, the paragon of virtue, sings in a high soprano. She accompanies herself on the upright piano in the hall.

> *Pale hands I loved, beside the Shalima—a—ar*
> *Where are you no—o—ow . . .*
> *Where are you no—o—ow . . .*
> *Who lies beneath your spell?*

It shrills through the house. When she has finished that one, she goes into her other one.

On the road to Mandalay
Where the flying fishes pla–a–y
And the dawn comes up like thunder
Out of China cross the ba–a–y. . . .

My brother Joe, in knee pants, is practicing "Poet and Peasant" on the fiddle. And between her high soprano and his scratching I am losing my mind.

My sister is perfect. She gets to do everything before I do and does it better. But I am friends with my brother, climbing telephone poles with him and his gang.

"Watch out for her," Joe warns. "She's little but she packs a powerful wallop."

And he and his friends run from me as I tear after them.

"Watch out! She has fire in her eyes."

I refuse to take piano lessons. Impossible to compete with my sister. When I am eleven, I take drawing lessons every Saturday with a twenty-year-old Yale art student, Reyna Ullman. She gives me paper, charcoal sticks, and a sandpaper scratch pad on which to sharpen them. I enjoy the black dust it creates. I also have a soft chamois cloth and a kneaded rubber eraser that can be twisted, even into a point. There is a still life set up, usually bottles or other household objects. It is while I am drawing these objects that the infinite possibilities in the way we see things first hits me, a sensation I am never to forget.

Later on, when I am fourteen, I study painting once a week, on Saturday, with an Italian customer of Pop's. Vincent Mondo. He is a church painter who specializes in flying angels, sad Madonnas, and the Christ figure, set against swirling cerulean blue skies.

"Vincent Mondo makes good money at his art," says Pop.

What is bad money? Could I make money at art? I wonder. I have seen some reproductions of a French artist named Cézanne. The work is nothing like my teacher's.

"Have you ever heard of an artist named Cézanne?"

A moment of silence.

"Ceizanno."

"No, Cézanne."

"Yes. Yes. *Ceizanno*. A faker. He cannot draw. Forget *Ceizanno*."

But I cannot forget Cézanne. I try to emulate him. I am working on a painting of my grandfather sitting in a wicker chair. He is an old man in shirtsleeves and suspendered pants. I try to fracture the color, to make the planes turn with warm ochres and cold blues. His face is a mass of small strokes creating form.

I am so absorbed that I do not see the janitor when he comes into the studio to turn out the lights.

He tilts his head to one side, studying my painting.

Sympathetically, he says, "Why don't you ask Mr. Mondo for a tube of that flesh color he uses?"

So much for my theories. Obviously, I am alone in my direction. At least in New Haven.

"Come in, my dear. Don't be shy," says the man in an immaculate dark suit with a white silk cravat knotted around his neck. "I won't eat you."

I'm not so sure. What an odd place to be painting, a store, in full view of the world. Arthur Diehl sits at his easel surrounded by landscapes from all over the world.

"I paint, too," I venture bravely.

"I thought you might. I've seen you looking in before."

He has an English accent. His eyes bulge out. They have a terrible intensity.

"Doesn't it bother you, people watching?"

"Not at all. Sit down, won't you? Be comfortable."

I sit on the edge of a stool. He continues working on a scene that seems to be Morocco.

"How do you know about the light like that? How do you remember it?"

"I worked for years from nature. Now it is all there, a reservoir I can tap."

"What do you think of Cézanne?"

Mr. Diehl has a spot of viridian green on his fingers from a tube he has just squeezed. He wipes it off carefully.

"I think he's a great artist. The greatest."

"My last teacher told me he couldn't draw."

"He can draw."

I am not alone. Suddenly I have a friend, and he seems to regard me with respect.

"Let me show you something. This is a six B pencil. Very soft. I want you to practice this." He draws eight vertical lines, varying in intensity from the blackest black to the palest gray. I try it, but it is harder than it seems to get a hair's breadth of difference between the tones.

I drop in almost daily after school to cull nuggets of information.

"When you're at the beach sometime," says Arthur Diehl, "pick up some sand. What color is it? Separate the grains. Look closely. You will see, it is all colors, even black and blue. Color mixes in your eye. See?" He puts a tiny pat of red on a green area he is working on. "See how much greener the green is now?"

Mr. Diehl puts aside his landscape and takes up a strange painting of a Sphinx with a real woman's head. She is resting it on her hands, crouching as if she is about to spring.

"Would you mind posing for this? I'd like to get the hands right."

I rest my elbows on a table, hold my head in my hands and try to look inscrutable. Around the store and in the windows are paintings of Cape Cod—a place called Buzzards Bay and some of Provincetown. On the wall is a drawing of people in early American Pilgrim clothes. They are sitting with their heads and hands through wooden contraptions.

"I call that 'Stocks and Bonds,'" says Arthur Diehl, as he sees me studying it. "Would you mind shifting your hand a little to the left?"

I am glad he does not touch me. We are quite safe behind that store window with the whole world watching. I'm sure of that.

"I'd love to travel everywhere, to see everything. But I don't think my parents would let me," I confide.

"'To hold by letting go. To lose by holding,'" says Arthur Diehl.

What a profound thought.

"It's not original," says the artist.

Freehand

One day, after a long school holiday, I walk back to the store studio. It is empty. As if it had never existed. The paintings are gone. Mr. Diehl has disappeared. The small tabouret is gone. In the window is a small sign. FOR RENT.

Now that Arthur Diehl has disappeared, I start a notebook in which I talk to myself about art.

I look at the paintings I have done. I'm dissatisfied. The one of Zayda in his shirtsleeves and baggy pants with suspenders is not bad, but there is too much Cézanne influence. Yet, I've decided he's a good one to follow.

I have started a portfolio of reproductions of modern artists' work. I cut them out of magazines.

There are no good exhibitions here. Nothing like New York. The only good thing is the Jarvis Collection at Yale. Right now there's an exhibition by a Prix de Rome student from Yale. What a bore. Nothing new.

"You're Gertrude's sister," my new teachers say at Hillhouse High School. "We hope you will do as well as she—all A's."

I know I won't. I will do well in the subjects I like, but I am not a grind. When I bring home a report card with three A's and a B, Pop says, "Why didn't you get all A's?" A C is not acceptable. Failing is out of the question. I decide to coast through. I love English and French. Math is impossible. In study periods, I look out the windows so tall they have to be pulled down with a pole. I watch two clouds in the sky drift together to make what seems to be a huge lion's head. A black spider derrick bisects my picture. The bell rings. Latin. Miss Watrous.

I am so nearsighted that I am always given a seat in the first row. I can see better that way, but I am also seen better by the teacher.

"There are only three major events in anyone's life," my Latin teacher shouts. "You are born. You get married. And you die. I skipped the middle one. I've only one event to look forward to and before that happens I'm going to drum some Latin into you."

She pokes her finger straight into my middy blouse.

"You!" she thunders. "Miss Perelmutter! Translate this passage."

I stand beside my seat and read hesitantly.

"Are you *sure?*" Miss Watrous bellows.

I am not sure. I get up again and attempt a whole new version of what is going on between Dido and Aeneas.

Miss Watrous folds her arms triumphantly over her large bosom. A spinster has no right to such a bosom.

"You were right the first time, young lady. Stick to your guns. Stick to your guns."

I feel my face turning red. You only die once. But I have learned something. If I'm going to bluff, I'd better stick to it.

I am in love with my French teacher, Miss Wilbur. She learned French in France. Her father was an ambassador or something. I want to have a beautiful accent like hers. When I take a bath I run the water hard to mask the sound of the guttural r's I am practicing. She singles me out for a great honor. I am to have lunch with her and help her grade the term papers.

Prospect Street, where she lives, is not for Jews. It is off limits, like the Lawn Club. The Harmonie Club is for Jews. There is a caste system in New Haven. Old money is secure. At the Shubert Theater on opening nights, the smell of mothballs rises high from the old sealskin coats worn by Yankees. They do not need to wear mink. I notice that the class lines, now that I am fifteen, are beginning to tighten. I am no longer invited to birthday parties of my Christian friends. There are sororities and fraternities at high school to point up the differences. Some are for Protestants only. Some for Catholics. Others for Jews, upper or lower class, German or Russian ancestry. Rich or poor. Sharp lines.

Lunch is meager. I can hardly believe it. Baba would be horrified. No wonder Miss Wilbur is so thin. She eats nothing but raw carrots. I munch away while I am correcting papers. When I get home, I cover a piece of rye bread with thick slabs of butter and eat half a juicy salted tomato with it.

"Your poetry," says Miss Garvan, my English teacher, "has the delicacy of a Fragonard."

Freehand

I look up Fragonard in the public library and revel in the comparison until I hear Miss Garvan tell another girl the same thing.

I am in love with the handsomest boy in the class. I think of him as a cross between Buddy Rogers and Lord Byron. David Sandler loves poetry as I do. He is tall, with thick black wavy hair. His eyelashes curl in a way I can only achieve with an instrument of torture that pinches my eyelid every time I use it. David's smile exposes perfect white teeth.

Once in a while, on Sundays, our family goes to Sandler's Kosher Restaurant where David's mother, unseen, does the cooking and his father bustles around the tables. I always look for David, but I never see him there. I try to peek backstage where the waiters, balancing large trays of *latkes* and *flanken* over their heads, fly to and from the swinging doors of the kitchen.

David's father is everywhere. I can't help seeing him. He is enormously fat, full of his wife's good cooking. Her chopped chicken liver swims in golden fat. Her *knishes* puff lightly. Her mushroom-barley soup is so thick there is hardly any liquid in it. I shudder when I look at David's father. How unlike they are!

All the girls in school are in love with David. To me, he is the unattainable. I have nothing to offer. I am mousy, flat-chested, and plain. *They* have breasts bursting in their brassieres. I don't even wear one. *They* have long, manicured nails. I bite mine. I wear glasses. Evidently they don't need to see things far away. The crucial difference, I'm sure, is that *they* go all the way.

One night at seven o'clock, the telephone rings. It is David. I'm sure he is calling about a class assignment. But no.

"I love you," he says in a quiet voice.

I cannot believe it.

"What did you say?"

"I love you," he says. There is no mistaking it. The miracle has happened. We hang silently on the phone. An electric stillness.

My brother and sister scream with laughter each night at seven when David phones. We talk little, preferring to hear the quiet waves flowing between us. Our love is a platonic one. I can tell because on the all-important Saturday nights, David and

23

Jerry Adelman cruise Chapel Street. David lets it be known that I am a nice Jewish girl who reads poetry. A different category from certain gentile girls who do other things. I resent this, but there is nothing I can do about it.

Romantically, David and I walk up East Rock. We take a small book of Shelley with us and read poems to one another. The day seems so sacred that we decide to bury the small volume under a tree. We push aside leaves, dig a hole with our fingers, and hide it.

"Someday we'll come back together and dig it up," says David. But we never do.

I am visiting my girl friend, Winnie Shalett, in New York. Winnie's mother doesn't like me, and I know it. You-are-a-bad-influence-on-my-daughter is what her mother conveys to me with her disapproving looks. Doesn't she know it's the other way around? Winnie is the instigator and the perpetrator. *I* would never think of taking a needle and thread with me to dances and sewing my name and phone number into the lining of a boy's coat. I am in awe of Winnie.

I didn't want to leave New Haven that weekend at all, because Zayda was sick, but Pop insisted I go. Zayda kissed my hand, looked lovingly at me with his pale blue eyes, and said, *"Geh gesunterait."*

Winnie and I return from the movies—Al Jolson in *The Jazz Singer*. We are spent with tears. Our eyes are swollen into red slits. Winnie's mother is angry. We are late getting back. She is right in the middle of a lecture when the telephone rings. It is Pop. He says that he had to take Zayda to the hospital after I left. He is dead. Of leukemia.

Winnie's mother, overwhelmed by death, is all solicitude. She helps me pack and puts me on the train to New Haven. I feel like a clod. I cannot cry. I am all cried out from the film.

When I get home, I find that Zayda is there. He is in the living room in a casket, his beautiful head resting on white satin, his eyes closed. The house is full of people. I feel betrayed. Here they have killed Zayda off while I am gone. Never again will he kiss my hand, making me feel like a Russian princess. The din-

ing room is a circus full of clowns, shoveling food into their mouths while they sing the praises of my grandfather.

"A learned man."

"*A sheiner mann.*" A beautiful man.

"*Azamin philosophe.*" Such a philosopher.

"Pearls of wisdom from his mouth . . ."

"A lawyer in the old country."

Some of them stop eating long enough to observe, "The little one isn't crying."

How can I cry in this house full of people? I'm angry at them for being there. I won't share my private grief with anyone.

Mom cries a lot, but I see her catch her own eye in the mirror as she passes it and preen at her image in her new black dress.

"I carried him in my own arms like a baby to the hospital," Pop says. "He was like my own father."

And Baba is just a peasant without Zayda's phrases to lift her into another sphere.

Late at night, while the *minyan* of ten men is praying around Zayda, I look at him again. He was so vain. He loved it when I drew him. . . . I get a sketchbook and a pencil. The men move their chairs away so that I can stand near the casket. I draw Zayda as if he were sleeping. Again I explore the deep sockets of his eyes, his sharp nose, the fine vaulted arch of his forehead and the hairs of his Vandyke beard. It is only as I finish that it dawns on me. I meet death head-on, like a collision. I realize this isn't Zayda at all. This is a smiling cadaver, a masterpiece of the mortician's art.

I am grown up. Shopping. Almost sixteen. I pretend to be blasé as I watch the salesgirl in Shartenberg's Department Store ease a pair of white kid gloves on the shiny wooden fingers of Belgian glove hands that stand on the counter. I remember to straighten the back seams of my stockings that are fastened to a lacy garter belt. I wear crepe de chine chemises, georgette dresses, and cloche hats. I crisscross my arms wildly over my knees when I do the Charleston or Black Bottom. I am a flapper, modeling myself on John Held, Jr.'s drawings.

My brother is going out with a girl who was in my class at high

school, Elaine. Gert approves. The Langrocks have a big store in downtown New Haven and sell clothes to preppies and Yale boys.

I am in love with a friend of my brother's, an older man of twenty. Hecky Rome. Everybody calls him Hecky. His real name is Harold. My family thinks he is peculiar. A poor boy who has spent three years at Yale Law School only to decide he doesn't want to be a lawyer at all, but an architect. He has switched to Yale School of Architecture and earns his way playing piano at Miss Day's Dancing School where short little boys push taller little girls around in a fox-trot or waltz.

I find him a wonder. I think it is sensible not to have your life gobbled up working in something you hate. I am in love with Hecky's sidelong glances as he plays the piano, with his dimples, with his thick, wavy hair, and yes, even with his glasses. I like talking to him about art, about books, about everything.

One night the phone rings. Hecky asks for my brother.

"He's not in."

"Oh. I was going to ask him to go to the movies with me."

"He's not here."

"Oh. . . . Well, do you want to go to the movies?"

My heart pounds. I'm sure he can hear it over the phone.

"I'd really like to," I say, "but I won't."

"Why not?"

"Because," I say, "if you want me to go to the movies with you, don't pretend you want my brother. You know perfectly well he's out."

"Would you go to the movies with me?"

"Yes."

> *My heart goes out to you*
> *In melody. O can't you see*
> *That's my way of telling you*
> *A lot of things that aren't true.*

I drape myself over the upright piano in the hall while Hecky plays me the song he has written for me. I am enthralled. Hecky is my brother's friend. I deserve a corny respect and, to my

dismay, I get it. It is torment. There are long kisses goodnight. Necking only. Petting is too dangerous. I am convinced that the reason we are in this exquisite agony is that I am a virgin. The best thing to do is to be rid of this, to be deflowered by someone else. That won't upset the code. But it is not easy. Sidling up to boys with that suggestion doesn't work. It scares them. Some of them are virgins, too. Meanwhile, Hecky and I coast along.

In the class yearbook at graduation from Hillhouse High School, the principal advises us that we should obey our conscience, that it sets off "stop" and "go" signals and that we mustn't think that we can take chances and get away with it. We are forced by the inexorable laws of life to "pay the price." A lady on the faculty photographed with a wreath of artificial flowers resting on her long hair looks out tenderly and suggests we "carry a vision of heaven in our hearts." I am glad to be going away from all this. I expect to take chances, to pay the price, if any, and to get on with it.

August. My sister Gert had spent a month in Provincetown. Now, as usual, I am allowed to follow in her footsteps. I am to study art with Charles Hawthorne's assistant, Henry Hensche. Pop and Mom drive me there. I sit in the back seat with my black tin painting box while we follow Route 6A along the shore, weaving through Hyannis, Dennis, Orleans, Wellfleet, Truro, and finally, Provincetown.

The landscape changes. The pine trees get smaller and smaller. Naked dunes rise up on both sides of the road. Trees, engulfed in sand, have their roots exposed. Heather and low bushes nestle on the pinky-beige of the dunes, like pubic hair on a large nude.

As we reach the top of a hill, there is a ludicrous row of tiny beach houses. They have flower names to differentiate them. Petunia. Morning Glory. Rose. Marigold. Delphinium. Hollyhock. Aster. Crocus. They are all exactly alike, with the staccato of ocean blue gleaming behind them. On the other side of the road is Pilgrim Lake. Looking ahead, I see the whole of Provincetown. It is looped out into the bay and the Atlantic Ocean, curled like a puppy dog's tail. All the buildings, low and horizon-

tal, are interrupted by a rising vertical monument that looks like a Sienese tower.

The streets of the town are narrow, with great trees and small houses, gray-shingled or painted white with differently colored shutters. Hollyhocks stand almost as tall as the houses. I am to stay with a Portuguese family. Room and board are eight dollars a week. Mom admonishes my landlady to "take good care of my baby." I wince. Pop, his shoulder stiff with bursitis from the long, twelve-hour drive from New Haven over all those curvy roads, winces too.

As soon as they are gone, I fly down the west end of Commercial Street, sniffing what seems to be a watermelon smell in the air, but it is only low tide. The waters recede so far that I run up and down the low flats, in and out of tide pools laced with froth and seaweed. There are treasures everywhere. Bottles transformed into milky opalescence. Skeletal bits of fish, small white sculptures. Horseshoe crabs trudge stubbornly in armor. Snails I pick up retract their feet hastily into their tiny houses. Far out, the fishing boats are coming in with their orange masts vertical against the horizontal ocean. A special light exudes from the water and sky. I am drunk with it, bathed in it, purified by it.

I take a great lumbering Paige Brothers bus careening down Commercial Street and ride out to the Provincelands for a nickel. Then I take it back to town. I attend my art class spasmodically. It is full of old ladies in smocks painting jugs and flowers. Wandering on the dunes, I meet a handsome Portuguese boy who puts ships into bottles. I think he is a genius until Julia, the elocution teacher from New Haven who is supposed to be keeping an eye on me, says at dinner, "All he has to do is pull a string. That releases the sails." I feel betrayed.

One day, walking on the flats, I hear music coming from a Victrola up on a wharf. Girls are dancing, trying out for the part of a gypsy dancer in a new show at the Wharf Theater.

"Would you like to try out?"

I would. I improvise a little dance. At night, for a whole week, I dance in the show. Afterward I go out with the actors. The male lead is handsome but beginning to wrinkle. Boris Glagolin, a Russian character actor, whispers to me, "When I am too old

to *make* love, I am too old to *play* love!" Sitting on a barrel and staring at a candle dripping great globs of wax all over the table, I feel I am really living. During the day, I wear my costume in the street just to hear people say, "She was the gypsy dancer in the play last night."

My sister Gert is getting married.

"But what about your course at Yale Drama School?"

"I'm going to make a career of marriage."

How do you do that? I wonder. Is marriage a career?

"By you next," everyone says.

The fiance seems almost inconsequential in all the activity. He is quiet, almost shy. My sister is made of stern stuff. As a child, she punched holes with a pin in raw eggs and sucked out the insides. Just the thought of it makes me sick.

"But how do you feel about him?" I ask Gert.

Her engagement ring flashes sparks as she addresses envelopes that insert into other envelopes. The announcements are from Tiffany's. The ring, like everything connected with my sister, is flawless.

"I feel fine."

"Don't forget," says Mom, "put on the list, from our side, the Wax family in New York."

"But what about the theater? I thought you wanted to work in the theater."

"In case you didn't notice," says my sister sarcastically, "it's not so easy to get a job. College girls are fighting to be elevator operators in Macy's. I told you. I'm going to make a career of marriage."

"But do you love him?"

"Love, shmov," Mom says. "What is there not to love? A nice boy. From a good family. Phi Beta Kappa, even. It doesn't hurt."

"All this stuff . . ." I wave at the mountains of mail, the long lists. "But nobody talks about whether you love him or not."

My mother and sister regard me with surprise.

"You don't love him."

Gert smacks me across the face. Hard.

"You shouldn't upset your sister. She's upset enough already."

My face smarts. Nobody ever hit me like that. Ever. I had struck some nerve in my sister. She is settling. "Settling down" is the expression they use. It scares me. It sounds miserable, like giving up. Is that what she is doing? I will never give up. I don't think my brother Joe will either. He must not be so crazy about Elaine, because he is seeing other girls. I think he will be a rebel like me. He won't do what they expect him to.

The day of the wedding is perfect. It is held in a rented summer villa, a stucco madness at Woodmont, built by Sylvestre Z. Poli, an Italian owner of a string of movie dream palaces. I have had my bitten nails manicured and painted a brilliant scarlet. My hair is set in marcel waves.

After the wedding, the two Gordon brothers, Ernie and Bob, want to know if I will go out in a canoe with them. Why not? The show, as Mom puts it, is over. My sister and her husband have departed for their honeymoon. The caterers are sweeping up the rice on the veranda.

I sit in the bottom of the canoe. The boys paddle out so far that I can barely make out Baba's little fat figure sitting on the beach. They rock the boat from side to side.

"Stop it. You'll get my hair wet." I hold my hands protectively over my marceled head. I should never have shown fear. Over we go. I am taken by surprise, but as the gunnel looms above me, I remember instructions from camp. If you should be in a boat that overturns, reach up and grab the gunnel. I reach up to grab it, but it grabs me first. Right in the shoulder. I hear a crack and feel a sharp pain. The boys are holding the edge of the canoe and laughing.

"Something is wrong with my arm. I can't swim."

"Go on. Swim to shore. We've got to bring the boat in."

Nobody is going to help me. I dog-paddle with my right arm. It seems like miles to shore. When I stand up in the shallow water, my body is distorted. There seems to be a declivity where my shoulder should be.

"Lilinyu. Lilinyu," says Baba.

Someone drives us to a doctor. I am sure there is no way in which I can be put together again. Water drips from me as I sit on the examining table.

"Relax," says the doctor. My body tightens further. "I'm afraid you're too tense for me to set it. It's dislocated."

I yield in gratitude to a whiff of orange-smelling cheesecloth and lose consciousness. When I come to, my shoulder is round again, my left arm in a sling. Baba is there to take me home. Pop and Mom are, as usual, somewhere else.

I am going to be a painter. It is too ostentatious to say I am going to be an artist. I am supposed to go to college.

"Your sister graduated cum laude from Smith," Pop and Mom remind me. "Your brother went to Yale and Yale Law School." I know Joe is going to open an office in Seymour, a little town nearby in the Naugatuck valley. "William Lyon Phelps said the valley is the asshole of the nation." I am shocked to hear that one of my brother's professors said such a thing. "But I don't care. They need a lawyer there." Does he want to be a big frog in a little pond? I think I want just the opposite.

"Gert quit the Drama School at Yale," I point out.

"Only because she met Lou," Mom says. A good marriage excuses everything.

When Mom and Pop ask me which college I want to go to, I say, "The University of Wisconsin."

"*Vus is dus,* Visconsin?" asks Mom.

"It's out west."

"Vest? *Vus is der mer vit* schools east? Smith *oder* Vellesley." She regards an invisible audience. "For Lilinyu, must be different."

"If I have to go to college, that's the one I want. They've got an experimental program there run by a Professor Alexander Meiklejohn."

"Meiklejohn Shmeiklejohn," says Mom. "Nobody knows from it."

"Maybe I could go to Yale Art School," I suggest. "I'm going to study art anyway."

"You could live home," says Pop, "and take the Orange Street bus to school."

So it is decided. In the back of my head is the thought that Hecky is at Yale Architectural School.

"Painting is a nice hobby for a girl," Mom says.

"It's my life work," I say.

"Anyhoo," says Mom, "it's a nice hobby."

"My dear young lady," criticizes Professor Diedrichsen, looking at my charcoal drawing of a white plaster cast of a lady covering her privates with a limp hand, "pectorals are not doorknobs." They might as well be. When am I ever going to draw from life? In the Gothic halls of the Yale School of Art, life moves slowly toward a Master of Fine Arts degree. Five years, although I have managed to shave off the first by presenting a portfolio of cast drawings like this. And still I am supposed to continue working with dead stuff.

To my amazement, as if this were not a graduate school with students as old as twenty or twenty-one to my almost seventeen, we are graded on our work. Like high school. The purpose of the school seems to be to aim for the brass ring—the Prix de Rome. Yale always gets it. I will never make it. I don't want to try. I don't want to teach, either. I want to paint.

In addition, whatever I do seems wrong. Noticing that some of the girls wear pants, I go to Shartenberg's and buy some. Unfortunately I cannot find dark ones, and so I buy what they have. Orange overalls. In class, I notice that fifth-year students are standing behind me. I assume, as they look over my shoulder at my painting, that they are admiring my work.

The dean of women calls me to her office.

"Pants," she says, "are worn only by fifth-year students."

"I didn't know."

"And also, Miss Perelmutter, word has filtered down to me that you often wear jodhpurs to class."

"Only if I'm going horseback riding after classes," I mumble.

"That will cease. In the future you will wear normal clothes and a smock over them."

At last, released from plaster casts, we are in still life, but even there we set up dusty objects. A copper bowl. A wax apple. A tired piece of cloth. Why do I get 89 as a mark? Why not 90? Or 6? How do they judge? I know that there are moments in the middle of these dreary arrangements when I feel that something

beyond me has taken over, when I paint well. Can they judge this? Should they?

I make another gaffe. I decide I want to paint a living object. A fresh apple, perhaps, or a pear. I go to State Street and walk around. A silver fish catches my eye. I take it to class. It is winter, and each night for a week I place it outside on the snowy ledge to freeze. The silvery scales are fun to paint.

I am called to the dean again.

"You are not to bring perishables of any kind," she says firmly. "No fish, no fruit, nothing in the way of food."

"What did she want?" asks Lois, my best friend.

"No fish. No fruit. No art, either, I guess. Just a bunch of dumb rules."

Lois is so beautiful with her white skin, dark hair, and her chin that flows smoothly into her graceful neck, it is no wonder that John Canaday, a lanky fifth-year student, is in love with her. When we are washing brushes sometimes the three of us play a game of throwing cone-shaped paper cups of water over the partition. Not this day. This day I can take no more chances. I might hit Miss Penrose.

I take a train to New York to see a first loan exhibition in the Heckscher Building at Fifty-seventh Street and Fifth Avenue, by a group that calls itself The Museum of Modern Art. There are paintings by Cézanne, Gauguin, Seurat and Van Gogh.

The galleries are crowded. At last I see original paintings by my idol, Cézanne. Vincent Mondo was wrong. He can draw. I am stunned by an early self-portrait, the color laid on so thick that it is already crackling. In it, the artist has a small mustache and a beard. Going on to the later self-portraits, Cézanne's color gets thinner, his form more ample and his beard more luxurious. I love a harlequin and the painting of Cézanne's wife sitting "like an apple" and paintings of apples architecturally solid enough to last for centuries. An aisle of trees has the abstract quality of an oriental rug.

Gauguin's bold color, his Tahitian ladies, his "Spirit of the Dead Watching" answer my own dream of far places. Seurat's "Sunday at La Grande Jatte" is too cerebral. It takes me a long

time to appreciate his pointillism and relate it to Arthur Diehl's sand colors that mix in one's eye.

My heart leaps with Van Gogh's cypresses climbing up to a whirling sky, his poppies, and the spears of iris that grew near the asylum whose corridors and arches he painted. I had read his letters to Theo and suffered with him, but the glory of the work obliterated the pain.

Carried away with the show that violates everything I am supposed to be doing at Yale, I venture east down Fifty-seventh Street to Number Nine where a sign says "New Art Circle." I walk up a flight of stairs and discover the man who will be my mentor, J.B. Neumann.

He is a dealer from Munich and, I am soon to find out, a great appreciator. He seems to give himself to the artist in worship. Next to Rowlandson, El Greco, and Hieronymus Bosch, the walls are hung with Klee, the young Lee Gatch, Max Weber, and a primitive painter, Arnold Friedman, who works as a postal clerk. Neumann makes no differentiation in time between artists, and sells the dead to support the living.

On Sundays, J.B. goes to the Metropolitan Museum. Sometimes I join him in his mad rushes through, learning how to see, stopping with him in front of a new acquisition, a Van Eyck diptych, and studying the descent to hell and the ascent to heaven through a magnifying glass. Every inch is monumental.

Neumann doesn't treat me indulgently, as my family does, as if art were a hobby and I a little pig waiting to be sold at the marriage market. He treats me respectfully, delicately, as if I were the artist I hope to be.

"You live in New Haven. Have you seen the Jarvis Collection?"

"It's in the building where I go to school."

"We'll look at it together. I'm coming to New Haven. And after that, I'll come to your house and see your work."

We meet at the Yale Gallery and walk rapidly through the room full of early American ancestors until we reach the thirteenth- and fourteenth-century Italians. Neumann likes the earliest periods, when men's eyes were innocent. I appreciate Giotto and Sassetta's purity and am caught up in the tempera pale

green underpainting of skin tones washed over in warm glazes, the flying magenta robes, the Christ figure as a baby with a fat belly and curling toes.

Later, in the den at 709 Orange Street, I kneel before J.B., who sits like a Buddha, while I take drawing after drawing from the portfolio that holds all the work of my seventeen years. When he nods, I place that one in a special pile. It is sacrosanct. It has been blessed. The ones he does not notice go in another pile. I make a bonfire of them.

Neumann likes my painting, my most ambitious one so far— "Family Group." In it I have Baba as a round-bosomed peasant. She has a babushka on her head. I appear twice. Once as a little girl nestled into Zayda's arm, and again as a bride, inclining my head toward a slit-eyed boy who only I know is Hecky without his glasses.

Rising from my votive position, I see that Neumann is looking at a charcoal drawing of two fat *putti*, one of them blowing a trumpet. It is done from a plaster cast. Mom was so proud of its accuracy, she had it framed.

"What's that?"

"I did it at school."

"Oh. I thought it was a photograph."

He has spoken volumes. He is the ultimate maven. I know now that the direction I want to follow deserves all my efforts. Courage and conviction, I say to myself. Courage and conviction.

History of Ornament is my nemesis. I can never catch up. I shall be forever in Egypt, in the land of the lotus motif. It is all because of my shoulder. Ever since the boat accident on the day of Gert's wedding, it keeps slipping out of joint, and finally it is operated on. Doctor Henze removes three quarters of the tendon in my left leg to tie up the bone in my left shoulder. I walk with a crutch and have my arm in a sling. When I return to school, I try to catch up on Byzantine ornament, but I cannot seem to make it.

Now, in addition to hating what I am learning, or not learning, I am fearful of failure. I yearn to escape. My cousins in New

York have spent a summer at Isadora's sister Elizabeth Duncan's Dancing School in Austria. I seize on this as a springboard to freedom when the doctor says exercise will benefit my stiff arm and leg. I have an ally in my cousin Rose, Tante Bronfin's daughter. Housebound, wanting escape from the daily insulin shot she must administer to her diabetic mother, she and I talk about freedom. Rose convinces my parents that it is all right for a young girl to go to Europe alone. Perhaps Mom is tired of my thrashing around and wants to be rid of me.

"Gertrude Bonime is in Paris. She could meet Lily and take care of her and see that she gets to the school." Since she is my uncle Dr. Wolf's sister-in-law and a concert pianist, her credentials are impeccable.

Isadora Duncan. I have read about her life and tragic death. I expect to live my life with her intensity and panache.

Success. It is unbelievable. Here I am, on the deck of the *Lafayette,* on my way to Paris. Endless possibilities are before me. It is impossible to imagine them all.

A very short man approaches. He is about my height, five feet three. He carries himself like a small German general. His back is very straight and his hair is clipped so short it stands straight up, like grass.

"Allow me to introduce myself," he says in dulcet, deep tones. "I am Prince Michael Romanoff."

"I am Lillian Perelmutter. From New Haven."

Is this a prince? He looks more like a little Jewish tailor who might work for my father on Grand Avenue. I try a few Russian words on him.

"I do not speak Russian with commoners," he says, but softens that insult by adding, "That's a very pretty dress."

It is a sample, right out of one of Pop's wholesale houses. The better line. The best line, in fact. Nineteen ninety-five.

"But," continues the prince, "you're not wearing any jewelry with it."

I put my hand self-consciously to my bare throat.

The prince grabs my other hand, puts something in it and stalks away rapidly, proud and erect.

I look down and see a string of pearls coiled in my palm. Oh, God! Here I've only been away from New Haven a few days, and already I've been compromised by a perfect stranger. I know the rules of the game. Flowers, yes. Candy, yes. But jewelry, no. Underwear, furs, motor cars, no.

I run after the prince, but he has vanished. I bump into one of the seventeen Princeton boys I'd met at dinner the night before. Up until now that was the high point of my trip.

"Do you know there's a stowaway aboard?" Paul asks. "They say he lives in one of the dog kennels on first class and only comes out at night. In a tuxedo."

The prince. A stowaway. Does he go around laden with Woolworth gems to foist on innocent young girls? I hide the pearls in my cabin, look everywhere for the donor, but cannot find him until we get to Europe and Customs. I wave to him, but he avoids me. "Ignore me" is the frantic message in his eyes. Now I am sure I am smuggling in the Romanoff jewels for him.

Where is Gertrude Bonime? She is nowhere. A man in uniform, a concierge, approaches.

"Your cousin, Mademoiselle Bonime, wishes me to take you to her hotel. Unfortunately she was unable to come. I shall take your luggage."

"Can I mooch a ride with you?" yells Paul.

The streets and the cafés of Paris, although it is night, are crowded with people. Horse-chestnut trees are abloom with large, heavy blossoms. The air is springlike and soft. Excitement buzzes in me.

"I'm not the least bit sleepy."

"Me neither," says my Princeton friend.

As the taxi bumbles along the Left Bank on the Boulevard Raspail, there are cars full of young people in costumes. They are half-naked, yelling and screaming.

"It's the Medical Students' Ball," says the concierge. He shakes his head disapprovingly. "It's worse than the Quatres Arts Ball, and that is bad enough."

At the Hotel Cayré desk, there is a note from Gertrude. She hopes I will have a good night's sleep. She will see me in the

morning for breakfast. She is sure I'm very tired after my trip. I have never been less tired.

"She's not here," I tell Paul.

His face lights up. "Let's go to the ball."

"But don't we need tickets?"

"We'll crash."

"I'll put my luggage away and figure out some kind of costume. That'll help."

"My hotel's near. I'll check in and meet you at the Café du Dôme. It's just at the corner."

When I unpack, I know exactly what my costume will be. The first two-piece bathing suit ever worn on the beach at Woodmont. My mother heard about it from her friends.

"It has nothing in the middle!" they told her.

"It's the latest thing," my mother countered as though that would remove the sting of my lewd behavior. Fashion over all.

When I put it on in Paris it does not look obscene. Compared to what the revelers in and on top of the cars were wearing, it seems downright tame. To liven it up a bit, I paint a wicked red arrow, pointing downward, on my bare belly. I draw a black heart-shaped beauty mark in eyebrow pencil on my right cheekbone. I make red roses with black stems and leaves twining around my bare legs. I fling a coat over the whole wild outfit.

At the café, I open my coat for a moment.

"Gee whiz!" says Paul.

"Is it good?"

"Good? It's swell! It's great. What will you have to drink?"

"What are you having?"

"Pernod."

Behind Paul, the waiter shakes his head negatively at me. Carefully, when Paul leaves to go to the men's room, I pour the whole drink into a potted palm.

He is full of admiration. "You're some drinker!"

We take a taxi to the ball. I am caught up in my own high spirits. I feel as if I am living a wild, wonderful dream. It is a feeling I am going to have for a long time.

"I'll get in, and then I'll get you in," I whisper to Paul, as the man at the entrance says, *"Le billet d'aller et retour."*

In sign language, I indicate that I'm returning inside. A friend

is waiting for me. I wink at Paul. The ticket-taker doesn't believe me. As if to teach me a lesson, he takes me brusquely by the arm, leads me inside, and says, *"Où est-il?"*

Where, indeed? I look around me. Even if this is a dream, it is hard not to faint dead away. All around me are masses of people, mostly naked. Or almost naked, which is worse. A man with nothing at all on but a bright green penis is looking at me. In my black bra and shorts, even with the painted roses and arrows, I am the most overdressed person in the place.

"Alors, ma petite," says the ticket-taker, *"Où est-il?"*

Where is he? Where is he? I am scared of everyone there. Suddenly I spot a man in a tiger skin that covers him decently.

"There he is," I point, and am dragged over to him.

"Have you been waiting long?" I ask in English.

"All my life," he answers.

Then I am left standing self-consciously with this handsome stranger.

"I am Pierre Duval."

The young interne is with a party of people. It crosses my mind that Paul is outside, and I am supposed to get him in, but Pierre says it is an impossibility and that he will deliver me to my cousin.

"Stay for a while." And of course, I do.

One of the ladies in Pierre's party wears a piece of transparent gauze around her hips and another one over her swinging breasts. My costume doesn't create a ripple of excitement, except to one passing stranger who puts his hand firmly on my privates. When I haul off and slap him in the face, he looks amazed.

There are floats with obscene motifs, huge penises, with naked ladies bound to them. An auction of these beauties starts. People in groups start to create intricate heaps, and it is almost three in the morning.

Looking at my startled face, Pierre says, "Time to leave now. Anything goes. It won't be safe for you."

Outside, Paul, naturally, is nowhere in sight. We all go to Pierre's apartment for breakfast. He makes coffee. His friends mother me as if I were Snow White.

A blush of dawn is breaking.

"Now I will take you to your cousin," says my protector.

Vaguely I wonder what happened to Paul, but I am not really concerned. I have spent my first night in Paris. As Pierre drives me through the streets, I see the shops opening, the bustle of the city, the beauty of the buildings, the workmen on their way to work. I haven't missed one moment.

I rub out the evidence of the lipstick tattoos with cold cream, wrap myself in a huge towel bathrobe after my shower, when there is a knock on the door.

"Who is it?"

"Gertrude."

I'd almost forgotten her.

"I'm so sorry I couldn't meet you. Something came up. Did you sleep well?"

"Like a baby," I lie.

"Well, get some clothes on. We're going to have breakfast. Your first breakfast in Paris. *Fraises des bois* and *crème fraîche*."

Like a pussy cat, I sop up all the cream.

"What would you like to do your first day in Paris?" Gertrude asks.

"I'd like to ride a horse in the Bois de Boulogne."

Out of what romantic novel I have taken this I can't remember, but I must do it.

Gertrude phones a riding academy.

"You cannot ride without a groom."

"OK, I'll ride with a groom."

"And they want to know—do you want to ride like a man or a woman?"

What on earth do they mean? It dawns on me. They want to know if I want to ride *sidesaddle*. Is that possible? Is it still being done? But it must be.

"Like a man."

When I appear dressed in jodhpurs, there is the groom looking like a print from the nineteenth century. He is even wearing a cravat and a high black hat. He looks at me in horror. I can tell he doesn't want to be seen with me, but he is committed.

The trees under which we ride are magnificent; the day is perfect. I do the unforgivable. I gallop.

"*Au trot, mademoiselle, au trot!*" yells the groom. "It is not permitted to gallop in the Bois."

I rein in and am a perfect lady all the way back.

"A cowboy. She dresses like a cowboy. She rides like a cowboy!" he mumbles as we dismount. He accepts money for this hour of torture as if it is soiled. I know I will never ride in the Bois again. Not with him.

I never want to leave Paris. I cannot believe the light, the bridges, the architecture. In the Louvre, I catch my breath at the scale of the Winged Victory, overwhelming at the head of a long flight of stairs. I stand small, staring up at it. None of the photographs I'd ever seen prepared me for it.

"We're going to the Grand Prix," says Gertrude, "with a friend of mine, a New York columnist."

I have no idea what a Grand Prix is, nor do I ask. I am afraid to show my ignorance. I always pretend to know. Faced with an unknown, like a lobster or an artichoke, I act nonchalant, and hope to God someone will make the first move.

"Wear something dressy," adds Gertrude. "It's really like a fashion show."

I wear a long red taffeta dress, buy a floppy black straw hat and black lace mitts, and swing a crocheted drawstring bag from my wrist. Looking in the pier glass, I think I look like a femme fatale.

Gertrude's friend calls for us. His name is S.J. Kaufman. Gertrude calls him Jay, so I do too. He is a portly man who has a hawklike nose and a high forehead where his black hair grows from a pronounced peak. He has a dashing way with women.

The Grand Prix is like a scene from a Degas. The women wear long dresses and big sun hats. In the middle of the day at the horse races at Auteuil, I feel like a long-stemmed red rose. There is such a crowd it is hard to see above the heads of people. Jay finds two little chairs for Gertrude and me to stand on. When the races are over and Jay lifts me down, do I imagine it, or has he slid my body slowly against the length of his?

"It's too bad you aren't staying longer in Paris," he says on the way back. I couldn't agree more. But I am to leave soon. In my mailbox, the day I am to leave I find a note from Jay. *When you return to Paris,* it says, *I shall be at 9 rue Delambre, or you can leave a note for me at American Express.*

I didn't imagine it. I am becoming a woman of the world. When I see Hecky again, he'll see the difference in me. Waving goodbye to Gertrude from the train to Salzburg and watching her tiny figure with its aureole of red hair disappear, I wonder for a moment about her relationship with Jay. But it couldn't be anything. Why would he leave me a note if there was anything between them?

We stand like little dolls in our crinkled Greek dancing tunics.
"Ganz langsam, ganz relaxiert."
We droop like pastel flowers.
"Bend to touch the earth. Feel the pull of the earth," shouts Anita Zahn. "Reach up and touch the sky." Between us, linking us one to the other, long chiffon scarves billow and float.
"That's enough now," says Elizabeth Duncan, Isadora's sister.
We run over the green lawn of the summer palace of the Emperor Franz Joseph. Always with us is Abraham Walkowitz, an artist who had followed Isadora everywhere and was said to be one of the few men who was never her lover. Valky, as he is called, did endless watercolors of Isadora; here he never draws, only sits and watches us going through the familiar dance steps.
We take our showers in the cold cellar. We are hungry, as usual. There will be everything white for lunch. Pasta or potatoes. Something filling. Fattening. The school is poor. There are girls from all over the world. German, Czech, French, Italian, English and American girls. Some had been part of Isadora's dance troupe. The hum of languages is dizzying.
My roommate, Aranka de Rescke is petite and pretty with short, dark curly hair. We rest, lying on our beds after lunch. In the wardrobe our clothes hang. My few and her many.
"Aranka, where did you get all those beautiful clothes?"
"From my mother."
"Doesn't she want them any more?"
"She's dead."

"Oh." She had never told me that.

"They're from the best designers in Paris."

Aranka leaps up, flings a scarf around her neck and teeters around on a pair of satin high-heeled pumps.

"This is Chanel," she says, "This is Lanvin. My mother committed suicide. And my father was dead already. That's why I'm here. I had no place to go."

"I'm sorry," I say inadequately.

"Don't be sorry. Lord and Lady Mountbatten sent me here. They were good friends of my mother's. When I'm old enough, they're going to see that I have a proper debut in London. Don't be sorry. I'm going to have a wonderful time."

Could she be lying? The girls here lie all the time. But Aranka is wrapped in a fur coat and lost in her image in the mirror. The girls talk endlessly about sex. One girl goes so far as to say she has been seduced by the handsome husband of one of the dancing teachers.

My best friend is not Aranka, whom I find bizarre, but an American girl, Carol Lewisohn. She and I exchange glances in Herr Merz's Saturday music classes, which he uses as an excuse to put down American *Kultur*. He says there isn't any. And yet the school is run by virtue of its American supporters. Carol and I find Herr Merz insulting. We cut classes as often as we dare, develop headaches, or say we have cramps. "The curse," we call it.

Herr Merz is friendly with a new politician named Adolf Hitler. Like him, Merz dislikes Jews, and, in fact, I feel an undercurrent of anti-Semitism in Salzburg. A brother of one of the Austrian teachers tells me I am not like the other Americans.

"What do you mean? I'm American like them."

"No you're not. They're Jewish."

"I'm Jewish, too."

"You don't look Jewish."

"Yes, I do. I look very Jewish."

"It's a long distance call for you. From Paris," says Herr Merz as he holds the receiver at his chest and hisses, "It's a man. He says his name is Hecky. Is he your fiancé?"

"He's a friend of my brother's." And with Herr Merz standing

guard and listening, Hecky tells me he and some friends have played their way over to Paris on a ship.

"How long will you be in Paris?"

"Only until the ship sails, a few days. We're playing the return trip, too."

There is nothing I can say with Merz's evil eye on me. When I hang up, I am burning with rage and hatred. I shall run away. I am sick of being treated like a child. First Yale and now this place. I am sick of it.

I have enough money to go third class on the train to Paris. The girls are happily convinced I am running away to meet Hecky, but I am sure he will be gone when I get to Paris. I have no idea what I will do then. In the back of my head is a little voice that says, *Maybe Jay will be there.* And it draws me irresistibly. I go back to the only place I know, the Hotel Cayré. I tried to reach Hecky but he had already left for the States. Gertrude is no longer there. *So much the better,* says my evil little voice. *Now I can do as I please.* I shall be free for the first time in my life. I can hardly wait to see what will happen. But I do not leave any note for Jay at American Express. I mark time. I am afraid.

Wherever I go, I carry Prince Michael Romanoff's pearls coiled in the bottom of my pocketbook. I know what I will say if I run into him. I will take the pearls out of my bag and hand them back to him. "I am not that kind of girl," I will say proudly. My mother would be pleased. But I do not run into him.

I wander all over Paris walking and looking. One day I am eating in a small bistro. Next to me is a French lady with her small daughter. I look in my pocketbook for some object to amuse the child. My hand touches the pearls. I hand them to the child who fingers their roundness. When they are about to leave, the mother hands the pearls back to me.

"*Merci,*" she says, "*vous êtes très gentille.*"

"*C'est rien.*"

The little girl is sniffling.

"*S'il vous plaît,*" I say on impulse, "*accepter les perles comme un cadeau.*"

"*Mais non,*" the mother stammers.

"*Il n'y a pas de valeur*," I say, hoping my high school French makes sense. "*C'est de* Woolworth."

These seem magic words. Mama smiles. The little girl smiles, and I am absolved, as they leave with the Prince's pearls. I will never know if I have given away a czar's treasure or a five-and-ten-cent bauble. Someday, I think, this little girl will grow up and remember the mysterious strange lady who handed her a real pearl necklace in a bistro.

Meanwhile I have written my parents that I am in Paris, that the school was unbearable and anti-Semitic and that, since I am in Paris, perhaps I could stay for a while.

Letters in Pop's beautiful Old World calligraphy come from New Haven. Mom never writes. I doubt if she can. When she is in a restaurant she studies the menu carefully, then says, "Here, Ben—you choose." I have done the inexcusable. I have been invited not to return to Yale. There is a bitter taste in my mouth. Just because I failed History of Ornament. Those academic bastards. Couldn't they have forgiven me, so pathetic with my arm in a sling and on crutches?

I suppose they want me to grovel and beg to come back, to say that I will make up the work. Well, I won't. I didn't like it there anyway. But in the Perelmutter family it is unheard of to fail at anything. Now I am a black sheep. Letters go back and forth across the Atlantic.

What is the matter with you? Pop wants to know. Yale doesn't want you. You ran away from the school in Austria. I write back: It was anti-Semitic. You wouldn't want me to stay in a school that hated Jews, would you? What will you do now with your life? Pop wants to know, as if I am doomed. I'll stay in Paris, I write back. All good artists have to study in Paris. I'll study. No, more than that. I'll study and get a job.

Meanwhile the checks keep coming. I have already pointed out that it is cheap to live in Paris. I write almost daily. I hear a new word: *chaumage*. They are having a depression here as well as in the United States. Reluctantly Pop writes that I may stay, but I must do something—study or get a job. At this point I gather up courage and leave a note for Jay. He wonders why I

took so long getting in touch and finds me a job in a textile-design atelier run by an American friend, a Mr. Gottesman. We swipe Persian patterns from old books. I dip fat sable brushes that taper to a hairline point into bowls of gouache and find that one stroke can make a leaf, a petal, or a stem.

Not only was I right about Jay's reaction to me that day at the Grand Prix, but he makes me feel as if he is the wolf and I am Little Red Riding Hood, a tasty morsel waiting to be devoured. What's more, I want to be. I have decided to be, but I am not in a hurry.

Jay woos me with food and drink. We eat. Dear God, how we eat! In the black-and-white clothes he affects, Jay looks like a penguin. Headwaiters fawn on him, while he puffs with pride at my youth. In addition, he has the power of the press. He writes a gossip column. He can make reputations and maintain them. A coterie surrounds him. Prince Troubetzkoy, a sculptor. Emile Boreo, an actor. Two Peruvian artists—Malaga Grenet and Reynaldo Luza, who draw elongated ladies for *Harper's Bazaar* and *Vogue*. Their ladies in tones of black, white and gray are stretched out to measure eight or nine heads to the body rather than the more normal seven.

"Paris has so much to offer," says Jay. "I want you to experience it all." He looks lovingly at me, as if I were an hors d'oeuvre. "First we'll go to this little Russian restaurant near the Bourse. For blinis and caviar."

We scurry from there to another restaurant.

"They have the best chateaubriand here." A cart is wheeled to our table, while the waiter carves the beef into slices, crusted outside and rare and juicy inside. It is served with round puffy small potatoes that have nothing but air inside them. The *haricots verts* bear no resemblance to Baba's string beans. Vegetables were not her forte. Nor salad, I discover, as the waiter mixes oil and vinegar over delicate leaves, allowing just enough to fall from a spoon to coat each leaf, and no more.

We drink fresh Beaujolais or full-bodied Burgundy. Golden Château d'Yquem sauternes slides down my throat like honey.

Dessert is in yet another restaurant where a tray of *mousse au*

chocolat, pots de crème, or a choice of napoleons or fruit tarts are presented to us. I cannot make up my mind.

"Mademoiselle will try a bit of each," says Jay.

Finally, we waddle off to the Boeuf sur le Toit, where we have demitasse and a fine cognac. Night after night we dine on the freshest fish. I dip artichokes into vinaigrette; rare racks of lamb are wheeled up on rolling tables and sliced; *crème renversée* slides delectably down my throat. All my senses are tingling. It is only a matter of time.

I move from the Hotel Cayré to my very own apartment, six flights up and across the street from Jay on the rue Delambre. The floors are of red clay tile. There is a balcony from which I can see the Café du Dôme. The toilet is one floor down with a sign on the door: W.C. To take a bath I must light a contraption in the kitchen that heats the water and threatens to blow up. But it is my own apartment and I sit at the kitchen table admiring a geranium I have put on the balcony. I refuse to think of myself as a tourist. I haven't even been to the Eiffel Tower.

"There's one thing you must see," says Jay. "The Rose Window at Chartres."

The cathedral is human scale, stone on stone, with unequal spires that reach for the sky.

"Close your eyes," Jay commands. "I'll guide you. Do it my way."

I close my eyes but I want to look at everything.

"Now! Now—look!"

Light is streaming rosily through the stained-glass windows. I am hustled out and not allowed to look at anything else.

"I don't want you to spoil the sensation."

"It was marvelous, unbelievable," I say. I'll come back alone and look at it my way, I tell myself. I'll take all the time I want —not be like a camera zooming in on one spot and missing the whole.

That night is special. We eat a whole dinner in one place instead of leaping all over Paris. We start with snails. "The sauce is so great," I say, "that if anyone stuffed rubber bits of tires in the shells, they would still be delicious."

"Wasn't Chartres wonderful?"

"I would have liked to see more of it."

"Of course it's worth more than one visit," Jay says magnanimously.

I eat dinner slowly. I am afraid. I feel the whole day has been a prelude and that in the long-drawn-out sexual game I have been playing, the stakes are in Jay's favor. In New Haven, there is "necking" and "petting." Here I can see that crossing my legs will be no use. I am going to pay for all the dinners. I'm sure of it. I even want to get it over with. After all, wasn't that my object?

Jay's duplex is dimly lit. Street light filters in through the long red velvet drapes.

"Stand there, in the light near the window."

I stand there.

"Now, take your clothes off. Slowly."

I remove my shoes and draw up my dress in slow motion. I feel like a fool. I stop at my chemise.

"Just raise it, a little at a time."

I raise it, inch by inch. I stand there naked. I am cold.

Jay walks me over to his bed and runs his hand lightly over my body.

"You love this, don't you? Say you love it."

"I love it."

When Jay tries to penetrate me, he can't. I close my legs shut, but he pulls them apart. He is not gentle. I feel an intense pain as his penis enters, and a ripping sensation. I scream. Jay puts his hand over my mouth to muffle the sound. I feel blood running down my leg. So this is what it's all about. I hate it. And more than anything, I hated Jay's hand over my mouth.

Jay is amazed. I am his first virgin. All along he thought I was being coy. He is proud of himself and treats me tenderly.

The next day, I cannot wait for the crazy heater to make bath water. I go to a public Turkish bath. I bathe and bathe. A lady attendant dries me with a big towel.

"Mademoiselle must have her period," she says. There are red blotches on the towel. I am still bleeding.

Instead of feeling I've accomplished my mission, I feel sad. I know I have done irreparable damage to my relationship with

Hecky. And, in a way, I blame him. I am angry at him. If he had allowed the flow of our love, this would not have happened. And now, nothing will ever happen between us. I have fixed it. And I am angry at myself. I have lost my job, too. Jay has left Paris and returned to the States. Mr. Gottesman, no doubt obligated to Jay in some way, calls me into his office.

"You do nice work," he says, "I'm sorry to have to tell you this, but you don't have a worker's permit."

"A worker's permit?"

"You're supposed to have one. I'll get in trouble."

A worker's permit evidently, is impossible for me to achieve. I am not going to be able to get any job now.

Jay's final words to me when he left were said with emphasis and long, dark looks: "The first shall be the last and the last shall be the first."

I certainly hope not.

My biggest madness in Paris is hats. I cannot pass a shop without buying another glorious one. They are so cheap, I forget that I am no longer working to supplement my modest allowance from home. I am broke. One hat too many.

I stop eating and hole in, waiting for the mail. When I come downstairs, the concierge says there is no mail from the States, and I burst into tears.

"What's wrong?"

"I'm broke," I wail. I cannot tell her why. She is so poor, she could never understand my squandering.

"Here," she says, "I'll give you a few francs."

"I'll pay you back soon."

I go to the Café du Dôme, order a café au lait, and put about three teaspoons of sugar in it. At the next table, two girls are talking.

"They want extras. But who can play tennis? I can act. I can sing. I dance. But they want tennis players."

"Excuse me." I lean over. "Would you mind telling me where that is? I need a job."

"Sure. It's at Epinay-sur-Seine. The Studio Tobis. They want a tennis player. *Sans blague.*"

Kidding or no kidding, I'm going there.

At the *boulangerie* across the street, I buy a beautiful baguette of bread and tear off pieces as I march back up the six flights to my apartment. It tastes better than cake. Nothing ever tasted so good.

The alarm goes off at six-thirty in the morning. I iron my tennis dress, still damp, and wonder about makeup. Should I take it or is it provided? I throw my cake mascara that dissolves best in spit, my bright-red lipstick, my rouge, and a hairbrush into a bag.

As I pass the concierge, who sometimes leaves catalogues of art shows in my cubby, she looks at me with sad eyes.

"I'm on my way to get a job. In the cinema. I'm going to pay you back."

"I'm not worried," she says, "but let me give you some advice. If I were you, I'd be careful. Of young men."

Obviously she has been observing my behavior. I have been flinging my favors around.

"Old men are better. They don't get you pregnant," she adds. "And rich men are the best of all."

At the movie studio, a short, thin actor with his face painted a startling yellow-rose leads me to the set. There is a lineup of girls. Across the net of the tennis court, the director, a tall, wiry man, is hitting balls to the girls, who pass a racquet from one to the other.

I say to myself, over and over again, *Keep your eye on the ball. When it is your turn, keep your eye on the ball.*

I hit the ball hard, as hard as I can. So hard that the director is unprepared. It hits him right in the stomach.

"Formidable!" he says. And I have the part.

The job is silly, a sort of Busby Berkeley musical with girls in the shortest of shorts playing tennis, girls walking up and down stairs, girls with feathers on their heads, and girls singing sad love songs to boys. It seems even sillier than its American counterpart because it is all in French. I am never called upon to open my mouth except to sing in a chorus. Luckily my voice is drowned out. I cannot carry a tune.

Enough of this folderol, I think, after the job is over, doing everything but what I want. I enroll in life-drawing classes at the Académie Colarossi, where there are no teachers, only models. And what models! Sometimes I write captions under my drawings—Jezebel, the Whore of Babylon . . . Kiki. . . . None of them does anything but pose. They are not studying to be actresses or artists. They take pride in doing their job well, holding long poses, having infinite variety in the short five-minute ones. To my surprise, in art classes in Paris, unlike those in the States, the male models do not wear jockstraps. I had almost thought they were part of a man's anatomy.

I draw in ink to train myself to be positive, to put something down without fiddling around. Besides, it's more permanent. One of the students tells me about an atelier, a small one, in Montmartre. It is run by Paul Colin. He and Cassandre are perhaps the two greatest poster artists in the world. The students do work projects and at the same time study. One has a chance to earn one's tuition if work is accepted. Colin has more work than he can handle.

There are only twelve students in the class.

We never know what we are going to do any day. Hatboxes stream in.

"For the Folies-Bergère," says Colin. "Paint great flowers on them. Remember, it has to carry all the way to the back rows."

On the days that we draw from a model, I am alarmed to feel my teacher pinching my bottom as he gives me a criticism.

"*Audace*," Colin advises. "*Plus d'audace*."

Evidently he lives by that.

"You will," says our teacher, "at the end of the day have *le bon fatigue*."

But at day's end I still don't have the good tiredness. My glands are going full steam, I am full of energy. I eat alone in a family restaurant, where I have graduated to my own napkin ring. I order soup, eat it, then absentmindedly order something that turns out to be another soup. I look at it in surprise. At the table next to me a handsome American bursts out laughing.

"You must love soup."

"Not that much. I guess I just forgot."

"*Violettes! Violettes!*" a little old lady calls out, going from table to table. The American buys all her flowers. Then he brings them to me.

"May I join you?"

How can I refuse him? Besides, I've never seen a man as good-looking. He tells me his name is Ron Mason. He is an artist. He loves Segonzac's work, and although I am not as intrigued by it as he, I bury my nose in the white violets. Their scent makes me giddy. We drink a lot of wine and brandy. Ron walks me the short distance to my apartment.

"May I come up?"

I hesitate.

"I won't do anything you don't want me to. Please, Lilith." Ron has changed my name. I am to be Lilith. Lilith, he said, was the first woman. Before Eve.

When Ron comes upstairs with me, the most amazing thing happens. He doesn't do anything I don't want him to. But, for the first time in my life I have an experience of total fulfillment. Unlike with Jay, everything leads to a crescendo with Ron, for me as well as for him. Knowing it can happen that way sustains me always, even after Ron leaves for the States. His memory must be as tender as mine, because through the years to come he writes me always. "Dear Lilith," the letters begin.

Mom is psychic about me. How can she tell, across the Atlantic, how bad I am? Pop writes that Mom is coming to Paris to see how her little girl is doing. She is worried about me. Where am I living? What am I doing?

Mom, looking pleased with herself, plump and tidy in a brand-new outfit, seems equally pleased with me.

"You look fine, Lilinyu," she says and shows me off proudly to a couple she has met on the ship. She makes friends easily.

"Mr. and Mrs. Salzman," she says. "I think they are even *meshpocheh*. Relatives. *Landsleit* from the old country. This is my baby." I wince. "I told them you're already in Paris a long time. Tonight, we'll take them to dinner."

"I know a wonderful Russian place." Yes, and I know a

hundred other places. I know all the good restaurants. Jay had seen to that.

At dinner, the Salzmans are impressed with my ordering.

"We have a daughter, Sally, about your age," says Mrs. Salzman. "You will meet her in New York. We have a nephew, a doctor.

Mom beams.

"Who knows?" Mrs. Salzman goes on. "I want you should be in my family." Mr. Salzman says nothing. He does not join in the conversation except to comment, "This is excellent borscht."

Mom, panting after the six flights up to my apartment, is shocked.

"Better than this we lived on Grand Avenue. All the *macharikehs* to light gas. A person could kill himself to take a bath. I vil find you another apartment."

We shop a lot. I get a pair of black suede pumps at Charles Jourdan. They have a silvered edging running all around the instep. We see the perfect hat to go with the shoes. It is in the window of the Grande Maison de Blanc. It is like a matador's hat, of black felt with a stiffened brim. A jaunty silvered feather soars on one side.

"Let's see how much it costs," says Mom.

"You've bought me enough already," I say, full of guilty knowledge about my behavior. Somehow I must do penance. The God of my father insists.

"It never hurts to ask," says Mom.

The tall saleslady who approaches us could be a queen. We are peasants. Undaunted, Mom says, "Ve vould like to see the hat in the vindow. The vun vit the feather."

"She doesn't speak English."

"Speak French."

I translate, and the hat is removed from the window. It is perfect.

"How much is it?" asks Mom. The saleslady understands this question in any language. She answers in francs.

"How much is that in real money?" asks Mom.

"Ten dollars."

Mom does not bat an eyelash.

"Offer her half."

"This isn't Grand Avenue. This is Paris. This is one of the best shops here."

"Five dollars, not a penny more," says my mother.

"My mother says she is willing to pay five dollars," I say in French.

Silence. They will throw us out.

"*Un moment.*" The saleslady retreats. She has, no doubt, gone for the police.

"Madame," she says when she returns after what seems like a long time, a slight smile breaking on her frozen face, "may have the hat for five dollars." She nods at my mother in admiration and we sail out with the trophy snuggled into the white tissue of an elegant hatbox.

"Vile I am in France," says Mom, "I'll go to Wittel and drink the vater." I am familiar with Mom's consumption of water. She has only one kidney and drinks an enormous amount of water. In a way, she has used the excuse of her health to get here, just as I used my arm. She is also a master of deception to my father in other ways. She lies to him about the cost of anything, since he can always get it cheaper. "But before I go, I'll find you a nice place to live."

I love my apartment, but she is adamant, and I am dependent on those checks from home. She finds me a room in a hotel-pension on the Right Bank. As soon as I move in and Mom has left, I discover that we had chosen it during the only fifteen-minute period of the day when the power plant next door shuts off. There is no letup in the constant buzzing. Day and night it goes on. After a while I convince myself that it is soothing, that I love it, that I cannot sleep without it. What else am I to do?

I bump into Walkowitz at a café.

"You are a naughty girl," he says. "Why did you run away from the Duncan School?"

"I didn't like Herr Merz."

"Nobody likes Herr Merz, but not everybody runs away."

"That wasn't it at all," I say stiffly, contradicting myself.

"Are you still painting?"

"Yes. And I'm writing poetry, too."

"You must read your poems to me."

"Wait here. I live nearby. I'll get them."

Walkowitz leans back while I read the poems.

"More?" I say, after a few.

"More. You are a good poet."

"I'm glad you liked them. I've never read them to anyone before."

"Only one thing."

"What's that?"

"Stop painting. You're a good poet. Not a good painter."

What can he know, an old man like that? My heart hardens. I have no intention of giving up painting. Ever.

The depression deepens. More and more Americans leave Paris. I think about it, but cannot make up my mind. I am invited to go to dinner with a Russian composer. When we are ushered into a private dining room, I notice that there is a couch in the room as well as table and chairs. Embarrassed, I pretend not to notice, hoping I am wrong about the whole setting.

My companion pours two drinks of colorless liquid from a bottle.

"Vodka. How you say . . . bottoms up?"

He downs his drink all at once. I sip.

"Not like that. Like this." He spreads caviar on black bread. "A bite of this, a drink of vodka."

Perhaps if I eat enough, the vodka won't affect me. The wallpaper of twining leaves performs a jungle dance. I am drunker than I have ever been in my whole life. In the morning, I have a terrible hangover. I can't remember anything beyond the crazy leaves.

I hear from the Russian some time later. He invites me for lunch. I do not want to go but he insists. He says it is very important for me.

"Mademoiselle," he begins gravely, as I sit down, *"Vous êtes malade."*

What does he mean? I never felt better in my whole life.

When he explains that he has gonorrhea, which he must have gotten from me, my face burns. It is like some terrible joke, but it's not funny. I have been so promiscuous, I don't even know where I got it. I don't even know what it is.

"I was sure you didn't know," he says kindly. "You may see my doctor if you wish."

I do wish, and it is confirmed. I write Pop that I am ready to come home.

When my mother sees me fresh off the *Lafayette* with my brand-new Josephine Baker haircut, little spit curls marching forward on my face and my hair plastered down with brilliantine, she gasps. My father is struck dumb, which is probably just what I wanted.

Jay is there, too, to meet me. My parents cannot figure this out.

"Er is azoy alt!" my mother says.

I do not tell her that he is not only old, but married. Not only married but a roué, a despoiler of young virgins, if possible, and that I had been not only possible but determined. I put on a brave front until the moment in New Haven when I will be forced to tell Mom and Pop I must see a doctor. How on earth will I do it?

As usual, they suggest Dr. Wolf. He must, of course, when he sends me to a gynecologist, have told my parents why. What I do not expect is that they never say one word about it. It is as though it never happened, a conspiracy of silence to make the awful fact disappear. Their brave suffering is the final indignity.

To counteract all this, I behave like a monster. I say the coffee cups at home are not big enough. I condescend to eat a bagel, not finding a croissant fresh from the bakery for breakfast. I yell *"Entrez"* if Baba knocks on my door. How can they stand me?

Daily I follow the treatment the gynecologist prescribes for me. I lock myself in the bathroom, take the tube of a large white enamel douche, insert its penislike end into my vagina while I lie in the bathtub in shallow lukewarm water and let the gentian violet medicine flow in and out of me—observing strange shapes like purple seaweed swimming all over.

My sister Gert is safely in Bridgeport. Married. She doesn't do terrible things like me. My brother Joe with his gaiety and pranks is a relief from my self-flagellation. To him, I am still the kid sister.

Sunday afternoons in New Haven are boring. Pop falls asleep with the newspaper spread over his face and snores. There is nothing to do. My brother and his friend Milton Baker try to think of something. They are masters of practical jokes. They have released live doves in the Shubert Theater to the consternation of a matinee idol in the midst of his big love scene, set alarm clocks under the seats of the theater to go off at ten-minute intervals, and one night they tied the doors of a friend's car with rope and watched him struggle to get it open so that his date could enter.

"It's a shame," Joe says, "to waste that French you have. We should be able to figure something out."

My brother and Milton Baker hit upon a wonderful idea. I am to be a visiting French girl.

"A name! What's your name?"

"Michèle Calvé."

"Great. Nobody will recognize you. You've been gone a long time, and you certainly look different."

"She looks French, really French," says Milton Baker, who is my brother's follower and not the instigator.

"We're going to call some friends of ours. You get on the phone. You're going to make dates with all of them at the Hotel Taft. Every half hour, another one. Milton and I will watch from the mezzanine."

"Zis is Michèle Calvé," I say. "Is zis Jerry? My friend Sally told me I should call you. I'm staying at ze, how you call it?—Hotel Taft, just for ze day." I describe what I'll be wearing, a red dress and the black matador hat Mom bought me at the Grande Maison de Blanc. They can hardly wait. After all, they are bored, too. Three boys bite, and even a fourth, although he is not exactly a boy, Ab Ullman, the assistant district attorney of New Haven. "But he won't show," my brother and his friend say. "He's too smart."

We start at three o'clock. I sit in the lobby of the Hotel Taft.

Jerry arrives. His face lights up as he sees me. In the mezzanine, my brother and his friend are already laughing.

"Are you Michèle Calvé?"

"No, I'm not."

A lavender-haired lady looks on approvingly as I answer the fresh boy. I am the only young girl in the lobby.

"Are you sure you're not Michèle Calvé?" Jerry asks again as he completes another circle around the foyer, looking intently into the faces of surprised old ladies hidden in deep fireside chairs.

"Look. If you don't stop bothering me I'll have to call the hotel manager. Or the police."

Jerry leaves, but almost immediately another boy arrives. And another.

When Ab Ullman walks in, my brother and his sidekick are just about to descend to the lobby and congratulate me on my performance. The assistant district attorney is handsome. I had forgotten how handsome. Luckily he had also forgotten me.

"Are you Michèle Calvé?"

"*Mais oui.*"

As I walk out, clinging to Ab's arm, I turn back and see Joe and his sidekick looking bewildered.

"Shall we have a drink first at my place? It's too early for dinner." He runs around politely and opens the door of his car for me.

So this is what it is like not to be Lillian Perelmutter in my hometown. I like it. In Ab's bachelor apartment on Lawrence Street, just around the corner from my home on Orange Street, he arranges me comfortably in his best chair.

"What would you like to drink?"

"*Absinthe, s'il vous plaît.*"

"I'm sorry, I don't have any."

I didn't think he would. I tell him I'll have whatever he is having. Ab goes off to the kitchen to mix a Manhattan and I phone my brother.

"Where the hell are you?"

"At Ab's apartment." I speak softly.

"Does he know who you are?"

"No."

"Tell him and get the hell home."

Ab comes back with a drink in each hand.

"I'm not Michèle Calvé."

"You're not? Who are you?"

"I'm Lillian Perelmutter."

"Oh my God! Your brother Joe put you up to this, didn't he?"

"And Milton Baker.They thought it would be funny. I'm just back from Paris. They didn't want to waste it."

I'm not even going to drink my drink. I can see that. He's angry. He's not even going to laugh, this ambitious young man, moving toward the state attorney's position. He looks as if he could kill me. "Promise me you won't tell anyone about this."

"I won't."

I run home. Milton and my brother sigh with relief; they have saved me from a fate worse than death and all of us from a boring Sunday afternoon.

Chapter Two
1931–1940

I AM TO BE PRACTICAL. I must make a living at art. I am enrolled at the Parsons School in New York at Eightieth Street and Broadway and will live at the Parnassus Girls Club on 115th Street. The girls' cubicles are sacrosanct. Boys are not allowed above the lobby. We sign in and out. Curfew is ten o'clock. To stay out until midnight or later we must be in full evening regalia. I am sure I am in this setting because my parents consider me "damaged goods." Just the same, in the morning, when I walk the thirty-five blocks to school, I relish the city, the anonymity, the bustle of stores opening, the fruits and vegetables arranged in colorful heaps, the people hastening to the subways.

I am told we are to draw by dynamic symmetry.

"What's that?"

"It's the golden mean."

They teach with a diagram, a bisected oblong. Everything must fit into it. It strikes me as stupid. I don't need guidelines to draw. It inhibits me. I think it is meant for people who can't draw and will never learn.

"Where are your guidelines?" asks the teacher. There are none. I have drawn it freehand.

He cuts ruthless geometry all over my lovely sketch.

"It seems to check out," he says, and he leaves me alone after that, but I clench my teeth. I hate instructors who work on my drawing.

"I don't like Parsons," I tell Mom and Pop. "I'm going to get a job."

"Fine and dandy," they say. "Fine and dandy."

The depression is in full flower. It is hard to find a job. I answer an ad for an art director in an advertising agency.

Can you do layout, they want to know, can you do fashion? Certainly, I lie. I've already lied about my age, adding five years to my nineteen to become twenty-four. Why not lie? All is fair in these hard times. "I was trained in Paris by Malaga Grenet and Reynaldo Luza, *Harper's Bazaar*'s best artists." The nearest I got to these Peruvian artists was a brandy at the Café des Deux Magots.

To my surprise, I get the job. It pays a magnificent fifteen dollars a week and I have my very own office. If artists phone, I am to tell them we have no work. I discover why. I am supposed to do all the work.

A.S. Beck sells five-dollar shoes, but now they want to appeal to rich or formerly rich ladies who may deign to wear them. I design a series of layouts with the *audace, plus d'audace* of Paul Colin, but from the first "Beach Dreams" advertisement of reclining girls with summer shoes drawn around and through them, I realize that what would be tame in Paris is outlandish in New York. The project fails. I am given one more chance.

"Run over to Fourteen Hundred Broadway and see Mr. Epstein at Girly Frocks. He needs a new brochure."

"I want it should look like in the best fashion magazines," says Mr. Epstein.

"Certainly," I say, sketchbook at the ready.

"Here's Sally. She'll model the new numbers. Start with our Number Six Twenty-eight." And he leaves us in the showroom.

"Would you mind not chewing gum? It's distracting."

Sally glues the gum under a table and gives me a look that says she knows perfectly well I've never done this before.

When I come back with the drawings I've worked up, Mr. Epstein is not satisfied.

"What's wrong?"

"I don't know."

"Let's look through some of these fashion magazines and see what you like."

We thumb through *Vogue* and *Harper's Bazaar,* but Mr. Epstein does not like any of the work by the leading artists.

"Maybe it's that you don't show buttonholes," he says. "You leave out things. In our Number Six Twenty-eight is three buttonholes."

"I thought the idea was to get the dress as line and flow, get the essential features."

"Now here," says Mr. Epstein, "is more like. This one is good."

"But Mr. Epstein, that's a photograph."

"I can't help it. *That* I like. Shows everything."

I am fired shortly after.

I don't dare tell Mom and Pop I have lost my job. I have already used up my quota of failures. In Bridgeport my sister is being a good wife and is about to be a mother, while I flounder about. I cannot find another job. Besides, I don't want to work in art anymore, not that kind of art. And so I become a model. I consider that more honest.

I pose in the altogether for a sculptor in Brooklyn Heights, Robert Laurent. He uses me in a simple, kneeling pose, but also hires Babette, who has bigger breasts, to pose on alternate days. We are a composite. Her breasts, my ass. The knee on which I rest my weight becomes numb toward the end of the twenty minutes.

"Rest, please," is a welcome sound.

We talk about Pascin, who was a friend of Laurent's and stayed in this house.

"He was living with Lucy Krohg. They quarreled all the time," says Laurent. "She used to get so mad at him, she would run to the cab stand at the Saint George Hotel where the taxis are all lined up. She'd grab the door of the first one and yell her only two English words, '*French Line!*' Pascin would race after her. If he got there in time, he'd drag her back. Otherwise he'd have to go all the way to Manhattan, to Pier Fifty-seven. Then they would start all over again."

"I would have studied with him at the League. He was going to teach there."

"How could a man who drew like that kill himself?" I ask Laurent, but he has no answers.

"Some of the drawings I can't figure out. How did Pascin get his line the same thickness throughout?"

"He used to draw blind on a sheet of paper covered with oil paint laid face down on another."

"I'm going to try it."

When I go to a sketch class at the League, I follow the contours of the model with the back end of a brush. It is hard not to peek, but it is a wonderful sensation, like a caress.

Laurent, as well as two painter friends of his for whom I pose, likes my new drawings.

"How would you like to enter two in the Hamilton Easter Field Foundation auction?"

"I'd like to."

"Well, I'll get them matted and framed for you and take care of it. Don't worry, I'll deduct the cost from your salary," says Laurent. I know he is a fortunate artist, the adopted son of the art patron Hamilton Easter Field.

My brother Joe comes with me the day of the auction. I am terrified of the ordeal but sure he will sustain me despite the abysmal ignorance he claims about culture, particularly art.

"When you get good enough," he whispers, "I'll let you paint my barn."

The auctioneer calls out names, well-known names. Mostly Woodstock artists. Speicher, Blanch, and William and Marguerite Zorach. Suddenly he stops and squints at my two drawings on the easel.

"What am I bid?" he calls out. "What am I bid for two drawings by Lillian Perelmutter?"

A mumbling in the audience. "Who's that? What did he say?" Silence.

"Do you want me to bid?" It is my brother.

I am about to say yes when someone behind us raises a pencil and someone else coughs. Both drawings are sold for eighteen dollars each. I am redeemed.

Based on this success, I finally get up courage to confess that I've lost my job as an art director and that I've been offered a job in Woodstock with Emil Ganso. I say I am going to appren-

tice in the studio and help a little with household jobs, baby-sitting for Nina, doing dishes for Fanny, Emil's wife. I do not say I am going to pose for Emil and that he specializes in sexy nudes.

Back in New Haven until summer, Mischa Richter, a friend of mine at Yale School of Art, invites me to a party. Mischa strums his guitar and sings sad Russian songs. He introduces me to Peter Graham Harnden, who is at the Yale Drama School.

I catch my breath. Peter is lean and flamelike. He looks like an El Greco, I think, but then I change my mind. His face is like that of an Egyptian prince painted on a sarcophagus at the Met. Peter is exactly my age, nineteen, and, like me, he's already in a peck of trouble.

"Did you see the article about me in the Bridgeport *Herald?*"

I know that the Sunday edition of that paper is the ultimate in scandal.

"What did it say?"

"All about me and a townie."

I smart. After all, I am a townie too.

" 'Diplomat's Son Accused by Local Lass' " Peter continues.

"Accused of what?"

"She says I got her pregnant. It was just a one-night stand. She said she would have an abortion, but then she changed her mind, and now it's too far along. As soon as the baby is born, though, she's agreed to take some money from Pat, my mother, and give the baby up for adoption."

I am staggered. I confide in Peter that I have been kicked out of Yale Art School, but that I really didn't care for it anyhow.

The very next day I meet Peter for lunch in the cafeteria of the Yale Drama School. Like me, he is persona non grata, and will not return the next semester. Behind the counter is a student earning his way through school. Elia Kazan wears a white jacket and dishes out our salads with a dramatic flourish. He looks Jewish, but I know he is Armenian and intense. Whatever he does has flourish and passion.

"Do you mind if I call you Lille?" Peter asks as we take our trays to a table.

1

Zayda

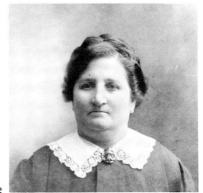

2

Baba

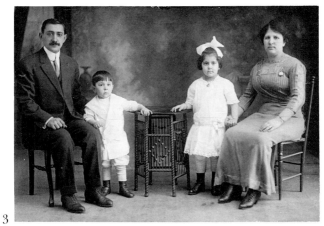

3

Pop, my mother, my sister Gert and my brother Joe

Me, at three years of age

MY FAMILY

4

LILY

5

At graduation from grammar school

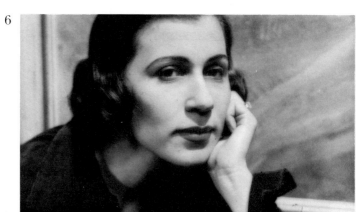

6

As a young artist

On her own, 1940

7

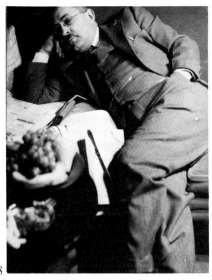

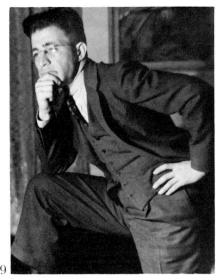

8

9

Pop on a Sunday afternoon *Sidney Harmon*

THE PERELMUTTERS

Triple birthday: left to right, standing: family friend, me, husband Joe Hirshhorn, niece Carol, brother Joe and Mom; seated: sister Gert, niece Mary-Lou, daughter Amy, brother-in-law Herbert Louis Cohen, daughter Jo Ann and Pop 10

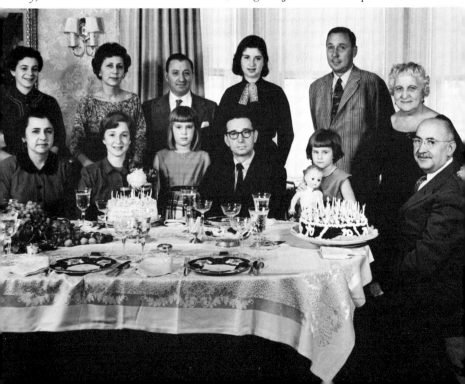

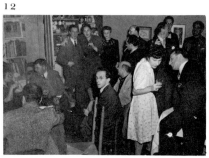

With painting of Peggy Wood—1938

Kuniyoshi in Woodstock

ART AND ARTISTS

A party in the studio on Tenth Street. Raphael Soyer, center; Philip Evergood near kitchenette; back right-hand corner, Frank Kleinholz and Chaim Gross. Joe Hirshhorn and me in foreground

In Alfredo Valente's studio on 57th Street with my painting of his wife, Miriam

Easthampton. Seated, Ella Baron and Marussia Burliuk. Standing, David Burliuk, Joe and Herman Baron. Seated on ground, me

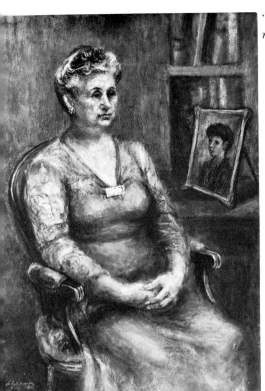

"The Lady in Blue," portrait of my mother

PAINTINGS AND PAINTERS

17

First visit to Huckleberry Hill, with Herman and Ella Baron on left, March Avery perched on my shoulder. Sally Avery, center. Milton Avery with coat on his arm. Joe Hirshhorn next to him

...sociated American Artists gallery group in the 1950s. Me in center between director ...eeves Lewenthal and Marion Greenwood; farther on my left is Tom Benton (with mus-...che); Chaim Gross standing (in dark shirt); and Raphael Soyer seated, front center 18

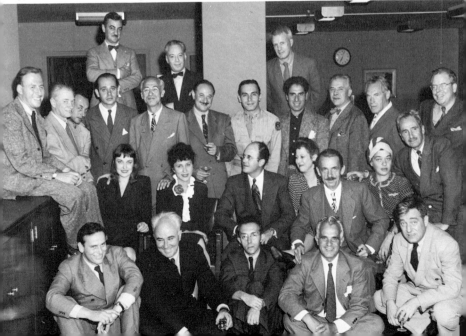

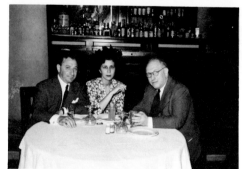

Three on a honeymoon. Joe and me with Dr. Friedman in Havana

19

Joe and me with Amy in New York town house

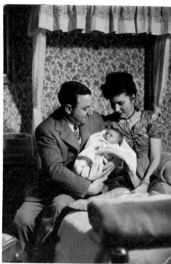

20

21

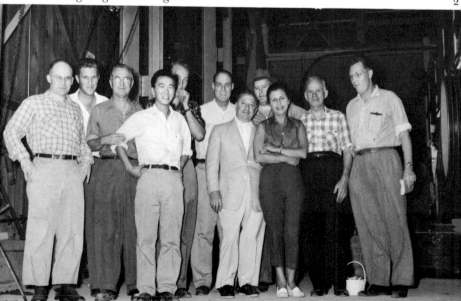

Joe and me with Amy and Jo Ann in Port Chester, N.Y.

Uranium mining camp in Canada. Franc Joubin, geologist, far left; Joe and me center with other geologists and engineers

2

Arrival: Philip Johnson, far left; Joe next to him; me center with Amy and Jo Ann. Temperature 25° below zero

23

Bootlegger's Bay, the house designed by Philip Johnson

24

25

BLIND RIVER, ONTARIO

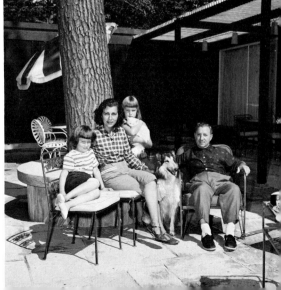

The family at home

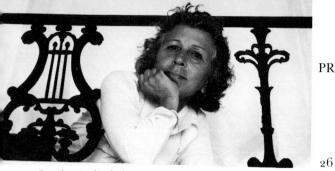

PROVINCETOWN, 197(

26

On the studio balcony

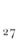

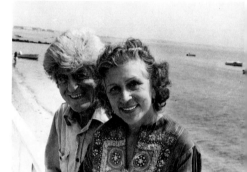

Milton and me on the deck 28

29

27

*A drawing of my husband Milton
Schachter*

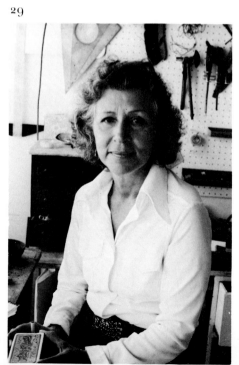

In the studio

"I don't mind."

"I don't think your name suits you." I don't either.

"Have you ever been to Majorca?"

"No."

"It's my favorite place. I went there when my father was consul in Seville. I love it. I'll take you there someday. My mother and father are divorced."

My head spins. I don't know anyone whose parents are divorced.

"My father's in Göteborg now and my mother, Pat, lives with a girl violinist who's her protégé."

Peter kisses my hand when he says goodnight on the stoop of 709 Orange Street. Nobody has done that since Zayda died. It is inevitable that we go to bed. When we do, some weeks later, it is an intense, even a gymnastic, experience. Peter is so troubled by his father's predilection for young men that he proves himself over and over to be the answer to a young girl's dream. Just the same, when it comes time for me to go to Woodstock, I say, "I'll miss you, Peter, but I've got to go. I've a lot to learn. Maybe you'll come to visit when you finish the semester at the Drama School."

Posing for Emil is restful. Usually I lie on a couch or sprawl in a chair, naked except for a string of beads around my neck, or stockings draped around my ankles, or my chemise with its strap hanging and one breast exposed. Emil, too, talks of Pascin.

"It's a good thing you didn't get to study with him," Emil says. "He'd have seduced you. I asked him once about a model I sent him." Emil makes a circle with his thumb and forefinger. 'She behaved like a buttonhole,' he said, 'like a buttonhole.'"

Would I have behaved like a buttonhole? I wonder as I get sleepier and sleepier.

"Did you know how I got to this country? I jumped ship," Emil says as he smudges a line with his thumb. "I was a pastry chef on an ocean liner. I went back and forth, back and forth, making rosettes and leaves, squeezing frosting on fancy cakes. Finally I got off and stayed. I met Mr. Weyhe."

I know all about Mr. Weyhe and his wonderful bookshop and art gallery. I have often coveted art books there.

"Mr. Weyhe put me on an allowance so that I could make art. Rest now. . . ."

What I have to rest from, I can't imagine. After lunch, I help Fanny with the dishes. If there are no other chores in the house, I go back to the studio and share a still life Emil has set up to paint. He usually does peaches with their pink skins looking like young girls' bottoms.

Sometimes we grind color. This is a lost art, but Emil is a German technician, and frugal besides. There are bags and bags of powdered color from Fezandie and Sperrle. We grind them on a marble slab, bearing down around and around with glass mullers until the color cannot absorb any more oil, and the particles no longer sound scratchy.

With spatulas, we force luscious colors into the bottom of the pound tin tubes, then roll them up and label them. Alizarin crimson. Terra verte. Rose madder. Yellow ochre. Naples yellow. Zinc white. Ivory black. We invent a burnt ultramarine blue.

After dinner we go back to the studio to print. I learn how to soak Arches paper between blotters until it is in the proper state of dampness, how to ground an etching plate, how to ink it with a crumpled wad of tarlatan until the engraved line absorbs enough ink, how to pass the palm of my hand, dry with whiting powder, lightly over the copper in a final hand wipe. And then there is the magic moment of suspense when Emil turns the star wheel, pulls back the felt blankets, and reveals the print.

Emil works on wood blocks but gives me linoleum.

"Better you start with a softer material," he says. Jealous, I watch buttery curls of pine flow from Emil's knife, while rubbery linoleum comes from mine. It isn't the fact that I am a woman and have weak hands. I have strong hands and can use them. It's the cost. I sketch Emil playing chess with Konrad Cramer.

All day long Fanny, like most artists' wives, wonders what goes on in the studio and drops in as if to catch her short, dumpy husband and me in *flagrante delicto*. Why can't she realize that hanky-panky with Emil does not interest me? The tension mounts.

One sunny day, as if in answer to a prayer, Peter shows up.

He looks handsome in an open green Packard touring car. Now Fanny will see there is nothing between Emil and me. I am excused from work for an afternoon and Peter and I take off our shoes and go wading in an icy brook that flows through town.

"Everything is settled," Peter says. "She took the money. The baby has been adopted. Now I have a good idea."

"What?" The water flows cold between my toes.

"Let's get married."

I hadn't thought of that. It occurs to me that it isn't a bad idea. I could escape.

"Look," continues Peter as if he read my mind, "the summer is ending. What are you going to do? Go back to New Haven? There's nothing for you there."

How well I know it! How right he is.

"My mother and father wouldn't like it."

"Why not?"

"You're not Jewish, for one thing."

"I'm circumcised," says Peter brightly.

"That doesn't make you Jewish."

"It helps."

"We're too young. Nobody would marry us."

"They would in Brewster."

He has thought of everything.

"My father will want to know what you do for a living."

Peter twirls a curl of his hair behind his left ear, a childhood habit.

"I can handle that. Let's go to New Haven and tell your parents."

"We're going to get married," we tell the Gansos. "We'll be back in a few days." We take off in the beautiful green car that drinks a quart of oil at each gasoline stop. I snuggle cozily next to Peter's tweed jacket. Maybe everything will be all right. After all, Peter is, as the *Herald* described him, the scion of an old American family.

"What about your mother?" I ask as the car swings down Chapel Street.

"Pat will love you."

I cringe when Peter calls his mother by her first name.

"What will we do if they won't let us get married?" I say as we drive down Orange Street.

"What *can* we do? We'll elope," says Peter. "If they say no, I'll wait for you in the car around the corner. We'll get married in Brewster."

Sitting on the screened porch upstairs with Pop, who has exiled my romantic mother to the kitchen to make iced tea, the first question is, "And what do you do for a living, young man?"

"I intend to study for the diplomatic service. My father's in that."

"Peter is great at languages, Pop. He speaks Spanish fluently. And French. Even a little Swedish."

"Hm–mmm," says Pop. Then it is quiet.

We talk about how well we get along, how many interests we have in common. Pop clears his throat.

"I think you should wait."

"How long do you think we should wait, Mr. Perelmutter?" Peter says in a voice which suddenly seems very high-pitched.

"I think you should wait about six months," says Pop. "And then not do it."

There doesn't seem to be anything else to say. Peter leaves. Mom comes in with the tea.

"Vere's Peter?" she says, disappointed.

"He's gone."

"He couldn't stay for a glass of tea with lemon?"

"No."

"You feel all right?" asks Pop as I sit docilely, looking down at my hands in my lap.

"I feel all right."

How well they know me. I am a mass of screams inside.

"I've run out of cigarettes," I say.

"I'll get them for you," says Pop. He hates my smoking.

When he comes back with the Chesterfields, I sit smoking until Pop tires of watching me and goes back to the store.

"I think I'll take a little walk," I tell Mom, the innocent.

Racing madly to Brewster, I look behind to see if we are being pursued by my irate parents. I sneak glances at Peter, my hus-

band-to-be. His beautiful hands rest firmly on the steering wheel. He is a great driver. A great dancer, too. I know little more than that about him. I liked Hecky more, but that was finished. I had finished it myself, but I still blame Hecky, just as I blame my parents now for what I am doing. They brought it on themselves. Maybe I am doing the wrong thing, but I'm going to make it work.

In Brewster, we stop at a five-and-dime store and select the simplest fake-gold ring from a tray full of ornate ones.

"Where is the justice of the peace?" Peter asks the saleslady.

"He works at the railroad station. He takes tickets."

"Where to?" asks the old gentleman in the ticket booth.

"We want to get married."

"How old are you?"

Just to be on the safe side, we both add a year.

"Twenty."

The justice of the peace emerges. "Do you have any witnesses?"

"We didn't know we needed them."

The justice looks around the station. "Hey, Pugsley!" he yells. "Hey, Murty! You wanna be witnesses?"

Two painters climb down from their ladders and stand near us. Reverently they hold their caps with *Pillsbury* on them to their paint-stained white overalls while the justice of the peace marries me to Peter.

"By rights," thunders Pop, "it should be annulled." He and Mom have caught up with us in Woodstock. Too late. All hell breaks loose. The Gansos stand by, bewildered. Peter's elegant mother, Patricia Graham Harnden, has also joined the act.

"They're not old enough. It doesn't make sense," says Pop.

"Maybe it's not so bad," Pat says soothingly to my father. "I'll support the children while Peter goes to Georgetown University."

Pop doesn't care if Peter becomes a diplomat or not. He is determined that everything should be as hard as possible.

"They made their bed. Now they have to lie in it," is as close as he can come to acceptance. Emil opens a bottle of wine. Mom

and Pat are an unlikely but friendly pair. Pop looks glum and angry.

A few months later I am pregnant. I am surprised. So is Peter. "I don't see how you got pregnant."

I do. We haven't taken any precautions other than Peter's withdrawing sometimes or my douching.

Dr. Wolf's first words when I set foot in his office with Peter and Mom are, "Well, how far along are you?"

Dr. Wolf enumerates obstacles on each finger. "You don't know if the marriage will last. He's not Jewish. He can't make a living. You're too young."

Mom says gently, "Give the boy a chance. You're married such a short time. He's going to school yet. You can always have a baby ven the times comes. The right time."

And what am I supposed to do with the wild joy I feel?

"What do you want me to do, Peter?"

I am surprised when he says, "Maybe it's not the right time, Lille. Maybe later, when we're all set in Washington."

There's that nasty word. Set. Settled.

"You think I should have an abortion?" I'm a wife, not a townie. But at least she *had* her baby.

"You can always have a baby, Lille."

Can I?

"I have no responsibility in this matter," says Dr. Wolf in his office on Park Avenue when he hands us the name and address of an abortionist. The slip of paper in my hand feels as if it were made of fire. I am singed already. I hate Mom. I hate Peter. The joy dies in me. Mom takes a train back to New Haven. "You'll be glad, *bubele,*" she says. She has saved her "baby." What about mine? Nobody wants to let me grow up.

The doctor's office is like a speakeasy. It has a hole in the door. He can see us, we can't see him. When he opens the door a crack and peeks out at us I want to say wildly, "George sent us," but Peter says quickly, "Dr. Wolf sent us," and we are admitted. The office is dark and quiet. There is no nurse. From the magazines about mothers and babies on the end tables in the waiting room, I imagine the doctor is a respectable obstetrician who is earning some extra money.

"Do you have the money?" he asks, and I hand him the money Mom gave me. "You know you can't stay here afterward," he adds while he is counting it.

"I'll be driving my wife to the country," Peter says, and from the look on the doctor's face, I can see that he doesn't believe we are married. Why would we be doing this if we were? I don't know myself, but I allow myself to be led into the inner sanctum where I disrobe and lie on the table, my feet in stirrups, ready to be stripped of the life inside me. Am I to be knocked out? Am I to have anesthesia? I am afraid to ask, but as he begins, I know I am to have pain, terrible pain. A strange scraping sound—I grit my teeth and try not to yell. When I have lived through it, I manage to get off the table and get dressed. I waddle out to Peter with the Kotex between my legs moist and heavy with blood.

"Are you all right?" Peter is pale.

"I'm all right," I say. I can barely walk to the green Packard, and the drive to Woodstock is a quiet one. I try not to think of what the doctor threw in the garbage pail. I feel bathed in blood.

Recovering in our rented cottage, I lie in a hammock outside. Peter cannot do enough for me. I have no appetite. He makes me an elaborate fruit salad. "I took out all the pits," he says, as I observe the grapes sliced in half. But I don't care.

We arrive in Washington and we cannot cash a check. We have no money. The Packard has drunk it up in gas and oil. Undaunted, Peter knocks on any door. He knocks on the door of a middle-aged lady artist, Yola Siebenthal, in Rock Creek Park. Peter affects women, all women. She not only takes us in and will accept no money but is desolate when we leave.

Peter starts at Georgetown University after we've found a small apartment in the mews behind a bank at Dupont Circle. I do spasmodic housekeeping. I am dying to paint a nude.

"Of course I'll pose," says my mother-in-law when she comes to visit. "How do you want me?"

I spread a sheet on the floor and Pat lies on it. She has a wonderful body for her age—she must be at least forty. I regard her with admiration from the canvas, the largest I've ever attempted.

It goes so well, I am surprised. It's my masterpiece. The more I look at it after it's finished, the more I like it. I must share it with someone. The logical person is Duncan Phillips, whose home and collection are open to the public on certain days as a museum. I go there frequently to look at the Klees and the cities Kokoschka painted, to admire the Bonnard landscapes with a feeling of spring rain in their moist fresh color.

It is such a windy day that I decide I'd better wrap the painting up. The only thing big enough is a sheet. As I try to navigate, the picture acts like a sail and almost takes me down the street with it. The wind whisks me up the stairs to the house. I ring the bell. A butler in a white coat answers and stares at me.

"Are you expected? Mr. Phillips is not at home."

Just then, a car pulls up and a delicate gentleman emerges from it, walks up the stairs but cannot enter. I am blocking the door with my painting.

"I'm Mr. Phillips. What can I do for you?" he says gently.

"I'm Lille Harnden." Peter has changed my name, all of it. "I've brought a painting of mine to show you."

"Come in."

The butler tries to help me with the painting.

"I can manage." I maneuver it carefully as Mr. Phillips leads me to the living room.

"The light is good here," he says. And so it is.

When I pull back the sheet I am surprised myself by the painting. There is Pat, her somewhat dissolute face lit from below. The scooped-out hollows above her heavy eyelids are exaggerated. The nipples of her full breasts are painted very carefully. She is thin in the middle and her rib cage protrudes. Her hips are full, her pubic hair dark, her legs heavy. I admire the way I have handled the hot colors of her skin against the swirling cool-white sheet. She is the nudest nude I have ever seen.

Mr. Phillips catches his breath. He blinks his eyes, as if blinded. When he finally pulls himself together, he says, "At the moment, we are not making any purchases."

"I hadn't thought about selling it. I admire your collection and your taste. I just wanted someone to see it."

"It's unusual," says Mr. Phillips. "Very unusual."

Encouraged by this encounter, I take the painting of Pat to a gallery. Mr. Caz-Delbo, the owner, likes it so much he puts it into the window, where it occupies the whole space. A week later it is no longer there.

"Where is it, Mr. Caz-Delbo? What have you done with my painting?"

"People kept coming in to the gallery and complaining. I love the painting, truly love it. I hated to be parted from it. I took it home with me. Hung her in my bedroom so I would see her first thing in the morning, last thing at night. But she was too much for me. Too naked. She is in the racks."

"I'll take her home."

"Just a minute," says the dealer, as I start to walk out with the painting. "You mustn't walk through the streets with her like that." He unrolls great sheets of brown paper, wraps Pat up and ties her with rope.

We are always broke. Pat, when she leaves for Rome with her girl violinist, sends us all her furniture. Trophies from Seville. We move to a new apartment in a mews to accommodate the refectory tables riddled with holes, priests' chasubles and embroidered vestments, wrought-iron wall sconces for candles, and straight-backed chairs with needlepoint seats. Somehow it all goes well in the apartment, which has a fountain right in the middle of the living room. Our new German shepherd drinks from the fountain, and if he bites the nozzle, the whole room is flooded. Two white rabbits a friend of Peter's gave me for a birthday gift deposit round pellets everywhere except the fireplace in which we had hoped to train them to go; but they die eventually after nibbling a steel-wool pad under the refrigerator. I am not a good housekeeper. Their death is on my head.

We give parties. The Abbey Players are on a tour in the United States, and Barry Fitzgerald comments on the lack of vermin in the Washington theater. He says a theater without rats in the alley is unlucky, but their run is a huge success. We give parties on any provocation.

"I think I'll get a job," I tell Peter. "Here's one in the paper.

The Wilmark Agency, whatever that is. They train you and pay you."

I get the job.

"Our work is security."

"You mean I'm going to be a detective?"

"Something like that."

I am thrilled.

The first day out, I am one of a group of trainees given money to make purchases in a store. We are to go in consecutively and note the amount on the cash register. The object is to catch thieving clerks.

"I think it's sneaky stuff," I tell Peter when I get home. I had envisioned cloak-and-dagger activity.

Another day I go alone to a department store where a sale is in progress. I am to case the joint for shoplifters. I circle a stack of heaped blouses around which women are swooping like vultures. At lunchtime a store detective follows me out and at the proper distance places a hand heavily on my shoulder.

"Do you have anything belonging to us?"

I have a hard time convincing him I am a detective from the Wilmark Agency.

"Try to be less conspicuous," he says, finally releasing me.

"Here's twenty dollars," says our supervisor. "Go to the Peoples' Drug Store with the group. You're going to make the most expensive purchase. Ergot-apiol."

"I can't ask for that." I know what it is. It's to induce abortion. I have all I can do to ask for sanitary napkins. I usually put it at the end of a long list. Nail-polish remover, please . . . and . . . um . . . Johnson's baby talc and . . . ummm . . . (in a small voice) . . . a box of Kotex, please.

"You'll have to ask for it."

To my amazement, I catch a thief. The little clerk who rings up my expensive purchase pockets most of the money. Not only that but he confesses he has been stealing all year. I am sick. The supervisor congratulates me and I resign immediately.

"We'll both get jobs," says Peter. "I'm tired of Georgetown University anyhow. I don't want to be a diplomat."

"But what can we do?"

"I'll teach languages and you'll teach art."

"I don't have a degree."

"We'll see."

We go to a hunt breakfast at a chic Chevy Chase school. The director is an old friend of Pat's. At this annual event the pièce de résistance is a whole suckling pig which arrives bearing an apple in its mouth and reminding me of the butcher shops on the rue Lepic near Colin's atelier in Paris. Only there, they were white and limp. Here, I'm sickened anyhow despite the crisp brown skin.

While we are having coffee, Peter says he is looking for a job to teach languages in a school.

"The Nelson School for Boys is looking for a Spanish instructor," says the lady director. "But you might not want that job."

"Why not?" asks Peter.

"Well, they take Jews."

"Lille is Jewish," says Peter. As if I were some exotic bird, all present regard me uncomfortably.

The next day is, appropriately enough, Yom Kippur, and I do a strange thing all by myself. I find an orthodox shul, sit upstairs with the women, listen to the *dovening,* and watch the children running freely up and down the aisles. The mood and minor key of the music match my melancholy.

Peter gets the job, but they don't need an art teacher. As part of his job, I am to help with a small boy, but I am not to be paid.

William is my assignment. There is something wrong with him. I am supposed to keep him out of sight of people visiting the school. He might say or do something wrong. A bad image.

I am fond of William.

"Oh! There's a dig-ditcher!" he exclaims in delight while we are sitting on a window seat, looking out.

"A ditch-digger."

"That's what I said, a dig-ditcher."

"Say 'ditch.' "

" 'Ditch,' " says William.

"Good. Now say 'digger.' "

" 'Digger.' "

"Now say 'ditch-digger.' "

"Ditch-digger."

"Good, William, good. Now what is it?"

"It's a dig-ditcher."

Summer is coming. We do not want to stay in steamy Washington. With our usual good luck, we meet Lars Hoftrup, an artist who has a farm in Pine City near Elmira, New York. He is a generous man and invites artists to share his home. The other guests are a French painter, Vargny, and a Swedish sculptor, Andersen, and his wife and child.

We share the kitchen and the work. Mrs. Andersen laughs while I iron a shirt of Peter's.

"You wrinkle it as you go. Let me show you how."

Sure enough, her system works.

There is no electricity, no running water, no gas. Not a convenience of any sort. There is an outhouse. I am so busy hauling water, cooking, washing, and ironing that I have no time to paint. Neither does Vargny, what with his hobby for gathering herbs to make French liqueurs, figuring out fifty-seven different ways to cook potatoes, and collecting hats. They are all shabby, but he picks out one he claims is formal on the day Mom and Pop are coming to visit.

I am washing sheets outside near the water pump.

"For this we came to America!" slips out of Mom immediately as tears well up in her eyes. I tell her I love it.

Inside the house, she cannot help seeing the black irons lined up on the coal-and-wood stove and the kerosene lamps Mrs. Andersen is cleaning.

"Aruvgearbeit!"

I can see Mom doesn't think I've worked my way up. Lars smiles sweetly at my mother and father. He is quite deaf and hears none of their comments. He makes strong, old-fashioned coffee in a blue-speckled pot. He brings the water to a boil, throws coffee in, lets it foam for a hot minute and then subside.

"Do you like it?" Peter asks, preening in a new tweed jacket exactly like the old one with suede patches on the elbows. We are back in Washington.

Freehand

As Mom would say, "Vat is not to like?"

"It's beautiful, Peter, beautiful."

"I had it custom-made. Couldn't find anything like the old one from Munich. I found a tailor who made it for seventy-five dollars."

I am stunned. I don't dare buy a dress for five dollars.

I wake up one day with a terrible toothache. Peter is teaching his Spanish class. I go alone to a strange dentist who wastes no time pulling a wisdom tooth. The great hole in the back of my mouth throbs and won't stop bleeding. I resent the fact that Peter wasn't with me. I feel like a little girl, abandoned. I am three years old again and no one comes when I call. When Peter comes home, he doesn't console me enough. There isn't any *enough*. All my rage at the abortion, at the awful job I'd had, at being a Jew among Peter's chic friends, and at the seventy-five-dollar jacket seems centered in the great throbbing, bleeding hole in my mouth.

"I think I'll go home to New Haven—to my own dentist. There's something wrong. And I don't know if I'll come back. I don't think I want to be married."

"Of course you want to be married," Peter says, twirling a curl behind his ear. "And you'll come back."

"Oh, Lille," says Peter when he kisses me goodbye.

"And I don't like the name Lille, either," I say as I leave for New Haven.

Home is like a warm bath. Everybody pays attention. Our family dentist stops the bleeding. Baba says, "Have some 'deserve,' Lilinyu." I love the way she describes dessert. I am stuffed with vanilla ice cream to assuage the pain. Unlike the time I refused it, when Mom and Pop said I was going on a trip and I thought the hospital where my tonsils were removed was Grand Central Station, this time I eat the ice cream and relish it.

"Is that a long-distance call?" asks Pop.

It is Peter, in Washington, asking when I am coming back.

"That young man doesn't care how he spends his money. Or his mother's money," says Pop. Nobody talks about the fact that I am married. They pretend everything is the same, and I

am beginning to believe it, sinking back into the comfort of home.

"When are you coming back?"

"I don't think I want to come back."

"I'll call you tomorrow afternoon."

My head buzzes. I cannot sleep at night. I cannot make a decision. I collect sleeping pills. How many sleeping pills cause death? I do not know. All I know is that I cannot make up my mind.

It is almost time for Peter to call me. In the bathroom, I look at the pills. I start to swallow them. I can only take one at a time and follow it with a sip of water. I think I take about twenty.

I go to my room and lie down on my bed and wait for death. I am not sleepy, but then a delicious haze starts to develop. Far, far away a telephone rings. Baba is shaking me. I don't want to wake up.

I'm walking. I am held up on either side. Why do they make me walk? I am being forced to drink coffee. They won't let me rest, and when I am finally allowed to sleep, and then wake up with Peter holding my hand, somehow I have made a decision. Two decisions. I want to live, and I don't want to be married to him.

THE BIGGEST LITTLE CITY IN THE WORLD, says the banner across the main street of Reno. I am to claim I intend to reside here permanently, but I know and my lawyer knows and the judge knows I shall leave the day of the divorce. I am not to set foot outside the state of Nevada for the six weeks of my residence. I settle down in my incarceration. I shall go from that to penance in New Haven. I shall be punished for my foolishness. I'm sure of that.

At least I can work while I am here. Around the ranch tumbleweed floats lazily over the rolling hills, and I wander around Virginia City, a ghost town.

"Spend the weekend with us," say a young couple who live in a converted brewery I am sketching. "We have a lot of guests. You must dig a little each day. There are silver tailings under the house. From the old mining days. We pay our way with it."

The house lists crazily to one side but is not yet undermined. A lady named Caresse Crosby shares a bedroom with me.

"Upwards, always upwards," she says at night as she strokes cold cream on her face. "Not to break any blood vessels. To firm the skin. Did you know, I invented the brassiere?"

Why should she have invented the brassiere? She doesn't need one. Her breasts are sensational.

"You must come to visit me in Virginia, my dear, I have a lovely house there. Salvador Dali enchanted the brook for me. It's full of bizarre things."

I find it hard to believe Caresse. Did she and her husband, Harry, really form the Black Sun Press, and did they have something to do with the publication of *Ulysses?* In an old cemetery nearby, I draw a sentimental statue of an angel standing tall and white with clasped hands.

At the end of the long six weeks, I stand in front of a bored judge with my bored lawyer. He claims mental cruelty. I am glad Peter does not hear me say in a little voice, "He didn't like my friends" and other nonsense. And whose shoulder will I lie on now when I go to sleep? What will I do for sex? Who will hold my hand? What have I done? To myself and to Peter. The gavel comes down. I am free. On my way to the bus station, I stop and fling my ten-cent ring over the bridge into the Truckee River. I had been married a whole year.

The bus drivers change every eight hours, but I stay on. I sleep spasmodically, go to the bathroom, wash up, and eat greasy hamburgers at each two-hour stop. Again the conflict: how to make art and a living. It seems impossible to solve.

I live in New Haven and commute to New York. Going to galleries, I become familiar with John Marin's watercolors of fractured skyscrapers and islands of Maine like jagged music, with Hopper's plain people and houses in revealing light and lonesomeness. I see John Sloan's rooftops in Greenwich Village where women sun themselves and dry their hair and Prendergast's impressionism as well as Maurice Sterne's Balinese studies. Two ideas continue to run through my mind. I want to be an artist. I need to make money. When Emil Ganso sees my Reno

sketches he thinks they would make good lithographs. And so I study at the Art Students League with Harry Sternberg and learn enough to work on an edition of "Virginia City Angel" at George Miller's Print Shop on Fourteenth Street.

"Be careful about the stone," says Mr. Miller. "Don't abuse it."

I treat it like a baby's behind; that's what it feels like. I know why George Miller wants me to tickle, tickle slowly with a sharp-pointed grease pencil: he wants a foolproof edition, easy to print. I am dying to maltreat the stone. I want to be sacrilegious —to cut with razor blades, to brush strokes of liquid ink tusche, but I obey the rules. Mr. Miller is happy, but I'm not. Just once, at least once, I will wreck a stone just to find out what happens in the printing.

At home, in the attic studio, I spend long hours escaping my parents who treat me like a temporary resident between marriages, my sister who considers me a total failure, and my brother who sees me as a bird in a cage.

I have separated my drawings and watercolors into two piles: the good and the bad. Baba misunderstands which is which. I wring my hands when I see the fire in the garbage can in the backyard.

The Polish maid comes upstairs. "I hope you don't mind. I kept these."

I seize on them gratefully. She has kept my Paris sketchbook. Aside from that and a few drawings, the past is obliterated. I sulk for a long time, feeling the fragility of art, before it dawns on me—I can make new ones.

"Vy don't you vant to go?" asks Mom. "A veekend vit the Salzmans. Vot could be bad?"

"They want me to meet their nephew, the doctor."

"So?"

I can see that the marital sweepstakes is not over. Peter was only a prelude. I must get back in the ring or there will be no peace. I want to go to bed with someone but I do not want to get married.

"I'll go, I'll go."

"Mrs. Salzman's Sally is already married like you," sighs Mom, "and already divorced. Vot is happening in the vorld? Could be

it's by the Russians. 'If ve break up the family, ve'll get our vey vit the country.' " I am familiar with Mom's bizarre theories and not surprised. At movies, she is always careful to point out the moral. *"Die mushel is . . ."* And she explains the picture.

When I spend a weekend with the Salzmans I do not like the nephew, the doctor, but Sally and I hit it off. She invites me to a party and introduces me to Sidney Harmon.

"He's a producer," she says. "Just did *Men in White.*"

I am impressed. Sidney is telling a story to a group of people. When he finishes and we are standing alone I say, "You do a ballet with your thumbs." I watched, fascinated, as he gesticulated—up, down, and sideways to make a point. He made boxes in the air.

"If you tied my hands, I'd be speechless."

As we talk, I discover that Sidney is a frustrated writer.

"I don't write well, though, so I create through writers. I give them ideas for plays."

I wonder about this. What kind of writers are receptive to this? I always thought that writing, like painting, was a lonely process.

"I'm a painter."

Sidney is enchanted. He doesn't know any painters. He is from a middle-class Jewish family like me. His name had been Heiman but he changed it to Harmon. Better for the theater.

We make a date and Sidney takes me to see *Men in White* which he produced in association with the Group Theatre. Afterward we go backstage, where I meet J. Edward Bromberg, who turns out to be a youngster, not at all like the old doctor he portrays in the play; and one of the orderlies is Elia Kazan, whom I remember from lunches at the Yale Drama School cafeteria.

We go to Sardi's and sit in the "good room." Sidney explains that tourists are shunted elsewhere. At twenty-seven, he is called the Boy Wonder of Broadway. Success is sweet.

My new beau courts me in accepted fashion. My family is leery of anything to do with the arts, but Sidney endears himself to Pop when he goes to the store and says, "It's grand—much bigger than my family's haberdashery in Poughkeepsie." He plays tennis with my brother Joe who says, "He's not bad, not

bad at all. His backhand isn't so good, and he runs a lot, but he's not bad." Mom and Baba think he is "a *sheine yunge mann.*" A good-looking young man.

Only my sister Gert is not enchanted. She watches Sidney spoon his soup in instead of out while drops spatter his foulard tie and crumbs from his roll fall unheeded over his dark-blue suit.

"He has atrocious manners," she says later.

"He just gets carried away with his stories," I defend him.

"Where was he brought up? In a barn?"

"In Poughkeepsie, that's where. And I'm invited for Yom Kippur."

"At least you won't have to watch him eat." She always has the last word.

At the Heimans', I can see that Sidney needs their approval as much as I need my family's. Fasting will test my stamina. At the Perelmutters' on High Holy Days, mercy in the form of orange juice is extended. "God didn't mean for little *children* to fast" is Pop's theory.

Here, brushing your teeth in the morning is forbidden. A drop of water might slide down. Fuzzy-toothed, I sit in the synagogue all day. I know I cannot smoke until sundown. I wonder what Sidney's parents would think if they knew that the Perelmutters are not only *trayf* but go so far as to eat shellfish. No pork, though. The Heimans are so orthodox that Sidney must lay *t'filin* in the morning with his brothers, Bill and Sam. As long as her parents are alive, their sister Marion confides, she will never be able to marry Dick, her Christian boy friend. Will I be forgiven my early marriage to a goy, since I divorced him?

I do not like Sidney's wizened father, who behaves like the king of the house. I like his tiny mother, self-effacing and quiet but actually the mainstay of the household. I love her delicate and rosy Hungarian chicken paprikash with which she breaks our fast and her homemade *ruggelach* that melt in your mouth.

Both families approve. To top our happiness, *Men in White* wins the Pulitzer Prize and seems destined to run forever. Aside

from our making love in the locked bathrooms of both houses, Sidney does everything properly. He gives me a square-cut diamond engagement ring with lots of carats, but a small flaw. I am sure Gert will spot it with her terrible X-ray eyes, but when I flash it, all she says is "Hm–mmm. I prefer rose-cut."

Despite Emily Post's advice to wear pastel pink or blue for a second marriage, I wear a traditional white wedding gown with a veil, orange blossoms, and a train that catches up in a circlet on my wrist. Sidney and I stand under a *chuppa* covered with flowers and are married by a rabbi who knows me. The sound of the crunch as Sidney's foot shatters the wineglass is reassuring.

The wedding is in Woodmont at one of Poli's rented cottages, just like my sister Gert's. Upstairs in one of the bedrooms are the wedding presents that outline the good life I am supposed to live. A whole set of sterling silver flatware from Gert and her husband. Wedgwood china with a lacy raised border, service for twelve, from Mom and Pop. A magnificent Minton platter edged in silver from Sidney Kingsley. Eddie Kook, whose Century Lighting Company does all Sidney's shows, and his wife, Hilda, have given us a dozen demitasse cups, each hand-painted with a different flower, from Tiffany's. We have monogrammed towels, monogrammed sheets, and the largest collection extant of candy dishes in china, silver, and glass.

A shower of hard rice descends on our heads as we escape to a borrowed car for our honeymoon. Tin cans dangle on the back and a sign says JUST MARRIED. I sneak a proud look at Sidney. He looks just like Spencer Tracy, all angles, square angles that George Bridgman, professor of drawing at the League, would approve. I'm sure I'll be happy with him. I'll be able to paint. After all, he's in an allied art. I'll learn to be a fine Hungarian cook, like Mama Heiman. I'll make him happy.

Our honeymoon is a tour of summer theaters starting in Westport, Connecticut, at the Langners' Westport Playhouse, extending to T. Edward Hambleton's Matunuck-by-the-Sea in Rhode Island, to Cape Cod and Dennis and Provincetown, all the way up to Ogunquit, Maine. Everywhere we have free house seats. I learn to keep my mouth shut. The author or producer may be

nearby. Never, never do we walk out, no matter how bad the play is.

The most beautiful day of all is in Provincetown, where we take a fishing boat. Someone photographs us standing next to the mast, happy, windswept, and smiling into the future. At night we sleep in the bridal suite of the Provincetown Inn, where we have to climb a little ladder to get into the high antique four-poster bed. Snuggled contentedly with my head on Sidney's shoulder I look through the net canopy. "Let's have a bed like this someday," I say before we fall asleep, spent with the sun and sea and our lovemaking.

Coming back to New York, we move into our first apartment, a furnished sublease at 310 East Fifty-fifth Street. A sudden roar, so intense it rattles the windows, makes me aware that we are half a block from the Third Avenue El. Oh God. Still, it is only temporary. Our lives are to be based on the Call. Any minute Sidney may get the Call to Hollywood. His ever-ready attitude, "We must be flexible," means no permanent apartment.

Theater people do not seem to see my paintings that hang on the walls. They are not visual. They talk about "properties" and play memory games about who was in which show in what year.

I bump into Walkowitz. "Are you still writing poems?"

"Sometimes, but I'm still a painter. My name is Lily Harmon now."

"You got married?"

"Twice."

"Well, I hope it works this time."

"My husband's in the theater. I just did a painting of Judith Anderson."

"Send it to the Independents Show. There's no jury and it will get in. Everything submitted gets in."

When the painting of Judith Anderson, looking tall in her Fortuny gown that cascades over her sensuous body in rivulets of narrow pleats, is hung in the show, nobody notices. It is as if I dropped it in a deep well.

I give a series of watercolors of *Four Saints in Three Acts* to Mrs. Martin Beck, the producer's wife. Sidney pays off his obligations

to his friends with gifts of my paintings. I paint my own interpretation of *Recruiten,* a show given by Artef, the Jewish workers' theater, and eleven paintings are exhibited in their basement tearoom, but unfortunately they get stowed away with the tables and chairs in some warehouse and I never see them again.

I have one friend in the theater who sees. Alfredo Valente was an artist before he became a photographer on the staff of *Stage* magazine. He likes my paintings of *Recruiten.*

"They're the first modern paintings I ever liked."

The very first show that Sidney produces after *Men in White* is *The Milky Way.* He does it with the aid of an affluent partner, James Ramsey Ullman. Later Jim strikes off on his own and takes up mountain climbing. The show runs for a while but when it closes after forty-five performances, Gladys George, Brian Donlevy and William Foran are out of jobs, and our furnished apartment is stuffed full of furniture we inherit from the show.

One day shortly after this catastrophe, Robert Rossen, an old friend of Sidney's from his New York University days, is walking by the Empire Theater Building at Broadway and Fortieth Street and is seized with an urge to go to the toilet. Glancing up at the half-moon window, he notices the lettering SIDNEY HARMON—THEATRICAL PRODUCTIONS, and takes the rickety elevator up to the second floor. Sidney gives him the key to the men's room.

"What are you doing now, Bob?" Sidney asks Bob when he comes back with the key.

"I'm selling paint for my father."

"Too bad."

"But I have a play. . . ."

These magical words start a chain reaction. Perhaps, in a way, it is my fault. Sidney has almost, but not quite, forgiven me for reading a script called "Three Men on a Horse" and giving him my opinion. I told him it was contrived and commercial, had no message, was trash and not worthy of him. It is still running on Broadway and a smash hit, playing to audiences that get the message, which is laughter.

Bob's play is a comedy, too. The lead part of an adorable

dumb blonde is written with a specific actress in mind—Polly Walters, who was so marvelous in *She Loves Me Not.* There is only one thing wrong when Polly shows up for rehearsals. Whereas she had then been cuddlesome and cute, she was now just plain fat.

A failure as a play reader, I am now assistant to Bianca Stroock, who will costume the show. She is married to James Stroock, who owns Brooks Costume Company. They are parents of two beautiful stagestruck little girls, Gloria and Geraldine, who act as soon as you set foot in their home.

"Do something," Sidney says to Bianca. "Do something about Polly's shape."

It is too late for a diet.

Bianca turns to me. "Run out and get Polly a girdle. No, that won't do it. Get her a foundation. A corset. The best damned one in the world."

"You can't imagine what I found," I report to Bianca. "Warner's Corset Company has a brand-new foundation called, believe it or not, 'The Body Beautiful.' " That is the name of Bob's show.

"Great. We should get it for free."

We do. But when Polly steps into the foundation, pulling it up inch by inch, it only relocates the bulges, like squeezing a balloon.

"I hope I can say my lines in this thing," Polly gasps. "I can hardly breathe."

"Get used to it," Bianca says. "You look better. Now what about your hair?"

"What about it? I *like* a lot of hair."

"Not that much. Lily, take her to Antoine at Saks Fifth Avenue."

"*Incroyable!*" says Antoine as he hacks away at Polly's mass of straw-colored hair, but she does look adorable when she emerges with a tiny cap of golden curls close to her head.

Opening night is a disaster. Garson Kanin, who is in the show, comes before the curtain to explain the delay in its rising. Although he is very funny, and gets laughs with his ad libs and

unshaven face, there is no laughter during the play except in the wrong places. By the time the curtain comes down at the wrong time in the third act, slicing an actor's line in half, nobody cares. They are too busy escaping into the aisles.

Waiting for the notices at Sardi's is like a wake. We all know what is coming.

"I'll bet I could sell you to Hollywood," Sidney says to Bob, who is on the verge of tears.

"Come off it," says the author. "Now?"

"Yes, now. In Hollywood, you're still a promising playwright."

"Not for long."

"For three hours. There's a time difference."

Sidney collects change from everybody at the table, quarters, dimes, and nickels, and sends them careening down the slot of the pay telephone. He comes back smiling. "What do you know? I did it. I got you a six-month contract. Producer, director, writer. How do you like that?"

Our apartment becomes a repository for more trophies from Sidney's flop shows. I inherit designer outfits and sport a particularly lovely gray wool suit with a skirt that flares magnificently. It should. It is a Valentina, cut from a large circle with no seams. The jacket has soft velvet lapels framing a jabot of jaunty gray net.

These are troubled times in the theater. Were it not for their being subsidized by the government agency WPA, many artists and theater people would not survive. I picket with the artists against pink dismissal slips, even though I am not on the project.

Sidney and I go to shows nightly. In Harlem, Orson Welles puts on a black *Macbeth.* John Howard Lawson does *Processional.* The Group Theatre has already done *Awake and Sing.* John Garfield has become a star. Lillian Hellman, in her thirties, is successful with *The Children's Hour.* Sidney delights in imitating Barry Fitzgerald in the Abbey Theater's productions of Sean O'Casey's *The Plough and the Stars* and *Playboy of the Western World.* We both memorize whole passages from Shakespeare's *Richard the Second,* now playing with Maurice Evans. We recite

them at parties. To attract attention, I do them with a Yiddish accent.

Sidney, chastened by *The Body Beautiful,* goes back to his metier, serious drama. He produces *Two Hundred Were Chosen* by a professor at the University of Iowa, a man with the improbable name of Ellsworth Prouty Conkle. It is about the plight of midwestern farmers exiled by the drought and relocated in the Matanuska Valley in Alaska. Will Geer and Tony Ross are in it. A display of huge vegetables grown in Alaska is in the lobby to prove that farming is possible in the far north. Nevertheless, the play closes after thirty-five performances. But E.P. Conkle sends Sidney a couple of one-act plays by a student of his, a boy named Tennessee Williams, and Sidney sends them to Audrey Wood, the agent.

Virginia, E.P.'s wife, has a habit of greeting everybody in New York with a friendly "good morning." I try to explain this is not a good idea in New York, but she counters with "Everybody looks so lonesome. They like it. In Iowa City, I always say good morning to people in the street."

She and her husband return to the tranquility and picnics of Iowa. E.P. works on *Prologue to Glory,* a play about Abraham Lincoln, which is a success when it is done by the Theatre Project of the WPA.

Sidney's next two plays, *But for the Grace of God* by Leopold Atlas, which he does in association with the Theatre Guild, and *Robin Landing,* with T. Edward Hambleton, his new partner, a fresh-faced young man who looks fifteen years old, are both failures.

Hecky Rome has at long last completed his five years at the Yale School of Architecture only to find out that 95 percent of architects are unemployed. Luckily he still has his music and has written a revue.

"Maybe Sidney can help you to get a producer."

We love the music and lyrics of "Sing Me a Song of Social Significance," as well as "It's Not Cricket to Picket" and all the other songs, but none of the people to whom Sidney introduces Hecky are willing to take a chance on it. Finally, David Dubinsky

puts on *Pins and Needles* with an amateur cast from the International Ladies Garment Workers Union, and it is a smash hit at Labor Stage before it moves to Broadway.

Why does such a surge of jealousy come over me when Hecky appears with Florence, his new bride? She is not only pretty and clever, but she is wearing an adorable outfit, a suit that exposes a tantalizing inch of ruffled petticoat. She can even, unlike me, carry a tune.

In the periods between shows, we are broke. At one point, when our bank account is almost zero, I summon up courage. Not telling Sidney, I go to see Mrs. Salzman, the only rich person I know. She is sympathetic when I ask her for a loan of a few hundred dollars, but she also regards me with pity as if to say, "None of this would have happened if you married my nephew the doctor." Her answer, sweetly phrased, is no. The experience is so humiliating I decide I must earn money somehow.

Alfredo Valente's face is as warm as southern Italy. He has a large ski jump of a nose, and under his heavy eyebrows his eyes are dark and sympathetic. His thick black hair rises in front like a pompadour. It would be hard to tell from his studio at 119 West Fifty-seventh Street what he is selling. True, there are some photographs of Ronald Colman and Sam Jaffe in *Lost Horizons* and some of Lynn Fontanne and Alfred Lunt, but there are also an overwhelming number of wooden carved madonnas with their hands folded demurely over their high pregnant bellies. Carved gold-leafed *putti* extend winsomely from the walls. There is a melange of Italian termite-drilled tables with an exquisite patina.

Alfredo's falling in love with my lost paintings of *Recruiten* has led to his collecting art. Some of the artists he met through me, but he took off on his own in a rage of collecting. He often asks us to paint to size for the elaborate Renaissance frames he collects. I see Marsden Hartley often, looking gaunt and spent, waiting for some recognition, some money, and Alfredo helps to carry him along. There are paintings by Raphael and Moses Soyer, Max Weber, Tschacbasov, and Lebduska, the primitive, as well as many others.

"Guess who was just here?" Alfredo asks, coming out of the darkroom.

"Who?"

"One of the best dealers in New York," Alfredo chuckles. "I asked him to come see my Breughel the younger."

I nod. I know the Breughel. Not a good one.

"I'm tired of it. I like modern art. I wanted to sell it, but when I showed it to this expert, he wasn't interested. He wanted to know how much I wanted for my Rouault." Alfredo laughs until tears stream down his cheeks.

"Oh my God. What did you tell him?"

I know the Rouault. Sometimes Alfredo, in a hurry to fill one of his magnificent frames, paints something himself—often in the style of Rouault, whom he admires. The intense colors and patterns go well with the frames. He never signs them.

"I told him it was not for sale. What could I say? I said it wasn't signed. He said he'd know an original any time. It didn't need a signature. Every brush stroke was one, he said." Alfredo wipes his eyes.

"What an idiot," I say. "What a tribute."

"What an ass," Alfredo adds.

"Someday, Alfredo, there may be a lot of confusion about your Rouaults."

"Not unless the whole art world is crazy."

"I brought you the little self-portrait you wanted. Seven by nine inches."

Its designated frame, when we fit it in, is so ornate it almost overwhelms the painting. What is it the new Dutch framemaker Henry Heydenryk says? "The frame is the reward of the artist."

I summon up courage. I am on a mission. "Is it hard to be a photographer?"

"Why?"

"I've got to make some money. It's hard for Sidney between shows."

"But you're an artist, a good artist. Did you ever find those paintings you did of *Recruiten?*

"No. And if I did, who would want them?"

"I would."

"Thanks, Alfredo, but I have to make some money."

"I'll teach you photography, if that's what you want."

"I'm afraid of the technical part."

"That's the easiest. The hardest part you have already. An eye. You know lighting. You know composition. You'll need equipment. Not too much. Most people have too much."

Alfredo teaches me how to load film into holders in total darkness. It makes me think, *This is what it would be like to be blind.* I learn to put a black cloth over my head and peer through the eight-by-ten studio-view camera at upside-down images. It doesn't bother me. After all, I've been turning canvases that way for years to check the composition. I have a huge, four-by-five Graflex for outside work with an extension bellows to make it even heavier and portable floodlights on tripods. Sidney curses at the enlarger in the bathroom, the trays, the smell of hypo, the negatives hanging from clamps, the prints drying on the top of our canopy bed.

All the aspiring young actresses I know are willing models. One thing they all have in common is that each insists she has only one good side to her face. I learn how to retouch when Arlene Francis, who acted in *The Body Beautiful,* needs thicker eyelashes. Miriam Valente, Alfredo's wife, a subtle retoucher, teaches me how to do this, as well as how to touch out any blemishes or imperfections in the negative. I light to bring out every good attribute. These girls need jobs.

Only weeks after I start, Louise Campbell needs a whole bunch of pictures. She is going to Hollywood and orders fifty glossy prints from the many studies I made of her. I am a photographer.

Despite my telling myself I am only doing this to make money, I cannot help seeing that the camera has other possibilities. One day, walking on Fifty-second Street, I am intrigued by a window full of feather fans. I go up one flight and ask the owner of the shop, who caters to Sally Rand, if he can help me. He is obliging, and one evening I lug the heavy Graflex and my lights to find a group of dancers awaiting me in G-strings, waving their fans fore and aft. The most spectacular one turns out to be a man, her breasts of rubber, her luxurious blond hair, a wig, her bulging mons veneris concealing a penis.

The shots that please me most are two, both of a blond girl.

In one she is looking at herself in the mirror with a quizzical expression and scratching her head, and in another I show only her callused feet and legs to the knee with feathers drooping beside them.

Some time later the *Daily News* has a headline about this blond beauty. She jumped out of a twenty-story building, stark naked, and landed on Broadway. It was the ultimate protest against the Great White Way.

A theatrical press agent and poet, Manny Eisenberg, did something similar. He always flirted outrageously with Mildred Harris and Ruth Goode, two writers, and me. It was always in front of our husbands. Alone with him, we were as safe as in our mother's arms.

"Perhaps he was a fairy," we said comparing notes afterward. Certainly he wasn't gay. It was hard to imagine anyone more tortured.

Manny hired an airplane, grappled with the pilot, who tried to stop him, and jumped out. He meant to land on Broadway, but instead he landed in the Hudson River.

Sidney was on salary throughout production of Stanley Young's *Robin Landing*, with Louis Calhern, and we managed to save a little money. At long last, we have an unfurnished apartment and fill it, as usual, with furniture from flop shows. I even have an extra bathroom for a darkroom. It is at this precise moment that the Call to Hollywood comes. We sublease our new apartment to five Jewish boys who assure us they will take very good care of it. They want a place for a year, one last year together before they settle down.

In North Hollywood we sublease the actor Douglass Montgomery's frame house. It could almost be a New England house except for the geraniums that grow to such obscene heights they have to be trimmed with a hedge clipper.

My whole nature rebels against the sameness of the days broken by minor excitements like a small earthquake that makes glasses tinkle on the shelves in the Brown Derby so that a startled waiter spills a little Scotch on me.

A sudden flash flood washes out cliffs of sand and telephone poles slide like toothpicks into chasms made by the rain. I miss

the visual parade of the seasons and the invigorating cold. Our Japanese gardener waters our stubbly green lawn often so it will not revert to straw. Christmas celebrated among palm trees is ridiculous. I miss art galleries and museums. Taking a walk is suspect. Everybody whizzes from place to place on wheels. It is Car City.

Worse than everything is the caste system in the motion picture industry. In New York I thought the five hundred dollars a week Sidney would be making was wonderful. Here, as one writer said, "Nothing scares so easily as one thousand dollars a week." And hardly anybody makes less than that. So we are underprivileged.

Luckily there are enough old friends from New York who dare to overlook the rule: Thou shalt not associate with anyone in the lower echelons of cash. Dore and Miriam Schary don't care. Garson Kanin, bewildered at being hired by Universal Studios, given a huge salary and nothing to do, is happy when I interrupt the monotony of his day with a request to use the studio darkroom. "It won't last," everybody says later on when he marries the actress Ruth Gordon, much older than he.

Poor Sidney is sucked into a What Makes Sammy Run situation at Paramount. He discusses ideas for stories with writers who run quickly and present them as their own. He gets no credit. When I drive to Paramount daily to pick him up in the car, I watch Cary Grant having his hair cut or getting a shave in the barber shop across the street. A pleasant sight. But when Sidney comes through the gates, he looks crushed.

Almost every day Lionel Stander's wife, Alice, and I drive to sketch at Palos Verdes, beautiful verdant farm country next to the ocean. Like good little housewives, Shephard Traube's wife, Mildred, and I shop at the Farmers' Market where we squeeze fruit, select lettuce and watch a benign Boris Karloff buy bread. Inspired by the Traubes' delicious marshmallow of a daughter, Vicky, I decide I want to have children. Sidney agrees, although he is not enthusiastic. I put that down to his torment at Paramount. Nothing happens. But I have faith. Month follows month. I do not seem to be able to get pregnant. Could I be sterile? It makes me feel inferior. Unwomanly. Inadequate.

Trying to get pregnant, trying so hard, is probably not a good

idea. I sit in our little garden writing stories, usually about shoe-string producers like Sidney. He is pleased with my newfound activity. He likes writers.

"You're looking at me with *money eyes,*" I tell him. "I'm just doing it to pass the time away." I have no studio. Aside from sketching with Alice, I am bored.

Sidney takes "Maharajah Up His Sleeve," a tale of a producer who gets a potentate to back his play that is so bad it becomes a comic success, to Ruth Morris, William Morris's sister. She wants to know the name of the man who wrote it. She is surprised when Sidney tells her I wrote it, and she goes over it with me suggesting changes and acting as if I were a writer.

"I didn't know Sidney would take it to you. I don't know how to make changes. I'm really a painter," I stammer.

Perhaps we agree, because she doesn't press the matter. I continue whiling away the time, pouring out my anguish about the world of the theater through fiction. And trying to get pregnant. I spend a lot of time trying to get pregnant. But Sidney and I do not succeed. Could it be because of that abortion I had when I was married to Peter?

We go to a doctor, who asks embarrassing questions. How often do we have intercourse? At what time of the month? How? Then he gets down to cases.

"First we shall blow out your fallopian tubes." I find this alarming but I lie down while air is pumped into my nether regions as if I were an automobile tire. I feel a sharp pain all the way up to my shoulders and let out a scream.

"Good," says the doctor. "A perfect reaction."

"But in my *shoulders!*"

"That's it. Just where you were supposed to feel it."

But the next month I am menstruating as usual. The tube-blowing hasn't worked.

"I want you to have intercourse," the doctor says. What does he think we've been doing? Does he want us to do it right now in his office? "At home," he says to my relief. He hands Sidney a sterile bottle. "Afterward you must drive here as quickly as possible. I'll do a count of spermatozoa. We must check you both, overlook nothing."

Tearing down the Speedway with the still-warm semen, we

wonder what will happen. We find out. The count is nowhere near the thousands or millions it is supposed to be. No wonder. Subjected to that mad race, the spermatozoa, as well as we, are discouraged.

A whole year in Hollywood has gone by. Neither of us is surprised when Sidney's option is not picked up. He has been outrun, outclassed. I am glad we are going back to our New York apartment, but I weep when I see the shambles the five Jewish bachelors have left. There are bizarre dildos in the drawers and exhausted condoms under the beds.

I still want to live what I consider a full life. We have saved money from Hollywood. I want a baby. A new gynecologist tells me I have a tilted womb. I visualize the pinball machines Sidney loves to play, their lights flashing, bells going ting-a-ling. *Tilt.*

"It might have something to do with your sterility."

I wish he wouldn't use that word. It makes me feel empty and guilty; still, I would rather accept the blame myself. I didn't like Sidney's reaction to the sperm count. It had made everything worse.

"What can I do about it?"

"It's very simple. An operation. Just two small cuts. They won't show—your pubic hair will grow over them. We straighten your womb." And will I then fly right?

But it is no use. After the operation, on the first day I am able to take a walk, it is snowing. Wet flakes hit my face. I am happy to be out, despite the mad itching in my privates as stubble grows back in. The doctor hadn't told me I would be shaved. Nor had he guaranteed a pregnancy, and I do not get pregnant.

What am I going to do with my life? I am twenty-seven, getting old, I think. I am tired of latching on to Sidney's life. What about mine? I seem to have forfeited it. And having children is not, after all, a substitute for my own life. I have been gone from the art scene for a long time and feel like a novice. I shan't try to connect myself to Sidney's life any more. I shall go back to school again.

The pungent odor of turpentine is in my nostrils again. I

choose Arnold Blanch as my first teacher at the Art Students League. It seems to me that at twenty-seven I am the oldest one in his class. Beginning. It doesn't bother me at all when I sit in the coffee shop with the younger students. I am back in my element. Deep in the problems of paint. It stays wet too long. If I add dryers it's too dry to be juicy. Gene Karlin draws like Picasso. His line flows smoothly and surely around the contours of the model. Joan Brambila, another friend, looks like a Tahitian straight out of Gauguin.

I rush back from the League to our apartment to cook dinner. Each night we go to the theater. I am tired. I would rather not see every show on Broadway. My mind is with my painting.

After some months in Blanch's class, I find the students copying his work too slavishly, and I enroll in William Von Schlegell's class. No danger there—he rarely shows and I've never seen his work. I find myself painting pink and blue nudes while the class is doing them in brown. Von Schlegell doesn't try to change my style. He is the best teacher I've had because he doesn't inflict his own work. I feel happy and released.

We have a short model. The class is idealizing her beyond belief. Von Schlegell wants to point out the characteristics of her body. He gets up on the model stand. His figure towers above her.

"You see," he says. "You have made her tall. You see how we look together."

The class gets the point. She is the exact opposite of our teacher. Her short legs look even shorter.

He is a good teacher, but I sample teachers like a hummingbird going from flower to flower. In Kenneth Hayes Miller's class I build forms with white and glaze them with color. I am sated with studying and want to have a studio of my own. I realize I haven't had a place to paint since I married Sidney. All our apartments were dark and there was no room.

A cheap studio is available at 30 East Fourteenth Street, a sublease of George Rickey's, a painter who will become a sculptor. The building is full of painters. Down below is Janice's Dress Shop and all the ruckus of Fourteenth Street. Reginald Marsh nearby on Union Square looks out of his studio window observ-

ing the life of the streets through his binoculars. My little room with a skylight is on the fifth and top floor, across the hall from Yasuo Kuniyoshi's studio, which faces the street and is the best on that landing. Next door to me two young painters share a studio. Morris Kantor, Charles Keller, and other painters are in the building. Now I am one of them.

I find an old kitchen table with a porcelain top for a paint table, put it on wheels, and buy a good easel. George Rickey left racks for canvases, a chair for a model, and a studio couch. A room of my own. I haven't had that feeling since my attic studio on Orange Street.

Sidney is deeply involved with a new writer from Chicago, Philip Yordan. He is dark and oily. I can't stand him. I'm glad to escape to my studio, away from the endless stories they bat around.

"What do you see in him?"

"He's got a lot on the ball."

"Maybe. But he's inconsiderate. He uses every towel in the bathroom and drops things all over the floor for me to pick up. He's rude."

"He's a little uncouth," Sidney admits.

"He's a lot uncouth."

Perhaps Philip Yordan is a catalyst for what happens. I spend longer hours in the studio and I get in a peck of trouble.

It starts innocently. Like many other artists, I admire Kuniyoshi's work. He's called a painter's painter, a high tribute. Daily I see him entering or leaving his studio, his slight figure clothed in beige tweeds, a pipe in his mouth, and he walks softly, almost like a cat. He visits my studio, studies my canvases, and flatters me with attention and approval. It never occurs to me that he might have some ulterior motive, like a compulsion to seduce a young artist.

In his studio, I watch him arrange a still life, turning a Victorian table upside down so its legs claw the air like an animal on its back. He draws in charcoal and fixes it with spray before he begins painting. Unlike me, he doesn't deviate from his original idea an iota. The line is always visible while he leaves light around the edges.

"What's the name of that painting?" I ask about a woman holding a flat wooden decoy bird on a stick.

"Rook, it fries!"

Ah, yes. Look, it flies, I translate mentally. Why does he choose titles with all those r's? He can't pronounce them. For that matter, why do radio announcers often have speech defects? Kuniyoshi's way of talking serves him well. He is the most popular of artists, for speeches, for committees. He has wonderful humor. He sees himself as an anachronism and paints a self-portrait as a golfer dressed in plus fours. An Oriental man geared for America. Assimilated.

My admiration is akin to worship. There is communication between us. I have none with Sidney. It is almost as if he is married to Phil Yordan. I see Kuniyoshi as the embodiment of art. Eventually I give myself to him on his Victorian sofa as if I am becoming one with art itself. He is as delicate and adroit in his lovemaking as in his paintings.

In the name of honesty, which is sometimes more like cruelty or revenge, the first thing I do is tell Sidney about it. I am surprised at his reaction.

"How could you?" Sidney cries, wounded.

"I don't know," I say in a small voice.

"A Jap!"

Now my mettle is up. Would it have been all right to have an affair with someone else? Sidney is transformed into an angry ogre. I can think of nothing else to do but move into my studio. There I take baths in a tin washtub à la Degas and use the toilet on the landing below.

Kuniyoshi takes no such drastic measures. He talks as though he might leave his second wife, Sara, but obviously he forgets to mention it to her. For him, life goes on as usual with the added fillip that I loved him enough to leave my husband and give all to art, i.e., to him.

"Now we live with steam!" Burliuk said when he moved from a cold-water flat. It was a dangerous thing to do. There is nothing like the sympathy aroused in the bosoms of rich collectors for a poor artist. The Kooks take mercy on me in my plight and

commission me to paint their daughter, Pat. Deeply influenced by Kuniyoshi's style, the portrait is a tribute to him, with a difference. Kuniyoshi's children are obscene, fat grotesque little objects. Mine are lovable. I am paid one hundred dollars for the painting of Pat, and I buy a used Model T Ford and take off in my Tin Lizzie for the summer. I have room and board at a farm in New Milford.

Yas, as Kuniyoshi is called, spends the summer in Woodstock, meeting me occasionally to visit his dealer, Edith Halpert, whose home in New Milford is full of early American folk art. Lord knows what she thinks about our being together, but she is too much of a lady to say anything. Perhaps it is not the first time she has seen her prize artist with a girl in tow.

The Polish farmer's wife is an extraordinary landlady. Having no background in art, not even a high school education, she is an instinctive and discriminating collector. While her neighbors buy furniture from Sears Roebuck, she searches out early American pine pieces and glories in their simplicity. She lets me use the corn crib for a studio, takes gouaches from me in lieu of rent, and even gives me a bonus of an old student's desk from which I scrape the paint with broken bits of glass. She is the first, but not the last, collector I meet with natural taste and a built-in love of beauty which has no explanation.

A stab of pain. When I go back to New York, Sidney is no longer angry, merely calm and indifferent. He is no longer jealous. Kuniyoshi, on the other hand, enjoys the power he wielded to make me leave my husband of six years—which isn't the same as my feeling that we were both very much in love. My new lonesomeness terrifies me. I question myself about why I couldn't have gone back to painting without all this agony, but it is too late. The scrambled eggs will not go back in the shell. It doesn't matter who did what to whom.

When Sidney and I meet for a farewell lunch the day before I am to leave for Reno—What? Again?—my parting gesture is to present him with a possible new wife.

"Please see Liz Wallerstein, Sidney. She's a poor little rich girl who lives in Westchester. She wants to work in the theater."

I know darned well that if Sidney meets Liz, something will happen. What I don't know is why I arrange it. As we walk around the smorgasbord table helping ourselves to tidbits, my eyes tear.

"I'm sorry," I say, as we settle down with our plates. "I didn't mean to cry." I cannot stop.

"You should get some help." Sidney writes a name and telephone number on a napkin, and I put it in my bag without looking at it. Before we go our separate ways, he says, "I'll take you to the train tomorrow."

"I'm working my way up," I say brightly as Sidney stows away my luggage. "Last time I went to Reno it was by bus."

The divorcees in Reno are a mixed bag my second time there.

Fifi G. is shedding her rich husband who manufactures and processes film all over the world.

"I had it with him," she confesses while she files her nails. "He has nasty habits. I got tired of peeing into his black top hat. There's just so much a girl can stand."

She isn't the least bit worried; she fingers her jewelry and expects a large settlement. Not me. I expect nothing, nor does a tall exquisite white-haired lady who teaches teachers and is so immaculate it's hard to imagine her married at all. Most of the ladies are getting married the day of the divorce. They wouldn't have come without hedging their bets. Sometimes I feel as if the gunnel of the canoe is about to hit me again, and this time I won't be able to swim to shore. My only lifesaver is my work. I cling to it desperately.

In the gambling houses and bars, the models are free and absorbed. They don't notice me sketching. They are busy with dice and blackjack and the cherries whizzing around in the quarter slot machines. There's always the possibility of hitting the jackpot. Frumpy older women, discards for younger wives, wear hats with veils to hide their tear-reddened eyes and lean on the piano listening to the piano player bang out their favorite tunes. Behind them, moose heads with convoluted antlers and glass eyes stare from the wall.

Letters come from Pop. He and Mom are at their wit's end

about me. I know the substance of what they hope. I am supposed to give up art. "It makes her crazy," my sister's father-in-law had said at a Seder. "There's nothing the matter with her except art. She should give it up." Later, Mom had tried to console me. "All ve vant for you, Lilinyu, you should have a friend in the world." "I want that too, Mom, but I have lots of friends." "Strangers you have, not family." But I could never explain to her that my friends, especially the artists, were my real family.

DEAR LIL
My sister writes. She knows I hate to be called Lil.
I don't know what you plan to do with your life now that you've messed up your second marriage, but you'll surely have to give up painting and get a job. Perhaps if you're lucky you'll get something at Macy's.

How can she write this? I am tortured enough. She comes at me from her security as a wife and mother of two little girls and the smugness of Bridgeport.
My only ally is my brother, who also has committed a sin. He did not marry the rich daughter of the clothier to Yalies, but a blues singer from Bridgeport. We have both fallen in the social strata. Joe's wife, Edith, comes from a poor family.
"She looks just like Rita Hayworth. She's beautiful," I say in her defense. "And she sings like Ruth Etting."
"Who's Ruth Etting?" My sister breathes fire from her nostrils. "A nobody." I sometimes think that Gert wants our handsome brother all to herself. No girl would be good enough for him. The fact that Joe and Edith have two children is immaterial. His marriage makes her unhappy and she has Mom and Pop saying *"Es past nicht."* It is not suitable.
There is a letter from Kuniyoshi in the same mail as the one from my sister. What would my family have thought of him? He tells me we had best continue our separate ways as artists. It will be better in the long run. I am hurt that he overturned my marriage so casually, but in a way I am relieved. I can't imagine

being married to him and overwhelmed by his style and certainty in art. Still, I smart at my own naiveté.

"Maybe I shouldn't get the divorce," I'm surprised to hear myself say over the phone to Sidney.

"If you've made a mistake, we can always get together again. You've been there almost the whole six weeks. You might as well get it."

I hang up, agreeing, like a good little girl.

Chapter Three
1940-1945

I HAVE SHINGLES. I have giant hives. It is as if my very skin rebels against the news that Sidney and Liz are not only married, but about to have their first child. So soon. And I had tried so hard. A rabbit died in a test whenever one of Sidney's new shows opened. I would be sure I was pregnant, I was so nauseous, but it was only fear. Fear of what the reviews would say.

I am living in a railroad flat way over west on Fifty-seventh Street with three girl art students from the League. My first day there, a large box full of Winsor & Newton colors arrives. There is no card, but I know it is from Kuniyoshi. It's his way of saying "Shape up. Fly right. Be a painter."

I take a volunteer job at the Riverside Community House teaching art to kids after school. Cleaning up spilled pots of paint, washing out sinks running with color, kicking fresh boys out of class, I don't have time to be dreamy about how much I want children. My class is free and imaginative. One little girl, whose work is colorful and original, says, "My teacher in *real* school doesn't like my work, like you do. She says I can't do perspective." I could kill her teacher.

I make no pretense of looking for a job, a paying job. This time I tell Pop straight out, "Please help me. I want you to help me until I can support myself." Will I ever be able to do this with painting? How long will it take me? I think it may take me

five years just to rid myself of Kuniyoshi's influence. What are my own convictions?

Every week, on Tuesday, when Pop comes to New York to buy at the men's wholesale houses, he meets me for lunch at Lou Siegel's and gives me my weekly allowance. I eat a lot. Pop doesn't spoil me with money. My priorities are good paint, brushes, and canvas. There are runs in my stockings.

"Baba is in Coney Island."

"What's she doing there?" I say between mouthfuls of gefilte fish.

"A good question. The answer I don't know. She wants she should live her own life." How marvelous, I think. So do I. "Seventy-seven," Pop continues, "is no time to run away from home. Go see her. Maybe you can talk sense into her."

I find Baba, a darkened silhouette against the horizon, sitting on a folding chair with the waves rolling close to her feet. We hug one another.

"A *mechiah* to see you, Lilinyu."

It is a delight for me, too.

"Pop wants you to go back to New Haven," I say when we walk to her neat little room.

"You want a *glessele* tea?"

"OK. Don't you want to go home?"

"Enough already," bursts out of Baba, as she bustles around a small electric burner. "I brought up all the children. You and Joe and Gert. I even *shlepped* around the corner sweet-and-sour meatballs for your Aunt Emma and her good-for-nothing husband, Abe. Leonard and Evelyn, her *kinderlach,* I brought her children up, too. Now I want to live my own life. Is that a sin?"

"No."

"You I wouldn't mind to live with."

Shortly after my roommates leave, one by one, to get married or go back home to Kansas, Baba moves in with her large cooking pots and her Ivory soap.

"You should remember, Lilinyu," she says while she slices innumerable onions into lamb stew, "vit bones is the sveetest part. . . ."

"There's so much. It's just the two of us, Baba."

"*Ver veist?*" Who knows? A person could drop in.

Free as a bird, no longer playing second fiddle to Zayda, Baba assumes his mantle. She goes wherever the spirit leads her. It leads her into public buildings, where she helps herself to free brochures which she spreads out proudly on the kitchen table. She cannot read them. I tell her what she has brought home.

"*Vus es dus*, Senate?"

"It's a branch of the government, in Washington."

"I vould like to see it. Maybe *ich vil gehen zu Vashington*."

Any minute now she may take off.

I paint Baba mending my stockings. Her work-chapped hands are so rough, they catch on the silk. Next to her rests her oval straw basket stuffed with spools of thread, scissors, and the round form of her darning egg.

"*Du host gildener hent, mein kind.*"

"You have golden hands, too, Baba. Nobody can mend the way you do. I can't even see where the hole was."

"*Die zelbe zach.*"

Yes, it's all the same thing.

Baba, whom I never remember being sick a day in her life, catches cold. Ill health surprises her. She recovers from what turns into pneumonia. That bout is only a preliminary for the main event.

Cancer does it. Cancer of the throat. She is starving to death. Sometimes I dream about walking down the long corridors of Kings County Hospital, the old people sitting in rows outside their rooms. From their wheelchairs, they clutch at me as I pass. "Please, Miss. Nobody pays attention." In their wrinkled faces, dried up from too much living, their eyes reprimand me for being young and healthy. I want to wake up before I get to the last room where Baba lies in bed. I bring her my nightgowns to wear. Hers hang on her like sacks. Even mine are too big. I am amazed at the delicacy of her framework as death whittles away at her. I want to remember her fat and apple-cheeked, her underwear smelling of sunshine and soap.

"Nobody would mind," says Pop to Dr. Wolf, who is taking

care of Baba, "if you gave her a little too much sleeping medicine some night."

"I can't do that, Ben. I'm a doctor. I'm not allowed to take life."

"I love her like a son," says Pop. "My own mother died, I was nine. She is my mother."

And Mom, angry that Baba deserted her, angrier still at the devotion her unconditional love inspired, seems to wait patiently to inherit the same emotion.

Baba was my real mother, I think, while she lingers on fighting. She does not go easily. At the end, with her breath going, she sighs, "*A lange chulem!*" So that's what it was. A long dream.

From Baba I inherit an inability to cook for two. I recreate her huge casseroles of lima beans and brisket from taste memory. She never used a recipe in her life. "A little of this, a little of that," she would say when I asked her how to make something. *Bullets* she called her matzoh balls that descended like lead to the stomach. Mine turn out light and fluffy, but I want them to be like hers. Now plain boiled chicken, the bane of my youth, is appealing, even delectable.

She tempered her *Du bist a gute neshuma,* you're a good soul, with *Ober du bist ein akshun.* Only I was stubborn. To her I was always the *kleininke,* the little one. I am still sustained by her telling Mom I should be hidden away when my beautiful older sister's suitors came calling. It would not be fitting if I married first.

It never occurs to me that Gert could be jealous of me. After all, she is the lucky one. First in everything. I dreaded each new class in high school when the teacher would greet me with "I hope you do as well as your sister. She was an honor student." Gert was the first to go to college. The thought of competing there made me tired and I didn't even go. She was the first to be married, stay married, and have children. Unlike me.

I am the first, too, in other ways. Black sheep ways. The first to get married and divorced, not once but twice. The first to be kicked out of Yale Art School. The first to have the clap. I am probably the first who couldn't get pregnant. The first with the worst. My distinction.

Without Baba to lean on, Mom at last has to face what she always disdained, running the house on Orange Street and cooking. She achieves competence in odd items like squash pancakes and sweet-and-sour meatballs.

When I come to visit she says, "Lilinyu, eat some squash pancakes. I made them just for you. Your favorite."

"I hate squash pancakes." Baba knew what I liked, *kasha varnishkes,* that's what I liked.

"All your life you loved squash pancakes." How would she know? She never set foot in the kitchen. I eat the pancakes. Why couldn't I have had a mother like other kids? Why was I foisted off on Baba, who would die and leave me alone for so long?

Bearing down as hard as I can, I cut openings with a mat knife in the seventy-five ice-cream-colored pastel mats I have chosen to enhance the children's work for the year-end show. My stomach muscles ache. I go home to my new apartment on Twelfth Street, where I am living alone. Why am I so tired? My menstrual period seems endless this month. Eleven days. Is that possible? Maybe I feel so lousy from cutting all those mats.

I open the door and barely manage to weave over to the studio couch and call my doctor friend, Mauch Naftalin. He and his wife, Ruth, live nearby on Waverly Place.

"I don't know what's the matter with me, Mauch. I think I'm going to pass out. I've been having my period for eleven days . . . I cut a lot of mats. . . ." The phone slips out of my hand. Did he say "Hang on?" He said something.

Two strong policemen lift me carefully on a stretcher. A siren screams as we whizz to St. Vincent's Hospital.

"You're going to have an operation" a concerned-looking Mauch is saying. "You've been bleeding internally. You have an ectopic pregnancy."

"What's that?"

"You're pregnant in the wrong place. Your fallopian tube."

What irony. I don't even know whose baby it is. I hear myself laughing.

"It's not funny," says Mauch.

I know it's not. A nun gives me an enema. I keep thinking of

Mom saying, "Ven the heart is broken, vun gives avay the pieces." Is that an old Russian proverb?

"I could never do anything right," I mumble to the incongruous nurse in a starched white coif and black vestments who is torturing me. "Hold it *in*," she is saying. "If I had to be pregnant, why couldn't it have been in the right place? At the right time?" But the sister has no answers.

I am lucky to be alive after the operation, and I leave St. Vincent's with a mean scar marching down my middle and only one fallopian tube.

"Don't worry," says Mauch. "One is enough." It has to be now.

I feel as if I am being chiseled down, hacked away at by some determined sculptor. Still weak from the operation, but condemned to live, I try to paint, but the ghost of Kuniyoshi's style assails me. I cannot overcome it. I am more and more depressed. The idea of suicide occurs to me again. What do I have to live for if I can't paint?

I find the slip of paper with a doctor's name on it that Sidney had given me at the smorgasbord restaurant. Should I dare to go? I think art comes from a magical place. Would analysis threaten it?

Dr. Friedman is probably the ugliest man I have ever seen. He is short and rotund, has sparse red hair, pasty white skin, and a bulbous nose, but his voice is melodious and reassuring, even as he says he thinks I should see him five times a week. There is a matter of money. When I tell Pop I want to go to see a head doctor five times a week, at fifteen dollars for each fifty-minute sessions, he clears his throat.

"*Meshugge* you're not. Crazy you're not. Nobody in the Perelmutter family is *meshugge*. But maybe this doctor can help you. All you need is good advice."

It isn't like that at all.

"Say whatever comes into your mind."

Odd things do. I like to make messes. Evidently there is a connection between art and shit. It is hard to look at my palette without flinching.

"I'm a quick study," I say one day.

"What is that, a quick study?"

I am always being reminded that my doctor is an emigré from Poland by way of Paris, Vienna, and Cuba.

"You don't even understand English," I say bitterly. "I'm teaching you English at fifteen dollars a session."

"The hardest things to understand in a foreign language," says Dr. Friedman gently, "are poetry, slang, and jokes."

"A quick study," I say, chastened, "is a term actors use. It means they learn their lines quickly."

"*Ach so!*" comes from behind my head, and the usual followup: "What does it mean to you?"

Back in the studio, I draw myself naked, encased in a block of ice from the waist down, and scribble "Frozen Assets" under it. I draw Dr. Friedman without his clothes and give him an obscene George Grosz belly protruding over tiny genitals.

Am I curing myself? I cannot understand the process, but as I go back to my familiar fear of abandonment at three when Baba scooped me up on Grand Avenue, there are some days when I sail lightly out of the doctor's office. For the life of me, I cannot figure out how it is all happening. The analysis seems to release energy. I don't have thoughts of dying. I want to live. Facing each new canvas is an aphrodisiac. Endings are another matter.

"I can't talk about what's happening," I say to Dr. Friedman. "I can't understand how people make cocktail conversation about analysis. I can't."

"Good," says Dr. Friedman.

I am so grateful I offer him gifts. "Wouldn't you like one of my drawings?"

"I can't accept presents."

"How about a lithograph?" I say, lowering the ante, but he isn't having anything.

Perhaps the implication that I am trying to bribe my doctor with gifts of art is true; anything would be better than having my nose shoved back into my own messes.

But gradually the black moods subside. The painting no

longer seems to be "in spite of," nor is there any need to hide my own femininity. I am not afraid to bring my tones high and light and play lemons and Naples yellow in a register of warm colors or do canvases where hot and cold alternate, where blues and greens mix. I try to open myself to painting like a lover—to be receptive and allow it to pour into me.

In the dressing rooms of S. Klein's, I have free models—ladies who gyrate in and out of dresses and are oblivious to me. In my neighborhood, I pick up people to pose—mostly mothers and children. Gradually, sending pictures to large art annuals, I begin to have some accepted. I think of putting a huge letter C in the studio. For Courage. Conviction. Confidence. Maybe even Consecration.

It is wartime. I am an air-raid warden, and at the wail of a siren, I put on my red, white, and blue civilian defense armband and rush downstairs to patrol my station, Twelfth Street, between Fifth and Sixth Avenues. I yell "Blackout!" to any lit windows until shades are pulled and curtains drawn.

In Europe, it is not a make-believe war.

"We regret to inform you . . ." the letter to my Aunt Emma said, and went on with the news that her only son, my first cousin Leonard, had been shot down piloting a plane over Sicily.

Two months later I receive a posthumous gift, a big battered package from Morocco, and I sit crying with my lap full of presents. Tiny, embroidered golden slippers with upturned toes, a coin purse of tooled leather, intricately folded, and a pierced silver hand to ward off the evil eye.

"Son-of-a-bitch-bastards," I scream out loud to the empty studio, remembering dancing in the Rainbow Room with Lennie in his brand-new white officer's uniform, while a horrendous thought entered my mind. *You're nothing but cannon fodder.* Like Alice saying, *Why, you're nothing but a pack of cards.*

I beat around in a frenzy, trying to do something for the war effort. I take courses in first aid, in mechanical drawing, sketch wounded boys and give them their portrait-drawings to send home to Kansas or Texas or Arkansas.

Daily I read of destruction in the newspapers. Daily I work on

drawings or paintings, as if to fill the void. Despite my crash course in orthographic projection and the neat ink drawings with no blots that I make with mechanical instruments, I am turned down for jobs at Western Electric and Fairchild Aviation. I cannot pass the simplest math test. I should never have skipped the third grade. Oveta Culp Hobby of the WACs doesn't want me either, although most of the male artists I know like George Schreiber, Joe Hirsch, Lawrence Beall Smith, are doing wartime sketches. I donate a painting which sells for the highest price in war bonds at an auction. Seventy-five thousand dollars. And Peyton Boswell in the *Art News* wonders

Why is it that artists are usually the first to be called upon to contribute and are so frequently the last to be given credit for their contributions, their paintings. Why not ask Lilly Daché to donate her latest in feminine adornment? Or have the brick-layers union pledge so many square feet of brick terrace to each bond buyer? . . .

Boswell's point is well taken. Just the same, I keep giving. To Russian War Relief. To the Joint Anti-Fascist League. And to the *New Masses* auctions—no doubt establishing myself on the blacklists of the future, despite a citation from the government for sketching wounded soldiers and raising all that money in war bonds.

I am selling paintings. When I tell Pop I am through with my analysis, that I seem to be functioning, and that I will no longer need his weekly allowance, am I mistaken, or has a look of regret come over his face?

"If you need anything, let me know," he says as we part company outside Lou Siegel's restaurant; and he wends his way to the men's wholesale district and I go back to my studio on Tenth Street.

October first in New York is like a great game of musical chairs. Everybody swaps apartments. It is better to move and get a new paint job. My new apartment at 27 West Tenth Street is the ultimate. It has a skylight. The building has five stories of

yellow brick with a gnarled, grabbing wisteria vine clutching its way up to my top-floor balcony just big enough to stretch myself out to sleep on hot summer nights.

Every night I read Delacroix' *Journal.* "Not to distrust oneself, not to be one's own enemy. . . ." In the morning the light filters softly down from the skylight while I go through the ceremony of starting the day. I always think of Cennino Cennini's four-teenth-century treatise on technique which starts out by admon-ishing the artist to pray before he begins. He then goes on to describe practical matters of mixing pigment with urine.

If I am lucky, some outside force will take over. I squeeze color out on my palette while I wait for Sheila O'Rourke Mur-phy, the six-year-old daughter of a dentist down the street, to show up. First, juicy coils of white—the largest amount; then a spectrum of yellows—cadmiums, lemons, and earthy ochres. The shock of scarlet vermilion. The depth of deep alizarin crim-son. A muddy terre verte contrasting with a bright permanent green. Blues from the cerulean of Veronese skies to ultramarine once made of lapis lazuli. And a final crescendo of dark burnt siennas and umbers and blacks ranging from a warm Mars to a cool ivory.

I am lucky. My model doesn't have a cold. She shows up. The surface of the picture is just right. Tacky. What Phil Evergood calls "the skin of the painting." I get lost in the tendrils of Sheila's hair.

As Sheila wanders around the studio eating a cookie and watching me paint, I work from memory. It is an exercise in patience and in sticking to one's original idea. Beyond the first five minutes, the pose will never be the same again.

"Let me look at your eyes for a moment."

Sheila blinks and makes funny faces, but it doesn't matter. I only wanted to see the color. A marvelous blue. She doesn't stay long, and when she leaves, I think, It's a good day. I didn't ruin the painting. Some days I destroy more than I create. What is it Picasso said? "A painting is a sum of destructions. . . ."

I wash my brushes, pushing the bristles around and around on a cake of Ivory soap and then way down in the palm of my hand, making sure that the suds go all the way to the ferrule

and the water runs clear. Then I clean the center of my palette until it is a shiny island rimmed by the leftover mounds of still juicy colors. It is hard to wait for tomorrow and the new daylight.

Always concerned about the economic status of the artist, I am a member of organizations that flower and fail—from the Artists Congress to the Artists Front to the Artists Union and United American Artists all the way to the Artists League of America. Chosen to head a ways and means committee with Bob Gwathmey and Ruth Abrams, we organize a Salute to Spring costume ball to raise money.

"Get Zero Mostel," someone says. "He's an artist but he's an entertainer too. He's working at Café Society."

When I get in touch with him, we find we have two things in common aside from being crazy about Klee. We were both analyzed by Dr. Friedman and guided in art by J.B. Neumann.

Jack Gilford is Master of Ceremonies. He perks like a pot of coffee; he becomes a windshield wiper by darting his eyes back and forth. Jazz buffs turn out in droves to hear Art Hodes' swing band. Drag queens in fantastic costumes with towering headdresses win prizes for the best costumes. Dan Hurley plays boogie-woogie piano and a young lad named Richard Dyer-Bennett plays the guitar and sings folk songs. Bil and Cora Baird present their sophisticated marionettes. A dissolute little piano player thumps away at a tiny piano with a cigarette hanging loosely from the corner of his mouth.

Zero, his fat frame teetering on small feet, his tiny hands waving in the air, has everyone in stitches. The party is a huge success and becomes an annual affair.

Looking for walls to hang my paintings, I join the National Association of Women Painters and Sculptors, although I do not believe artists should show in categories. Later, I take my chances of rejection and enter juried shows for national exhibitions. There I compete with artists such as Stuart Davis, Marsden Hartley, Charles Sheeler, Joseph Stella, John Sloan, Raphael, Isaac, and Moses Soyer, as well as some women artists —Claire Falkenstein, Doris Lee, Ethel Magafan, Martyl, Hen-

riette Wyeth, and Marion Greenwood, who lives nearby on Tenth Street. She and I become friends. She looks like Trilby with her straight-cut bangs, long hair and large cat's eyes. She is a dedicated painter who has done murals in Mexico. We compare notes.

"What we both need is a wife," she bellyaches. "All the men artists have them. Someone to clean and cook and *shlepp* pictures around to exhibitions while we paint." I couldn't agree more.

Marion is bawdy. At an opening of Phil Evergood's she is absorbed in the paintings while a male escort hangs around bored.

"Get lost!" she hisses at him. "Go jerk off in the men's room, but don't bother me."

Phil's work has the quality of James Ensor's. His railroad workers play cards in a siding with fretwork like a fairy-tale illustration. His women all have pale faces like Juju, his wife. Phil's lines, drawn into egg tempera, make me think of William Blake's "Madmen see lines and therefore they draw 'em."

Bob Gwathmey, Phil's closest friend, is at the opening. He paints black sharecroppers. No matter how long he lives in New York, he never loses his Southern accent, any more than Phil loses his elegant clipped one acquired when he studied art in England.

"Ah had the funniest thing happen this mornin'," Bob says. "Ah picked up the phone out of a sound sleep. Someone said, 'Is Miz Gwathmey there?' She sounded lak someone from mah hometown. 'Rosalie's out,' ah said. 'Who's this?' "

" 'This is B. Altman.' "

" 'Hiya, Bea,' " ah said. 'Y'all from Rosalie's neck of the woods?' And would you believe it? She wasn't one of Rosalie's school chums. Just a Southern lady in a department store."

Chaim and Renée Gross are there. They are kind, feeding me rye bread and butter at their home. They are poor, as we all are. Sometimes we swap work. Chaim gave me a carved wooden circus figure in exchange for painting Mimi, his three-year-old daughter. Renée brought the child, with her dark hair, curly like her father's, and enormous black eyes, to my studio. She clutched her doll all afternoon and uttered not one word. She

was a long time learning speech and to Renée's relief, when Mimi finally talked, she talked whole sentences.

I love my artist friends. They are my family. My male friends come in categories. Some for dancing. Some for dining. Some for laughs, and one at a time for sex. Twice burned, I expect to stay single from here on out. The Valentes have introduced me to a friend of theirs, a collector. Their object for me is matrimony. Not mine. He has an enormous number of drawings and paintings by Raphael Soyer. Raphael, a tiny man, is a powerhouse of determination at meetings of artists' organizations and a vigorous defender of artists' rights, belying his delicate and shy appearance.

"I'm a Romanian Prince," the collector jokes. "Tall, handsome, well built."

He is the victim of his Jewish mother's love and does not want to be "caught" in marriage. He has nothing to worry about with me.

Nor does a patent attorney whose hobby is woodworking and who sets up a power saw in my studio to build my paint racks. Miss Grigsby, my landlady, says that complaints about the constant buzzing are coming from half a block away, and so I break off with him and hire a carpenter who doesn't intend to build a monument for himself and finishes the work in a few hours.

The apartment next to mine, the other half of a floor through, is vacant. Curious, I watch movers struggling up the five flights with two objects, a wide box spring and a mattress. Peeking in, I see that that is all there is. They deposit them in the apartment. Just a bed. Is there a hooker next door?

That night there is a timid knock on my door. Outside, a blond girl clutches her bathrobe around her.

"I seem to have locked myself out. . . ."

Yola Miller, my new neighbor, works in the theater. She is the daughter of a famous Yiddish poet, has an infectious giggle, and obviously did not get a stick of furniture when she was divorced. We become good friends and Yola poses for me. We have a rule before dropping in on one another. We phone first to protect our privacy. The apartments are so close that when the phone rings at Yola's I can hear her answer through the bathroom wall.

Artists send collectors on to one another. Someone sends me a collector with a particular penchant—fifty-dollar paintings.

"I like this one," he says of "Sunday Best," a new one of a girl in a flowered hat.

"That one is one hundred and fifty dollars."

"I'll give you fifty for it."

"Choose another one," I say stubbornly.

"I like that one."

"I'm sorry," I say.

"Other artists gave me paintings at that price."

"Well, maybe they gave you their second-rate ones," I say haughtily. "This is first rate Harmon, and it's one hundred and fifty." Where did I get the courage? I wonder as I hear him clumping downstairs empty-handed. My rent. I've turned down a whole month's rent.

I must find a dealer. I don't want to deal with these people myself. I want to be free to work. A lot of my artist friends are at Associated American Artists Galleries. My former teacher, Arnold Blanch, is there, as well as Marion Greenwood, Frank Kleinholz, Raphael Soyer, and Ernest Fiene, but I do not want to ask anyone to speak for me. I shall go there with some drawings and let the work speak for itself.

The address is 711 Fifth Avenue. Is it to be my lucky number? Armed with a portfolio, I wander timidly around the galleries until I see Pegeen Sullivan alone at her desk. I have already, in my mind's eye, hung all the walls with my own paintings.

"Would you look at some of my drawings?"

Pegeen, a white-skinned, blue-eyed, dark-haired Irish beauty, is deceptively fey, discussing leprechauns and other unrelated matters which usually lead to her selling a painting. She makes appreciative sounds as she looks through my portfolio.

"I like them," she says and adds a non sequitur. "I knew I would. I didn't like you the minute I saw you."

I overcome my rage. What in God's earth did she mean?

"I didn't bring paintings. They're too big to carry. If you like these drawings, I thought perhaps you'd come to my studio."

"Where do you live?"

"On Tenth Street. Between Fifth and Sixth."

"My mother-in-law lives down that way. Perhaps I'll drop in someday when I go downtown to visit her."

"I don't see why my career should depend on your mother-in-law," I explode. "Either the work is good enough or it isn't." And I flounce out with my portfolio.

"Guess what?" I say to Mom on the telephone.

"Vot?"

"I got two paintings in the Artists for Victory Show at the Met."

"*Vus es dus,* Met?"

"The Metropolitan Museum of Art," I breathe with reverence. "Where they have Rembrandt and Goya and Titian . . . and I'm going to have two paintings hanging there."

"Dot's nice," Mom says. "Is it raining in New York?"

"Yes."

"Wear your galoshes, you shouldn't catch cold. Button up your neck."

"Mom!" I scream. "Did you hear what I said?"

"It's raining there."

"No, not that. About my paintings."

"You got them in somevere."

"The Metropolitan Museum. They accepted only two hundred paintings out of thousands of entries and I got *two* in!"

"Dot's nice," Mom says soothingly.

"I'll take you to see the show when you're in New York," I say, deflated.

"Hokay."

At the exhibition, Mom, with her hair neatly washed and set in a new marcel wave (her hair, I notice, is turning a silvery gray), stations herself like a satisfied hen next to my two paintings and listens for comments or makes them herself to surprised gallery-goers. She becomes an art authority and explains Ivan Albright's prize-winning painting to a man and woman who express confusion about what it means.

" 'That Vich I Should Have Done, I Did Not Do.' Here you are seeing a funeral wreath on the door. Inside, somebody is dead. Vot the artist is telling you is you should be nice to a person before he is dead already. Before there is flowers on the door. By Christian people, they send flowers. By Jewish people, ve roast a chicken or a turkey. *Ve* bring cakes and strudel. *Ve* believe in food for the living."

The couple look bewildered and move on hastily.

Walking down the steps of the Met, Mom says, "All my life I loved beautiful things. Ven I vas carrying you, before you vas born even, I was buying such dresses, such colors, for the ladies' side of the store. No vunder you are an artist."

There is to be a show called "Friends of Burliuk" at Herman and Ella Baron's ACA Gallery on Eighth Street. They ask me to do a portrait of Mrs. Burliuk. David Burliuk, much loved by all the artists, paints small jewellike canvases thick with pigment. His gnomelike people with large heads sit around golden samovars sipping tea.

His delicate wife, Marussia, sits for me in a white blouse with a ruffle around the neck wearing a Monet-like black hat with a flower perched on it. While she poses, she talks about poetry and her "beautiful ocean." And so I paint her with a background of a stormy sea with two windswept sailboats.

When I deliver my painting to the ACA, I see that Raphael Soyer has the most portraits: "Burliuk in His Studio," "Mr. and Mrs. Burliuk Together," "Mrs. Burliuk Alone," "David Burliuk Painting Out-of-Doors." Among the other painters are Bob Gwathmey, Arshile Gorky and Milton Avery. The sculptors Chaim Gross and Minna Harkavy have modeled heads of Marussia.

One of the artists tells me about a new collector.

"He buys like a maniac. Not one, but dozens. If he shows up at your studio, remember what I tell you. He's a sucker for a sob story. Tell him you're pregnant. . . ."

"I couldn't do anything like that," I say stiffly.

"Tell him you can't have the baby," the artist continues, carried away, "and you need money for an abortion. Some sob

story. No, maybe you should say you have a slight case of leukemia. He might buy up everything in your studio."

Walkowitz greets me at the opening. He is always the first one at every new show, a familiar figure, squinting at the pictures because he is losing his eyesight.

"You're getting to be a painter," he says.

What about Paris? What about the day you told me to give up painting? I say nothing.

"Why doesn't anybody recognize my work?" Valky asks bitterly. "I'm as good a painter as Max Weber. Better. And they're noticing him. I'm older."

"They will someday, Valky."

"Someday. I won't be here someday. I'm going to start a new project. I'm going to pose for one hundred artists. Do you think that's a good idea? 'One Hundred Artists and Walkowitz.' How they see me. The different ways. Do you want to paint me?"

"Of course."

"I'll come to your studio."

Out of his pockets he takes drawings and stuffs them into my hand.

"Here, I want you to have these."

Looking down, I see sheaves of drawings of Isadora Duncan. If it is true that among all her followers Valky was the only one who had not slept with her, his devotion to her memory is all the more touching.

"I couldn't accept them."

"Yes, yes, you could. In memory of the school at Salzburg. The Schloss Klossheim. Remember?"

And he vanishes into the crowd.

Looking for him, I bump into a short man, just my height. We see eye to eye.

"Oh, excuse me. I was looking for Walkowitz."

"He's gone."

"Oh." I knew almost everybody at the show, but I had never seen this man before. "Who are you?"

"I'm a herring salesman."

"*Maatjes, marinierte* or what?"

"*Schmaltz,*" he answers. "By the barrel. From Norway."

"Oh."

"Who is that little man?" I ask Herman Baron. "He told me he was a herring salesman."

"He's the new collector, Joseph Hirshhorn."

"Does he really sell herring?"

"He does something in Canada. He buys pictures, that's the important thing." Love shines in Herman's eyes. "He bought a Gorky and a Soyer before the show opened."

Things are really looking up. A letter from Pegeen. She has sought out my two paintings at the Met and thinks she has a possible client for them. She wants me to send them to the gallery when the show is over. Reeves Lewenthal, the director of the gallery, wants to meet me. The current reigning triumvirate of American art, Thomas Hart Benton, John Steuart Curry, and Grant Wood, are at Associated American Artists Galleries. Perhaps I will be, too.

I am received like royalty by Mr. Lewenthal.

"Murray, would you bring Miss Harmon's paintings into my office?"

The tiny shipping clerk in the beige jacket sets my two paintings before us.

"They're beautiful!" escapes from my lips, as if these were not my own work. Suddenly the imperfections of the studio are erased by time and I see only my success, not my failure. Reeves laughs.

"*We* think they're beautiful," he says in mellifluous tones. "I'd like to see your other work. Perhaps you could have a show with us. I'll come to your studio."

"I've never had a one-man show."

"Maybe it's time now. Make an appointment with Miss Mandel on your way out. Early April."

I stop at Estelle Mandel's office and make an appointment.

I can't resist stopping at Pegeen's desk.

"Mr. Lewenthal is coming to my studio," I say.

"Good," says Pegeen. "I've sold one of your paintings. Send me more."

How to show paintings to a dealer? I have no idea how it is done. Reeves Lewenthal is due. I ask advice from Alfredo Valente and also Frank Kleinholz and Alex Dobkin, two painter friends. First, Alfredo shows up with some carved frames to use temporarily.

He and I hang as many canvases as we can, hammering nails recklessly all over the walls. As soon as we are done and admiring our handiwork, Frank and Alex appear with a huge bottle of rye.

"To celebrate," they say.

Frank looks around the studio.

"What are the paintings doing on the wall?"

"We hung them."

Both Frank and Alex shake their heads.

"Oh, no. Not like that."

"Where should they be?"

"In the racks, that's where. In psychological order," says Frank.

"What's that?"

"Lewenthal comes in," says Frank. "He looks around." Frank walks around, as if he were a dealer. "He looks at the walls. Then he says, 'Let's see the paintings!' And you have none to show him. They're all up on the damned walls."

Frank and Alex, between large slugs of rye, remove all the paintings, leaving great scars where the nails were.

"Now," says Frank. "That's better. We put them into the racks, in psychological order. Lily, start slowly and build to a climax. Your best work should be about three-quarters of the way through."

I arrange the paintings in the rack.

"Now let's see you show them," says Alex.

And I start.

"You're doing it all wrong," says Alex.

"I'm showing them."

"Not like that, all over the place. You must treat them as if they were the crown jewels at Cartier's. One at a time on the easel. He must only see one at a time. Take it easy. Put each

one away before taking out the next one. *That's* the way to show art."

On the great day, the apartment is shining. It has never been so clean. The telephone rings and I jump to answer it.

"This is Miss Mandel. Mr. Lewenthal is terribly sorry, but he had to go out of town unexpectedly. Would next week, same time, be OK?"

"Yes, of course."

How to console myself? I can't think what to do. I must give myself a present. I go downstairs to the fish market and buy myself two little silver trout. I'll sliver almonds all over them, pamper myself with a gourmet dinner.

The day I decided to become a gourmet cook happened not long ago. I sold a painting and decided to celebrate. I would do something extraordinary. I would buy myself a magnificent dinner at Charles French Restaurant, right around the corner, where Valente's collector friend often took me to dinner. I would take myself to dinner.

First I soaked in a long, luxurious bath, scrubbed my nails with a nail brush to remove all Prussian blue from under them, and then sprayed myself with Coty's Emeraude. Then I dressed in my one and only best outfit, combing my hair into feminine curls down over my forehead. I thought I looked just like Marie Bashkirtseff, my heroine, who had written a journal of her life in art. Very nineteenth century.

As I passed the druggist and his wife in their store on the corner of Tenth Street and Sixth Avenue, I nodded happily to them as they stood near the large bottle of colored water and the counter where I had sketched two colored girls, and later called the painting I made of them "Strawberry Soda."

It was early for dinner. A sea of white napery on empty tables met my eyes as the headwaiter advanced.

"How many?"

"One."

"A table for one?"

"Yes."

Looking at me as if I had some dreadful disease, he said, "There are no tables."

The waiters, witnessing my humiliation, and perhaps as embarrassed as I was, bent their heads low, arranging silver and glasses, poking flowers into tiny vases.

"But there are all these tables . . ."

"Reserved, mademoiselle," the maître d' said sternly. "All reserved."

Walking home, it came to me. He thought I was a hooker, that's what. A single lady had to be there for that purpose. I wanted to go back and picket the place. Instead, I walked up my five flights of stairs and made myself two hard-boiled eggs that landed in a lump in my chest. I would be a gourmet cook, that's what. Nothing would be too good for me.

The trout almondine is lovely, and I am throwing the skeletons away when the telephone rings.

"Did you sell your 'Mrs. Burliuk' yet?"

It's Sigmund Colten, the photographer, with whom I sometimes swap paintings for photographs of my work.

"No, Siggy. Al Arnold wanted it, but he wouldn't pay what I asked."

"You know I want it too."

"Yes, but I can't make a swap for it."

"I'm with Joseph Hirshhorn. I told him I wanted that painting of the Burliuk show. He likes it too. He wants to talk to you. Here, I'll put him on."

"I'd like to see the 'Mrs. Burliuk' again," says the strong voice of the man I thought was a herring salesman.

"When?"

"Now."

"Right now?"

"Yes."

"Have you had dinner?"

"Yes."

"Would you like coffee? I'll make coffee."

"I'll bring dessert. I'll be there in fifteen minutes. Twenty at the most."

Thirteen minutes later, no sooner have I washed my dinner dishes and assembled cups on a tray than the bell rings downstairs and I press the buzzer. Mr. Hirshhorn stands outside my

door, breathless and panting. He hands me a box without a word. I am used to speechless people after the five-flight climb.

"Sit down. I'll have coffee in a moment."

Mr. Hirshhorn sits gasping while I open the box to find what every starving artist needs—four dozen pastries from Sutter's.

"Thank you. There are so many!"

"Well, you'll have some left over." He has caught his breath. "How can you stand it?"

"What?"

"All those stairs."

"The fifth is the killer. I try not to forget anything when I go downstairs."

I want to practice my act to rehearse for Reeves Lewenthal next week. "Would you mind," I say after the coffee and cake, "if I showed you all my work? The 'Mrs. Burliuk' is a little further along in the racks."

When we get to it, and I have observed the rule, declining assistance as I put each painting back before going on to the next one, Mr. Hirshhorn asks, "How much is it?"

"It's two hundred dollars."

"I'll take it."

He rips two hundred-dollar bills from a large wad held by a money clip and hands them to me.

"May I show you more?"

"Of course."

When I get to a sepia ink drawing called "Grief" Mr. Hirshhorn stops me from putting it away.

"How much is that one?"

"It's not for sale."

"Why not?"

"Everything else is, but not that one. I'm keeping that one to show myself how I can hit it sometimes." My cousin Marjorie had posed for it. I wanted to do a large painting of women and the war, and this particular drawing of a weeping woman seemed to say it all. I never did the painting.

"If it were for sale, how much would it be?"

How stubborn he is. There is nothing like a "no" to this man.

Even the 'Mrs. Burliuk' interest was kindled by Siggy's wanting it. The hard to get seems precious to him.

"But it's not for sale."

"It would be going into friendly hands."

"I haven't even shown it yet."

"You could borrow it back. I live just around the corner at Number One Fifth Avenue."

"It's one hundred and fifty dollars." That'll stop him. Nobody pays that for a small drawing.

"Good. I'll take it."

He peels off more large bills and stuffs them into my hand, curling my fingers around them.

"You won't be sorry," he says as he leaves with the two pictures under his arm. "I told you. They're going into friendly hands."

When Reeves Lewenthal shows up the following week, I sail through the psychological showing again, but he doesn't let me finish.

"Do you think you would be ready to have your first show a year from now? April's a good month. Meanwhile you could send paintings in as you finish them. We'd like an exclusive with you. And don't sell paintings from your studio any more. You won't need to. We'll take care of everything."

How nice. I like it.

When I call Mom with the latest news that I am to have a one-man show, she sighs.

"A painting of your own mother you can't do?"

Why shouldn't I? Other artists have. "I'll do it, Mom. Come next week."

"Good. Vot do you vant me to vear?"

"Something simple and a nice color."

"I'll vere my new blue dress."

"Blue should be good with your hair."

"A new gorset, I'll buy a new gorset, the dress should fit better."

"I'll see you next Tuesday. OK?"

Mom arrives with a suitcase full of clothes, complete from her evening dress to matching slippers for her tiny feet. She strug-

gles first into her new corset, a monstrous construction made of
some powerful fabric so strong that it rearranges her whole
body, pushing her bosom up and encasing her hips as if they
were in plaster. She sits down after one last downward yank of
her underpinnings and assumes a noble look.

"Relax, Mom, relax. I'll turn on some music." I turn on the
radio.

"I love music."

"I know."

"It makes me vant to dance."

"Sit still," I say. I forgot Mom was a wiggler. The new corset
doesn't help either. How to explain to Mom that all Cézanne
ever wanted from a model was for her to behave like an apple?
"I'm not a camera, and I'm not going to go 'click.' " I feel the
way a surgeon operating on a loved one must feel. I find it hard
to ignore the I-love-you, *mein kind,* my child, expression Mom
insists on assuming. "Please, Mom, it doesn't matter how you
look," I say as she straightens her dress. "It matters how I feel.
I'm doing it. All you have to do is relax and listen to the music."

"I'm sitting good, no?"

No. Please, Mom! Let me be free to place you in space. There
are hazards to overcome in this painting beyond the technical. I
see myself in you—my deep-set eyes, my bone structure. We are
strung on the same skeleton, even if yours has more padding. It
is hard for me to face myself in the future. Many Tuesdays later,
the portrait is finished.

I have performed the operation and my mother lives. She sits
proud and erect. Her silver hair catches light. On the shelf be-
hind her I have painted myself in a little photo frame. Mom
loves it. I love it.

"Would you mind if I exhibited it at the gallery before I give
it to you?"

Mom doesn't mind. She is delighted. I send the painting to
Associated American Artists and call it "The Lady in Blue." I
mark it NFS. Not for Sale.

"Hi!" says Estelle Mandel on the telephone a few days later.
She is in charge of public relations as well as vice-president of
the gallery. "I sold your 'Lady in Blue.' "

"*What?*"

"Upjohn wants it."

"But it was marked 'Not for Sale.' It's a portrait of my mother. I painted it for her."

"They'll pay fifteen hundred dollars for it. They want it for a full-color ad and to go into their collection. They're using fine artists. You can paint your mother again."

I can, can I?

"She'd have to sign a release," says Estelle. "That's standard procedure."

My God, fifteen hundred dollars would be my rent for two years!

"I'll ask her."

"Guess what, Mom," I say on the phone.

"You got married."

Why is this the only joyful subject in the world?

"No. You know your painting. . . ."

"Of course."

"I called it 'Lady in Blue' and sent it to the gallery for a show."

"You told me that."

"Upjohn wants to buy it. They're a big drug company and they want it for an ad in full color. It would be in *Time* and *Life* and all the big magazines. It would go into their collection. I don't have to sell it, even if they want it. I marked it 'Not for Sale.' I don't understand how this happened."

"How much did they offer you?" Grand Avenue speaking.

"One thousand five hundred dollars."

"Fifteen hundred dollars!"

"Would you want me to sell it? I could give you half."

"I vouldn't vant any money. Fifteen hundred dollars, and I vould be in all the magazines. *Time* . . ."

"And *Life.*" I had forgotten my mother's vanity.

"And *Life.* Vy not? You could paint another picture of me. I have a new dress. I vouldn't mind to pose again. For you, *mein kind,* it's a pleasure."

"You'd have to sign a release. That means it's OK to reproduce the painting."

Mom signs. When the ad appears in *Time* magazine, there is

my mother in full regalia and the caption running below it—IS
THERE DIABETES IN YOUR FAMILY?

"Joe Hirshhorn wants to know if you'll join us for dinner at
Longchamps," says Herman Baron. "We're going to celebrate
his buying your pictures and Phil Evergood's."

"Why didn't he call me himself?" I never know when my New
Haven training will crop up.

"He's in Canada all week and asked me to arrange every-
thing."

"OK."

The dinner is lovely. I am seated next to our host. We drink
champagne and toast *L'chaim!* To life, to art, to one another.
Herman and Ella are almost nauseatingly grateful for all Joe's
purchases. Phil's big voice booms and Juju looks as wan and
white as Phil's painting "Lily and the Sparrows."

I am at a loss as to what to say to this collector.

"Have you read Delacroix's *Journal?*" I hear myself saying.
How stupid. It's like being at a high school prom and saying to
a boy, "Have you read any good books lately?" But I am ill at
ease.

"I never have." He seems aglow with interest.

"It's called the painter's bible. I'll lend you my copy if you
like."

"I'd appreciate that."

Mr. Hirshhorn puts his hand affectionately on my arm in
what seems to be a lingering caress. I'm surprised to feel a shock
go through me at his touch. My drawing has indeed gone into
friendly hands. Maybe too friendly.

A call from Toronto, "Have dinner with me Friday when I get
back to New York. Meet me at Longchamps. Fifth Avenue and
Twelfth Street. Six o'clock sharp. I like to eat early." And he
sings

> *Lily, Lily of the valley*
> *Be my Lily*
> *Be my Lily*
> *Be my forget-me-not!*

Is there such a song, or has he invented it? It must be before my time.

"You're late!" he says when I show up at five after six.

"I'm sorry."

"You don't have a watch."

"I've never owned one."

"You're kidding."

"No. But I'm usually on time, Mr. Hirshhorn."

"Call me Joe. J.J. O'Brien, that's my name." Something in me is hurt by his joke. He twinkles and looks as if he is about to break into a buck-and-wing. "I'm enjoying that Delacroix you loaned me."

"I read it to cheer myself up."

"Let me cheer you up." And he orders champagne.

"What will you have to eat?" asks the waiter.

"What's ready?" he asks.

I am attracted to his haste to absorb everything, whether it is food or art or books on art. He is like a suction tube pulling in information and sensation. I feel needed and valuable.

It is inevitable, when we start seeing one another every weekend, that we become lovers. I am full of curiosity about his energy. He makes me feel that his need for me is overwhelming and indeed it is. He is pleased with his sexual prowess and so am I.

"I'm an old man," he says. "What do you want with an old man like me?"

What makes him think I want anything? It is true that he has wiped away my defenses against involvement. And all my categories of men disappear. He is different. I love his energy and especially his enthusiasm about art, all art, and my art in particular. He loves everything I do.

Joe is forty-four to my thirty, but I have a hard time keeping up with him. He doesn't walk, he runs. He is addicted to telephones and calls me nightly from Toronto where he says he talks on three phones at once.

As soon as he arrives at my studio, he calls his children and talks to all four of them.

"They don't love me."

"Why do you say that?"

"They only call me when they need something. They only want money."

"Do they have enough?"

"They each have a trust fund when they get to be twenty-one."

"But they're not twenty-one yet."

"Jenny has money."

I wonder about Jenny, Joe's childhood sweetheart whom he'd been married to for some twenty-odd years.

"You can divorce a woman," says Joe with propriety, "but not your children."

"Don't worry," Joe said the first time we went to bed, "you won't get pregnant. I had a vasectomy."

"What's that?" I said, alarmed. I had never heard of it.

"My tubes are tied. I can't get you pregnant." Well, I was only flying on one tube myself, but what kind of woman would let her husband have an operation like that? Did it have something to do with an affair Joe had told me he had with a manicurist? "She turned out to be a dope fiend," he said, but never elucidated further. He liked to keep secrets.

One of the most awful things about falling in love is that you are doomed to tell the story of your life again. Sometimes I think it is the greatest deterrent to a change of heart there is—especially as you get older and there's more of it. It bores me. But perhaps it is a penalty one has to pay. My own background seems like a bed of roses compared to Joe's stories of his youth, which seem one with the quest for the streets paved with gold that Pop talked about. His fight to overcome anti-Semitism is familiar as is his face—that of a *yeshiva bocher*.

"I never had a toy. My father died in Latvia when I was a year old. I was next to the youngest. My mother had thirteen children. We all came to the United States when I was six. My mother worked in a pock-a-book factory. In the morning, before she left for work, she put a big pot of soup on the stove and it cooked all day."

I make sympathetic sounds.

"The butcher gave her the bones for nothing when she bought the cheapest cuts of meat."

"Like lung?"

I noticed that if we ate in a Jewish restaurant, Joe would always order *lungen* stew. He loved this food of his childhood almost as much as I loved mine, *kasha varnishkes.*

"Liver and lung were for free. Nobody wanted them. She'd have to buy a little chuck or something."

Things are certainly different now. Joe wears custom-made cashmere jackets from Dunhill Tailors, shirts made to order at Sulka's, with pleated fronts so intricate they are almost impossible to iron and need a special laundress. Even his shorts are handmade and initialed JHH. He uses Yardley's Old Lavender soap and douses himself with Charbert's Eau de Cologne. He is immaculate and smells like a flower garden. Anything to wash out the stink of poverty.

"I stopped school at fourteen and went to work in a jewelry store. I liked that. I liked the stones and the settings. But I wanted to make money. I read Horatio Alger all the time. I wanted to have a real desk, not an orange crate turned over. Then I got a job on the Curb Exchange in the days before it was indoors. I learned to talk deaf-and-dumb language. All the runners did. Here, I can still do it." And he spells out something with his hands.

"What's that?"

" 'I love you.' You see, I still remember it. I wanted to learn more and so I started asking for jobs in a big skyscraper. I started at the top floor and knocked on every door. Nothing doing. Finally, on one of the bottom floors, I got a job with a publication and learned to do stock charts. Cecil Rhodes was my idol," Joe says, his eyes clouding with reverence. "He made wealth where there was none before. Mining. Taking things from the bowels of the earth. Not like the clothing business." I think of Pop putting in long hours on Grand Avenue, and I wince. Joe talks on my phone in what he calls telephone numbers. The Canadian stocks have curious names. Junior Frood. Goldfields. Dakamount Exploration. He is always telling people to buy. I never hear him say "Sell." A foreign world.

"There was this fire in the tenement where we lived," says Joe. "A neighbor tossed us kids out of the window, one by one. We

were all saved, but we were taken in by different people and it was a while before we all got together again."

I am so full of sympathy that it is hard for me to remember I mustn't fall in love. I am apt to lose control. I must remember my shibboleths. Remember Peter. Remember Sidney. Remember Kuniyoshi. *En garde.* Never get involved with someone who doesn't understand art. But Joe does, doesn't he? And he isn't an artist, with whom I'd have to compete.

Marion Greenwood, neck and neck with me as a worrier, is having her first one-man show at the same gallery, just before mine.

"How are you doing?"

"Terrible," she says. "Today I painted out a whole new canvas. How about you?"

"I'm ruining more than I'm painting."

"How many paintings do you have?"

"Good ones?"

"Any kind," says Marion.

"Well, I think I have twenty good ones," I lie. I have thirty. "But I'm aiming for fifty, and then I'll choose the best."

"The gallery is so big," bellyaches Marion, "I'll never fill it."

I am happy that the gallery is selling my work, but it is a two-edged sword. Every one they sell means one less for my show. After all, they don't want walls of paintings all borrowed back. A few are permissible. I work many canvases at once, in varying degrees of wetness. I am afraid that if I desert them, they will take vengeance on me.

I am painting children and children's games, which fascinate me. I am painting a child with a cat's cradle from finger to finger and kids kneeling in the street playing jacks. I am painting a kid eating a section of red melon with green skin. Whatever it is I paint, Joe wants it and I have to tell him I need these new paintings for my show. I can't have him buying them all. He is like a vacuum cleaner of art.

It gets so hot with the summer sun beating down on my top

floor that I invest in an electric fan that sweeps circles of hot air in an illusion of ventilation. Sometimes I go to air-conditioned movies. On unbearable nights I sleep on my narrow balcony, waking up to the sounds of Tenth Street and sprinkled with a fine layer of soot like pepper grindings imbedded in my skin.

"Adding tired to tired," in the words of Frank Lloyd Wright, I get to the point where I feel I deserve the luxury of a weekend at Joe's farm he always talks about—Huckleberry Hill in the Poconos near a village called Angels. Herman and Ella Baron, Milton and Sally Avery and their daughter March are going as well as some other guests.

Joe is angry as we drive up a long tree-lined road.

"Where is the sign? They've ripped it off again. If anyone told me I was buying four hundred and fifty-two acres right in the heart of Ku Klux Klan country, I'd never have built here. I give money to them for their policemen's ball, their firemen's ball, and see what happens."

We are on top of a mountain and in front of a large French Provincial house made of local stone.

"All quarried here, right on my own land," says Joe proudly. "Look at that roof. Ludovici tile, from Italy. The finest kind. Heavy. It could last forever."

We all admire the roof.

"That's the farmer's house," Joe points out. "Over there is a four-car garage. We have cows in that barn. Plenty of milk. We get our own eggs, too. That's the chicken house. We have a machine shop, and a guest house, but we're staying here in the main house."

Entering a huge room, I am stunned to see a dining table in the center that looks as if it can seat twenty-four people.

"The room is twenty-eight feet by forty-six," says Joe. "That's why we put a fireplace at each end. Did you notice the paneling? It's pecky and knotty cypress from Florida. Never needs painting."

He shows us the children's bedrooms, arranged like dormitories with eight bunks in each. Like a summer camp. I wonder who dreamed this up. Was it Joe or Jenny?

"We had counselors and tutors for the children," says Joe. "It was noisy as hell. Could never get any rest."

We tag along after Joe on the grand tour, up a circular staircase leading to a soundproof music room with a piano in it. There are two other Steinway Grands in the living room, one at each end.

"This is a baby grand," Joe points out. "The children are all musical." He sits at the piano and plays the one song he knows. "I took lessons once, but this is all I learned."

When he finishes playing, he waltzes Sally Avery around, singing "Sally, Sally in my alley. . . ."

"I don't have any help in the house," Joe says when we go downstairs to the kitchen. "The farmer and his wife are busy; you'll all have to make your own beds."

But who is going to cook? There are nine of us.

"I don't trust any one of you in the kitchen," says Joe, "but Lily."

I am going to cook! Everyone dashes off to see the great out-of-doors where Joe has compensated for his deprived youth by building a tennis court, damming up a brook for a swimming hole, creating a baseball diamond, an archery wall, several miles of bridle paths, plus a billiard room in the cellar.

I am left alone in the kitchen. I face it. In the center are two electric ranges, back to back. I have never used an electric stove in my life. The four-burner gas range in my studio is so old-fashioned it doesn't even have a pilot light and has to be lit with matches. My stove has a flame I can see and adjust, but these monsters have six burners each and nothing but buttons that say On-Off. Front-Back. Low-Hi. I turn one on. Nothing happens. Gingerly I touch a circle with the tip of my finger. A sizzle of flesh tells me. It's on.

Sucking my burnt finger, I put away the groceries we've brought in one of the two refrigerators. Are there two of everything here? It's as if a blitz were imminent. I open doors of cabinets. There are dozens of cans of tuna fish, tomato juice, plums, peaches, and salmon, all from R.H. Macy. Jenny must have made a lot of lists. In other cabinets are white porcelain soufflé dishes in every size, waffle makers, large iron griddles

for pancakes, roasters, and some utensils so complicated I don't know what they're for. I look at the pressure cooker with fear. I find a simple pot.

Outside, Milton Avery is sketching a cow. I curse my fate.

"Brought you some things," says the farmer, placing dozens of eggs, quarts of milk, and buckets of cream on the counter. But no butter. I decide, for some mysterious reason, to make butter. How do you make butter? Simple. Whip the cream. I can't find a churn, and if I did I wouldn't know how to use it. I find an electric blender and pour the cream into it, then turn it on high; it seems to be making butter, but when I take the cover off to peek, it is like the shit hitting the fan, only in this case it's butter—butter spats all over the ceiling in ugly fat globs. I scrape off as much as I can, but it leaves greasy spots. A tiny bit of butter is in the bottom of the blender.

Oh, I am not to be trusted in the kitchen as Joe thought. I am not a boy scout.

I manage to produce dinner without any more catastrophes, but there's a lot to cope with here at Huckleberry Hill, and I hate it. . . .

The nine of us take up very little space at the large dinner table. I kid about myself, faced with all the appliances in the kitchen, all the appurtenances of the good life.

Suddenly Joe says, "Don't you want security?"

"But I *have* security," I answer quickly, wounded that he cannot understand that for the first time in my life I am making a living at what I love to do. What greater security can there be than that? I am angry and want to get back to my studio.

"I meant," says Joe, "don't you want nice things?" We have finally gotten outdoors to take a walk. The others are walking down a path in front of us.

"Of course I want nice things, but security, or the feeling of it, is something else again."

"Sally walks like a duck," says Joe. "She waggles her head from side to side."

I'm accustomed to his comparing people to animals. I do too. I see Joe as a turtle, poking his head out from a heavy, protective

shield and going on stolidly, steady and determined. And I am scared.

The paintings Joe is accumulating in his small apartment at Number One Fifth Avenue are everywhere. Under the bed. Stacked against the wall. In the closets. He is carried away with the quest, the searching out, the adventure. He runs to artists' studios and is flattered when they tell him he has chosen their best work. He buys thirty paintings from Avery in a day. He buys a bunch of Gorkys and Arshile Gorky, grateful, invites us for a dinner of shashlik which he cooks himself. We are wined and dined by more and more grateful artists. Joe prides himself on his eye and says proudly he will collect only American art, only living artists. He loves meeting them and the feeling of power and discrimination they give him. "I don't do it for investment," he says scornfully of other collectors. "I use the market for that. I do this for love." Joe must move. The paintings are crowding him out. He asks me to find him a larger apartment and I find a duplex in a private house on Waverly Place that belongs to an elderly sculptor and his wife. They occupy the first two floors but rent the upper two.

A monumental plaster cast of a horse and rider is in progress on the ground floor of Rudolph Evans's studio. His wife is a beautiful woman, but she mystifies me because when she answers the door she is always wearing a hat. Is it a ruse to avoid people? She can always say, "I was just on my way out." Or is it because she hasn't combed her hair? Has she hair?

"We don't just rent to anyone," Mrs. Evans informed me. "This is our own home. We're fussy."

On Sunday, when Joe comes back from Canada, I am worried. He is wearing his jazziest jacket and his loudest red necktie. The Evanses are so refined . . . what will they think of him?

Mrs. Evans answers the door haughtily in a Queen Mary hat. She towers above us, cool and remote. As she shows us the upper duplex, Joe drops names. Important Wall Street names. None of them are Jewish. It is as if, incongruous as it may seem, he grew up playing polo with them all.

"This lovely lady," says Joe, "should have a champagne

brunch at Longchamps." And so we walk there. By this time I am not worried about Joe's getting the apartment. I can see that he has captivated the Evanses. After lunch, walking back, Joe whispers to me, "Everything's gonna be all right." And indeed it is, as we sit in the Evanses' apartment and Joe takes out folding money for the deposit. My only worry now, judging from the light in Mrs. Evans's eye, is that she will never leave him alone. There is a look of fondness on her, a look that says, You are my own, my adorable rich uncle and I love you.

"Do you know that banker you were talking to the Evanses about?" I ask when we leave.

"No, of course not."

"But you knew all about him—where he lives, how many children he has, his daughter's wedding . . . I thought you were there."

"I read a lot," Joe says.

An understatement. What a memory! He must have gleaned what he said from the social columns of *The New York Times,* the *Wall Street Journal,* and even *Town and Country.*

My birthday. November 19, 1943.

We are going out to dinner. I am annoyed as I walk to Waverly Place. Why didn't Joe call for me? Perhaps it's only because he hates to climb my stairs. At least his apartment has a creaky little elevator. I pull aside the grill door, remembering to shut it carefully behind me, and ascend slowly to the upper floor of Joe's new duplex.

Joe stands waiting for me, gives me a kiss and says "Happy birthday. Let's go downstairs and have some champagne before we leave."

It is so dark walking down the stairs to the double-height living room that I am afraid I will stumble and break my neck. Suddenly lights blaze on.

"Surprise . . . surprise. . . . !

Beaming at me are Phil and Juju, Miriam and Alfredo, Bob and Rosalie, Herman and Ella. A surprise birthday party. I've never had one in my whole life.

"You *were* surprised, weren't you?" asks Joe like a little boy.

The dining-room table is festive with party favors, funny hats, whistles, and the amenities that Joe points out he had to buy—there weren't any in the apartment. Individual silver ashtrays. White matchbooks. Glass cigarette holders with silver bases. Fragile champagne glasses. I am seated at the opposite end of the table from Joe. Just before coffee, he passes a package down which goes from hand to hand of my friends before it reaches me. I open it. In the small leather box, a circular pin nestles. An antique. A small spider web of mine diamonds, some suspended and quivering like dew interlaced with seed pearls. It shimmers on a dark-blue velvet cushion.

Joe raises his glass to me.

"Happy birthday!"

"Happy birthday," echo my friends.

"It's so beautiful," I say, torn between loving it and embarrassment at sharing what I think is a private moment.

Another movement starts down the table. This time, a pair of tear-shaped pearl earrings reclining on a red velvet bed.

"I used to be in the jewelry business," Joe says. "I get them on the Bowery in the Diamond Exchange."

I am beginning to feel I am being bought—with witnesses. The last present is different, a brand-new gold watch from Tiffany's.

"You'll never be late again," says Joe. Why do I feel ashamed?

A huge cake is in front of me.

"Blow out the candles!"

I take a deep breath and blow out thirty-one candles. And one for good luck.

Joe has everything. What gift can I give him? I know—the ultimate—my former analyst, Dr. Paul Friedman. When I broach the subject, I am surprised to hear Joe saw an analyst when he left Jenny. I would never have known.

"Who was he?"

"My wife's."

Not Freudian at all.

Joe seems devoured by guilt. He will not stop phoning his children constantly. He has some recurrent nightmare from

which he awakens screaming Help! so loudly that I am afraid he can be heard blocks away. It scares me half to death. "They were chasing me, all of them. They wanted to kill me. . . ." But he does not know who "they" are.

It is love at first sight when Joe goes to see Dr. Friedman. It must be—he arranges appointments at seven in the morning whenever he is in New York. The results of Joe's analysis are good, just as mine were. We do not discuss what is going on except for one revelation Joe finds astonishing. "I know now why I can't buy my children presents. I'm jealous of them. Jealous of my own children for having things I didn't have. Roller skates on shoes. I always wanted roller skates on shoes. I have them now. I bought a pair for myself."

Dr. Friedman charges Joe more than he did me. I can understand that. What I can't understand is why Dr. Friedman, who was adamant about taking even the tiniest drawing from me, should accept tips on mining stocks from Joe. I feel jealous and crushed.

Good news. Estelle Mandel says Encyclopaedia Britannica has bought "Strawberry Soda" for its collection, but will allow me to include it in my one-man show. I have managed to fill three large rooms of the gallery with paintings and some drawings. Seeing my work wrenched from the studio, it looks different, perhaps the way one's children do at a party. Better. Just the same, I would have liked to carry some of them a little further.

Phil Evergood would go to some patron's house for dinner and remove his painting from the wall.

"I just want to put a little retouch varnish on it," he would say. "It looks a little dull." By the time he got through it might be a whole other painting.

"But we liked it the way it was," the owners would say. Too late.

Sometimes I imagine a person whose job it would be to go to the artist's studio, grab the brush from the artist's hand and say, "Stop! That's it."

But now, standing vulnerable surrounded by the autobiography of the past years that is hanging on the walls behind me, I

am terrified. A slight nausea assails me like the fear I had at Sidney's openings in the theater. But this is worse. My own self is laid bare for the critics to dissect. I suffer, also, from a feeling that I will have a total amnesia about names. I will never remember who is coming. There will be long-gone relatives. Will I recognize them?

The first person who signs my guest book at the opening is Abraham Walkowitz. Joe is proud of me, but no prouder than Valky, who tells him, "You know how long I've known this little girl? Since 1931, that's how long. Since she was dancing at the Duncan School."

He walks around squinting at my paintings. Does he see them? Does he not see them? His eyes are cloudy. He has glaucoma. He seems to be getting tinier all the time. He had climbed my five flights of stairs a number of times for me to do his portrait. How many steps did he struggle up for the ninety-nine other artists who were part of the One Hundred Artists and Walkowitz Show? One hundred different aspects of himself still didn't give him what he hoped for. Recognition of his work. Only death would do that.

"She was my protégée," he tells anyone who will listen. The sting of Valky's advice to give up painting and stick to poetry is long gone. I almost convince myself that he encouraged me.

"My baby," says Mom, beaming and acting as if she were co-hostess at a Jewish wedding. "From me she learned vot is beautiful. In the store, I did all the buying for the ladies' side."

"Your Mom is a pistol," Courtney Onet informs me. "What a ball of fire!" What had she said to him?

I am buttonholed by a perfect stranger who says, "Miss Harmon?" and wrings my hand. "You are a finished artist."

"Don't say that. I hope not." I shudder.

The combination of relatives, friends, and art lovers leaves me spent. Seventeen paintings are sold.

The reviews haven't clarified anything. *The Times* says that on the one hand, the work is too tentative to warrant such a large showing; and on the other hand, a real talent is emerging. The *Herald Tribune* claims I have growing confidence, avoid slickness with my scumbled paint, have a good technical groundwork,

and calls me a neo-impressionist. The *Sun* says my feminine grace is disarming. From none of it do I learn a blessed thing. But the artists seem impressed. "She can draw," they say, and I feel satisfied that I have broken the ice. I have managed to survive the exposure.

Estelle has been carried away with her own success ever since she sold my mother to Upjohn.

"Eaton wants one of your drawings for an ad. Just a woman reading a letter. In your own style. The art editor wants to meet you."

"What for?"

"Probably to tell you the size."

"We want something like this—" and the art editor whips out a layout.

"What's that?"

"Just a rough idea of what we want."

"Why don't you get *that* artist to do it? I thought I would have absolute freedom, and now I see you want a vertical. I planned doing a horizontal. I want to do it my way."

"Oh, your way, of course."

Just before leaving, gathering up her things, the art editor says, "We love your freehand line, Miss Harmon—that's why we chose you." And, at the door, she adds, "By the way, if you could make the model look like you, that would be nice."

Damn! Isn't there any way to outwit these jokers? Who looks like me? Geri Pine? Edna Rostow? It takes one hundred sketches to get one I like. What Estelle assured me would take ten minutes took days. Who is Estelle kidding as she pencils in "free and loose, huh?" on these orders? I tell myself artists have painted to order for a long time. For the church. For patrons and the pleasure of the rich. And now for the business corporations of the world.

A holiday! A free holiday. Encyclopaedia Britannica is planning the first exhibition of its collection at the Chicago Art Institute. I am invited with a number of other artists. Entering the compartment of the Twentieth Century Limited, I see I am

sharing it with Marion Greenwood. We wonder if we are the only two women chosen for this shindig. Comparing notes and our typed schedules, we see we are both staying at the Hotel Drake, we are to attend press conferences, a luncheon at the Arts Club, cocktail parties, and a dinner before the grand opening. We are to be interviewed on radio by different ladies.

We each have a copy of the catalogue, a book called "Contemporary American Artists." There are photos of each artist and a biography as well as a photo of the painting in the collection.

"They don't describe men artists the way they describe us," grumbles Marion. "Nobody cares what they look like."

About Marion, they say, "In 1932 a youngster with long soft hair and enormous hazel eyes who looked more like a glamour girl than a serious artist went to Mexico and disproved the theory that mural painting was too strenuous for a woman. Her beauty was no deterrent to her seriousness or her talent. . . ."

And about me, "In appearance, Lily Harmon is slender, dark and very pretty. She tells you in her soft voice that she is positively grim until a picture is completed—that she is a champion worrier but has a sense of humor. . . ."

"A little sex to sell copies," says Marion as she rubs cold cream into her face, puts fat rollers into the bottom of her page-boy haircut, and winds a brown mesh net over her head.

"I'm so excited," I say, as I massage lotion into my hands, dry from turpentine. We climb into our berths and fall asleep like children before Christmas. We dream of sugarplums.

"They called me 'the Brooklyn-born Gauguin,' " says Frank Kleinholz, who gave up law for art at forty. He was the one who taught me how to show my paintings in psychological order to Reeves. John Steuart Curry, a shy man, and Thomas Hart Benton, mustachioed and cocky, are there—two of the current great triumvirate—but Grant Wood is missing. All the artists lap up Scotch like water at the series of parties we attend. Released from the solitude of our studios, we can't help being flattered by the photographers who pursue us popping flashbulbs in our faces as if we were movie stars. We know our brief moment of glory will end and we will all go back to confinement in our

studios. Meanwhile, we live it up for free at the Hotel Drake. Britannica is picking up the tab.

Fred Taubes, who wrote *Technique of Oil Painting* and who grinds his own paints, says, "I explained to the lady who interviewed me I don't pick bristles out of pigs for brushes."

We are in proximity to directors of museums, art critics, and other allied people whom we seldom meet. At the main preview after a dinner at the Drake, Daniel Catton Rich and Katharine Kuh seem to be our hosts at the Chicago Art Institute, where all our works are hung. I cling close to Marion Greenwood, but as the evening draws to a close, she is nowhere. I hate to go back to the hotel alone and I'm not the least bit sleepy. Damn! Marion has gone off somewhere. There's hardly anyone left.

"Aren't you in the collection?" asks a man with a sharp nose.

"Yes."

"Which is your painting?"

" 'Strawberry Soda.' "

"You must be Lily Harmon. We're proud to have you in the collection."

Who on earth is he?

"I'm William Benton. Of Britannica."

I have no idea who he is. I've met a lot of people. Curators. Press representatives.

"We seem to be the last two," says Mr. Benton.

"I was looking for Marion Greenwood, but I guess she's gone."

"Why don't you join me? I'm going to the Pump Room to meet Mortimer Adler."

"Who's Mortimer Adler?"

"Don't you know?"

Should I? I rack my brains.

"Something to do with Adler Elevator shoes?" I venture. I am hooked on their radio program with Henry Morgan.

"He's a philosopher. I'm seeing him about a new series. We call it the 'Great Books.' " And William Benton laughs so hard he cannot stop. "Adler Elevator shoes. He'd love that!"

"What do you do, Mr. Benton?"

"Call me Bill. I used to have an advertising agency with Ches-

ter Bowles. Benton and Bowles. I retired from that and bought Britannica. I'm chairman of the board now." He looks like a bird, some kind of bird. A predatory one with an incredibly thin beak.

"Oh . . . I hope you don't mind, but I've got to get back to the hotel early. I'm supposed to be on June Baker's radio program at the crack of dawn."

And Joe will be calling. He calls every day.

"Don't worry. You'll be there. How often do you get a chance to sit in on a session about Great Books?"

Not often, that's true. At the Pump Room, the waiters in red jackets run around with flaming swords speared with meat, and Mortimer Adler turns out to be a handsome Jewish prince and well aware of it. I can see that he resents my being there, and I don't like him either.

He and Bill Benton toss names around. Socrates. Plato. Aristotle. Einstein. I toy with a roll.

"Isn't there going to be anything about art in your series?" I ask.

Mortimer Adler looks disdainfully at me and then at Benton as if to say, "Where did you find *her?*" But I am only the slightest lull in the conversation as they continue. Newton. Karl Marx. Evidently art is out.

Finally the interminable conversation ends. In the taxi, Bill Benton says, "Have you seen anything of Chicago?"

"Just the places on the schedule."

"That isn't anything. Driver, go around the lake."

We pull up in front of a large apartment house.

"What's this?"

"This is where I live. Marvelous view. I want you to see it."

"But I've got to get to the hotel."

"You will, you will."

I'm a big girl, I figure. If this is a big seduction scene, I can handle it. Besides, I have to go to the bathroom. We do a lot of running around the apartment and a bit of wrestling but nothing happens. It reminds me of fighting with my brother and his friends. Like them, Bill Benton seems stimulated by my frenzy, but I don't want to be collected in that way. The person doesn't

go with the painting, I think as I fend him off in no uncertain way. Eventually, to my relief, he gives up and takes me back to the Drake.

My bitterest fears are realized. The moment I enter my hotel room the telephone is ringing.

"Where have you been? It's four o'clock in the morning," says Joe.

"I've been here," I lie.

"I've been calling every half hour since midnight."

"The operator must have been ringing the wrong room."

"I got you *now*, didn't I? It was the same number."

"Please, Joe, I've got to get some sleep. I've got to be on this radio program in the morning."

A lady named June Baker asks me idiotic questions to which I give equally idiotic answers interrupted by her sales pitch to buy a chocolate drink. And then, as Mom would put it, the party's over and it is time to go home to face Joe's wrath, among other things.

On the Twentieth Century back to New York, we are only twenty-seven miles out when the news is radioed to us in the lounge car—Franklin Roosevelt is dead. To all of us, the festivities seem remote. It is as if our father had died.

"But how *could* the operator have been ringing your room all night and not get you until four in the morning?"

"You're possessive, Joe. My God, you're possessive. You don't own me."

"Haven't we talked about getting married?"

"I'm not sure I want to. With my batting average . . ."

"We're practically engaged."

"Don't be silly. That's Victorian."

"Then I'm Victorian. Is that bad? I can't help it. That's the way I am."

"Please, Joe."

"Why don't you tell me where you were all night?"

"You won't believe me."

"Of course I'll believe you. Just tell me the truth."

"I was with Bill Benton."

"Who's that?"

"He's the head of Britannica. We went to the Pump Room. He had a conference with Mortimer Adler. And then he took me for a ride around the lake."

"And then?"

"And then he showed me the view from his apartment."

"You mean to say you went up to this Benton's apartment in the middle of the night?"

"I had to go to the bathroom."

He does not believe me when I say that nothing happened. To make matters worse, when he takes me back to Tenth Street after dinner and we climb the long flights of stairs, there is a great round box, beautifully wrapped, in front of my door.

"What's that?"

"I have no idea. Didn't you send it?"

When I open it, it is candy from Rose Marie's on Fifth Avenue, a shop that delivers bonbons by horse and carriage.

"Well," says Joe in a rage, "who is it from?"

"It's from Benton," I say in a small voice. "Bill Benton."

"But don't you see?" I explain for the hundredth time, "if I was the pushover you think I was, Benton wouldn't be sending candy, would he?"

I feel guilty anyhow. Obviously Joe thinks I am lying and has decided to be magnanimous and forgive my transgression. But things are not to be that simple. I am awakened one morning at six thirty to the shrill sound of the telephone.

"Lily . . . wasn't it wonderful last night?"

"Yes," I say sleepily. It must be Joe, but why is he calling so early?

"I love fucking you. . . ." This can't be Joe. Not like him at all, and I hang up.

"Did you call me this morning at half past six?" I ask Joe at dinner.

"Now why on earth would I do that?"

"I don't know. I thought it was you for a while."

"It's Benton!"

"Don't be silly, Joe. That kind of talk . . ."

"What kind?"

"Dirty, that's what kind. I was so sleepy, I kept listening. I thought it was you talking about last night."

"Me?"

"Well, it certainly wasn't Benton."

If the phone rings when Joe is there and I answer, I hang up quickly and say "Wrong number," but Joe says bitterly, "It's that bastard Benton." Desperate, I phone the police. They say that if I can keep my caller on the phone for twenty minutes, they can trace the call. I enlist Yola's aid.

"This nut is going to break up Joe and me. You've got to help me."

"Sure, Lily. How?"

"I'll keep the guy on the phone for twenty minutes, but you have to phone the police."

"I get it."

"Do you have your panties on?" says the familiar voice, all seduction.

"Hold on a minute," I say, "I have something on the stove." I grab a broom and bang three times on the bathroom wall between me and Yola.

"OK, OK," I hear her yell.

"Are you touching your pussy?" my caller asks softly. My God, twenty minutes is a long time.

I call the police when my caller, all passion spent, hangs up.

"Did you trace the call?"

"We did. Good work."

"Where was it coming from?"

"Times Square. A telephone booth."

"Did you pick him up?"

"He was gone when we got there."

Desperate, I arrange what may be my own murder when the police suggest that I make a date with the anonymous telephone lover.

"You'll be in no danger. We'll have an officer there to protect you."

Oh, yes. He'll arrive to find me raped, a stocking tied around my throat. But next time I get a call, I say sweetly, "I'd love to meet you."

Reality isn't my caller's forte. He's a master of fantasy. He hesitates.

"I live alone," I say, as provocatively as possible.

We make a date and I phone the police.

The doorbell rings five minutes before the scheduled time. Could he be early? Is there a policeman downstairs? Trembling, I press the downstairs buzzer and hear the steps that may be my doom. I fasten the door with a chain and open it timidly. Just a crack. But it is a girl friend of mine.

"I didn't expect you." I am shaking all over. "But I'm glad you're here."

"I could come back some other time—if you were expecting someone."

"Only a rapist."

"What?" She looks at me as if I were mad.

"And the police. I'm expecting a policeman, too, any minute."

This time when the bell rings, a skinny, pimple-faced adolescent is at the door. He looks scared to death and I am so sorry for him I could weep.

"Won't you come in?" I say, as if I were at a garden party. "A friend of mine dropped in. Shall we have tea?" Milk would be more like it.

"Thank you," he is saying as his embarrassed eyes meet mine when a big, burly policeman walks in and grabs him.

"Do you want to come down to the station and press charges?"

"I'm not sure." My friend, on the verge of laughter, leaves, and the incipient rapist, the law, and I walk to the local precinct.

"Really," I say on the way over, "you shouldn't be doing this, a boy like you—making these calls."

"I've never been in trouble before," the boy bursts out at the station. "I live home with my mother and sister. I go to church every Sunday. I only make calls sometimes. . . ." Tears flow down his acned cheeks. And the police let him go after taking away his little black book full of girls' names from the telephone directory.

"You see? It wasn't Benton at all," I say to Joe, vindicated. "I told him when he called to see if I'd gotten the candy not to call me and I told him about the crazy calls you thought came from

him and he laughed and laughed." Just the idea of Benton of Britannica reduced to heavy breathing makes me laugh, but not Joe.

"I'm still not sure."

A few weeks later Joe phones. "I'm with your brother. We want you to meet us at the Savoy Plaza."

"Sure." Joe gives me the number of a suite. Is my brother staying there? When the door opens, it is Bill Benton who answers it. I can hardly believe it, but behind him my brother and lover are there to interrogate us like criminals as to what happened that night in Chicago.

With the greatest grace, my supposed seducer absolves me of blame and apologizes for his own rude behavior. He does it so skillfully that the accusers leave with only a few dire threats as to what they will do if he ever communicates with me again. I am whisked off like an insulted farmer's daughter.

Joe is as satisfied as if he fought a duel for me and won. In fact, the excitement and rivalry seems to precipitate us into marriage.

"I'm sick and tired of climbing those five flights. You know we're getting married."

"I do?"

"Of course. It's silly to go on like this. We have so much in common."

Isn't a collector, like a dealer, my natural enemy?

Don't be a snob in reverse, I tell myself. He can't help having money. He had to. He had to own a Gutenberg Bible, a Bougereau. He was so poor. I can't imagine being so poor. *We ate garbage*, he said.

"I think I'm going to marry Joe Hirshhorn," I tell Mom.

"But vot does he do?"

"I think he owns a gold mine." How can I overcome that? Still, I feel secure. I have discipline and good working habits. It doesn't seem possible anything can break my rhythm. I must be strong enough to live with another person. Joe respects me.

"She's Lily Harmon in the art world," he says proudly when he introduces me.

Dazzling as I am in Joe's eyes, a goddess enshrined, with his

reassurance of eternal devotion supporting me like water wings, there seems to be no way I can sink. Still, something nags me.

Why else, when I visit Leah Kleinholz, Frank's wife, who has incurable cancer and is in the hospital, do I burden her with my fears about my impending marriage? Is it because I know she is going to die and will not bear witness against me?

"I'm terrified, Leah. I don't know why. He's so jealous—so possessive."

"Do you love him?" she asks from her hazardous perch in this world.

"I think so, but I can't tell. It's so mixed up in my head. As if there were two Gods—one of fear, one of love. Perhaps I can't tell the difference."

And if I can't, I will be punished. But what is the crime? I bury the thought. It goes with Leah to her grave. I am ashamed, I told her, ashamed of my weakness. Still, I ask Dr. Friedman, whom I can never see as a patient again, for the name of a psychiatrist and go to see Dr. Fessler. He is a Viennese who certainly doesn't have a fancy office. I am cheered by the fact that no decorator's hand has touched it. There are books everywhere in stacks, the walls are hung with oriental rugs, there are brown paintings from Vienna. The place is musty. Dr. Fessler drinks wonderful Turkish coffee behind me. The aroma is marvelous. He never offers me any. I spend a lot of time complaining about Dr. Friedman's taking stock tips from Joe. I am deeply hurt, and it costs a lot of money in sessions before I can even begin to talk about Joe and my impending marriage. By that time, I am committed to it.

Chapter Four
1945-1952

RABBI ROBERT GOLDBURG IS SO YOUNG and nervous, he acts as if he had never performed a wedding ceremony before, let alone been ordained. He is the new rabbi of the Temple Mishkan Israel in New Haven where I went to Sunday school and was confirmed.

My brother Joe, our witness, with his usual odd sense of humor whispers to Joe, "Are you sure you want to go through with this? It's not too late to back out."

Why doesn't someone ask *me* if I want to go through with it? Here I am, getting married for the third time (obviously I'm no good at it), to a man thirteen years older than I, with four children who will surely be hostile. I may have to give up the best studio I ever had. Probably, marrying a rich man I'll lose caste with the artists. I'm scared about Joe's money and the responsibility it must entail . . . and how do I know I can cope with any of it?

Smash goes the wineglass!

"Everything's gonna be all right," my husband says. And he sings me a new song as my brother and his wife, Edith, who never sings any more, drive us to New York to celebrate at dinner.

Oh, it's lovely to be married
To be be be be be be be be be be married. . . .

Still, no matter how lovely the day has been, the phone is ringing when we get back to Waverly Place, and Joe must take a night flight to Toronto on business. I am left with my brother and his wife and a magnum of champagne.

"I'm spending your honeymoon with my wife and your wife," my brother says when my husband calls later. But it isn't so. They will be driving back to New Haven, leaving me alone.

"Forgimmee," says Joe.

I am too shy the first two weeks of our marriage to say anything to Joe about money. I pay all the bills, including the services of Helen, my once-a-week maid, now full time. She used to refer to the hot-water bottle that kept my feet warm in my single bed at the studio as "Miss Harmon's husband" to her friends. Now my feet are warm, but my bank balance is getting lower and lower. I get up courage to tell Joe.

"My God! You should have said something before. Here." And he stuffs hundred-dollar bills into my hand.

"Don't you have anything smaller?"

"No. And we'll have a bank account, too, for the house."

Where does Joe get all that cash? "If anyone asks you what I do," he said, "tell them I'm a financier." Whatever that is. Obviously it is some strange business where money breeds money.

"I'll use my Harmon account for my art expenses." And for the feeling of independence it gives me, as well as the fact that changing one's name gets tiresome and confusing. I figure I have as much right to the nom de plume as Sidney, and I like to sign it on canvases. I am used to it. Lily Harmon. Lily Harmon. It has a nice ring. But the butcher, for reasons of his own, prefers Hirshhorn. He says he finds it easier to remember but I know he doesn't trust ladies without husbands. Neither do the other tradespeople. Charge accounts had best be in the name of Mrs. Joseph Hirshhorn.

"Keep a separate account for art if you like, but when you have a big balance, I'll invest it for you. My money is to go out in the world, meet other money, and spawn."

Joe's children find it hard to accept me. Part of the problem becomes clear when we bump into his daughters, Naomi and Gene, with friends at the theater. How do they introduce me? If they say, This is Mrs. Hirshhorn, their friends will think I am their mother. I'm not old enough to be their mother. "Stepmother" has evil implications. Besides, it implies death, and Jenny is alive. I am sure of one thing—that it will be a long time before the children accept me. Surely they know I didn't break up Joe's marriage to Jenny. Nevertheless, if they are friendly, will their mother think them disloyal? I am curious about her. Based on my experience at Huckleberry Hill, I conclude that she makes lots of lists, but I know nothing else about her.

"I'm Lily Harmon," I volunteer as the silence mounts, "Mr. Hirshhorn's wife."

Joe's eldest daughter, Robin, first out of the nest, is the least hostile and also the nearest to my age. She is married to a brilliant young physicist at Yale, Robert Cohen. She invites us to New Haven for dinner, a bride's dinner of a roast chicken so succulent and crisp I will never eat a better one.

Gene, next to Robin, has a typical second child's outgoing nature. Naomi, the youngest, when she visits at Huckleberry Hill and sits next to me in the front seat of the car, makes herself small and shrinks away as if our bodily contact would pollute her.

But it is Gordon, Joe's third child and only son, who seems to have the hardest time.

"What does he like to eat?" I ask nervously when Joe says Gordon is coming for dinner.

"The usual thing boys like," says his father. "Steak."

"And potatoes?"

"And potatoes."

"What's his favorite dessert?"

"Chocolate anything."

"I'll have a mousse. The richest I can dream up."

When Gordon shows up, his father is on the phone and I answer the door.

Gordon is in his teens and looks a bit like Joe, only taller. He also looks as if his worst fears are realized at the sight of me. In

the living room, waiting for Joe, he looks miserable as he picks up a mining magazine and leafs nonchalantly through it.

"Are you interested in mining?" I ask brightly.

"I hate it."

"Oh." There doesn't seem to be anything else to say. We look at each other through a welter of unhappiness.

When Joe finally appears, things do not get better—they get worse. At the dinner table, right in the middle of the steak, Gordon and his father have a knock-down, drag-out argument that happens so quickly that I can't figure out what it is about, but it culminates in Gordon's saying firmly and sullenly, "But I *don't* respect you!" and Joe, raging at this statement and furious at its being made in front of me, his new bride, hustles Gordon, bigger than he, taller and stronger, out of the apartment.

"I don't know what's the matter with that boy."

I look sadly at the half-eaten steak. "He never even got to the mousse."

We go to galleries. Joe buys as if he were at a roulette wheel, placing chips on a lot of numbers. True love shines on the faces of the dealers and the artists. It is a look that becomes familiar to me.

I cringe when Joe says, "I'll take this and this and this," and offers so much less than the artist is asking.

"She can't stand my bargaining," he apologizes for me as I slink away from the scene of the crime.

In the brown velvet-lined inner sanctum of a gallery, a dealer mounts a Soutine on the easel and explains what the artist was thinking as he painted it. As if that were not bad enough, I recognize the tortured hillside of the landscape as one that an artist I knew owned. He must have sold it to eat; he had loved it. Only there is one thing different about the painting now. It has a bold signature in red in the lower right-hand corner. *Soutine.* That wasn't there before.

"Who signed it for you?" slips out of me.

And just as quickly, the dealer tells me. An artist I know. Alive. Which is more than Soutine is now.

"He was there in Soutine's studio when he painted it," the dealer says. "They were good friends. All he did was verify it."

And did he get paid for his forgery, I wonder? The dealer is furious at me for queering his sale. I am furious at his dishonesty. This episode is the last straw. I want no part of these inner sanctums.

There is also another aspect to all this. Joe's vanity about his own taste and judgment. He boils with rage if a painting is listed "From the collection of Mr. and Mrs. Joseph H. Hirshhorn."

"Just insist on your way, Joe. Tell them *Mr.* Joseph H. Hirshhorn. No 'Mrs.' "

No matter. Dealers still sidle up to me and whisper in my ear, "But you collect for him. . . ." I jump. "He makes his own decisions. He has his own taste. I have nothing to do with it." It is hard to hang on to my own ego in the face of artists and dealers using me as a wedge. I talk to him about art, but so do many other people—Curt Valentin, Sam Salz, the Tannhausers. Lots of people. He takes from everyone. He is a quick study.

There is a more frightening aspect to Joe's collecting—at least in terms of my own work. He makes a joke of it. "I had to marry her, it was cheaper."

Joe wants *all* my work. In the beginning, I give him some as gifts. Later I say, "But I'm working toward a show. I can't have *all* the paintings be from the collection of Joseph H. Hirshhorn." I am happy that he likes them, but it is a sword of Damocles too. Where is my independence? I don't relish the idea of painting for an audience of one. He buys some and I give him some, but not all. He is like a squirrel burying his nuts, and the art he owns begins to disappear into Manhattan Storage Warehouse, engulfing forever the painting of Zayda I did when I was fifteen.

Once I gave a painting to a friend of Sidney's to whom he owed a favor. It was one I cherished because J.B. Neumann put his finger to his full lips, considered carefully, and said, "*Now* you are beginning. . . ." The painting had gone into a closet, lost —perhaps the maid took it, they said, but one they bought later hung in a place of honor over the mantel.

"I'd like a chance to have some of my paintings owned by museums."

"I'll have a museum some day."

"Yes." But in the meantime, I want a chance. I want the work to be seen. I pray for all the hidden art. I am still painting in my studio on Tenth Street, which seems part of me, but Joe is already talking about getting a town house big enough for all his paintings and for my needs, too, he assures me. Twenty-seven West Tenth Street is like a talisman. I don't want to part with it.

I stay away from the safaris at galleries, and Joe goes with my old friend Eddie Kook, Bill Weintraub, and other men on raids to the artists' studios where they cut a large swathe and help a lot of artists to eat and pay their rent. The men have a great time, buy a lot of paintings, and gradually also acquire ten-cent mining stocks in Canada from Joe.

"I'm prejudiced," I tell people who note my absence from the bargaining scenes. "I have definite opinions on art, and my feelings are tied up with my own work." Still, there is nothing to stop me from exclaiming when Joe brings home some new paintings, "Why don't you buy the artist he's imitating? This is wallpaper. She doesn't work by the yard, Viera da Silva." Next thing I know, there is a run on Viera da Silva. I realize this is a potent weapon, and I watch myself carefully. Endless numbers of Eilshemius, Evergoods, all the Soyers, and other contemporary American artists arrive, then suddenly, inexplicably, French impressionists are acquired and I cannot figure out this logic in view of Joe's saying the collection was to be American. But I have accepted the fact that Joe's behavior is his own and not to be questioned. Inconsistency could be his middle name.

But there is no way to avoid twinges of jealousy as Joe brings home new loves. In my studio, the walls are always bare and white, not to influence me. The breakers of art keep rolling like tidal waves and I am hard put not to be swept away.

Finally, we are going to have our delayed honeymoon.
"Dr. Friedman is going with us."
"Going with us where?"
"To Havana."
"You're kidding."
"No, I'm not. He thought he'd go to Miami for the holidays, but the weather is so bad there, he'd rather go with us."

"But it's our honeymoon."

"He doesn't mind. Besides, he knows a lot of places there. He spent a lot of time in Cuba waiting to get into the United States."

We are going to be three on a honeymoon. In fact, when we change planes in Miami we are almost four. A friend of Dr. Friedman's seriously considers joining us but at the last moment decides to stay in Florida.

We change into summer clothes when we arrive in Havana. The night is balmy as we sally forth to dinner.

"It's such a beautiful night," says Paul Friedman. "Let's walk."

"I've never worn these shoes before," says Joe. "They're new."

"I know a wonderful little restaurant right near here."

We walk and walk.

"I think I'm getting a blister," says Joe, looking ruefully at his white shoes. "And I'm hungry."

I know that Joe is like a child when he doesn't eat on time, but maybe his analyst doesn't.

"It's just around the corner."

But it is not around that corner, nor is it around any of the other corners that come and go. It is becoming obvious that Dr. Friedman hasn't the foggiest idea where this restaurant is. It has been a long time. He has forgotten.

"This restaurant is not a tourist trap," says the doctor, heaving and panting a little himself. "It's worth finding." We get the idea that if a restaurant, any restaurant, showed up, he would say that was it to save his face. But none shows up.

"My feet are killing me. And I'm hungry. And I have a blister."

A taxi drives by. Joe hails him and he stops.

"What are you doing?" asks Dr. Friedman.

"Get in, get in," says Joe. "Driver, take us to a restaurant. Any restaurant. The nearest one."

"*Sí, señor.*"

"It's a tourist trap," insists Dr. Friedman, but Joe doesn't care as he slips off the tight shoes and eats happily in his stockinged feet.

Shortly after the trip to Havana, Joe discontinues his analysis —probably a combination of the tight shoes, the hunger, and

the fact that Dr. Friedman wanted to know how his stock was doing and when to sell.

"Can we afford all this?" I ask when we have finally found a town house, a large Georgian one on Eighty-second Street, just a spit away from the Met. Among the fifty houses I saw I liked a little one on Tenth Street best. It was too small, Joe thought, and was not impressed with the cast-iron pineapples of hospitality in front of it. This house he considers just right. It is twenty-five feet wide and almost one hundred feet deep. It has a magnificent spiral staircase sweeping up in a crescendo to an oval leaded-glass skylight. It also has an elevator and a separate back stairway for help.

"I'll let you know if I can't afford it," says Joe. "Would you rather live in a tent?"

"Tenth Street wasn't a tent." It was hard to give it up. Now, moving above Fifty-seventh Street would be difficult. Most of my friends lived in the Village and joked about "uptown." Now I would be "uptown."

"Are you still painting?" I am asked, as though proximity to money eliminated that need.

"Why wouldn't I?" I answer the question with a question. Without painting, my nerve endings are exposed like live wires. They sizzle and crack. With it, no matter how badly it goes, I am insulated.

My new studio is shaping up. The contractor breaks out the whole top floor front and replaces it with slanting windows. Zygmund Menkes, when he comes to visit, stutters, "It's mag . . . mag . . . magnificent, but you'll paint bl . . . bl . . . black. There's too much light!" I have shades installed, hoping to outwit the problem.

Joe is not content with the fireplace mantels. We have them ripped out and better ones put in from the firm of William Jackson. The wine cellar in the basement is stocked with cases of champagne splits. I have a lot of keys. I am a chatelaine.

"Let's not have any fake furniture," I suggest. "Let's collect some good early American antiques."

While Joe is away in Canada, I visit Mom and Pop on their

annual pilgrimage to Saratoga Springs. They are delighted I
have at last done the right thing and married a solvent husband,
although they are in awe of him and his reckless spending. It is
not their way. Joe treats them like innocent children. Their fru-
gality bores him. Harry Aarons, an old friend of the family, an
antique dealer from Ansonia, is in Saratoga, too, taking the cure
between sallies into the attics of the local bluebloods.

"I just got married and we need furniture."

"Why don't you buy it in New York?" says Harry, looking at
me with a jaundiced eye and waving me away with a glass of
mineral water. I can see that he doesn't regard a little girl raised
on Grand Avenue as a serious buyer. "Why should you *shlepp* to
my barn so far away in Connecticut when you can buy from my
old friend Israel Sack on Fifty-seventh Street in New York? We
handle the same things."

We take Harry's advice and go to Fifty-seventh Street, where
Israel Sack, a former cabinetmaker, tells us how he lectures
D.A.R. members on the fine points of their heirloom highboys
and lowboys, their fan-backed Windsor chairs with their original
paint, and the beauty of the rising suns and moons painted on
their Simon Willard clocks.

After ascertaining that Mr. Sack and he are *landsleit,* both born
in Latvia, Joe rests his hand lovingly on the fine finish of a large
table.

"How much is this, Izzy?" he asks.

"It's the rarest piece on the floor, Mr. Hirshhorn. A birdcage
table. Five feet around. Solid mahogany. The top is one piece of
wood. It's five thousand dollars."

"Call me Joe, Izzy. I'll take it." He whips out the cash in his
pocket and piles large bills in neat stacks on the surface of our
library table. "Count it. It's all there."

"I've been thinking," Harry Aarons says when he calls the
next day, "that maybe you and Mr. Hirshhorn could come to my
barn on Sunday. It isn't far by train, and I could pick you up at
the station." And, in a strained voice he adds, "I hear you bought
the library table I sold Izzy."

"My husband loved it."

"Tell your husband I buy for a lot of important people. For Henry Ford, for Dupont's Winterthur. And right now I happen to have an exceptional pair of slipper-footed Queen Anne chairs."

On Sundays we play a game. It's called "Who gets to Harry first?" If Izzy beats us to Ansonia we pay much more later on Fifty-seventh Street. Joe is like a bird dog. Point him in the right direction and he will take the lead. He is as engrossed with collecting furniture as he is with art, and he collects it in equally staggering quantities.

Joe and I go to Arthur Sussel's in Philadelphia. I discovered his shop on a trip with Blanche Brown, who took a busman's holiday from the Met when we went to study Eakins's work. I bought Joe a print cabinet that had belonged to Mary Cassatt's brother, the railroad magnate. He kept maps in it, and I figured Joe could use it to house the unframed drawings he was acquiring. Sussel's place is full of china, scraps of antique fabric, yards of used white linen runners that covered the stair carpeting of the Mainliners. Sussel was in burlesque before he discovered the beauty of antiques as well as iron hardware from Pennsylvania barns. We buy Sandwich glass, a Chinese vase with an oxblood glaze, astral lamps of shining brass and etched glass globes. Joe and all the dealers get along well. They seem to have the same hunger. They stuff themselves to the gills. They want to be obese with possessions, but somehow, it is never enough. They are insatiable.

The name of the game is "The best," not "How much?" I wonder what all this is costing, but after a few ineffectual lists I give up. Joe isn't interested in knowing. We select antique furniture and oriental rugs ourselves. Dore Schary's interior-decorator sister, Lillian Schary Small, is in charge of the ordinary tasks of furnishing. She orders yards of specially dyed carpeting from Edward Fields for the bedrooms and lampshades made to order of smocked silk with intricate edgings. It gives me pause that our drapes of Scalamandre silk come from Joe LiVolsi's where a woman has been reweaving one small bit of rare fabric for Winterthur for three years and could go blind from making tiny crisscrossed stitches.

Freehand

The house is almost finished. Max Schneider, a restorer of antiques, is rubbing down the stripped stair rail of mahogany with layer after layer of boiled linseed oil until it shines like satin.

"Who's going to take care of all this?" I ask Lillian. "Five floors of stuff."

"Don't worry," that imperturbable lady assures me. "You'll need a couple, but I'll take care of everything down to the last ashtray, the last wooden spoon in the kitchen. All you have to do is move in with your clothes. I'll have the hangers there. And I'll find you a couple." Thank God. I have no idea how to do this.

"You have no idea how lucky you are. I found this Finnish couple for Danny and Sylvia Kaye, my other clients, but they're leery of theater people. They'd rather work for you and Joe. They like to take complete charge of a house." This scares me a bit, but not as much as tackling that job myself.

We are not yet in residence when I drop by to meet a man who is measuring for window shades. Selma and Albert, thin, wiry, and a bit morose, are already occupying their three-room apartment on the first floor.

"I'm done," he says, "except for the cook's room. I can't get in there. She's lying down."

I know Selma well enough by now to know that lying down in midday is not her habit, nor her husband's. He is embarrassed.

"We must give notice," says Albert.

"Why?"

"We're not giving proper service."

"Never mind about that. Let's see what's wrong."

I knock on Selma's door.

"May I come in?"

"Yes, madam," says a weak little voice.

Selma is lying in bed, her eyes tense with pain. I tell the shade man to go away.

"I must find a doctor." Selma's face is drawn and distorted.

"A doctor?" says Albert as if I had said a dirty word. "Neither of us has ever seen a doctor."

"I'll have the devil of a time finding one. Tonight's New Years

Eve." I rush across the street where I am lucky enough to find a doctor just leaving his office, and I drag him over. He examines Selma.

"She has acute appendicitis. I'll call Mount Sinai and get her a bed. She has to be operated on immediately. You get her there right away."

I dress Selma carefully, carefully, pulling her stockings on as if she were made of bisque.

"We all have to go sometime," Albert says as soon as he hears about the hospital. Selma is operated on that night, makes an excellent recovery, and is back at the house in ten days.

We are finally in residence.

"Excuse me, madam," Albert interrupts me in the studio where, as Menkes forecast, I am busy painting black. "I must give notice."

"Why?"

"Selma isn't able to work yet."

"Of course not. She's still recuperating anyhow. And you do enough work for two. If you're not doing a good job, we'll let you know."

"Thank you, madam."

I think I should take a course in psychology to handle these situations. When Selma is well and working, the final straw comes. I order a washing machine for the laundry in the basement where, with the usual insouciance of the rich, there are only tubs and washboards. When the new appliance comes, I toss in a load of wash and watch it revolve.

Selma and Albert have crept to the head of the stairs and are watching me like the Bobbsey Twins.

"I wanted to see how it works," I say.

The next day when Albert gives notice again, explaining that if the lady of the house must do the wash they can't be satisfactory, and that they have never seen such a sight before, I let them leave.

In my studio on the top floor I struggle with the paintings. They will not lighten. I don't know why. I have everything I had on Tenth Street and more. I have a private sitting room as well

as the double-height studio with too much light, a terrace planted with flowers and two weeping willow trees, and a kitchenette where I can make coffee or boil an egg if I don't want to go downstairs for lunch. But something is wrong.

People suffer a sea change when they enter the front door, and it isn't into something rich and strange, either. It is as if the very perfection of the house were obscene. Artists lose their character and are consumed by jealousy. At a party, Bob Gwathmey takes the tiny Renoir off the wall and waltzes around with it while I tremble. It surprises me, because on the whole the artists do not treat me differently from the way they had. I don't interpret Bob's behavior as directed against me, but rather as a rage that Joe, who claimed to collect only living American artists, seems to be bitten by the accepted way, the safe way. Still, it is damned rude and not at all like Bob.

My sister Gert draws in her breath the first time she steps into the marble entrance hall. I think of Dorothy Parker's poem about the good little girl and the bad little girl who both had the same fate: they married rich men. And I cannot help a twinge of satisfaction that Gert hadn't been right in her forecast that I would wind up with the ultimate horror for her, a job in Macy's.

As if in answer to my thought, Gert's youngest daughter Mary-Lou, sticks her head out of the elevator, where she and her older sister Carol are playing a game of department store, and yells "Macy's basement!"

"All out who are getting out!" chimes Carol. "Housewares. Brooms. Canned goods. Toilet paper and napkins."

"Get out of the elevator, kids." I never take it when there is no one in the house. I am terrified of small, airless places.

I wonder what will happen to Gert's children to whom I transfer all the love I would give my own children if I had any. I am sure Gert has told them I am their crazy aunt; they regard me with curiosity and wonder, as if they are not sure what I will do next. Carol seems stubborn, like me. When I photographed her at three, I discovered that if I wanted her to play her tiny toy piano, all I had to do was say, "Play with your doll, darling," and she would do the opposite. It made me think of Baba saying, "You say black, she says white. *An akshun.*" Stubborn.

Gert left Mary-Lou many afternoons in my studio and invariably I painted her. Mary-Lou in her green beaver hat. Mary-Lou painting. Mary-Lou just sitting, looking into space with her black-button eyes, white skin, and orange-juice hair.

My sister, ravaged by my unjust rewards for my bad behavior, thinks of a way to strike back. A saver, she mails a package of old clothes to me at Huckleberry Hill. With it, she sends an open post card, probably to the delight of the postmistress, who reads everything, that says, "Thought you could use these." Joe is livid. I tell her please, please, never to do that again.

"I meant well" is her answer.

Meanwhile, I am hard put to it to cope with my happy lot.

In the hierarchy of help, the next couple are so specialized that we have to have a lot of other people. The English cook will not venture out of the kitchen, and her English husband, the butler, serves me wearing a white jacket and looking pained at my blue denims. His wife creates an amazing first course of eggs, all trembly out of their shells. How she gets them that way I can never understand, nor do I dare to ask her. There has to be some logical explanation, but her recipes are secret and she will give notice if I trespass on her kitchen floor. We have a parlor-maid for the living room and library, a chambermaid for the bedrooms, and the laundry, naturally, must be done by a laundress who is self-respecting and will not work in a house where she is not served a hot lunch. Soon there are more of them than there are of us. We are outnumbered and outclassed. Is it better to be maid rather than mistress—since that way one has control?

I shop and shop to keep up with supplies, but rolls of toilet paper disappear, cans of tomatoes diminish, liquor vanishes, and I fight a losing battle.

I mention this problem to Mrs. Peter I.B. Lavan, who seems to run her town house with a minimum of heartache.

"They will steal about three hundred dollars' worth of supplies a year," she says. "And you forget about it."

With my background and the memory of Baba checking fruit for blemishes, that is easier said than done. I am furious at all

the endless shopping. It is always someone's day off, but not mine. I am the relief shift.

"Don't go empty-handed," Joe warns, as if living on the top floor on Tenth Street hadn't been good enough training for me not to forget anything on another floor. He has tidy habits and picks up after himself, but we are the opposite about messes. His are concealed in drawers, his surfaces clean, and mine, messy on top, are orderly inside.

Every week flowers are delivered and followed by a woman who does "less is more" flower arrangements. I prefer great masses like the Degas chrysanthemums, but I stand aside and watch her trim, cut, and poke a few blossoms, a few leaves. And next week it will all happen again.

Joe said that whenever I wanted to adopt a child, he would be willing. His enthusiasm for this was like all his other enthusiasms —intense. We have already applied to the Stephen Wise agency, been interviewed and put on their waiting list for either a boy or a girl—we're not fussy, we'll take either. The agency likes that. Also they can see that we don't need a child to shore up a broken marriage. Joe cannot keep his hands from touching me. Sex is still wonderful between us.

A couple are dining with us. Her husband is a possible investor in Joe's new mining efforts in the Philippines. Our friends seem to come and go based on Joe's current ventures.

The dining room is beautiful. Candles flicker in old silver and at the windows concealed bulbs throw extra light on the absolutely perfect rack of lamb prepared by our unfriendly but gifted cook and served with aplomb by the butler. At no point is the place before us empty. The service plates of Minton rimmed with gold yield to dinner plates of Wedgwood. The Wedgwood gives way to Spode. We are sipping demitasse from Tiffany cups left over from my marriage to Sidney and talking about our quest for a child.

"Would you adopt a child right now if you could have one?" asks Marian, a strange smile on her lips.

"Are you kidding?" says Joe. "We want one." He is a yes-sayer. That's what I love about him. He never says no.

"We were going to adopt a second child, a little girl. She was born about six days ago in Chicago, but we feel that our son isn't secure enough yet for us to take her. We decided that we wouldn't. Of course, we don't know if she's still available."

Thinking of a child lying somewhere unclaimed like a bag of laundry is almost too much for me.

"We know the doctor who delivered the baby and a lawyer friend of ours was to handle the adoption," says Arthur.

"What's the name of the doctor?" asks Joe. Joe puts down his coffee cup, reaches for the telephone, which is like a part of his body, an extra arm, an extra hand, an extra mouth, and talks to the doctor in Chicago. The baby is still available. Our dinner guests get on the phone and extol our virtues as substitute parents, although how they can be sure of this I do not know.

Next night on the train to Chicago, I am lucky to have time to brush up overnight on being a mother. I kaleidoscope nine months of preparation into one night of Dr. Spock.

"Treat your first child like your second," he advises. How on earth do you do that? My head spins with formulas. The best thing the good doctor says is that a new baby is practically indestructible and has a tremendous will to live. I'm glad to hear it.

"Butterfingers!" I can hear someone say as the wet infant slithers out of my hands on to the floor.

Joe sustains me. He treats this adventure with aplomb and joie de vivre. I am nervous at the responsibility. Before we left for Chicago I asked my old high school friend Edna Rostow how she felt when she first saw Victor, whom she and Gene adopted.

"I didn't feel what a friend of mine told me I would—an invisible umbilical cord stretching between me and the child—I felt scared, and you probably will, too."

Thank God I talked to her, because in the hospital when a nurse holds up the baby—Amy we decided to call her after Joe's mother, Amelia (what a strange New England name for a Jewish Latvian lady)—I realize I have never seen a newborn baby before. Is this how they are supposed to look? All red and blotchy? Her face is contorted with pain, or is it hunger? I look at Joe and he nods affirmatively. We are parents. I must find some diapers, a blanket, and something to carry her in—a basket.

Next day when we go back to the hospital, the baby looks different. The nurse supports her wobbly neck with her hand.

"She smiled at us!"

"Probably needs burping," says Joe. "Gas."

I am impressed. Joe has been a father four times. He ought to know what's what. I don't. We are parents, but only on a six-month approval basis. A social worker will visit us then. The court wants to be sure we are worthy, which is more than is required of natural parents. Nobody checks their credentials. Our lawyer has seen Amy's real mother (and am I then her unreal one?).

"What was she like?"

"Attractive. Very attractive. About twenty-seven years old. She was reading a book."

"What book?"

"Proust. She was reading Proust. *Swann's Way.*"

I have never been able to get beyond page three of Proust. I am impressed.

When we get back to New York with Amy, Joe says, "Let me. Let me carry her," and he takes the grocery basket with Amy in it and carries her over the threshold like a new bride.

Life is almost too perfect. Oddly enough, Amy looks exactly like a child I painted long before she was born, a wispy-haired redheaded infant in a "Mother and Child." It is as if my imagination brought her into being.

Struggling with the joy of having a baby, an attentive, adoring husband, and a new life creates some inexplicable wedge between me and my friends. I am still seeing Dr. Fessler.

No matter how much light I block out in the studio, the paintings are still dark and colorless. My need to work is as strong as ever, but what comes out is confusion and alienation. The house weighs on me heavily. I do not seem able to adjust to what Joe calls "gracious living." I miss Tenth Street and the environment I was able to control. Still, the muse will come back, I assure myself. It is only angry at me for what seems like desertion. I stand and face up to white canvases, throwing washes of color over them to obliterate the blankness and tell myself, "Work

toward the light, toward the dark." And I hold Joe's bromide to my heart: "It will be all right. Everything will be all right."

When a friend of mine suggests that I join the Communist Party, it seems to me it is exactly the right time. I am guilty about marrying a rich man and depressed at painting black. My earliest experience with the Left was unfortunate. In my last year at high school, Dick Siegel took me to a dance at the John Reed Club. A black boy asked me to dance and I said no. Dick, serious about causes, looked at me angrily through his thick glasses.

"I didn't want to dance with him. I had just as much right to say no to him as if he were white."

But Dick didn't see it that way. I had failed him. He walked me home in silence. When he said a sullen goodnight on the front stoop of our two-family house, he spit out, "You, you're nothing but a property-owner's daughter!"

If ever there was a wrong time to join the party, this was it. There was such a climate of fear in 1947, staunch believers were quitting. I go to only one meeting. Earl Browder, former god, is on the hot seat. Nauseating breast-beating and guilt come over in waves. I cannot fill out a card. Naturally, all this comes up in my analysis, and I discover that my motivations are not what they seem.

"My reasons are all wrong," I tell the artist who had recruited me. "For one thing, I've never read Marx."

"I haven't either."

"Well, maybe your reasons are wrong, too."

And with this heresy, I pass out of the ranks and am gobbled up by the world of wealth.

A new organization, Artists Equity, is formed, with Yasuo Kuniyoshi and Leon Kroll spearheading it after they consult with a liberal woman lawyer, Lillian Poses, who has organized a union of designers and knows her way around. I am one of the founding members, as are Joseph Hirsch, Gladys Rockmore Davis, Katharine Schmidt, Stanley Hayter and Julio de Diego, who is married to Gypsy Rose Lee. Ravishing in her chic outfits, she is militant at some of our meetings. She overwhelms us, as well as Julio, and when their marriage breaks up it is she who writes a

cookbook but he whom we remember as taking three days to prepare chicken with a coating of crushed almonds.

We decide this will be an exclusively economic organization, like a union, devoted to the relationship of the artist to the dealer, to copyrights, to contracts, and we even foresee the possibility that the new medium, television, may present an opportunity for artists to receive royalties on the use of their work.

But when a Communist artists' faction tries to manipulate Lillian Poses, who not only is our first director, but graciously allows us to use her office as headquarters in what seems to be becoming a national organization, she resigns, and a new director, Hudson Walker, is elected.

As artists, we are always asked to donate for causes. Someone suggests that it is high time we did this for ourselves as a group. We all contribute a work of art. The signatures are concealed. Everything is the same price, one hundred dollars for the known and unknown. It is an exercise in recognition as the collectors dash madly into the Whitney Museum of American art, aiming for the best. The show succeeds beyond our dreams. We raise fifty thousand dollars and make our first mistake. We buy a building. Naturally, exhibitions, which we had not planned to have, follow. Little by little, the juice is taken out of what we hoped would be an ASCAP for artists.

Guided tours of Joe's collection do not include my studio. Curious artists, friends, and business acquaintances are taken to the fourth floor by elevator and then shown down the spiral staircase. One guest is always startled as the elevator doors open on a skeletal charwoman weighed down with two pails, a painting of Gregorio Prestopino's.

"I hate that painting," he shudders.

"But you never forget it," Joe says triumphantly.

Marc Chagall comes to see his own painting, which Joe has just acquired. He looks like a delicate aging faun with thin curly hair. He makes no comment until we get to the formal living room, where his own work is hanging in the company of an early Toulouse-Lautrec (his mother and father seated majestically in a fiacre with high-stepping horses), an exquisite small

Renoir portrait, a James Ensor self-portrait, and the head of a woman against a large bouquet of flowers by Odilon Redon. Then he stands in front of his own painting and says to me, *"Est-ce que vous l'aimez, vraiment?"*

"What did he say?" Joe asks.

"Du gleichts das, takeh?" Chagall repeats in Yiddish, for Joe's benefit.

I am amazed that an artist of international renown would want to know, in two languages, "Do you really like it?" It cheers me up. I assume it is the same kind of insecurity I feel, but perhaps it is only that he likes to hear compliments. We reassure him that we love the painting.

To my surprise, Marcel Duchamp looks at everything in the collection and is most impressed with Eilshemius, Joe's pet.

"He's so honest, so sincere. . . ." Like many avant-garde artists, he prefers the naive, as does John Graham, whose own paintings are of walleyed damsels like classical Picassos.

I am always drawn to Phil Evergood's painting of his wife, "Juju as a Wave," a large canvas. Juju's luminous light flesh is at a diagonal angle with white waves lapping behind her and sharply drawn black lines crisscrossing her body. A few crazy birds perch on the tree branches that bisect her body. Shells and starfish are sprinkled at her feet.

Joe is involved in a new enterprise in the Philippines. William Rosenwald is the prime investor, and Bill, who never comes to visit, is a force in our house. He keeps insisting that Joe match any money he puts into the Philippine-American Finance and Development Company. The effect of this on my husband is castration. Bill Rosenwald affects my sex life. He infuriates my husband. We are both frustrated.

"I can't keep up with him putting money into this thing," Joe says. And another possible investor shows up—Serge Rubinstein. He is arrogant and oily as he tours our house.

"Strange paintings you have here," he sneers. "You'll have to come to dinner at my town house. It's just around the corner on Fifth Avenue."

"I don't want to go," I tell Joe. "You can go without me. I don't like that man."

"He's good to his mother," Joe says. "She lives with him. He can't do enough for her."

"And he was a draft dodger, and he's slimy."

It is eight years before Serge Rubinstein is found murdered in his mansion. Almost everybody he ever met was a suspect.

Joe has been in the Philippines a long time, almost three months. I am home with Amy, who is almost a year old now, but conversation with her is limited. She can say Mama and Dada and not much else. I record everything she does in a baby book, the eruption of her two front teeth, her crawling, her raising herself up in the crib, her every move. Mom is sure when Amy hums that she is singing. Mom accepted becoming a grandmother overnight gracefully and thought Amy bright and pretty as a doll.

The fancy cook and butler are disgruntled with my dull routine of painting and no entertaining. I decide to give a party to liven up their spirits as well as my own.

Snow falls relentlessly on the day of my dinner party and piles up at the front door. The butler shovels desperately but it outwits him. A hush comes over the city as all transportation ceases with the exception of a horse-drawn sleigh on Fifth Avenue. We are in the midst of the blizzard of 1947. One by one, the guests call in to say they cannot possibly come. I sit at the end of the dining table set for twelve with Amy in her high chair next to me. The butler is as sulky as the cook as he serves us squab stuffed with wild rice. The phone rings.

"It's Mr. Hirshhorn from Manila," says the butler, pleased at some excitement.

"Overseas operator . . ." I hold my breath, but there is silence broken by a slight sound like waves hitting the shore.

"Sorry. We don't seem to be able to complete the call. I'll try you later."

Next time the phone rings the same thing happens.

"What seems to be the trouble?"

"I'm getting Signal Nine."

"What's that?"

"A typhoon."

"How bad is it?"

"On a scale of ten," says the operator, "nine is bad."

At last Joe is on the phone sounding remote and hollow by radio.

"We're having a typhoon," the strange voice says as if it were coming from under the ocean.

"Are you OK?"

"The roof blew off the hotel."

"What floor are you on?"

"Next to the top. I'm all right, but the Philippine girls are beginning to look awfully good to me. Why don't you fly here?"

"I'd love to."

"I'll have George Courtney make the arrangements. Sonia Ossorio is in New York. She'll get in touch with you about what clothes to take."

"We're having a snowstorm here," I say, but the connection is severed.

I decide to wear a skirt and cashmere sweater for lunch rather than my usual working outfit and am glad I added a string of pearls when Sonia Ossorio, a member of an extremely wealthy Philippine family, appears, a vision in a Hattie Carnegie rustling black taffeta and bedecked with diamonds sparkling at her ears, throat, and wrists.

"We always dress for dinner in Manila," says Sonia. "I'd say you could get away with five evening gowns."

"Five?" I have one.

"That would be the least."

"And for daytime?"

"Simple clothes like you wear here."

"Could I wear pants to sketch in the markets?"

"Ladies don't go to the markets," says Sonia, surprised.

After lunch, when Sonia says, "Now shall we look at your clothes?" terrified at the thought of this chic lady inspecting my wardrobe, I say casually, "Don't bother. I think I'll start from scratch."

The obstacle of the evening gowns is overcome when I see petticoats are in vogue, and I buy them in white eyelet and colors with different tops and hope that will do. Packing, I hesitate at my blue jeans, but throw them in anyhow.

It is eleven thousand miles by plane to the Philippines, a long
and tiresome journey, broken with a stop in Los Angeles, which
has grown more horizontal than when I was there with Sidney.
Then a stop in Hawaii where I have only a few hours to feel the
soft wind and after that the International Dateline makes two
days collide and result in a rash of meals. I wonder if Joe was
serious about the Philippine ladies looking good to him, but it
certainly galvanized me into action.

In Manila when Joe comes toward me with his quick rolling
swagger, I fling myself into his arms. He is glad to see me. Army
surplus called Jeepneys, no longer camouflaged in khaki colors,
scurry everywhere painted like bright insects with striped
fringed awnings to keep the sun away. The buildings are shot
full of holes, and rubble still litters the streets. I have never seen
a war-torn country before. I am shocked.

At the Manila Hotel, Joe shocks me still more.

"I woke up the other night and there was a man in my room."

"What was he doing?"

"Searching."

"For what?"

"I don't know. He didn't take anything. I just lay there quietly
until he went away."

It occurs to me that someone involved in the Philippine-
American Finance and Development Company could be angry
at Joe. He could have been murdered. But I say nothing.

Dawn comes up like thunder. I wake early. It is too hot to
work except in the morning. The streets are full of people and
I sketch the women at six o'clock mass in church, kneeling
and counting their rosary beads, lace mantillas on their heads
and the folds of their black dresses breaking behind them like
madonnas in Renaissance paintings. Outside, beggars stretch
out skinny arms. At the markets children carry siblings almost
their own size. A woman in a simple gown sits like a Grecian
figure on a crate of oranges with the symbol of a blue goose
painted on it.

While I am drawing a swollen-bellied infant lying on a wooden
platform, a voice behind me says accusingly "G.I. baby," and I

look around at a man whose eyes reproach me for this fact of war. Nobody wants to be reminded of these injustices, I realize, after I do a painting from the sketch, which nobody wants to buy.

Evenings at dinner, I see that Sonia was right. The Philippine ladies seem to be the most beautiful women in the world in their traditional gowns made of piña cloth, a pineapple fiber, standing away from their shoulders like gossamer angels' wings. My petticoats are considered whimsical and amusing.

While I spend my days in the market among the poor, my nights are spent among the rich. Joe and I are invited to dine with a priest. Could the church be interested in mining? Why else are we here? His Eminence wipes his lips on a delicate white lace napkin, offers us the best wine and the finest food. I think of the contrast between the great Spanish churches towering above the simple houses and the people I sketch and how they seem to relish the splendor and gilt angels at their morning mass.

What are they hunting in this war-torn country? Is it copper or manganese or gold? Joe and I fly to Baguio in a tiny plane. In this cool northern section the people look like American Indians and the mountains as we fly over them resemble the Adirondacks. Just as we are about to land on a tiny airstrip wedged between two mountains, the pilot swerves upward, missing a cliff by a fraction. Joe, usually impervious to the possibility of death, catches his breath, and, because my seat belt is not fastened tightly enough, my head bangs against the top of the plane.

Shaken, we step out and are met by a group of men from the Benguet Gold Mines. I am shunted off to a Mr. Smith delegated to give me a sightseeing tour of the mine. We enter a huge plant with conveyor belts moving and large machinery that towers above our heads.

"If that were a pot in my kitchen," I yell above the noise, "I'd say there was something the matter with it." Smoke and steam are rising.

"But it's not a pot in your kitchen," Mr. Smith screams back at me.

Just then, a siren sounds. The machines stop their clatter. The conveyor belts stop in their tracks and the men stop working.

"There *is* something wrong with that machine," Mr. Smith says in the sudden quiet. "Are you sure you're not familiar with this process?"

"I've never been in a gold-mine plant before."

"Well, little lady, I'm going to see that you get the grand tour."

Hours later, not having missed a process, we stagger out into the sunlight. I should have kept my big mouth shut.

Back in Manila I offer a mother posing for me with her child some money. She refuses, saying, "You have done me the honor." I have a hard time reconciling days spent drawing people in the streets and nights in the houses walled into compounds to keep them out. A woman from the Manila *Times* interviews me.

"You enjoy slumming?" she asks.

"Please don't use that word." I shudder, but nevertheless the headline on her article, front page, is AMERICAN LADY ARTIST ON SLUMMING TOUR. That's what I get for balancing between two worlds.

When Joe gets back from the Philippines, after I do, we fire our army of help and Joe finds a simple couple whom he knew in some other capacity. Their training was in their own home. Katherine, or Kathie as she insists I call her, doesn't mind if I come into the kitchen. She loves it. Kevin drives the car, polishes silver and waits on table. They assure us they can handle everything. I call them the Dream Couple. I just wish Kathie wouldn't tie pink ribbons on Amy's topknot.

"Could someone be trying to poison you?" asks Dr. Fessler.

How strange, an analyst recommending paranoia.

"It's just that I'm terribly tired."

"Yes, and what about that other symptom . . . your hair coming out?"

"Probably hereditary. All the women in my family have thin hair."

"What about your paints?" Dr. Fessler says. "Do they have lead in them?"

Lead poisoning now.

"I'll check them. I try to be careful. I don't put brushes in my mouth."

It dawns on me later. There is some medication in the medicine cabinet of the bathroom that a doctor recommended. It had some arsenic in it, but I took only a small amount, and long ago. When I look at the bottle, the liquid seems low. I'd hardly used any. Where had it gone? I told Dr. Fessler about it and threw it out. Gradually I seemed to feel better.

That summer at Huckleberry Hill I tackled the guest house and was busy painting it. We couldn't find a house painter and it seemed like a good idea at the time. I hated painting the ceiling, it gave me a crick in my neck. I got so tired I decided I would, for a change, drive the station wagon to town and do the marketing myself, instead of sending Kathie and Kevin.

"Where do you want this delivered?" asks the man behind the counter when I give him a large order.

"Huckleberry Hill."

"And who are you?"

"I'm Mrs. Hirshhorn."

"And who's that other lady?"

"What other lady?"

"The blond one."

"You mean the cook?"

"The one who comes in here all dressed up in the back of a Cadillac with a chauffeur in front is the cook?"

"Yes."

"And you're Mrs. Hirshhorn?"

"Yes."

"I called *her* Mrs. Hirshhorn and she never said no."

I remember Kathie saying, "I don't see your mink coat, Mrs. Hirshhorn."

"I haven't got one, Kathie."

"If I were you, I would. I love mink."

In Kathie's fantasy world when she was Mrs. Hirshhorn (whatever had she planned to do with Kevin? Kill him after she'd killed me?) she would certainly have a fur coat. Probably sable. Kathie, we also find out after we give the dream couple notice, trained for her future role as Joe's wife by sleeping alone in the double bed in the master bedroom whenever we were in New York.

"I can't afford it," says Joe about the house on Eighty-second Street. In the wine cellar, perhaps symbolically, the splits of champagne have all turned to vinegar and have to be thrown out. "I'm broke." The Philippines and Bill Rosenwald's asking Joe to match his money have done it.

What is Joe's idea of broke? Mine is about two hundred dollars in the bank. It is impossible to discuss money with him. I haven't the vaguest idea of what he had or has.

"Shall I look for an apartment?"

"I'd rather we get a house in the country."

How can I live in the suburbs? I have just about adjusted to living uptown. Now I would be a commuter to culture. When I say I consider the suburbs Siberia, Joe says, "People are people everywhere," and adds, "It would be good for Amy." That's true. She could run around outside and we wouldn't have to take her to the park. And I could paint anywhere, couldn't I?

"You're sure you wouldn't want me to look for an apartment?"

"I don't want to live in New York."

The phone has stopped ringing. Evidently things are terribly wrong. People don't seem to love Joe anymore. Since I married Joe, money always came from George Courtney, Joe's Man Friday, a former vaudevillian with a delicious Runyonesque sense of humor, who had more names for money than I could imagine. "Do you want some mazoola, Lily?" he would ask. Or spondulix. Or spinach. Or, quite simply, the green stuff. I always assumed the money came from Preston East Dome, Joe's gold mine.

"If it hadn't been for that crazy engineer," Joe said, "nothing would have happened, I would never have struck it rich. He was

a crazy person. He had this idea that a vein of Dome went east to Preston and he wanted me to put up thirty thousand dollars to find out if his theory was true. I told him I would give him the money, but what with one thing and another I never got around to giving it to him. I was staying in a hotel in New York on the twenty-third floor, and he called me. The minute he came up, I saw he was crazy. 'I want that money,' he said. 'I told you I'd give it to you.' 'That was a year ago,' he said. 'My word is my bond.' 'I know all about that. I want the money now. Today.' And he hauls out this gun and starts walking me to the window. 'If you don't give it to me, I'll blow your brains out—or, better still, I'll walk you right out that window, and it's a long way down.' I started to sweat. He was crazy enough to do it. 'I want you to go to the phone and get me that money. Right now.' What could I do? I went to the phone, got him that money, and what do you know? The son of a bitch was right. There really was gold in that vein."

I'm not sorry when Joe says we will have to sell Huckleberry Hill, too. The atmosphere was so hostile that I decided to learn to shoot in self-defense. The farmer taught me to use his twenty-two rifle, and I aimed at a target far away, rarely hitting it—but with the shots ringing out loud and clear, it was an answer to the vandalism, the felling of trees, the ripping down of signs.

In the brochure that Previews made, the farm was listed at $137,500. Joe told me it cost $300,000. The pamphlet said it had 452 acres. I remembered a nursemaid I interviewed, or perhaps it was the other way around, asking me sternly, "Madam, is there any place outside to dry diapers?" "Four hundred and fifty-two acres," I answered and had all I could do not to burst out laughing at the thought of it strung tree to tree with flapping diapers.

Huckleberry Hill is perfect for anyone with four children.

"Tell her to go away," says Milton Brown, the art historian who is overseeing a group of us weeding the garden when he hears Joan Crawford is considering buying Huckleberry Hill. "You can't sell the house, Joe, now that we've got the weeds out." But she does not buy it, and then Rush Kress shows up with his

young wife and four children. Joe sees the possibility of not only selling the farm but also latching on to Kress as a savior in his ongoing struggle with the Philippine-American Finance and Development Company.

Rush Kress comes to the house in New York with his lawyer, a man Joe has nicknamed "Gumshoe," who looks like a flat-footed detective. While he is touring the house, Rush Kress picks up a small bronze in the library and looks at it curiously.

"What is it?" he asks.

"It's a Henry Moore," Joe says proudly. " 'Reclining Figure.' "

"Oh. I thought it was a paperweight." Mr. Kress has no idea what a henrymoore is. No wonder. We have seen the collection of old masters of his deceased brother Sam, the Five and Ten King, at a penthouse on Fifth Avenue. "That one," Rush Kress had said, pointing with pride, "is a good one. At least three hundred years old." He rates paintings by age, like Limburger cheese. It seemed to me that the old masters had been restored to such glowing condition that they were almost the work of the restorer. Still, that was not our problem. Our problem was to get rid of Huckleberry Hill.

"It's hard to be an absentee landlord," Joe sighs. It wouldn't do for Mr. Kress to think that Joe is broke or needs to sell the farm. Raising money is easier when you don't need to, I've noticed. "I'll let you have the farm for one hundred thousand." Gumshoe's eyebrows shoot up. Mr. Kress looks alive. "Let's have a drink on it. Is it a deal?" We raise our glasses and clink them together. Out of the debacle I rescue one Steinway baby grand and some furniture, books, and linens. But Joe, gambling for high stakes, lost. Mr. Kress never put a dime in the Philippines.

The New York house is easier to sell.

A lady named Fleur Cowles comes one day, asks me the dimensions of the master bathroom, which I do not know, and stretches herself full length lying down on the cold tile to measure it by herself, but she goes away. Next morning the house is seen by a Mr. and Mrs. Herbert Goodman, who say right away they will take it. In the afternoon they return with their attorney,

who wants to check the sanity of his clients' rapid purchase, but
when he sees the house he agrees with their decision.

"It will never look like this again," say the buyers wistfully as
they walk through each perfect room.

Parke-Bernet, source and eventual recipient of all great good-
ies, gets many of the most expensive paintings. The Redon of a
girl's head mistily encircled with flowers, the large Chagall, the
tiny Renoir, as well as the early Toulouse-Lautrec and a self-
portrait of Ensor. They also auction off a number of our early
American treasures, among them the five-foot library table.
Nevertheless, when it comes time to pack, there are still so many
lares and penates that we have hardly made a dent in them.

We look at houses in Greenwich, Connecticut, but whenever
Joe asks about membership in the country clubs we pass, the
agent says, "They don't take Jews."

"They'd take me. J.J. O'Brien, that's my name."

But when we get home Joe says, "Look somewhere else.
They're a bunch of anti-Semites."

Across the border, only three miles away from Greenwich, but
in New York State, Port Chester will take us. They are not chic,
they will take anyone. The old house I find is cheap because it is
in the wrong part of town, where Route 119 and Westchester
Avenue are close enough to have turned Hawthorne Avenue
into a street of decayed gentility. Number Six is made of wood
and has a large porch that breaks into a round area like a band-
stand at one end, and a porte cochere at the other. It is a horti-
cultural dream with green lawns sweeping down to a border of
spirea that turns into white bridal bouquets in the spring. Aspar-
agus spears still stick up in the vegetable garden, and there are
not only strawberry beds but raspberry and blackberry bushes
as well as miniature peach, apple, pear, and cherry trees that
still bear fruit. Far at the back of the house, behind an old barn
and chicken house, are rusty old cages where the former owner,
whom I would like to have known, had kept birds. The marvel
of the place is a gigantic sycamore tree with its bark a master-
piece of mottled, scumbled pattern. From its lower branch an
old rubber tire hangs from a rope. A swing for Amy.

Freehand

The house itself has an aura of happiness and pleasing proportions with the rooms flowing from a center hall and winding up in an attic room for my studio on the top floor. In the square kitchen with a table as its center, the old stove has a flat surface and an oven at eye level, unlike the modern one in New York where one had to practically lie down on the floor to examine a roast. This time, I wouldn't make the mistake I made there, trading two black cast-iron restaurant ranges for a modern stove. I would keep the old one.

I wonder how the Li Chaucos, the Benedictos, the Jurados, and all the Philippine investors feel as the Philippine venture fades from our lives. Has Joe "written it off," as he sometimes describes things? Now, jaundiced by that experience, he concentrates again on his first love, Canada. Since Hiroshima, a new element, uranium, may be more important than molybdenum, zirconium, or even gold. Ten-cent shares of what Joe calls "toilet paper" stock (there's so much of it) proliferate. He likes to name his new companies beginning with the letter P since Preston East Dome had been so lucky. Perhaps Pardee, Pater, Penfield, Pronto, Peach, and Paragon will be too. Deerhorn is an exception.

"Did you know that Hirshhorn means horn of the deer?" asks Joe. "Deerhorn. Get it?"

The names of places in Canada have a poetry of their own, like the ring of Walt Whitman. Saskatoon in Saskatchewan. Medicine Hat in Alberta. Calgary and Moose Jaw. Big River and Flin-Flan. Great Slave Lake and Wandering River. Kamloops and Sault Ste. Marie.

Joe is in Canada all week. We have only one housekeeper, Ann, a Scotch lady who never ties pink bows in Amy's hair. She thinks all children should have pets so we go to the ASPCA and get a mongrel part German shepherd, Brownie, who follows Amy everywhere and guards her ferociously. We also get a female cat named Ginsberg who is not altered and gives birth to various Ginsbergs, the first, second, and third. Even fluffy Easter chicks thrive in a box on the radiator and grow to broiler size before we are forced to give them away. I am happy with all

the domesticity, and the suburban solitude is good for my work, no longer black.

Ann's only defect seems to be that she falls from grace about every six months and gets drunk when we least expect it. One evening we are having a dinner party and Ann reels in through the kitchen's swinging doors with a roast beef sliding in a treacherous sea of gravy. Alarmed, I watch her lean tipsily over the left shoulder of one of our guests, an immaculately dressed doctor, while a greasy brown rivulet pours down his jacket. The doctor leaps to his feet and glares at Ann. She glares right back.

"It was your fault!" she accuses him. "You moved. You shouldn't have moved."

Another time, a good bit after this incident, I trip over Ann's feet protruding from under the dining-room table where she is sleeping one off on the cozy wool carpet. I leave her there overnight. Next day, sober and again penitent, she says, "You're so good to me and I'm so mean to you."

I fire her four times in the eight years she is with us but always take her back. "A devil you know is better than one you don't," she says each time, and, until the fifth and last time, she is right.

We get a call from Chicago when Amy is three years old. There is another baby girl available for adoption. We never intended Amy to be an only child. Again Joe is a yes-sayer. This time, we fly to Chicago. On the way, we decide we shall call the new baby Jo Ann. She is only four days old. When I see her, I want to laugh. She has one big eye and one little eye. Her hair is long and stringy and she looks like a papoose.

That night Joe has to fly to Canada on business and I am left alone with the new baby in the Hilton Hotel. She cries up a storm on the next twin bed and so I take her into bed with me. She stops as soon as I cuddle her. This time I'm not afraid.

The airline will not allow me to travel alone with such a tiny baby, and so an elderly nurse who has never flown before comes with us. When a storm breaks out and lightning flashes play along the wings, she is more trouble than the baby. When we arrive in New York, the stewardess insists we wrap Jo Ann in an American Airlines blanket to protect her from the torrential rain. I turn on the windshield wipers in the car I've left at the airport but they make useless arcs against the rushing water.

"Can you see the road?" asks the nurse, already limp from her first flight.

"I drive my husband to the airport so often that the car can practically go by itself," I lie as we head for Port Chester. I can barely see the white center line and I try to follow the edge of the road. Little Jo sleeps soundly all the way. First Amy. Now Jo. Am I trying to have a quartet from *Little Women?*

"Does she have booties on?" asks Amy as we take off the borrowed blanket. Yes, she has booties. And a bonnet. She has everything. Tiny fingers that grasp, toes that curl. After a few days with everybody admiring the new baby and Amy treating her as if she were a doll, Amy says, "Well, that's enough now. Let's throw her down the laundry chute."

With a fine pen and ink line I draw three-week-old Jo Ann sleeping, as I had drawn Amy at that age. I caress the delicate half-moon of her eyelids, the intricacies of her ear, the full curve of her baby stomach and her bent legs. I paint Amy bundled up like a small clown in her winter clothes—her brightly knit cap with a pompon on top, her striped scarf pulled up to her nose, her mittens hanging limply from a safety pin attached to her coat sleeve.

I draw all the neighbors on Hawthorne Avenue—Mr. Macri, the contractor, half out of the cab of his red truck, and his son Evans lying in bed with a cold, listening to the radio. I do the housewives in their fresh flower-sprigged cotton dresses and Mr. Scoli, the Italian carpenter, with shiny black hair and a pencil tucked behind his ear.

From the car, I sketch the center of Port Chester, where all lines converge to a police booth and there is a fascinating o in the Optimo cigar ad. The scene could be almost anywhere in the United States. Perhaps the only difference would be that in one town the Florsheim shoestore would be on the right and in another on the left. I draw bare trees, all sepia in the winter, reflecting themselves in half-frozen ponds, and the sharp emphasis of grasses stiff with ice.

Charlie, a Swiss gardener, had shown up to care for the grounds. He planted them originally. They were his. He takes care of them, adding annuals for color to the perennial beds,

spraying the fruit trees, pruning the bushes, and mowing the lawn. In the mornings when I offer him coffee, he says, "Put a stick in it." I am bewildered but I find out it is rye. Never sober, but nobody is a better gardener. I draw him sitting on the edge of the cold frame holding a tender seedling in the great mitt of his hand.

By some metamorphosis I cannot understand, I have been transformed by my exile into a suburban housewife.

Looking at the sycamore tree with its huge head of buds about to turn into leaves, I see it is spring again. The garden is coming alive. I watch Amy swinging in the rubber-tire tube that hangs from a rope to the tree branch. Thank God she isn't stripping off all her clothes. The last time she did, one of the neighbors, catching sight of her little naked body running joyously across the lawn, said, "Hmmmph. You'd think they could afford to dress the child!" Jo Ann careens about madly in her walker. A misnomer. She doesn't walk it it. She zooms, threatening unwary adults with amputation below the knee.

I try to paint when the children are napping. If they wander into the studio while I am working, I give them material and let them work at a two-sided paint table. If I go into Amy's room and I am wearing my paint-stained carpenter's apron, she is angry. Despite the fact that I am home all the time, my absorption with my work bothers her as much as my mother's total absence bothered me. There is no way out.

Fridays when I pick Joe up at the airport after his hectic week in Toronto, I know we will hardly ever go anywhere. He will spend the weekend recuperating. It is almost as if our house were a rest home. He always says the same thing when he sets foot in the house. First he sniffs, and then, as the sweet odor of wax comes from the shining floor, he says, "The house smells good." From the kitchen wafts the perfume of freshly baked *challah*. I am in a yeast frenzy, making babkas and almost anything out of dough. The children like to play with it and it reminds me of Baba. Good smells should come from a kitchen.

Ann and I exchange glances of triumph. We are proud, like a regiment of two with Joe as our general, our own Napoleon. We have passed muster. We sigh with relief. Too soon.

"But what about that?" Joe frowns. We follow the line of his pointing finger, and sure enough, we have failed again. He has found our Achilles heel. It is amazing how he does it. The purple glass of the amethyst hall light on the ceiling is covered with a film of dust.

"There's a crack in it. I'm afraid to dust it. It might break," says Ann, but we both know that we have been weighed and found wanting again. Effort doesn't count. Perfection is all.

Way in the back of my head, I hear Pop say, "How come you didn't get all A's on your report card? How come you got three A's and a *B?*" and I shrink into my skin.

I am the only mother who stays with her kid for a month at nursery school. All the others leave after a week at most, but Amy falls apart when I start to go, and I wait for the magic of her acceptance that will free me for the studio. Eventually, she settles. When Jo Ann's time comes, the very first day she takes off in the station wagon with a cheery "So long, Mom." I scold myself that I didn't take Spock's words to heart—treat your first child like your second child—but it was never possible, as the good doctor probably knew all along.

And as for their adoption, this is another problem. I made no secret of it when we moved to Port Chester, trying to protect the girls from hearing about it outside. When Amy asked at three, "Where did I come from, Mommy?" I held my breath and told her the story, complete with her daddy carrying her into the house on Eighty-second Street in a laundry basket. When I was all finished there was silence and then she said, "Tell me again, Mommy." It became one of her favorite stories and I could not change one word of it.

But all this fades on a lovely afternoon while I am sitting in the backyard and hear Amy's best friend Alice taunt her with "She's not your real mommy," and I have to begin all over again explaining to Amy and Alice that my caring for my child determines my motherhood—but there is no way to heal the wound. Sometimes I think the Victorians had the right idea. Lie about the whole thing. Forget "the chosen child." Go away for nine months and come back with a baby.

Alfredo and Miriam are visiting. A rare happening—nobody comes from New York, although it's only twenty-two miles away.

"I'm so glad you came," I say gratefully to Miriam as we take a walk.

"We miss you."

"I miss you, too. I can't understand why nobody comes."

"I told Alfredo you didn't know."

"Didn't know what?"

"About Joe and the artists."

"What about Joe and the artists?"

"They buy stock. Joe tells them he's buying it for his own children. He tells them he guarantees it, or they assume it. Sometimes they lose money."

"Maybe Joe did, too."

"That's not what they say."

"I don't understand these things," I say miserably.

"I don't either," says Miriam, and we walk back to the house with the autumn leaves crunching under our feet and falling from the trees in small, circling motions until they hit the ground.

Sometimes, lately, I have a feeling that an ax is about to fall on my head. I try to console myself, telling myself I am living the good life with my husband, two adorable children, and plenty of fresh vegetables from our very own garden.

"What did Miriam mean," I ask Joe, "about you and the artists?"

"If they lost money, I did too," says Joe. "People are greedy. They only want to make money."

I have a sneaking suspicion that my whole family is taking stock tips from my husband—Pop as well as my brother and brother-in-law.

I kid Joe about how much he needs love; he even tries to charm the man taking quarters at the toll booths as we pass through in a brief moment. People who love him enough to trust his stock tips give him almost as much excitement as the artists who fawn on him. Whenever Joe asks me how much

money I have in the bank, I know he will tell me to take it out and invest it. I never question him and always do.

Once I dare to interrupt Joe in a sales pitch to our family doctor.

"You know, Jimmy, you can lose money as well as make it," I say looking at Joe with apprehension, but he looks amused at my *chutzpah* and is sure of his ground as Jimmy replies, "I know *that*. I'm not a child." And the conversation goes on. It is the last time I interfere in what I am beginning to recognize is the greed that permeates everyone and everything connected with Joe. The climate around him breeds it, like bugs.

"Get rid of that doctor," Joe said in New York when he had a terrible pain in his gut and had to be operated on for diverticulosis.

"Why? He's highly recommended," I said. "He's supposed to be a great surgeon."

"Too red in the face. Must have high blood pressure. *He* could drop dead while he's operating on me."

But I worry more about Joe's internist, who has sunk his savings in stocks Joe has recommended.

"Please, Joe, don't get any of the parents of the kids at school to invest in your stuff," I plead. But I am like the boy with his finger in the dike.

My second show at the gallery is a mixture of Philippine memories and my new life in Port Chester. "Child Acrobats." "Nursery School." "Look, Ma, No Hands." In the paintings is all the joy and none of the sorrows or problems of bringing up children.

Emily Genauer says, "Paintings are the best possible biography of an artist, even if they deal with no specific incidents in the artist's personal life. . . ." and goes on to say, "But it is the new tenderness one notes in them since Miss Harmon's previous exhibit six years ago, which really indicates what has happened to her in the interim. There is a new softness and subtlety which never stoops to pretty sentimentality. . . ."

Thomas Hess in the *Art News* disagrees with Miss Genauer. He finds "warm and tender" images but also sentimentality.

The *Art Digest* calls me a lyrical painter and says I am one of the best-loved women artists in America. How curious! Are there no best-loved male artists?

Homer Saint-Gaudens, son of the renowned sculptor Augustus, and director of the Carnegie Institute of Art, comes to my studio annually to select something for "Painting in the United States." Each year he snaps another candid shot to add to his portraits of the artists he visits. I hope my husband will not be in when he arrives. I have a positive paranoia about Joe's market tips.

And I am living two lives, one with Joe where I play ostrich and another private one in my top-floor studio.

Chapter Five
1952-1956

I AM DEEP IN DOMESTICITY. As I push Jo Ann on the swing hanging from the sycamore tree, she sings out an obligato with the movement.

"Is God everywhere?"

I push her higher, and with the thrust and in the same singsong answer, "Yes–s–s."

"Is God in this tree?"

"Yes–s."

"Is God in this yard?"

"Yes–s."

"Is God in the sky?" Her feet seem almost to brush against it, she is so high. "Can God hear every single word I say?"

"Yes–s."

"OK," she yells at the top of her lungs, "Pow! Sock-in-the-kisser God!"

As the swing dies down, she looks around to see if she will be, at the very least, struck by lightning, but God doesn't answer.

"May I ask you a question, Mrs. Hirshhorn?" says the principal of Amy's elementary school. I have been called in because Amy develops alarming stomachaches every morning she has to attend but recovers miraculously each weekend.

"Where is your husband's business?"

"In Canada, but he has an office in New York."

"How is it you do not live in Canada? I assume Mr. Hirshhorn is there the major part of the week."

"Yes." What business is it of his, anyhow? I feel guilty, but I don't know why. How can I tell this man that I can't live in Canada? It has something to do with taxes, according to Joe. "Mr. Hirshhorn is *always* home weekends," I say stiffly, and solve the problem by changing Amy over to a private school.

"It's better for me to have a husband who's away all week," I tell people who commiserate with me for my loneliness. "I can paint in peace, and Joe's more interesting for three or four days a week than most men are for seven," I say, carefully leaving out descriptions of his near-collapse at home. This is only partly true, but I hate to have people sorry for me. In a way, our arrangement does suit me. When Joe is away I am free to paint. The lonesomeness at night is alleviated by my reading. I discover Zen and the Bhagavad-Gita. I fall in love with Colette. After many attempts at reading Henry James, suddenly, like olives, he becomes an acquired taste. "The Beast in the Jungle" is one of my favorite stories.

In the morning I have coffee in bed even if I have to get up, make it, and crawl back in. I think of Paris, where I got the habit. It seemed to me that almost everybody took coffee in bed and I wondered who was the person who started the city. Reading *The New York Times,* a headline about "blue sky" laws hits me. Joseph H. Hirshhorn is being questioned about pie-in-the-sky stocks in Canada by the Attorney General. Joe's past history in Canada and an accusation about smuggling money over the border by couriers is mentioned along with the the name of someone who calls often. I think of the hundred-dollar bills. What upsets me most is that Joe hasn't mentioned anything about all this to me and that I must find out about it on the front page of *The Times.*

"What's this all about?" I ask him.

"Trial by newspaper, that's what it's all about."

And he refuses to discuss it with me further. I ask my brother,

the lawyer, to explain it to me, but all he says is, "He's your husband. No matter what he does, you must trust him."

Like a Mafia wife. Blind faith and no answers. I feel as if I will explode. Joe won't communicate or explain anything, and it drives me crazy until I commit an unforgivable sin.

It slips out of me. "Are you honest?"

What a dumb question, I think as I ask it. What do I expect him to say?

"I'm not a crook." And he gives me a look of such wrath that I know he will never forgive me. My brother had warned me. I had opened Pandora's Box and a tangle of snakes had jumped out.

From between the white sheets draped over my nether regions, Dr. Lynquist emerges after mercifully contracting the cold instrument which was pinching my vagina, and whips the creamed glassy gloves from his hands.

"Your tumor is the size of a grapefruit."

Last time it was the size of an orange and before that a lemon. Why must a tumor be diagnosed in terms of fruit?

"It's time to do something about it."

I know it. The grapefruit hurts when I have sex.

"We'll do a hysterectomy," says the doctor, "and check for malignancy."

Cancer. Funny, it hadn't entered my mind. My face must mirror my alarm.

"Don't worry, the incidence of cancer of the womb is slight, especially among Jewish women." How odd. I wonder why. Do I have cancer already? Is the doctor concealing it from me? I try not to worry as I drive from his office in White Plains back to Port Chester. I tell myself I'm not the least bit upset.

I tell myself I'm brave and hopeful. Why then do I tackle the house as if I will never come back from the hospital and clean it so thoroughly? I don't want Joe's next wife and the future mother of our children to think I'm a slob. My desk is in perfect order. She'll have no trouble finding anything. The blankets are washed and the curtains clean. All the bills are paid. Now I can die if I have to. As for my art, which is going better than it ever

has—in Alex Dobkin's words, which he may have cribbed from someone else, "The hell with posterity. What did it ever do for me?" Still, I have a lot of ideas I'd like to work out. Just in case, I straighten the studio.

I miss the sharp emotional swings connected with my lost monthly cycle after the operation. I have no hot flashes or any other evidence of my induced menopause. Neither do I have cancer, and I stop cleaning the house and let my desk get sloppy again. But either Joe is being extremely solicitous of me or he just doesn't notice me anymore. I rack my brains to think of some change so that he will see me and come up with what many women have thought of—I will become a blond!

Long ago I walked into a beauty parlor in Paris only to have the hairdresser scream at me. "Get out of here! If ever I saw a brunette type, that's what you are."

When I walk into a New York beauty parlor, they are not so honest. First they strip my hair down to a garish orange before they dye it an ashy blond. And Joe does notice it. How could he not? He says he thinks it is nice, but it is I who cannot stand it. It seems to wash out my features. After a week in which I notice that truck drivers whistle more at me, and Joe still does not seem to be anxious to go to bed with me, I have it dyed back to brown.

Perhaps we need a holiday. Haiti seems like a good place. I could sketch there and Joe thinks it's a good idea but unfortunately he can't get away just yet. He says I should go alone and he will join me later.

I pack pencils, a tiny thumb box of Winsor & Newton colors, brushes, pads, and penholders with my favorite penny points like the ones I used to dip into inkwells at school. The children are left in the care of Ann and Winnie, a beautiful black girl who came to do a day's laundry but will stay with me for eleven years. It is safe to leave, and I fly off to Haiti.

"Where will you be staying while you are here?" asks the black man who inspects my luggage at customs.

"In Pétionville, at Madelyn Lagazy's pension."

"What is the purpose of your trip?"

"A holiday."

"Tourism," he says, and adds, "And what are you doing to-night?"

I almost answer "Nothing" until I realize the question isn't official.

"I'm busy this evening."

"*C'est dommage.*" He stamps my bags. "I would have liked to introduce you to our national dance, the merengue, or take you to a voodoo ceremony."

"Thank you." It feels good to be noticed.

There are separate tables on the porch of the pension for the guests. In the morning, I wake up to the smell of coffee beans roasting. After breakfast, I rent a car and drive up a long hill with a luxurious hotel atop it. Although I don't usually like panoramas, the view is good, and I settle myself under a tree near the swimming pool. A workman in a faded blue shirt is repairing some tile. He walks over and looks over my shoulder as I work.

"That's a nice drawing," he comments. "Are you a guest here?"

"No." Is he going to tell me to leave?

"How would you like to use the pool? Where are you staying?"

"Please. It's hard for me to talk while I'm working."

Finished, I fold up my little sketching chair and stow my equipment into my bag.

"Don't forget," the handsome café-au-lait tile setter calls after me, "you can use the swimming pool any time you like. Just say that Charbert, Jacques Charbert, said it was OK." He waves goodbye. What a nerve he has, I think. He'll get it for inviting strangers to swim in the hotel pool.

Driving down the steep hill, the foot brakes don't work. Luckily the emergency does, and I use it, trying not to hit any of the magnificent Haitian women who walk like Greek caryatids as they balance baskets full of produce on their heads.

In Port-au-Prince I sketch the ornate architecture of the Iron Market and then find a building where butchers are working on flayed carcasses in what looks like a fairy castle with thin columns

and gingerbread fretwork. It says ABATTOIR 1893 HIPPOLYTE PRESIDENT D'HAITI. Blood flows down the stairs and hungry dogs lurk below. The stench is terrible, and I draw at a discreet distance.

At dinner that night, as I sit at my separate small table, Madelyn Lagazy, my landlady, joins me.

"How was your sketching?"

"I drove up the big hill out of Pétionville to a hotel where there was a splendid view all the way down to the harbor. There was a man working on the tile and he told me I could use the pool any time."

"What was his name?"

"Charbert, or something like that."

"Jacques." Madelyn laughs. "He's an engineer. He owns the place."

"Oh. I thought he had a nerve, being so generous."

"He likes to fix things. He's handsome, don't you think?"

As if I didn't know that! Next day I drive up the hill again after I receive a telegram from Joe saying something came up. He cannot join me yet. I am tired of feeling rejected and it is pleasant to sit on the edge of the pool, dipping my feet in the water after a swim and being flattered by the handsome engineer.

"Have you seen Kenscoff yet?"

"No."

"I'll take you there in my car." I've told him about my car and how I drove down the hill pulling on the emergency brake. "Better for you not to go in that rented car." We make a date for the following week.

In the meantime, I go sightseeing with Elsie, girl geographer, whom Baba would have described as a *mieskeit*. We drive to Jacmel in her Jeep. There is no real road, only dry river beds and rushing small streams. Elsie is merciless; she stops for nothing. For five hours I post the Jeep as if it were a horse while my kidneys jounce and jangle. I chicken out for the trip back when I discover I can fly the sixty miles back to Port-au-Prince in ten minutes.

A couple of days later Madelyn Lagazy and I join the indom-

Freehand

itable Elsie for the opening of the Artibonite Valley. We leave at
four in the morning to avoid the dust of other cars but the only
thing wrong is that everybody else has decided to do the same
thing. Fore and aft, clouds of dust cling to us.

Madelyn, always the French lady, dips a lacy handkerchief
into a bottle of 7-Up and washes her face in it. I do the same
thing but find it sticky. "I am so feelthy," she says. "If I were
home I would take a douche." "Shower, Madelyn, shower. That
has a different meaning in English."

Under a huge banyan tree at the spot chosen for the cere-
mony two red velvet thrones await the arrival of President Mag-
loire and his wife. Drums sound as they approach. She is
wearing a tailored brown suit which looks as if it came from Saks
and must be very hot. A light perspiration is on her forehead.
President Magloire, a huge black presence, makes a speech in
sonorous French about the glory the United States will achieve
for aiding Haiti by bringing a dam to this poor, dry valley. A
man in a white hard hat clamps one on the President's head and
one on his wife's, then puts a small apparatus that looks like a
bicycle pump in front of them. The President presses this gadget
and somewhere in the distance a faint charge of dynamite goes
off. Bravos ring out and the crowd rush to their cars to head for
the reception. Elsie decides to follow the President's white Cad-
illac to the party. All along the way, naked small children watch
in amazement as the car drives by. It dawns on us that not only
are we lost, but so is the President. We are the last to arrive at
the party, a good one with lots of champagne, and I wind up
dancing with a funny little man. Is his name really Papa
Doc?

By the time Jacques and I drive up to the mountains of Ken-
scoff, I have received a second telegram from Joe again post-
poning his arrival. I am beginning to think he will never show
up, and what's more, I don't care. When Jacques fills my arms
full of yellow mimosa, Joe seems more and more remote. At
night Jacques and I dance to the drums of 'Ti Roro beating out
the current rhythms of "Panama'm Tombé" and "Vive Mag-
loire," a paean of praise to the President of Haiti, all good me-
rengue music. We make love on the black sands of a private

beach where we run naked into the cool waters. I don't feel like a frustrated housewife any more. I know that the operation didn't change me. I was not castrated. We treat this affair as a perfect episode, which will have no repercussions. I have no intention of leaving my husband any more than Jacques has of leaving his wife. At this point, a telegram arrives from Joe saying that he will arrive that very day. I must meet him at the airport. I don't have time to tell Jacques that I will not be able to join him on his boat. Madelyn will tell him I've gone to the airport to meet my husband.

"You look well," says Joe, scrutinizing my tan. "The climate agrees with you."

"It's marvelous here." I wonder if he will notice that my tan is all over, but he seems tired and not sexy.

"I have to leave tomorrow, but I didn't want to disappoint you."

"I might stay on longer. There's going to be a Mardi Gras. I woke up the other morning and there were people painted blue all over running down the street."

"What is there to do around here?" Joe asks after I have introduced him to Madelyn and shown him Port-au-Prince and the Centre d'Art.

"We could go out in a glass-bottomed boat," I suggest brightly. "I've been so busy working I haven't done that yet." A twinge of guilt.

We board with the other tourists and are taken far out where we watch fishes darting and treelike patterns of coral in the blue water, which is warm to my fingers. Our guide is explaining marine life when there is a slight bump and the boat starts to sink slowly with the water rising to our feet and up to our knees. Luckily it is shallow, but a little French girl starts to cry and I hold her in my arms as I stand in water up to my waist. Joe is terrified.

"What the hell is happening?"

"It's not high." Joe is floundering about as if he were going to drown at any moment.

"Be calm," says the guide as we all stand, the boat having hit bottom. "This has never happened before."

"Oh, yeah?" says Joe. "I'm wet through and through."

Nearby, a yacht has seen our plight and released a dinghy to rescue us.

"You go first," I tell Joe, as I hand the little girl to him. "I'm all wet anyhow. I'll swim there."

A man is swimming toward me, and as he gets closer, I see that it is Jacques.

"Madelyn told me you'd gone to the airport to meet your husband. Where is he?"

"He's in the dinghy on the way to that yacht."

"Lucky I was out here to rescue you. You see, you'll have a ride to Port-au-Prince in my boat anyhow. How long is he staying, your husband?"

"He's leaving tomorrow. I'm staying for the Mardi Gras."

We swim slowly together to the yacht.

"I can't thank you enough," Joe says to Jacques. "What an experience!" He shivers as if we had been in danger. "That's my first and last time in one of those glass-bottomed boats. They're not safe."

"I assure you, monsieur," says the guide, "never before."

"Never again," says Joe while I dry my hair with a towel that Jacques has thoughtfully provided. When we go to bed that night, Joe, turned off by the boat episode, doesn't touch me. Next morning he flies out and I stay an extra week for the carnival, where I sketch tiny bodies mounted with huge papier-mâché heads, black queens in white dresses splattered all over with shining sequins, and groups of people dancing through the streets to the incessant beat of drums.

"More babies are born nine months after carnival than any other time of year," Jacques informs me. I believe him.

"It was wonderful," I say at the airport. "Thank you for everything."

And the plane roars away taking me back to the February grayness of Port Chester and my duties as a wife and mother.

On Yom Kippur and Rosh Hashonah, Joe and I go to services at the Port Chester Jewish Center. In New York we went to the Rivington Street *shul,* where Joe loved the *dovening* and the singing of the Twin Cantors, as well as being inscribed in the book of life and absolved of last year's guilt.

The girls attend a small nursery group at the Port Chester Jewish Center. I paint symbols on the children's cubbyholes so they can identify them. The kids are too little to read but they can understand a picture of an apple, banana, pineapple, star, or moon. I also teach an evening class of adults. All this leads to my being asked to paint a mural for the lobby. I choose "And ye shall raise them for the Torah, the *chuppa,* and good deeds" as my theme. The mural is illustrated in *An American Synagogue for Today* and *Art in Modern Architecture,* which comments, "For many centuries figurative art for Jewish religious buildings was taboo. . . . Recent excavations have uncovered early frescos where the human figure is a dominant motif. . . . In this mural for a Jewish Community Center, the colors turquoise, orange, white and black . . . glow with a freshness reawakened by a freedom of expression."

The figure of Zayda is prominent in the painting. He stands on the right wrapped in a *tallis* and holding a Torah. A pointer in the form of a hand, which I researched at the Jewish Museum, leads to a mother and child. There is a menorah on a white-clothed table and in the background under a *chuppa* are a bride and groom. The congregation loves it. I am considered their art maven, and they invite me to attend a meeting with an architect who has offered to design a new synagogue for them for nothing. There are nasty rumors about the architect.

"He was sympathetic to the Germans!" one of the elders says. "He's doing this for his conscience. We shouldn't accept it, even for nothing."

At the meeting, Philip Johnson, immaculately dressed and well-mannered, sets a pristine white scale model before the group. Silence. All look at it.

"It looks like a shoebox and a hatbox," says one committee member. "What are those slits?"

"They're stained-glass windows," says the architect. "They'll let in shafts of colored light." He is cool and self-possessed while criticism rages about him.

"Changes are possible, of course," he murmurs. I am sure, listening to him, that he will achieve whatever he wants. He is the soul of cooperation but he will get his own way.

"What do you think?" I am asked when some of the venom has been spent.

"I think it's beautiful and the forms will set a precedent even if they seem strange to you now."

After the meeting, Philip Johnson thanks me for my support. I do not know that in the near future Joe and I will live in a house designed by him in the bush country of Canada.

Through the children's attendance at the Windward School, we make new friends. Mary Sklar, sister of the art historian Meyer Schapiro, whose lectures on modern art Joe and I attended, lives nearby in an exquisite house on a lake with willow trees. Her husband, Sol, a lawyer, expounds reason at parent-teacher meetings at Windward. Mary and I share the bond of each having two adopted children and an interest in art.

Anne Geismar and I first meet on the telephone when a Windward teacher tells us we share the same illness—bursitis in the right shoulder. Neither one of us can comb our hair. We phone frequently to check progress.

"My doctor says I should walk my fingers up the wall."

"Mine says I should swing from a trapeze on the door. I can't even dress myself."

I recover first and drive to Harrison to see Anne. We laugh at our identical outfits. Button-down-the-front cardigans and skirts— a uniform to wear until the pain eases enough to enable us to put on something that goes over the head. Anne's father, James Rosenberg, is a lawyer who paints and goes to my art shows. He writes letters of congratulation to me beginning, "Dear fellow-artist." Max Geismar, Anne's husband, is a literary critic and teacher who shares her sardonic humor.

Jo Ann and I are outside the Port Chester Jewish Center one day when a tall, thin woman with her hat slightly askew approaches.

"Is this your little girl?"

"Yes."

"I wonder if my little girl, Vicky, could come and play with her."

I'm surprised at this total stranger's request.

"It's just that there are no children where we live. I'm Vera List. My husband and I live on Byram Shore. There aren't any playmates for my little girl."

"Of course." And Vicky, or, as Jo Ann calls her, Bicky, and she become best friends. When I take Jo Ann to visit Vicky at Byram Shore, I can see why the child has no playmates. The nearest estate is far away, not like Hawthorne Avenue where the children run freely from house to house. The Lists have great walls but few paintings. As they visit us they are impressed with the paintings and sculpture in our place and Vera begins to collect art. She becomes not only a collector of great courage but a sponsor, like Joe, who makes many artists happy.

"That child is a catalyst! He makes things happen." I am watching a little boy trying to saw one of my daughters in half. The nursery group believes in reality, but this is too much. I separate the children and a pleasant blond woman says, "Who are you?"

"I'm Lily Harmon."

Helen Haft Borenstein says, "We must be friends. You're the first person in Westchester I've met who uses a word of more than one syllable."

Helen asks me to paint her daughters, Terry and Jane.

"Do them any way you like. Any size. Do them as freely as you do your own daughters." I appreciate the freedom she offers, it is so rare.

Helicopters descend like dragonflies over the vacation lake country near Blind River between Sudbury and Sault Ste. Marie. Men dash out and pound stakes into rocky protuberances and lawyers quickly register their mining claims. Secrecy is of the utmost importance. When the news gets out that there is uranium in this area around the much-traveled Route 17, a main highway across Canada, it will be open season here—the fishermen will hold Geiger counters in their hands instead of fishing rods and the hunters will stalk different game. Meanwhile, Operation Helicopter has covered almost all available terrain in a one-day blitz and the bonanza is on.

Franc Joubin supplied the mining knowledge. "Franc, he knows rock," Joe said. He was a master of the soft sell, a gentle, soft-spoken geologist who assured Joe that uranium could be extracted by a leaching process. Whether the process was practical or not was anybody's guess, but Joe, master of the hard sell, was busy having shares of stock printed. "Joe, he knows money," Franc said. "Joe, he's got a brain like an adding machine." Rumor has it that this one-day venture may have 90 percent of the uranium deposits in Canada.

Those people who lost money in Joe's other ventures were angry that they were not included in this one. They all love him again. He has the Midas touch and the phone doesn't stop ringing all day.

At night, when we go to bed, Joe's head churns. The "toilet paper" shares are zooming.

"I can hear the wheels going around in your head. Please turn the numbers off." I have a vision of Joe's brain as a computer that remembers each person's investment. It looks like the stock-market pages of *The New York Times.*

"How can you tell?" he chuckles, but the picture has an almost physical reality to me.

At last Joe has a business and the children will be able to see what their father does, aside from talking on the phone. Amy, Jo Ann and I are flying to Toronto, where Joe is most of the time. He will meet us, and we'll all take an overnight train to Blind River. It is spring and the girls are wearing matching Easter outfits, tailored navy blue coats over their starched cotton dresses, shiny new black patent-leather Mary Janes, white stockings and straw hats. They are delectable.

Joe meets us at the airport and takes us to his apartment at the King Edward Hotel, where we have dinner. The girls are so excited they can hardly sleep. In the morning they are going to see Daddy's office in Toronto.

Joe doesn't seem to be his usual exuberant self the next day. Bubbling with anticipation, the girls skip merrily down the street in front of us.

"We can't go to my office," says Joe, heading us in the opposite direction. "We're going to my lawyer's office." There is a chill in

the air. The Canadian spring is not warm. The girls are shivering in their adorable Easter outfits, and I am cold.

"I thought we were going to Daddy's office," says Jo Ann. Doesn't Joe realize how disappointed a four-year-old can be?

"You promised," Amy says. At seven, she knows what's what.

"We'll go there later."

"Is this Daddy's office?" Jo Ann wants to know.

"It's his lawyer's office," I answer.

"Come with me." Joe leads me into Senator Hayden's private office while the girls are momentarily pacified with rubber stamps and pads in the outer office. Joe shuts the door behind us. We are alone.

"I have something to tell you."

I am suddenly sure he is going to tell me he's going to jail. The attorney general has caught him in some hanky-panky.

"We promised the girls we'd take them to your office," I say, the perfect mother. "We mustn't lie to them."

"We can't go to my office."

"Why not?"

"My secretary says she'll make a scene in front of them."

"Is that all?" I say, relieved that Joe is not going to jail.

"You don't understand. I've been having an affair with her for the past three years."

I do understand some things now. I do understand why Joe didn't sleep with me after the operation. I do understand why I didn't feel like a woman. I do understand the telegrams to Haiti. He was with her. Flashes of light go off in my head.

"Do you love her?"

Joe doesn't answer the question.

"We can't go to the office with the girls and have her make a scene."

"I'm not afraid. Let her." I would welcome it. I feel like a punch-drunk fighter. *Let me at her*, I think. *Let me at her*. I want to get out of my corner and fight, but what am I to do about the children? Who is Joe's secretary anyhow? She is a distant voice over the telephone saying, "Just a moment, Mrs. Hirshhorn, Mr. Hirshhorn is on the line. Hold on, please." She'd seen me on one trip I made to Toronto, but for the life of me, I couldn't

remember her face. I can't remember her name. I'm never going to be able to remember her name, no matter how many times I hear it. What a laugh! The nightly calls from Joe to check on his good wife—no doubt coming from her place. Try not to think about it. Try to be calm.

When we adopted the girls, I decided that this, my third marriage, was for keeps. No matter what happened, I would stick it out. It was different, having children, a pact of love. And Joe's butter-wouldn't-melt-in-my-mouth morality sickens me. What about my own? What about Jacques? But now I rationalize that for the past three years Joe hasn't been the least bit interested in me. And my affair was a short one and didn't threaten our marriage. Nor did Joe know about it. I would never tell him. I wouldn't be that cruel.

I am tempted. Joe is looking at me with a hangdog look, the look of guilt. I don't know him in this role. He is a stranger.

"The children are waiting," he says. That's right. I am a mother. Right now, I feel like Medea and could kill us all.

The girls, bored with rubber-stamping, wail, "Aren't we going to Daddy's office now?"

"We can't today," I say. Joe says nothing.

"You promised. You promised." Amy weeps and wails all the way back to the hotel as Joe whisks us rapidly down the street as though his secretary might pop out at any moment from behind a hydrant. He leaves us to do what? Elope with his secretary? Placate her? I have no idea.

When he comes back to the hotel that evening, we are bustled cheerfully, as if nothing had happened, into a roomette of the overnight train to Blind River, where the girls are so fascinated by the small toilet they forgive us for not going to Daddy's office.

All night, while the train hoots and howls its way to the bush country, I cannot stop crying. Toward morning I finally fall asleep, but a sudden halting makes me stop and I raise the blind to see where we are. It is Sudbury, the stop before our destination, a city that looks like the landscape of the moon, ravaged by the mining of International Nickel into ugly mounds and hills of slag. The scenery matches my mood. No green thrives there. All the life has been taken out of it.

I dash cold water on my face. My eyes are red and swollen into slits.

At the station, the mayor of Blind River is there to greet us. He is in a wheelchair. He is a charming man but he has no legs.

The town is so tiny it has only one motel and a greasy spoon diner where there is a choice of fried anything, all cooked in the same exhausted fat. The girls envy the children of the mining engineers who live in pup tents next to their parents' large ones. They listen to stories of bears sneaking in to dip their paws in honey, to tales of moose so large that a car would be demolished if it hit one of them and of wolves that howl.

The longest twilight I have ever seen reminds me of Ralph Blakelock's paintings as the whiteness of the sky stabs negative space around and through the trees.

Back at the motel, Joe's guilt confronts me like an iron wall. The girls, tired after all our roaming over the rocky, rolling land dotted with lakes, sleep.

"She wants to sue me for breach of promise."

"What's her name?"

Joe tells me.

I knew I would never be able to remember it. And now, it is already gone. We are always going to refer to her as "she."

"How can she? You're already married."

"She says I promised to marry her."

I know darned well he did. A yes-sayer. He promised her anything.

"Do you love her? Do you want a divorce?"

"I don't know. I don't think so."

I am afraid to ask Joe if he loves me. Already the past seven years of my dream world of domesticity seem bizarre, like something I invented. Worse than anything is Joe's humbleness and penitence. I hate him that way, I prefer him a scoundrel. The guilt is so thick between us that it is like a mass of treacle through which I cannot wend my way. Sticky. Is it revenge or a desire to remove the sludge that makes me say, "You're not the only one. I had an affair too."

"What?"

"I did."

"You're lying to make me feel better."

"No. It's true." I have become such an image of a devoted wife that I am like part of the wallpaper. Unseen.

"You're making it up." But a glimmer of life is in him. That's better. Evidently I am making a crack in his surface. I am getting his mind off his secretary.

"Do you remember the time in Haiti when we went out in the glass-bottomed boat and it sank?"

"Of course."

"Do you remember the man whose boat you got on, the Haitian, Jacques Charbert?"

"Yes. The one you were swimming with . . ."

"He was my lover, almost the whole time I was in Haiti. Remember? I stayed on an extra week? I wanted to be with him. You weren't sleeping with me after my operation. I thought I didn't care about sex anymore, but I did. Jacques made me feel I was OK. You kept sending me telegrams. Probably," I say with my newfound knowledge, "you were off somewhere with what's-her-name."

"I knew I couldn't trust you. An affair with a Haitian! How could you?"

"It was easy."

"I had a detective follow you once. . . ." Joe was raging, almost like his insane jealous fits during the two years of his courting me.

"Follow me? When?"

"Right after we were married."

"What did he find out?"

"You went to some apartment on Fifty-seventh Street one night."

"Oh. I remember. I had a bowl of borscht with Alice and Martin Provensen. She was my friend in Hollywood who used to be married to Lionel Stander. She and her husband are illustrators. Is that what you found out?" I cannot help laughing.

"It cost a lot of money."

"Good. I'm glad."

I can see that Joe is angry. He believes me. And what's more,

he wants me. A bad girl excites him; his wife doesn't. It's as simple as that. He throws me down on the bed and releases the fullness of his passion, his anger, and his energy at me.

Afterward I lie awake thinking, I'll be damned if I have a constant stream of lovers to heat him up. It's not worth it. My head aches trying to make sense out of the past two days that have changed everything.

A truce. Joe tells me he has fired his secretary but I'm not sure. It seems to me that the same elegant, supercilious voice answers his phone in Toronto. Am I imagining it? Am I paranoic? The wife is the last to know. What corn. And I am subject to it as well as bits of information from well-meaning friends— that "she" has a large home, plenty of uranium stock, a painting collection, drives a Cadillac and, I assume, knows where a lot of bodies are buried.

I am going crazy. In the street I look at all the women, trying to remember what she looks like. I am sure she has a small upturned Anglo-Saxon nose. My own seems very Jewish and growing bigger daily, like Pinocchio's. Probably she has big breasts. I have a flat-chested front like a wound-up watch with the springs tight in it. I don't know who I am anymore.

"I can't sleep," I say to our doctor.

"I didn't have any of Joe's uranium stock," says Jimmy mournfully as he writes a prescription for Seconal. I don't answer him. What is there to say?

A week later, I am back.

"Now I can't stay awake. I have to have my wits about me, Jimmy. I must." And so he gives me amphetamines, and when Joe comes weekends I am very lively. Food sickens me but I drink coffee all day long and my weight drops to one hundred pounds. I cannot keep my pants up and dresses don't fit.

I need a head doctor, not an internist. When Dr. Fessler ushers me in to his office with the familiar oriental rugs I burst into tears.

"Would you like a brandy?"

I am so surprised at his offering me anything (so un-Freudian) that I straighten right up and tell him all about it, including the uppers and downers.

"If there were a pill for it," he says soberly, "I would be out of business."

"He promised to marry her," I wail.

"A stiff prick will promise anything," says Dr. Fessler.

Amy knows something is wrong. One day when I take her with me to the art store, she looks fetchingly at the salesman, an old friend of mine, and says brightly, "Mommy is mad at Daddy because he's got a girl friend." Lou, searching for cadmiums, looks at me sympathetically and pierces me with one word. "Kids . . ."

Faced with the frightening thought that I may have the economic necessity of supporting my two children, I paint Helen Borenstein's girls with the consoling thought that she had said, "Any way you like." I do Terry and Jane life-size standing hand in hand, and lay the large painting in quickly in one session, but then it takes almost a year for me to finish it and not lose the spontaneity. Helen is pleased with the painting, and so am I, as well as with the fact that I can still earn money at art.

Everybody loves Joe again, and publicity, which he used to shun, is not a dirty word any more. In fact, Joe is carrying on a flirtation with Ben Sonnenberg, a public-relations man, who describes himself as a "midwife to rich men." He has ways of untarnishing their images. Philanthropy mostly. He shines them up, like the brass in his house at Gramercy Park. But the *shiddach* doesn't take. Joe, feeling his oats, prefers to build his own image with his own charities. Besides, the uranium stock that Mr. Sonnenberg is willing to accept as a fee for his services goes up every day in value. The truth is, enough money can wash anyone clean.

It is safe now to move back to New York. The girls do not want to leave Port Chester and their friends. To prepare them for life in New York, we spend a weekend at the Plaza. I bank on Eloise as an ally. And it works. In fact, so well that when I do find an apartment on Central Park West overlooking Fifth Ave-

nue and the free-form boating lake, Amy is disappointed. "But Mommy, it's not the Plaza and Eloise doesn't live there." The rooms are large with high ceilings and delicate plaster motifs in a border around the wall just below them. There are two halls so long the girls can race down them. It takes a long time to move in. The former tenants kept monkeys in the serving-pantry closets and it is a mess. We have a Cadillac and Joe yearns for a Silver Cloud. But the girls object to being chauffeured and prefer the school bus. The thought of a Rolls-Royce upsets them as well as me. It is hard for me to think of chores for Wilbert, who sits waiting patiently in the Cadillac to take me somewhere.

I try to paint the view at night—the incredible pinpoints of light, the flashing reds and greens of changing traffic lights against the black, but it is too corny and I give up. I manage to paint the rosy dawn over the lake and the misty park, and, in honor of moving back, a large canvas bursting with skyscrapers which I call "Good Morning, New York!"

"I think we should have a house in Blind River," says Joe. "I bought one hundred and forty acres there on Lake Huron. It's called Bootlegger's Bay. It used to be a spot to run liquor over to the States during prohibition."

"Perhaps we could get that architect—you know, the one I met at the Jewish Center with the shoebox and hatbox—to design it."

When Joe and I meet Philip Johnson at the train station in Blind River, the temperature is twenty-five below zero and our breath freezes in front of us.

"They call this the Banana Belt of Canada," I say, as Philip Johnson flails himself. "It's a lot warmer here than other places."

In snow up to our knees and surrounded by wolf tracks, we choose a site for a modest house. The grand main one Philip Johnson envisions as being nearer to the lake and having ceilings twenty feet high with large panels of Synskin (which I may paint) to draw across the windows like Japanese shoji screens.

"I'll come up later and draw white X's in chalk to cut down some of the trees for the view," says Philip Johnson.

Drinking hot coffee at the diner, I ask, "How can you build a cellar in that frozen earth and have the house ready by spring?"

"There won't be a cellar. I'll locate the heat under the windows. It'll be warm enough, you'll see."

"I want spring water in the house. Nothing like it," says Joe.

"I'll have a well drilled," says the agreeable architect.

"How would you like to design a whole new town site?" asks Joe.

Philip Johnson's face lights up.

"I'd like that. Who wouldn't? A chance to build a whole new town."

"I just bought Henry Moore's 'King and Queen.' "

"It could go in the town square. I see it as a large outdoor living room, a plaza, like San Marco in Venice." The architect is carried away.

"We'll call it Hirshhorn," says Joe, equally enchanted. "A town full of art in the middle of nowhere. . . ."

Philip Johnson and I walk through miles of acreage. He starts a plan, only to be informed later, after a lot of publicity in which Joe announces, "Maybe the miners won't appreciate it, but their children will," that the town will never be built. The reason given is that the mayor of Blind River implored Joe not to build a town in competition with his, but that was not the whole reality. Reality was that Joe, despite a statement that "I'm building this town site entirely on my own, if my money lasts," didn't want to use his own money, and it was hardly likely that anyone else would appear to help subsidize a town called Hirshhorn.

"Why am I consoling him?" Philip Johnson asks when he has heard the bad news. "I spent all the time doing the plans. Why doesn't he console me? Well—perhaps I don't need it. I had a lot of fun with the project."

Armed with blueprints, Philip Johnson and I go to Knoll Associates in New York and choose rugs, chairs, tables, beds, and all material for the new house in Blind River. It takes two hours and is totally painless. Three months from the snowy February in which we had chosen the site with wolf tracks all around us, the house at Bootlegger's Bay is finished.

A curiosity of modern design in the bush country, the new house looks naked on the cleared land. The contractor stands

proudly by as Ann, the girls, and I enter. Joe is, as usual, in Toronto.

"I want a glass of water, Mommy," says Jo Ann.

I turn on the tap in the kitchen, but nothing comes out.

"The toilet doesn't flush." Amy's voice from the bathroom.

"Where's the water?"

"Mr. Hirshhorn said he wanted a well," the contractor explains. "So far, we've been drilling all over the place, but we haven't hit water yet."

"You mean to say there isn't a drop of water in this whole house?"

"We're digging again, about half a mile from here."

"Where does everybody else get water?"

"From the Lake. Lake Huron."

"How long would that take?"

"A few hours to hook up a pump."

"Is it pure?"

"Nobody died from it yet."

"Do it, then, and we'll try again later on for a well."

Doc Morris, our nearest neighbor half a mile away, has a wildlife sanctuary and is supposed to be an expert with a dowsing rod. When Joe comes up, we drive over to see him. We are met by a pair of leaping, snarling dogs when we get out of the station wagon.

"Stand still!" I yell at the girls as the animals seem about to head for our jugulars. For once, the girls obey me. They freeze. We all freeze.

"I'm sorry about the wolves," says Doc Morris, as he calls them off and they slink away. "Not a good idea to pet them," he remarks to Amy and Jo Ann, but they no longer have the desire.

Joe and Doc Morris, following the vibrations of forked twigs over the hill and dale, make me laugh. They do not divine any water and we must be content with it from the lake like everybody else.

The great day is imminent. Two hundred brokers from the Toronto Stock Exchange are coming to Blind River to see the

great uranium strike for themselves. For this occasion I go to Blind River alone to meet Joe there and play hostess for him. A huge sign over the street says ALGOMA MINING DISTRICT WELCOMES TSE MEMBERS AND GUESTS TO CANADA'S BILLION DOLLAR MINING CAMP. I notice a black man, appropriately dressed in a beige safari outfit and wearing desert boots and festooned with cameras. *Life* magazine has sent a whole group of writers, and this photographer to cover the story of the bonanza.

"I thought you were coming here when I saw you at the station," I say to Gordon Parks while we are having coffee at the diner. "You were wearing exactly the right clothes for all the dust."

The counter is lined with newspapermen.

"Hey!" one yells. "Look at this headline in the Toronto paper. Hirshhorn's secretary is suing him for breach of promise!"

"Wow! That's timing," says another.

"Aren't you Mrs. Hirshhorn?" one asks me.

"Yes." Butterflies charge around in my stomach. I swallow a mouthful of fried egg and take a deep breath.

"Is it true?"

"It's nonsense."

"He isn't leaving you then?"

"Leaving me?" Nobody could be more surprised than I, although the fried egg is going around in circles. "We've just built a home here."

"What would you say about it?"

"I'd say that when a man gets as far as Mr. Hirshhorn, all sorts of people want to latch on, that's what I'd say. It's all nonsense."

Mr. Parks offers to drive me to Bootlegger's Bay and I accept gratefully. As soon as we walk in the door, the phone is ringing.

"Mrs. Hirshhorn isn't in," I answer. "This is the maid. I'll tell her you called."

Gordon Parks gives me a sad smile as he leaves. The phone keeps ringing but I don't answer it. I sit and study the lone tree on the terrace and the curve of Lake Huron below.

"What timing," says Joe as he and his lawyer come into the house. "Two hundred brokers and this has to happen!"

"There were reporters at the diner. They asked me about the headlines in the Toronto paper."

"What did you tell them?" Joe and his lawyer look worried.

"I said it was just because you were so important now and it was all nonsense—we've just built a house here."

"You're a trouper!" says Joe.

I know I'm not a trouper. A trouper would not be this worn out. But I have saved the day. A whole mess of days.

After the article on Blind River appears in *Life* magazine, complete with shots of Joe and me at our house at Bootlegger's Bay, I worry that the pictures seem like a blueprint for mayhem. Someone may try to kidnap the children. Wandering tourists peer into the house, every room of which has floor-to-ceiling glass sliding doors. A large truck, looking like something out of *Grapes of Wrath* appears on our lawn with a whole family and their children perched on top of the chairs and household possessions. They have heard in Ohio that this is a great bonanza and they have pulled up stakes to come to Canada. There are no jobs. The mining engineers rig up tents temporarily and tell them to go home.

Painting is impossible here. There is no place in the five-room modern house to work. Instead, I drive the road to Algoma that has been freshly cut through virgin woods, the station wagon clambering over stones in some places while I observe the light through the trees. I will paint it all later, I tell myself.

My old friends Edna and Eugene Rostow find my third husband more provocative than either Peter or Sidney. They disapproved of them, but think Joe is picaresque. Perhaps Edna, who had a rich uncle, puts him in that category, which would, in her case, imply love-hate. Gene is Dean of Yale Law School but was Assistant Secretary of State to Dean Acheson, and when Joe is looking to sell his uranium holdings, he introduces them.

"We're Mutt and Jeff," says Joe, gamboling affectionately at the feet of the tall, suave Acheson with his air of an aristocratic Englishman. Alice, Dean's wife, is a tall, shy lady who is an artist.

Freehand

She and I go sketching in Blind River while Joe takes her husband to hear the enchanting click of the Geiger counters crackling in the geologists' shacks.

The Achesons love nature and are constantly identifying the trees, flowers, and shrubs. He has a marvelous sense of humor, delicate and probing, and she and I share our humility in art.

We, in turn, visit them in Georgetown and are invited to the Duncan Phillipses' for dinner. Sitting at table, surrounded by Bonnards with fresh color like spring rain, I wonder how Marjorie Phillips, an artist, feels, living with this collection. I am assailed by memories of myself at nineteen standing at the front door of the Duncan Phillips Museum with my painting, and I cannot resist asking, "Do you remember me?"

"Let me see." The shy and courteous Mr. Phillips racks his brain. "Have we met before?"

"It was a long time ago. I showed you a big nude painting. It had a sheet wrapped around it. There was such a stiff breeze that day that I almost took off."

"Oh, yes." From the flush on his face, I can see he hadn't forgotten the nude. No one ever did.

And Pat, my obliging mother-in-law, is dead. On the canvas gathering dust in the cellar she still lies for eternity on the white sheet, her face eerily lit from below, her nipples sharp and distinct, her pubic hair thick and dark.

My husband, now called "the Uranium King," has invited the Earl of Bessborough to visit us at Bootlegger's Bay. Joe is playing footsie with Rio Tinto, an international mining company.

"He was the last governor general of Canada," Joe tells me, "and a lot of people will want to meet him. We must give a party. For about two hundred. And then there'll be a dinner—a small one for twelve."

How on earth am I going to do all that? The house is small, the kitchen tiny.

"You'll have to bring food from Toronto. There's nothing here."

"The Earl of Bessborough is going to stay with us in the house. He's an old man."

"If we served him food from the greasy diner, we'd kill him. I'll see what I can do."

It will have to be outdoors, the party. Luckily there is a garage, and George and Elinor Sweeney, the last couple at Huckleberry Hill, are visiting. With their help we turn the garage into a bar and run a long red carpet from the terrace of the house to it. This comes from some recess of my head that says royalty—and the Earl is related to the Queen of England—should walk on red carpet if possible. As for the food, I wonder if delicatessen is appropriate, but that's what Joe is bringing on the train from Toronto. Corned beef and pastrami and cold cuts of every description. Amazing fare for the bush country. As for the private dinner for twelve, I phone a restaurant run by French people far away and ask if they can send food and serve it from our small kitchen.

Luckily it doesn't rain on the day of the party. We are saved. The Earl, a tall, distinguished, elderly gentleman, is the soul of courtesy as he greets the guests who have come long distances to meet him. They are mostly mining people, French Canadians dressed in unfamiliar best clothes they must wear to weddings, wakes, and church on Sunday. They are interspersed with some bigwigs like Lester Pearson, the Prime Minister of Canada, and members of the Atomic Energy Commission. Everybody looks surprised at all the art in the house, which is visible from the terrace. The country people speculate on how we heat a house that looks like a glass box.

I have stationed Elinor Sweeney near the corner of the house, where she asks the names of the guests, where they come from and what they do, and then presents them to me, and I introduce them to the Earl. Standing in the reception line, Joe is amused for a while, but then is restless and breaks away to circulate among the crowd.

"Aren't you tired?" I ask the Earl of Bessborough. "After all, you've had a lot of traveling. Wouldn't you like to sit down?"

"I shall when I've greeted the last person."

"This is Dr. Pigeon of Blind River."

"You gave me a medal when you were Governor General of Canada." The country doctor has brought the medal with him.

On one side there are bas-reliefs of the Governor General and Lady Bessborough, and on the other two lions are rampant on a field clutching a shield surmounted by two crowns on a floating ribbon.

My feet are killing me. I envy Joe, who has gone somewhere, leaving me to stand in the receiving line where I am no match for this man who has been trained to perform his duty at any cost.

The dinner that night goes well. From the kitchen appear dishes miraculously assembled; it reminds me of the Marx brothers spilling out of a tiny room in a train compartment.

Next morning when the Earl of Bessborough is to leave I see him standing in earnest conversation with a man who is raking the lawn.

"Ah, there you are," he says, as I approach. The gardener tips his hat respectfully to the Earl and goes off about his job. "I have something for you." From his pocket he takes a box and presents it to me. There, on a black velvet background, is a medal just like Dr. Pigeon's. "I thought you should have this," the Earl says smiling, "for distinguished service in the line of duty."

In the *Telegram* of Toronto, the women's editor writes about our house.

You couldn't imagine a more beautiful place than Bootlegger's Bay. The name is no joke. It dates back to the days when prohibition in the United States made bootlegging such a profitable business, and boats used to take on an illegal cargo of liquor in this lovely sheltered harbor and make dashes to the United States.

Since then, it has been used as, of all things, a garbage dump. . . . Now there's a wonderful modern house there with lawns in front sloping down to the lake and another area about the size of Queen's Park which will be lawn in back.

Mr. Hirshhorn spends three days in New York and four in Toronto most weeks of the year, and his wife and their

two small daughters live near Central Park in New York, but since June first they have been here in the new house.

"It's easy to look after," said Mr. Hirshhorn, talking about his house. "My wife can take care of it even if she has no help."

Courtships go on. In New York Joe tells me, "There's a young man coming for dinner. Leon Lambert. His mother is a Rothschild, the Baroness Lambert. They own a little bank, the Banque Lambert in Brussels.

Leon is about twenty-six years old, speaks perfect English, was educated at Harvard, and seems to know a great deal about art.

"I hope you will visit us this spring when you and Joe are in Europe." Are we going? I hadn't heard. "My mother will be so happy to meet you. She enjoys art and artists. You'll like her collection of Marinis. We live over the bank."

How nice. I visualize the simple family bank with Leon handing out money from a teller's cage and running upstairs for a bite of lunch. I project Grand Avenue to Brussels.

"Are we really going to Europe?"

"We're going on a tour. There won't be any business connected with it, at least not until we get to England. Get yourself a whole new wardrobe." He looks at me affectionately. I have been a good girl and stood by him loyally in Blind River when I could have messed things up. We don't discuss Joe's secretary. The headline embarrassed Joe too much for him ever to forgive her, I assumed. I was told that he paid her off. The amount varied—I would never know how much. All I know is that this time she has really vanished.

We fly over to Paris on a plane where there is only one compartment with a little curtain over it and real beds. I am so upset that we are singled out to lie in splendor when everybody else is making do with reclining seats that the extravagance I never knew existed is wasted on me. I don't fall asleep all night.

I unpack my first truly coordinated wardrobe made for me by Frances Epstein, a Czechoslovakian lady of great talent whose arm has a number tattooed on it. It started with an A for Auschwitz and I tried not to look at it when she was fitting me. Helen

and Tommy, her children, came and went in the apartment with a workroom turned over to the seamstresses skilled in haute couture who work for Frances. I rarely saw Kurt, her husband, who had some simple job in the garment district. He was a handsome, proud man who had been an Olympic swimmer before the Holocaust. Weekends the family went to the country to breathe good air and to exercise. Frances, with clients like me —rich, troubled ladies—kept her family going.

She is an artist, I think, as I hang up the black broadcloth theater suit with four separate pieces—a long and a short skirt, a wicked one-shouldered top, with what Frances called a "modesty jacket" to go over it. I have my first dress with a name— "Afternoon in Delhi"—made of a sari silk print.

I put on a suit of cotton tweed ("It's cool," Frances had said) and the red blouse to go with it and pull on the twisted dyed-to-match red ribbon hat her friend Herma G. made that covers my chignon neatly. Am I beginning to enjoy all this?

"Where would you like to go first?" Joe asks.

"I'd like to go to the rue Delambre and see if that bakery is still there—you know, the one I told you about where I bought the loaf of bread after I hadn't eaten for three days."

Sure enough, when we take a taxi to the Left Bank, the bakery is still there with its marble counter just as I remembered, and Joe buys me a baguette which I clutch as I glance up at the windows of Jay's apartment and the balcony of my sixth-floor apartment that Mom made me move out of. It is 1955 now. I am twenty-four years older.

The bellhops look surprised as we walk through the lobby, me with the bare bread in my hand. When I taste it, it isn't the same. I am not as hungry as I was in 1931.

Leon is on the phone from Brussels.

"My mother would like to talk to you."

The Baroness Lambert would like to know if we would spend the weekend with them. Joe nods assent.

"Leon has told me how kind you were to him in New York. We are very informal here. We're having a small dinner party, but it won't be necessary to dress. I'm looking forward to meeting you and your husband."

"We'll rent a car and chauffeur. We'll drive there," says Joe.

I am pleased at my luggage. I have managed to compress everything into one small bag and a makeup case just like the one Caresse Crosby used in Virginia City. The chauffeur drives around the central square looking for 24 Avenue Marnix and then pulls into an enclosed courtyard.

"This must be it," says Joe.

"But Leon said they lived over the bank. . . ."

A footman and maid descend the red-carpeted stairs leading up to what seems to be a palace.

"*Permettez-moi, madame.*" And the maid wrests the two small pieces of luggage from my hands. She looks for more.

"*C'est tout.*"

She is as surprised as the footman who takes Joe's equally small bag.

We are miles apart in a suite with a sitting room and two separate bedrooms and baths. My bed is covered in gray satin caught up over the headboard which has a large N embroidered in gold on it. And am I, then, Josephine? I fall on the bed in a fit of laughter. A knock on the door. I smooth the satin and say "*Entrez.*" It is the maid to unpack. "*Je vais repasser votre robe,*" she says. I am about to tell her that it is one Frances made for me of black lace that never needed ironing. That was the whole point of it, but I can see that this could threaten her very existence, so I thank her as she marches off with my dress over her arm.

The Baroness Lambert is charming as are her guests, a French poet and an artist who seems to be in residence. Philippe, Leon's lighthearted younger brother, does not seem to have inherited his astute Rothschild grandfather's business ability.

"But you told me you lived over the bank," I chide Leon as I study the printed menu before me of what we are going to have for dinner.

"Well, it's not exactly *over* it. The bank is next door and there's a tunnel under the street that leads to it."

The waiter wearing white gloves and standing behind me presents the soup.

"I have an excellent chef," says the Baroness as I taste the incredible dish.

"Every three-star restaurant in France, as well as some royalty, have tried to steal him," says the poet.

"Some of my very best friends," adds the Baroness.

"You know what I liked to eat most in the States?" Leon asks me as the waiter presents a perfect chateaubriand with black truffles.

"No, what?"

"The egg-salad sandwiches at Liggett's."

In Italy we visit the sculptor Marino Marini with a letter from his patron, the Baroness Lambert. I am told that her comment on our weekend in Brussels included a curious statement about me. "How clever of him to marry her." What did it mean? I would never know. Maybe it meant my being an artist was disarming, like being a shill for Joe's shenanigans. Mercedes, Marino's wife, talks French to me, translates to her husband in Italian, explains his answer to me in French, and I translate it into English for Joe. Complicated, but it works.

Everywhere we travel in isolated splendor in limousines with a chauffeur. Except for a moment in Venice when we take a public boat to Lido Beach and sit lazily on the dock, we are hermetically sealed from ordinary people. I long for them.

In Madrid, we bump into Robert Rossen, a long way from *The Body Beautiful* now. He is directing an American film and the local people are vying with one another to be extras. Outside the Prado, a dwarf, straight out of Velásquez, is selling pencils. Inside, what amounts to a one-man show of that artist is overwhelming.

In Toledo, I am shocked to find that El Greco didn't invent the city. It is really there—but all sunny ochres instead of stormy blues. Great cliffs like the one that Goya painted really exist although no white birds swoop around them.

A young Spanish painter and I communicate with names.

I say Picasso and he rolls his eyes upward in appreciation.

"Morandi," he replies. I nod.

"Matisse?" He approves.

"Klee." We both waggle our heads.

We talk like this until we run out of artists' names.

Finally in England, we visit all those connected with Rio Tinto, from Sir Mark Turner to the Val Duncans, who invite us for a weekend at their simple fourteenth-century Edenbridge House

in Kent which turns out to be colder than Claridge's in London. At night a bedwarmer is slipped between the cold sheets. In the morning, to our surprise, our host dives into the icy waters of his pool.

"Would you like to have a dip?" he asks. "It's May. Spring already." We shiver just watching him.

Sir Denys Lowson, a fat jovial man, formerly Lord Mayor of London, was easy to imagine togged out in fancy robes. He dined with us in the States and relished the steak which he could not have in England's austere period. He entertains us at his home with a superb lunch winding up with fresh strawberries and cream. Afterward, like a little boy, he shows off a whole room in which he has a miniature railway, and we watch while he throws switches for the electric trains, making them whizz through tiny railway stations and towns complete to toy animals and people.

In London, Sir Jacob Epstein, despite Joe's rapid purchase of "The Visitation," a bronze pregnant Madonna, will not unveil the huge statue wrapped in canvas that stands in the middle of the studio.

"It's my obscene 'Adam,' " he says. "The one that created such an uproar." I am familiar with it from photographs. It is a great apelike man with an extraordinarily large phallus swept to one side, a companion piece to his "Genesis" about motherhood.

"Let's see it, Jake," Joe coaxes.

"*Sir Jacob*," the impressive sculptor corrects him. He came a long way for that title. From the East Side of New York to Paris where he knew Modigliani, Picasso, and Brancusi. To England and portraits of Joseph Conrad and many notable people. Back in America he did a portrait of Paul Robeson and testified about the famous Brancusi bird. Held at customs for duty as a "manufactured article," the bird needed a defense. "No, I never received a diploma for art," Sir Jacob announced. "Yes, the Brancusi is a work of art. It pleases my sense of beauty." Sir Jacob came a long way for that title, and no one was going to do him out of it.

The landmark for Henry Moore's studio is a small pub in Much Hadam. Around the house are large sculptures which

loom impressively against the sky. What I especially enjoy are the shelves of small maquettes, bone shapes and natural objects. Mr. Moore is modest, a coal miner's son, with no airs, as we take tea with him, his wife, and small daughter. I feel at home in this house which spills into studios, indoors and out, and I am lonesome for mine.

While Joe is busy at meetings with Rio Tinto executives, I haunt the National Gallery, still remembering a Medici prince at the Uffizi in Florence, as fat as a Kuniyoshi baby but jovial and clutching an unhappy bird in his hot little hand. I think of Evergood when I see the Jan Van Eyck married couple with the lady pregnant, her husband in a big black hat, a dog and cast-off sandals in the foreground. He must have seen it when he studied in England. I wonder if Vermeer used a camera obscura, but I don't think so. Unlike some of the paintings which are now being done from photographs, the Vermeer has a magic of time and space.

Our month in Europe is over. Somehow, it hasn't made me feel closer to Joe, if that was the object of it. It was connected with Rio Tinto and the Big Deal that looked promising; but Joe and I are no more together than before. Something has gone off the tracks like Sir Denys's little trains and does not want to go back on again.

"Lord," I say to myself, "put me in a state of grace." But the feeling I want of trust and security refuses to come.

I don't want to play games to keep him. I keep thinking that Joe is repeating a familiar pattern that he had with Jenny and that in a way his behavior is calculated for me to leave him.

In between painting memories of Canada like "Location X," "Near Sudbury" and "Lonesome Pine," I entertain at dinner parties for people I will never see again—members of the Hydroelectric Commission of Canada or the Atomic Energy Commission who discuss the market for uranium. While I serve coffee or tea, I think, "They don't care if they blow up the whole world as long as the price is right."

"Excitement can be boring," I say to Dr. Fessler. "All I want is some quiet time with nothing happening." But that seems im-

possible. "Maybe I should leave him. I'll never have any peace with him."

Joe wakes up at three in the morning.

"I have a terrible pain in my left arm and chest. Could be indigestion. What did we have for dinner?"

Alarmed, I telephone our doctor, who is in White Plains.

"I'm calling Beth Israel right away for an ambulance," he says, "and I'll meet you there. I'm driving in."

The doorbell rings soon after and two men rush in with a stretcher and clamp an oxygen mask on Joe immediately. They put him on a stretcher. He looks as helpless as anyone would in that condition, and in the ambulance as it screams its way downtown, I sit with him and hold his hand.

When Jimmy shows up I remember that he phones every Saturday morning to see how his stock is doing, and is now fifty thousand dollars in the hole. I wish he'd been in on the uranium. The cardiograms refuse to give a picture of a heart condition.

"You mustn't move," says Jimmy, "and you mustn't make phone calls."

Joe mumbles something.

"You must stay quiet."

Joe's concern the next day when his lawyer comes to see him is that nobody know he is ill.

"It could knock the hell out of the market, Sam, if anyone thought I had a heart attack."

"They don't know that you did," I say. "Don't worry, I'll handle the phone calls."

And when anyone calls, I say that Joe has nothing the matter with him except fatigue from working too hard. "You know Joe." I laugh. "About the only way anyone could get him to take it easy would be to put him in a hospital." Just the same, the market fluctuates all the time he is there. None of the tests indicate a heart condition.

The funniest thing to me is how concerned I am. It seems to me that Joe's energy, his forceful approach to life, is the most important thing about him.

"You've got to find out what's wrong with him, Jimmy."

As a last resort, they do a G-I series of tests—and the problem is located in the gall bladder rather than the heart.

Joe comes home.

I try. I try. But just the same, although I wish Joe health and he regains it rapidly and is back to talking on several phones as usual, I cannot see living as I have been.

"I really want out!"

Dr. Fessler says nothing. I know darned well he is drinking his Turkish coffee behind me.

"I don't care what happens. I want to leave now. I don't care about money either."

"Joe has nothing to give you but money."

Now what kind of statement is that from my Freudian analyst? When I learned about Joe's affair with his secretary, it occurred to me that, unlike her, I had not feathered my nest. I hadn't looked at things between us that way any more than Jenny had, I imagine. Joe's love was eternal. I think Joe can't love. He must get love. He is always asking Amy and Jo Ann if they love him. "Of course they love you. Why don't you just accept that? Why can't you say you love them?"

I can't get Joe to understand, and I am tired of trying. I go to see an old friend of mine who is a lawyer with a large firm.

"You should have left him when he told you about his secretary."

"I should? Why?"

"You've condoned his behavior. You've slept with him since."

I certainly have.

"I wanted to preserve our marriage. After all, we have two children. I wasn't a saint myself."

"Why have you stayed?"

"I don't know. Maybe because he needed me when that scandal broke. And then he was sick. I couldn't leave him then."

"But you want to leave now?"

"Yes. I want a divorce."

I feel relieved as the words come out. I haven't told my lawyer the whole truth. He doesn't know what it feels like to be caught up in a maelstrom of intense living, so intense that I cannot find myself, and the quiet places are always invaded. He doesn't

know what it feels like to have the continuity so necessary for working constantly being disrupted for more input. I want, like Ferdinand, to just sit and smell the flowers.

"A friendly divorce, if there is such a thing. My analyst doesn't want me to show my anger, and I think he's right."

My lawyer nods approval. He likes the idea of a venomless divorce.

"Once I asked Dr. Fessler during the time I was going crazy when I could tell Joe what I really thought of him and he said 'Never.' There's no question of being vindictive. I just want out."

"The first thing you have to do is have an accountant. We must establish your scale of living." And he introduces me to an accountant who studies my checkbook.

"Where is your beauty-parlor charge account?"

"I haven't any. I like to shampoo my hair under the shower." A demerit.

"Do you have a mink coat?"

"Joe bought me one when he was having that affair." A credit.

"Good. But you told me Joe bought a French poodle for the girls."

I nod. Joe was buying us a lot of gifts. The French poodle hates the children, jumps up on the crocheted spread of my bed, barks at them, and fawns at me.

"What about a fur coat for walking the dog? You can't wear mink for that."

"No," I say, catching on. "I need something simpler like a seal or otter in case it rains."

"That's right. Could you use a Jacuzzi?"

"What's that?"

"A whirlpool bath."

"Not really."

"Go to work on the beauty-parlor account. Spend money."

And he condemns me to the year of the bills.

"Your skin is getting dry," says Celestine as she strokes my skin with sweet-smelling creams making little knuckle movements between my eyes to wipe away frown lines. "You really should have a whole series of treatments." Money is no object—

224

of course I will. Celestine leaves me for her coffee break with a mask hardening and two wet witch-hazel pads on my closed eyelids. When she comes back, she removes the covering, now caked as a cracking desert, with wringing-wet hot towels and snaps my skin to attention with tingling Eau Verte. We both know that all her efforts will not turn back the clock. One thing I know that she doesn't. My sojourn in the world of beauty is only temporary.

"You have some hair on your arms."

I look at the fuzz. It never bothered me.

"I happen to have a pot of warm wax. Let's just see how it looks."

Using a wooden spatula, she applies a hot little strip down my arm. When she yanks it off, it looks like a piece of animal skin with hairs sticking out of it. Obviously, now that my arm looks as if it had an airplane runway down it, she will have to do the arm, both arms, since they must match.

"You really should do your legs. They're worse. A razor is so unfeminine and the stubble feels terrible."

"Only to the knee, Celestine, only to the knee. . . ."

My underarms are the most painful of all.

"You don't want *that* showing in a bathing suit," she hints, but I am not having her anywhere near my pubics.

Miss Celestine, as she is called in the beauty emporium, sells me everything, from shampoos to manicures to pedicures to body massage, which winds up with her hosing me down, naked and vulnerable, with a beating of water that is obscene. All along, Miss Celestine knows I am in serious trouble. She has seen ladies like me before. She knows what this forty-third year of my life is like.

Receive me, Bergdorf, to thy bosom. I walk in listlessly. I've already spent the morning at Bloomingdale's. What shall I buy now? Perfume bottles shine amber and gossamer-thin stockings hang on Plexiglass stands along the brightly lit aisles. There is a dull ache in me, a numbness. I must try to remember that all this will mean independence, never having our children beg from their father as his and Jenny's had to do. I station myself

near the front door where at least I will be able to breathe and escape my feeling of claustrophobia, especially in stores. I am near the evening bags.

"How much is this?" I pick up a French evening bag and dangle it from my wrist. It's a beauty, made of black silk with an exquisite coral cameo as a catch and crisscrossed with gold thread with tiny needlepoint flowers at each diamond-shaped intersection.

"It's two hundred and fifty dollars," says the salesgirl, and from the hauteur with which she says it I can see that she thinks I'm not worthy of it.

"It's lovely," I sigh. "My husband and I looked all over Europe for something like it, but couldn't find it—not even in Paris."

"It's the only one of its kind."

"I'll take it."

Carried away by my own bravery, I spot another bag. This one is all brown bugle beads with a lacy gold frame and a chain as supple as a snake.

"How much is this one?"

"It's the same price as the other one. Two hundred and fifty dollars."

"I'll take them both," I say to her astonishment and sweep triumphantly with my trophies through the revolving glass doors.

Chapter Six
1956–1960

JOE HAS FINALLY MOVED OUT after we talked for seven hours but wound up with no reconciliation. The die is cast, and my lawyer feels that since the meeting about our separation agreement is scheduled at his office rather than at Joe's lawyer's, we have the psychological edge.

I dress carefully for this important occasion in a simple suit made by Frances Epstein and use it as a foil for all the jewelry Joe had given me long ago at my surprise birthday party on Waverly Place. As I fasten my Tiffany watch, I realize I'd never owned a watch until Joe gave me this one. Now I can't do without one. I spray Joy in a mist around my head. It is a sunny April day.

Joe is already sitting in my lawyer's office when I get there.

"You look lovely."

My lawyer admires the jewelry I am wearing like medals.

"Joe bought them for me. He has marvelous taste."

Joe and I are so relaxed that we might be on our first date rather than what may turn out to be a nasty session.

"You might want to look at this year's standard of living," my lawyer says when Joe's lawyer enters looking somber and harassed. He hands him and Joe copies of my year of the bills.

The only purchase that gets a response is my extravaganza at

Bergdorf's. "Two hundred and fifty dollars *each,* for two evening bags?" Joe is shocked.

"They were the prettiest I'd ever seen. You know how we looked so hard in Europe and never found them. I'm sure if we had, you'd have bought them for me."

"What alimony did you have in mind?" asks Joe's lawyer with a look of fatigue as he puts aside the list of my year's expenses.

"We didn't think alimony would be practical. Joe's away a great deal, he's got a lot of things on his mind. We thought a lump sum would be better, and we've drawn up a figure to yield an annual income," my lawyer says.

"But Joe isn't that rich!" His lawyer studies the figure in disbelief.

"You'll see that it coincides with Lily's standard of living."

"Joe's done well this year, but he could lose money as well. It's happened before."

"You know," I interject, "when Gene Rostow introduced you to Joe, you invited me for lunch. You weren't sure you wanted Joe as a client, remember? And you asked me to tell you what I thought of him. I told you he was a genius. You know perfectly well that if Joe lost all his money this minute, he'd go right out and make a fortune again. Anywhere. Even in China."

"Think of the peace of mind Joe will have not worrying about monthly payments," says my lawyer. And it is done. Joe's lawyer looks daggers at me, but Joe seems content, and I am free to fly to Mexico for my divorce.

"But who's gonna cook?" wails Jo Ann.

"I'll be back in two days."

But she weeps bitterly and Amy regards me with hurt eyes. Do they think I am going to vanish like their father? At least he was with us on weekends. Now, who knows? How often will he see the girls? I don't know what Joe represents to them. In addition to worrying about this, I know that, since they are adopted, the girls are particularly vulnerable to feelings of rejection.

"You're not my real mommy," Amy says sometimes. "I don't have to do what you say."

Jo Ann, six years old to Amy's nine, argues with her about everything. Sibling rivalry is in full swing.

"Amy has more peas than I do," the little one says.

"I'll be damned if I count them for you," I assert myself. It is hard to hang on to my sanity. I steel myself, pack, and leave for the charade in Juarez. I come back with two decrees, one in Spanish and one in English, both decorated with gold seals and red ribbons.

May first. May Day. Symbolic. I take the subway downtown to Wall Street. Today is the great day when I receive the check for my settlement. At the Hanover Bank Trust Company I am ushered into a private room with Joe, our lawyers, and a number of bank officials. The ceremony of signing reminds me of "The Green Table" ballet of Kurt Jooss as we all dance around the baize-covered table in the center of the room and I sign the papers that are put before me. At home, I have one small bronze queen's hand, half of a pair by Henry Moore for his "King and Queen." Joe has the other half. They will never nestle together again.

When Joe and I come out to the street, leaving the others behind to take care of details, he asks, "How does it feel to be rich?"

"Wonderful." And I hail a cab to go to a cause party at Angier Biddle Duke's.

As soon as I enter, I am greeted by an old friend. He has become Senator William Benton, and his name in the newspaper always made Joe angry.

"I haven't seen you since your brother and Joe Hirshhorn came to kill me. The day I was so brave. I could have been admitting two lunatics. You married him, didn't you?"

"But we're divorced now. We were married for ten years and four months."

Joe's lawyer comes in and we are startled to see one another so soon.

"If I'd known you were coming here, we could have shared a cab. This is Senator Benton. This is Joe's lawyer. We just parted a few minutes ago at the Hanover Trust." Bill Benton introduces

us both to Senator Ribicoff, and when they move off, we stand awkwardly together.

"Don't forget to tell Joe I introduced you to Benton," I say wickedly to Joe's lawyer, who looks bewildered. I go home to Central Park West to face the good life.

I am forced to enter Joe's world. The world of investments.

"We can't change your portfolio until we sell some of these uranium stocks. Only God and Joseph Hirshhorn know anything about them." And neither He nor Joe are telling Kuhn Loeb and me when to get rid of them.

"How do you sell stocks?" I ask my lawyer in his office. I am ashamed of my ignorance.

"You just call Kuhn Loeb and tell them to sell."

"Is that all?"

"That's all."

"Do you mind if I use your phone?"

"Go right ahead."

"Hello, Bernie? I'd like to sell my uranium stock."

"How many at what price?"

"All of them. Now. At whatever price they are."

How simple it is. I have cut another tie with Joe, whom I've been calling and calling each weekend only to hear the time wasn't ripe. Not yet. Joe calls me in a fury. He was away on holiday in Jamaica. I have upset his market. That hadn't occurred to me.

"Do you realize how much money you lost doing this foolish thing? Why didn't you wait for me to tell you when?"

"I waited a long time. I'm sorry, but it didn't seem sensible for me to be paying investment counseling for nothing."

Bernie Einhorn calls me a few days later.

"How did you know?"

"How did I know what?"

"When to sell? You hit the top of the uranium market."

"I did? I did it for purely emotional reasons. I was tired of calling Joe."

But he doesn't believe me, and at Kuhn Loeb I am treated with respect.

My other worry is the children's trust fund, full of speculative stock and at Joe's nephew's brokerage firm. Joe's accountant, David Tarlow, and I are trustees.

One day Joe calls to say, "We're going to unload some of the girls' uranium stock."

"Good."

"We'll buy Hercules with the money."

"Would you mind if I call you back about it?" I know he must have my approval as well as Dave's. Hercules. I never heard of it, but that means nothing. I never heard of a lot of things. The whole market is a mystery to me. What is the difference between over-the-counter and under-the-counter? For that matter, what are commodities or debentures—incontrovertible or not? What is a stock called Bluebird? It sounds appealing. I know what Bulova is—a watch. But what is Diamint? A misspelling?

I know how to make damar varnish from scratch and about the properties of turpentine, stand oil, and sun-thickened oil, but in the land of Avon-to-Xerox I am lost. It behooves me to learn, and fast. I do not think I should ignore it.

Bernie is away when I call Kuhn Loeb, but his assistant, a stripling of twenty-two, takes the call.

"What do you think of Hercules?"

"For your account?"

"No. I know this is unorthodox. It's for my children's trust fund. You don't handle it, but I need to know."

"We wouldn't be buying that right now."

"What are you buying?"

"Otis Elevator."

"Why?"

The young man goes into a spiel like a Fuller Brush salesman.

"Just a minute. Would you mind repeating that?"

He doesn't mind. He loves it.

"I'm sure Hercules has a lot to recommend it," I say to Joe when I call him back. I am proud of myself, wrestling on turf with a pro. "But I'm told that right now Kuhn Loeb is into buying Otis. It's going to go up." And I quote my notes. If

anyone asked me ten minutes later what it was all about, I
wouldn't have known, but for now I know. And sure enough,
we buy Otis instead of Hercules. The game, with variations, goes
on for a long time. Sometimes we buy one of Joe's suggestions
after I check it with my investment counselors, but often Joe is
willing to take their recommendations. Eventually they have
chosen the major part of the portfolio. At this point I suggest
that we might as well put the whole account at Kuhn Loeb since
they have done so well and only they understand when to sell
this stock. The last of the uranium stock is gone, and the market
slithers softly downward.

Joe invites me to have lunch with him and Oscar Weiss, a
geologist from Johannesburg who was involved in the Rio Tinto
deal.

"You and Oscar always got on so well. He was upset to hear
about our divorce, but I explained to him that we're still
friendly."

At the St. Regis, Joe says, "Lily is well rid of a nut like me. I
don't know how she put up with a crazy man like me for so
long."

Oscar looks embarrassed. I pull out the soft insides of the
hard little rolls and fish the marrow out of the bones in my *petite
marmite*.

Why am I here? Is it to prove something to Oscar? If so, what?
It seems like a reverse technique where Joe claims guilt and is
therefore blameless.

They are talking about nickel deposits in Canada.

"Fifty miles north of Sudbury. That's where I think we'd find
it," Oscar is saying.

"South," I say.

"What do you mean, south?" asks Joe.

"If you're looking for land like International Nickel's, I think
I've seen it, but it's south."

"Where?"

When I was a little girl and we were playing ball and lost it, we
had a special way to find it. We would close our eyes, spin
around three times, throw a stone, and wherever it landed, that
would be the place. Sometimes it worked.

Freehand

"I don't know the exact spot, but the land was just like Sudbury before the mining. I can always strip things down to bare bones. The structure was the same under the green grass and trees. Fifty miles south." I don't pinpoint the exact spot. Let them look—and not find. There were enough landscapes of the moon. "I want ten percent of what you find," I add, but they don't hear me. They are too busy discussing south rather than north. I have a desire to laugh.

Reconstructing my life, the first thing I do is move my studio out of the little dark back bedroom and up to the front of the apartment. I get rid of the dining room and put the Duncan Phyfe table, the Queen Anne chairs, and the Sheraton sideboard away in the basement storeroom. I can imagine Joe's horror. "Don't you care about gracious living?" he would say. A carpenter builds racks for paintings and I have vinyl laid over the parquet floors and roll my easel, paint table, and drawing table in. It feels good to be in a light room with the park outside the window.

The next thing I have to do is unpleasant. Wilbert, our chauffeur from Trinidad, hangs around waiting for me to go somewhere but I am too busy in the studio and the girls would rather go to school by bus. And so I let Wilbert go, but it is not so bad. Joe hires him. Wilbert comes to see me and the girls often. I serve him tea. He has ulcers.

Associated American Artists has blossomed out with branches in Chicago and Los Angeles. Reeves Lewenthal built this chain of art on his five-dollar mail-order business. The artists commissioned to do editions of two hundred and fifty prints each were relieved of the responsibility of printing and selling them. We would sign and number each one while Murray the shipping clerk pushed fresh pencils at us.

Sometimes Reeves pretends Associated American Artists is a cooperative gallery and rounds up the artists for meetings.

"I don't make any money in this business," he says as we all sit around grousing and asking questions about the percentages paid on the work we did for large drug companies. "I take out

233

only two hundred dollars a week in salary. Of course, if you artists want to run the business, I could sell it to you. . . ."

Shivers of horror run through all the assembled artists: Joe Jones who is tall, gawky, and Midwestern, Joseph Floch, a dignified and cultured refugee from Vienna, George Schreiber and Ernest Fiene, stolid, serious, and Germanic, Arnold Blanch, my former teacher, with his romantic white bangs, and even Raphael Soyer, who looks as if a wind would blow him over, but whom I know to be a fearless fighter for artists' rights, all of them flinch at the dirty word. Business.

"We don't understand figures. That's not our job. We're painters."

"If you would like to see the books—" Reeves offers—"they're on my desk." But there are no takers. We are like children in his hands.

Just the same, Bill Gropper leans over and whispers, "I wouldn't mind seeing the figures."

And I whisper back, "I wouldn't mind either. Reeves can't possibly live on two hundred dollars a week. Have you seen his apartment?"

But times are changing.

"What is art?"

"What isn't?" Kurt Schwitters had answered the question with a question.

There is anarchy in the art world. Those of us who persist in drawing (a dirty word) are out of favor and out of fashion. Jackson Pollock is dripping paint on canvases on the floor and other artists swing their brushes like athletes in what is called "action painting." Some of us who thought art was a force for changing society looked at the social realism in Russia and its dull propaganda with horror and then took another look at the new directions. As for me, I am torn between both worlds—fantasy and reality.

Perhaps if Reeves had accepted the work of Jackson Pollock when it was offered instead of sticking with Benton, Curry, and Wood, he might not have lost his galleries in Chicago and Los Angeles. The final blow comes when Columbia Pictures buys 711 Fifth Avenue, where his galleries were, and he has to rent a much smaller space in a building across the street. There are

rumblings of discontent among the artists and Reeves invites some of us to lunch. He tells us how he is going to refurbish the new gallery, asks our advice, and feeds us well. After all, nobody but Reeves sends artists braces of pheasants for Christmas. Mesmerized, we listen to his hypnotic voice. After lunch Reeves dashes off and leaves us standing in the sunshine of Fifth Avenue, dazed and committed to staying with him. Joe Jones sums it up.

"Well! We're back with the same old wife!"

My third and last show at 711 was well received. Carlyle Burrows said I was a capable draftsman and a breezy sensitive painter and that I carried my familiar studies into a fresh, formal wonderland. And the *Art Digest* notes that in "Dancing Class" the red background was made redder by flashes of green and the forms of the young dancers were set down in swift linear rotation. After all my fears of exile from New York City, the whole show reflected an affection for children and the landscape of suburbia.

In my fourth show at the new gallery at 712, I am able to exhibit only seventeen paintings. The space is limited. There are more landscapes than figures this time. "Location X" showed a mining stake on a hill and "Bootlegger's Bay," "The Road to Algom," and "Lonesome Pine," which the Whitney Museum bought, were all about my Canadian experience.

Some people named Sigerson seem to be collecting my work, choosing from each show. To my surprise, I find that Mrs. Richard Sigerson is my old friend Yola Miller from Tenth Street. Unlike most collectors, she never tries to buy from my studio and save the gallery commission.

The odd thing is that although these are all painted at times of great stress, the reviews find "the mood poetic, the concept personal and the execution sure."

Joe, transformed into a once-a-week-on-Sunday father, asks the girls how they did at school, takes them to a movie, brings them back, and kisses them goodbye until the next time.

"I'll take them for the month of August," he says. "To Blind River."

Three months after the divorce, a telegram arrives from Naples.

SORRY DID NOT SEE YOU WHEN SAYING GOODBYE TO CHILDREN. WANTED TO TELL YOU OF MY PLANS. PROGRAM FOR CHILDREN BEING WITH ME DOES NOT CHANGE ANY. WILL BE BACK FIRST WEEK IN AUGUST. LOVE TO YOU AND CHILDREN. JOE.

I have no idea who the bride is. When my lawyer came up with the idea of detectives to follow Joe, I said that was contemptible, and I wouldn't dream of such a thing. Now I understand all the gift offerings and why our negotiations were so simple. Life had presented Brenda Hawley Heide, a young blonde formerly married to a candy king, conveniently working at Dunhill's, Joe's tailors. Rumor has it that she is so tall she has thrown away all her high heels and loves Joe enough to wear flats with everything.

My separation agreement with Joe is like a blueprint. It says I am allowed to purchase a summer house and a cooperative apartment in New York within three years. Or else. Or else the opportunity will vanish. And so I look for a summer rental to see if I can find something to buy. I am anxious to get away from New York. I bump into an artist who says how lucky I was to have gotten six million dollars from Joe.

"If he'd been that generous, I'd have stayed with him," I say flippantly. I don't say that if it hadn't been for Dr. Fessler, I'd have parted with nothing. How to explain to anyone that the one thing Joe couldn't bear was the thought that a colony had escaped. Robin, his oldest daughter, said we were all colonies to his merry old England, and she was right. I was lucky to have achieved independence, but I didn't want affluence. That carried other burdens.

Despite my impulse to hide somewhere in deep woods that summer, which Dr. Fessler discourages, I choose another alter-

native—to rent a house in Provincetown. I want to find roots for the children. I want to alleviate the guilt I feel about depriving them of a father. I am also afraid that Joe, especially now that he has a new wife, will seduce the girls away from me. I imagine him buying a large estate with horses for Jo Ann, who loves riding, and golden trinkets for Amy who is almost grown up and loves fine antique jewelry. I force myself to remember how hard it is for him to give gifts to his children.

The moment we unlock the door of the typical Cape house in June after the children's school is over, two things hit us. One is that the house is cold, as only a summer house closed all winter can be, and the other is that there are cabbage roses everywhere. The walls are papered with them, the toilet seats covered with them, and the headboard of the king-sized bed into which the girls and I snuggle is filled with them.

The very first day I thaw out, I bump into my old friend Mischa Richter, who is a cartoonist for *The New Yorker* and paints abstractions.

"What on earth are you doing here?"

"I live here."

"Why?"

"No other town looks like this. My God, I haven't seen you since I introduced you to Peter Harnden and never saw either one of you again."

Mischa is right about the town's not looking like any other. The remodeled houses have a style of their own, a hodgepodge of expediency with motifs of the sea. Wooden ship's knees support beams. Bathroom windows are portholes. Driftwood becomes lamp bases. Fishnets are curtains, and beach stones, sliced and polished, turn into tabletops. The houses themselves are treated like boats and moved frequently over the water to other locations. They creak and groan a little, but they go.

The girls have found friends down the street, Cheryl and Susan Saults, whose mother is a telephone operator. When I lift the telephone, instead of saying "Number Please!" she says, "Do you know where the girls are this morning, Lily?"

Mary knows everything. Sometimes I forget who I'm calling. We are busy figuring out the time of the Fourth of July parade

and deciding which fire engine the girls will ride. "I think they're going up to Pumper House Five." The telephone numbers are simple and easy to remember, like dates in history: 1492; 1066.

Mornings I go out to the sand hills covered with scraggly heather, beach plum and small wind-beaten pines to draw. Afternoons I paint in the studio, working from memory of a dune with what Chaim Gross described as a *shissele blut* of a setting sun above it. A little dish of blood.

I become a life member of the Provincetown Art Association. I plan to show there annually; the girls love this place. They run barefoot on the sand and swim all day with their friends until their lips turn purple with cold, and I love it, too. There are many galleries. The HCE is run by Nat Halper, an expert in chess and an authority on James Joyce, who is married to Marjorie Windust, a painter. Tirca Karlis gets up at six in the morning to scrub the floor of her gallery and sometimes doesn't get to bed until after midnight. Tirca is so nearsighted that she doesn't recognize friends, but she can tell a good painting when she sees one.

Daily, at the West End, Karl Knaths, wearing a beret like an artist but looking more like a red-faced fisherman, walks out to the Provincelands, and at the East End, Byron Browne, handsome and blond as an Apollo, strides along Snail Road playing his bagpipes as he heads for the dunes.

Chaim Gross, an embroidered *yarmulke* perched on his thick black curly hair, pedals his bike from one end of Commercial Street to the other, inviting friends to dinner. Renée courts poison ivy picking blueberries from the bushes around their large house on a hill that used to belong to George Elmer Browne, an old-time Provincetown painter. She serves marvelous Jewish food that reminds me of Baba's—crunchy thin potato pancakes or a kugel with a crust. Whatever she makes, the meal will wind up with fresh blueberries—in a pie, a cobbler, a pudding, or simply served with a dollop of ice cream.

Along the path to the school of Hans Hofmann, who is the leading guru, as Charles Hawthorne once was, are masses of flowers—jeweled spikes of snapdragons, six-foot-high holly-

hocks, day lilies mingled with coral bells, cultivated by Miz, his wife.

At his school for painting and print-making, Seong Moy cuts woodblocks as if they were butter. He knows how to handle a knife. A former chef, he embellishes Peking duck with special mandarin oranges his mother sends him from Hong Kong. He serves pancakes with scallions green and curly like flowers tucked into them.

Mark Rothko wants to know if his daughter Kate, who is around Jo Ann's age, can join a club the children have formed. Kate is lonesome and shy and has no friends her own age.

The doyen of the artists is Edwin Dickinson, dapper, bearded, and eccentric, who paints romantic self-portraits and mysterious landscapes or large nudes in tones of silvery gray. He mixes his own drinks at parties and insists on Triscuits. He is increasingly absentminded. One morning, after a party the night before, I find him at my front door.

"I think I have something belonging to you," he says, pulling a liqueur glass out of his pocket and handing it to me.

There are many women artists—Anne Brigadier who does delicate collages imbedded in wax, Sabina Teichman, whose people are almost as bizarre as Evergood's, Yeffe Kimball, an American Indian, who wears her hair in two tight little braids and works in a thick plastic medium, and a quiet, pretty young artist, Helen Frankenthaler.

In the former Dos Passos house, Ben and Hilda Sonnenberg are an anomaly among the artists and psychiatrists. Their house on the bay is full of couches covered in flowering chintz and shining brass objects like the house on Gramercy Park. The hedge in front of their home is so high, the house cannot be seen from the street and there is an arch cut in it to enter. When I visit them, the drawing I gave Ben when he courted me with gifts while he pursued Joe, is hanging ignominiously in the bathroom. After Edward G. Robinson is their house guest that summer, Hilda phones to say, "He liked your painting at the Art Association and the drawing we have. He says you're a good artist."

"I know, Hilda," I say, surprising myself as well as Hilda, and

thinking, Maybe now that it has a seal of approval they'll move my drawing into the living room.

Collectors breeze in and out of town all summer and are wined, dined, and fawned upon by the artists.

August in Provincetown. A white wake inches across the leaden waters. The harbor is bisected into squares of low tide, birds, bilious green seaweed in horizontal stripes. Children run splashing the low waters of the tide pools. A black dog runs madly, stops to defecate, and humps his body into the shape of a parenthesis. An old couple walk slowly, holding hands. Overhead, the dirty yellow sightseeing plane roars and the sound fades away in the direction of Race Point.

August heat, and a hush is over all except for the perpetual whining of the gulls, always hungry and telling one another tales of fresh garbage at the dump where they wheel and circle, and then careen off to overtake the fishing boats.

Downtown the tourists walk with cameras growing out of their chests. They stop long enough to eat foot-long hot dogs on the wharf, and their children's faces are smeared with pink cotton candy. Rubber chickens hang from their feet outside shops. NO BARE FEET, say the signs on the store windows. BY ORDER OF THE BOARD OF HEALTH.

I match the girls' socks, mend those with holes, and prepare the girls to spend the month of August with their father and his new bride. Sneakers are all they have, and they're outgrowing those. They've been running barefoot all summer.

Joe meets us at La Guardia airport; he seems awkward in this new situation.

"I'm sorry I didn't tell you I was going to get married."

"That's all right." I am equally awkward but annoyed because I know he didn't try. Secrecy was a form of power with him. I knew that.

"My feet hurt," says Jo Ann.

"She's outgrown her shoes. I think we'd better get her some."

We stop at a shoe store in Manhattan like a regular family.

"Shall I wrap them?" asks the salesman.

"She'll wear them. You can throw the old ones out."

When the salesman hands Joe the bill, he smiles a wry smile

and hands it to me. *"She'll* pay," he says, and I know that things are certainly different between us as I hand the man six dollars.

"Brenda has a daughter. She'll be at Bootlegger's Bay too. They'll have a good time," he says on the way to the apartment.

"How long do you want them to stay?"

"The whole month." Joe looks wounded. "I thought that was understood."

"Why don't we say three weeks and let them stay an extra one if they choose? They like it a lot in Provincetown and they have friends there. Would you have Brenda call me? After all, she hasn't met the kids, and I could at least tell her something about what they like to eat." But not how it feels to turn your children over to a perfect stranger. I wouldn't even send them to camp that way.

The apartment on Central Park West is stifling hot. When Brenda calls, I tell her that the girls hate fish and eat practically nothing except hamburgers and hot dogs. I also tell her Amy is very developed for her age and that in case she has her period, I want that experience to be easy for her. It wasn't for me. I don't discuss what it felt like to come home from school, flowing with blood, knowing nothing of what was happening, and having my mother and sister treat it like a big joke.

I also describe little ailments the girls might have.

"My daughter is *never* sick," says Brenda.

Joe arrives at the apartment to pick up Amy and Jo Ann. He has Brenda's daughter with him, a shy little girl. She is having a nosebleed and I run to the kitchen to get ice.

"I have them all the time," the child says. "Nobody knows why I get them."

"She and her mother are very healthy," says Joe. "I don't understand it." When the bleeding stops, they leave, and Joe brings Amy and Jo Ann back later after their meeting with their new stepmother.

"Brenda's a nice lady," they say. "She showed us how to put nail polish on. The trick is to turn the brush."

We are waiting to hear about when they will all leave for Bootlegger's Bay when the phone rings. It is Joe.

"Do you think the children would mind if they didn't go? I have to go to England on business. Something came up."

"They love it in Provincetown." I think of the discussion about whether it would be three weeks or a month. And now it was nothing. Was this an intimation of the future?

"So they wouldn't mind?"

"I'll make it up to them."

Trying to buy a house on the waterfront of Provincetown, I am told to see Vera Sterne, but when I go there, her husband, the artist Maurice Sterne, is on his deathbed. He lies there, gaunt and still darkly handsome, but no longer the great lover Mabel Dodge Luhan wrote about.

To discuss buying the house seems macabre under the circumstances. I express my admiration for his Bali drawings and his painting.

"It's almost too beautiful," I say of the view outside his window where the harbor glitters. "It makes me think of something you once wrote. It's almost already a painted sea and a painted sky."

Arthur Kober, who was introduced to me by Florence and Hecky Rome, comes up for a visit. He writes silly poems.

> *A girl who's rare and most uncommon*
> *Is my dearest friend, Miss Lily Harmon.*

> *Some like tea with a piece of larmon*
> *I like a gal, she's named Miss Harmon.*

Arthur's special trick for dazzling the children of divorcées is to tear a newspaper into strips and turn it into a Christmas tree. This is surefire with all children but mine. Amy and Jo Ann have their ways to wreck the possibility of romance for me.

Amy's method is to perch in any caller's lap before I do.

Jo Ann says audibly as I take her upstairs to bed, "You're not going to marry *him*, are you, Mommy?"

When I return downstairs, Arthur is chuckling.

"You can't tell me that child hasn't been coached."

I can't find any private house to buy. I set my sights on Marge Oliver's Colonial Inn. It houses a bar called The Stork Club of Provincetown. Arthur and I go there for a drink.

"Don't do it," he implores me. "Don't buy this place. I can see it all. You're upstairs, sound asleep. There's a banging at the door. It's one o'clock in the morning. You stumble down. It's a drunk, and he won't go away. 'Jush one drink,' he says, 'I know you have a bar in there.'"

"I'll buy it if I can. It's a good house."

"Well, at least change the name. Call it Harmony."

"How corny can I get?"

"That much."

To my delight, Marge Oliver comes to tea, drinks cocktails, looks elegant in a large picture hat, and agrees to sell her place to me.

But Ozzie Ball, the eccentric lawyer and real estate agent who is handling the sale, sends me a postcard with a little message. Marge Oliver has changed her mind.

Joe has sold the uranium stock to Rio Tinto and *Fortune* magazine calls.

"We're doing an article on Mr. Hirshhorn and would like to interview you."

"I'm not married to him. There's another Mrs. Hirshhorn."

"But you were with him at the time of the uranium strike."

"I'm afraid I couldn't be helpful."

"Could you suggest friends?"

"Abram Lerner, his new curator." Al had worked at the ACA Gallery and was a beautiful artist. I'd seen a show of his. Delicate and sensitive work. I doubted if he would ever paint again. He'd chosen another way.

"Well, he works for Mr. Hirshhorn," objects the writer.

"Herman and Ella Baron know Mr. Hirshhorn very well."

"He buys from them."

I suggest no other people. It occurs to me that I can't think of anyone. They are all bound to him in some way.

Me, too. I want the girls to have a father. I don't want to play games of hostility. Another writer phones from a newspaper.

"I called you," he says, "because I smell a rat. Nobody has anything bad to say about Joe Hirshhorn. What is that? Have lunch with me. Let's talk."

"Not a chance."

"What have you got to lose?"

"My children."

In order to get it, I must buy the whole thing—one hundred and sixty-five feet of waterfront—the big house, a little cottage and a garage. Three houses when I want one.

The Collins Guest House in Provincetown had fallen on evil times. It belonged originally to a retired doctor, Percival Eaton, who imported workmen from Pittsburgh for the job. A Georgian city house of crumbling stucco with a slate roof that can, in a high gale, release a barrage of small guillotines that could decapitate a person, it bears no resemblance to the simple, shingled houses around it. Half the bulkhead hangs into the ocean. When John Snow, the agent, ushers me into the living room, I feel as if I need a seeing eye dog, it is so dark. Outside, on a long narrow porch, a row of rockers is lined up for the view.

Space flows beautifully from room to room. I like it. I want to restore it to its former glory.

"I'll take it." John Snow is stunned. It is the fastest commission he ever made. I pay exactly what was asked and establish myself in town as some kind of nut.

Building is like a shot of Adrenalin. Playing with space, whether it is painting and fitting forms into the four sides of the canvas, packing a car, or doing over a house, is a challenge.

I hire an architect from New Jersey for the simple reason that he plans to winter in Truro and can supervise. Only, too late, I discover that his specialty is store fronts. Luckily Jesse Meads, the Portuguese contractor, although he is almost illiterate, is an instinctively good designer and craftsman. His crew is made up of many family members named Meads—Robert, Johnny, and Philip. All the other workmen are named Souza or Silva with the exception of a fisherman named Moka and a painter, John Encarnation.

The new section of bulkhead requires the experience of Jimmy Thomas, a little man deformed from birth who walks with the aid of two sticks but who skillfully operates machinery that hoists huge creosoted tree trunks over the deck. He and his crew assure me our defense against the sea will last my lifetime and longer.

All the work takes twice as long as I figured and costs twice as much. Five thousand bricks are laid over the disintegrating stucco. Bathrooms are redone all in gray tile. "Why all *gray* tile?" I ask, but the architect evidently got them wholesale, and there is no way to change them.

But at last it is finished. It has taken about a year. Chaim Gross asks if he can send over a large bronze to weather at the waterfront, and on the day that I have gone to Boston to shop for food for the housewarming, I return just in time to find two men trying to move a seven-foot statue into the living room.

"Not *inside, outside!*" I yell. "Next to the ocean. Mr. Gross has put a concrete stand for it there."

I invite everybody who worked on the house from Tiny Rivard, the plump electrician, to the mason, the carpenters, the tile setters, and all my friends, as well as my lawyer, Judge Welsh, Mr. Provincetown himself.

Phil Alexander, who is to do the planting, tells me there will be Japanese black pine and rugosa rose, among other things, to live next to the salt spray, but on the day of the party there is nothing but sand. That afternoon, looking out the window, I am amazed to see a green forest walking around the house. Phil, not to be outdone by the others, took some helpers, went to the dunes, cut evergreens, pointed their trunks and stuck them all around. So there was a garden after all, for about two weeks until the pine needles turned brown.

When the bartender sets up on the porch, the first guest is Judge Welsh.

"Your bartender looks familiar."

"He was highly recommended."

"I've seen him before," says Judge Welsh, sipping his drink. "Now where was it?" He narrows his eyes. "I remember. In court, that's where."

"What was he doing there?"

"Drunk and disorderly, that's what. I sentenced him. He must have just gotten out."

But the bartender not only does not get drunk but proudly presents me with one bottle of Scotch he saved from the party, which began at three in the afternoon and ended at three in the morning.

"I hid it for you. I could see the way it was going you wouldn't have any left."

The only criticism came from Marion Wells, who ran the Seascape House. "You invited *everybody*," she sniffed. "Four hundred people, I heard. You might as well have taken an ad in the *Advocate*."

"This is the only thing you didn't have," says the note from an architect friend which arrives with a gift of a pump for a water fountain. "Thanks for the present," I wrote. "I appreciate it, but I thought for sure when you said you were sending me the only thing I didn't have, it would be a husband."

Somewhere along the line, the thought has been implanted in me that I am nobody unless I am married, no matter how fulfilled I may be in my art. Like a programmed robot, I accept dates with unlikely men.

There is the compulsive and ambitious journalist who has in his favor the fact that he turned down a lucrative job with Joe. That was enough to set him apart in my mind.

"Tell your mother I cherish her," he says on the phone to Jo Ann.

"What's cherish, Mommy?"

But I do not want to be a cherished adjunct to his career. I have had enough of that.

I am courted by a gourmet who invites me often to his apartment for splendid dinners prepared by his French chef. I decide to show off and invite him for dinner. I consult Marcia Seeley, a doctor's wife and superb cook, about the menu.

"Start with caviar and plover's eggs," she says. I never heard of plover's eggs.

"They might be difficult, if not impossible, to find." Marcia knits her brow. "I think they're illegal."

Freehand

"Think of something simpler."

"Well, quail's eggs. That'll show him you know what's what."

"And what about the main course?"

"Osso buco."

"In the summer? That's a winter dish."

We decide rack of lamb is possible in all seasons.

"With flageolet beans and small new potatoes and a perfect Bibb salad." Marcia can almost taste it.

"I'll get that bread they fly over from Paris."

"No Frenchman in his right mind would eat it. It's stale when it gets to the airport."

"I'll get Mrs. Grossinger's praline ice-cream cake for dessert."

"Let me know how it all works out," says Marcia, exhausted with taste sensations. "Don't forget. I want his reactions."

With the first mouthful, I know.

"What's this?" he asks as the tiny egg slides down his throat.

"It's a quail's egg," I say proudly. "Of course, it should be a plover's egg, but they're against the law."

As the dinner progresses I can see that he not only cannot tell the difference between a quail's egg and a plover's egg, but a chicken egg would have done as well. The exquisiteness of the whole dinner escapes him, and besides, I don't really like him.

"You are lonesome, no, Lilitchka?" asks my favorite cousin, Nadya, who looks like a delicate Russian princess with her shiny dyed-black hair in a chignon. She has a charming accent.

"No."

"Me you cannot fool, darling. I know. You are lonesome. Sunday I am bringing you a surprise. Your cousin Boris from Italy."

"I never knew I had a cousin there." But then I had cousins in Constantinople I had never seen. And one once lived in Manchuria.

"He has never been married, Boris. He is so handsome. So artistic. A film director from Rome!"

The moment Nadya walks in with Boris, I know why he has never married. Every inch of him screams it, from his graceful movements to his elegant clothes, to his bracelets, and especially his petulant conversation about a film producer, who evidently deserted him.

247

"You do not have a maid?" he inquires as I bustle about making tea.

"She's off on Sundays."

He is disgusted, but not only with that.

"When Nadya wrote me to come stay with her on the Grand Concourse I thought it was like . . . like . . ."

"The Champs Elysées?"

"Something like that. Yes. But when I saw it . . ." He waves his ringed fingers in exasperation at the Bronx.

"I never knew we had a film director in our family," I say, searching for some common denominator and wanting to change the subject, although Nadya is so sweet she hardly notices the ungraciousness of her guest. "I never knew there were any more artists in the family."

"The whole family is full of artists," Boris replies. "You never heard of Natasha, the concert pianist?"

"Never."

"She played everywhere. In Moscow and Saint Petersburg. In Paris and Rome. She wore always black velvet pants. A great musician. How is it you never heard of her?"

"Nobody ever told me." I have a pang of annoyance that I am not the only artist, but I am dazzled by this strange creature, this George Sand of the concert stage, my unknown relative.

"He is handsome, Lilitchka," whispers Nadya as they are leaving.

"He is handsome," I whisper back.

Associated American Artists is no more. The name remains. Sylvan Cole, a young employee, runs it as a print gallery and mail-order house. The paintings are returned to the artists; some work is now homeless, some scattered to other galleries. Estelle Mandel left long before and opened her own place as artists' agent for illustrators.

Bogged down with all the paintings returned to my studio, and indecisive about what to do, I agree to have a show in hinterlands at the Ann Ross Gallery in White Plains. The lady who runs it seems to be a nervous type. Anne and Max Geismar reassure me. They say they'll have a party for me opening day

in nearby Harrison. The Sunday in March that the show opens is bleak and gray. Ann Ross, my temporary dealer, says, "I hope someone will show up." I reassure her. Hell, she is supposed to reassure me. Bored couples begin to drop by, quickly look at my paintings, but can hardly wait to get back to golf or a Sunday nap. I curse myself for having this show.

Anne and Max Geismar appear with Doris Lilly, who wrote *How to Marry a Millionaire.* She is with Roger Donaghue, a former prizefighter, and a writer from Chicago, lanky and Swedish-looking Nelson Algren. He likes my painting "Green Lady." After the show, I am to drive him to the Geismars'. I take a long, lingering look at the walls where my miniature retrospective hangs.

A long narrow nude, "Springtime for Amy," my daughter on the verge of puberty. "Siblings"—two sisters. "Dancing Class"— girls in red leotards. Jo Ann careening wildly on a bicycle, "Look, Ma! No Hands!" and "The Yellow Flower." I look at "Bootlegger's Bay" which I shall never see again and "The Road to Algom," a virgin landscape of rocks, trees, and a new path into the wilderness. All these found objects I have left here in White Plains to be seen by strangers.

I am glad when we get to the Geismars', where I console myself with drinks, but not too many because I have to provide wheels for Nelson's return to New York. He doesn't drive. Never has. We are both quiet as we ride down the West Side Highway punctuated with lights from the Palisades and the arched span of the George Washington Bridge. I am thinking about the death of my gallery after thirteen years, and this new show, wasted in White Plains. Nelson tells me this visit of his to New York is different. Last time *The Man with the Golden Arm* won the National Book Award. This time, nobody cares. It is worse for him than for me. I never reached such heights.

When he comes upstairs with me, we look out the window where the moon is hanging in the sky round as a street lamp, and we put our arms around one another and find solace. Our disappointments disappear and we are glowing with hope. "Lily-O, Lily-O," Nelson writes from Chicago, as he describes a day

like a painted wheel and leaves me limp with love. He embellishes his letters with a drawing of a crocodile listening to a jukebox, an owl, or a horse. He is pleased that I remember the song "Cohn on the Telephone." I write him about a horse with a blond mustache that I saw near the Plaza but could never find again. The more letters we write, the more we feel our choice is love or loneliness.

Anne Geismar's comment when I tell her Nelson and I are in love is, "Not to marry. A lover, yes. I think he'd be a great lover, but not a husband." She shudders at the thought. "I'd like him for a lover."

Dr. Fessler's reaction when I give him a book of Nelson's short stories to read, *The Neon Wilderness,* and tell him it is poetry in prose, says, "All right. He's Dostoevski. Who wants to be Mrs. Dostoevski?" I do. Just the same, the world I have just left, the world of a uranium king, is a far cry from Nelson's world of prostitutes, junkies, and convicts.

Nelson flies back to New York and I pick him up at the airport. He is ashamed of the miserable hotel where he is staying. It reminds him of failure and past glory. Nelson seems uncomfortable in the present. He is happier in the past or thinking of the future, but maybe that's a writer's predicament.

When he comes to the apartment, he makes Amy nervous. "He's like a tiger," she says. "He paces like a tiger." Maybe so. Probably being stared at by two little girls upsets him. But not nearly as much as any new man in my life upsets them. Nelson invites me to visit him in Chicago.

I have read Simone de Beauvoir's *The Mandarins,* which she dedicated to him, and it is about him although she uses another name in the novel. Nelson refers to her as "Frenchie" and says she is a schoolteacher type. I don't know what type I am. But when I visit Nelson's little house on the dunes in Gary, Indiana, a little Mexican cloth on the door is exactly as she described it, just as Nelson's falling asleep is, with his mouth open like a fish gasping for air, as well as the burble of morning coffee. It is like having an affair with the script already written. One episode in the cottage on the dunes is my own. We go for a walk in the rain and Nelson dries my hair with a towel when we get back. That didn't happen in *The Mandarins.*

But going to a rundown bar on the seamy side of Chicago did, and we do that. When a hooker reels over to us and calls Nelson "Father" because she thinks the white edge of his T-shirt is a collar turned around, Nelson gets restless. She drapes herself over him, breathes alcohol in his face, and says, "Father, I have sinned. Won't you accept my confession?"

"I'm not a priest," Nelson says, and turns to me. "Let's get out of here. Let's go to the Spectorskys' for some big party they're having."

"But Nelson, you told me we weren't going to any parties. Look at my dress."

"It's nice."

"It's not what you wear to a cocktail party. It's a cotton house-dress."

"Don't think about it. It doesn't matter."

The moment we walk in I know it matters. The Spectorskys' little girls in new spring dresses are passing hors d'oeuvres and there is a huge crowd. Mrs. Spectorsky doesn't object to Nelson's T-shirt—it's expected of a writer; but she eyes me among the ladies in their elegant outfits as if I were a blemish on the scene. She cannot remember my name. Every time she introduces Nelson to someone, she draws a blank on me.

"Please, Nelson, let's sit down somewhere. I don't want her to forget who I am again." Once or twice was permissible—but so many times . . .

"Sure. Oh, there's someone you'll like." And he points to a young man in a sweater. "He's a new comedian fresh out of San Francisco. Mort Sahl." The three of us sit in a corner. Listening to the young man's comments about a writing priest, about the begloved and bedizened ladies in their hats like gardens, it doesn't matter if Mrs. Spectorsky remembers my name or not. We're laughing too hard to care, and later, when we go to a coffee shop, the sign NO WEE BITS convulses us all over again.

Nelson and I pay a visit to his good friend Studs Terkel who plays rare records for us, and then it is time for me to go back to reality, to New York and then to the remodeling of the house at the Cape where Jesse Meads wonders how I can sleep at night and so do I as I write checks for thousands of dollars more than I anticipated.

Nelson has finished his new book, *A Walk on the Wild Side,* and is to visit us in Provincetown after a brief stop in New York. I pick him up at the airport.

"I sold it."

"Oh, good. We'll celebrate."

But by the time we have reached the house ten minutes later, Nelson is deep in gloom.

"I shouldn't have sold it."

"Why not?"

"I was having a drink with this cat and I got carried away. Probably got screwed again. Like the time with Preminger and the movie of *Man with the Golden Arm.*"

"Wasn't your agent with you?"

"I signed something. Better find out what it was."

Sure enough, when he phones his agent, she tells him he has done it again—unloosed a pack of lawyers. We stroll through the town. "It's a nice outdoor town," he says as we watch a man getting a haircut in a barber shop all open to the breezes.

He is fascinated by Jimmy Thomas with his Christlike face and his crippled body that manipulates the machinery for the bulkhead to hold back the sea.

"We should get married. You could put the girls in an orphanage," he suggests playfully, "and we could move to Marseilles. I'd like to own a prizefighter."

But I wouldn't. Nelson goes back to Chicago, falls in love with Geraldine Page, and I stay at my house in Provincetown which I call Harmony.

Max Geismar's new book, *American Moderns,* is being published and I give him a party in honor of his literary essays about the authors whom he invites, from James Jones, who arrives looking like a small, strong pugilist, nattily dressed in a dapper Wall Street outfit, to William Styron, whose *Lie Down in Darkness* sent Max into a paean of praise, to a promising young writer, Tom Chamales. The artists whom I invite mix well with the authors. Nobody is jealous of anyone. Zero Mostel, deep in discussion with Max Geismar, is so absorbed that he doesn't even

try to steal the scene. Nelson sends a telegram, but doesn't come. We write to one another for a long time. He looks for my name on the art pages of the Sunday *Times*. I look for new books of his.

I go to art galleries less and less. There is danger of running into Joe at openings and I hate the eyes eager to watch our encounters. In addition to this hazard, my sister, whose marriage folded at about the same time as mine to Joe, decides to become a sculptor. She haunts the galleries. "My sister wouldn't be caught *dead* at one of your functions," she says to the president of an art organization I support, and tells me about it as if she did me a favor. I am shocked. "How dare you put words like that in my mouth? I would have gone if I could." Mom and Pop, as usual, say she meant no harm. My sister can do no wrong.

We love the Cape so much that we go there for every holiday. It has turned out to be what I hoped, and the girls have friends there as well as in New York. They love going at Eastertime when the crocus and daffodils jump up, and especially at Christmas to marvel at the sight of the Provincetown monument strung with lights and to decorate the house with greens and make a frieze of Christmas cards. The air is fresh and clear. "It smells so good," they say. Driving up, no matter what time we cross the Cape Cod Canal, they have to be waked up to say, "We're here." It is as if we left the country and were in a foreign place. "We're over the Sagamore Bridge. We've left the United States." We are in our own world.

"I'm so tired of New York and the hustle and bustle," says Geraldine Morris, my friend who is a publicity agent and used to be married to William Morris.

"It's plenty quiet here. Why don't you fly up?"

Gerry breathes in large doses of clean salt air and loves the house, the tree all festive with a background of winter-blue ocean behind it.

"Come downtown shopping with me. I have to get some Portuguese bread. It's all chewy and marvelous. It has a great crust."

The streets are empty in the winter and I park in front of the

bakery where a small sign catches Gerry's eye: WE HAVE FLIPPER DOUGH.

"What's that?"

"It's the raw dough before they bake it. You can make it into bread or rolls yourself if you want to. The Portuguese make it into pancakes. They stretch it and fry it and then serve it with syrup or honey. It's delicious."

Gerry holds the bag of warm dough to her bosom, enjoying the sensation of the yeast that feels like a little warm baby. It moves. It is alive.

"It's such a great name, Flipper Dough," Gerry says at breakfast. "The pancakes are marvelous." A light comes into Gerry's eyes. "It could be marketed. I can see the town wharf with young girls in Portuguese costumes handing out free samples to the tourists when they come off the boat from Boston. 'Do you know/ Flipper Dough' " she sings and bursts out with a television slogan. " 'Let's go/ With Flipper Dough.' " She builds an empire of dough and wonders if it could travel daily to New York in the fishing trucks that go to the Fulton Fish Market without absorbing the smell.

I try to divert her mind from this obsession and take her with me to the dump where hundreds of gulls circle and cry over the trash, but she pays no attention. I drive her to the ocean side, commonly called the Backside, where winter waves are rolling in pink with the reflected light of the sunset, but it is no use.

"I'm sure I can get financing in New York on the name alone, but we mustn't lose sight of the fact that it will create industry here. There can't be any work here in the wintertime." She's right about that. Almost everybody is on welfare or unemployment.

"We'll change all that," Gerry says, sweeping poverty away with a majestic wave of her hand. "We'll create jobs." She has included me in her plans. I'm not sure I want to go along with them.

"It's not fair if we don't give local people a chance to participate in this. Now, who in town has any money?"

"Nobody."

"That can't be true. There's always *somebody*. Who's the local big shot?"

"Judge Welsh."

"We'll go to see him. We won't tell him what our idea is, but we'll tell him it's something that can take this town off the hook."

Judge Welsh says that Mickey and Velvel Finkel are very enterprising. I know Velvel. He sells me lobster at the wharf. There's something wonderful about buying it from a Jewish fisherman in high boots.

"But Mickey is the business brain," says Judge Welsh. "He's the one to talk to."

"We'll call him the minute we get home."

When I give Mary Saults the number, she doesn't ring it. "They've gone to New Bedford, Lily. Nobody home. Shall I try them there?"

"Try them there," Gerry insists.

A sad voice answers. "We can't call Mickey or Velvel to the phone. They're sitting *shivah* for their father."

Only death could have stopped Gerry, and here it was.

"Leave your number anyhow. Tell them who's calling."

The more I think about Gerry's idea after she goes back to New York the less I like it. I don't fancy myself as the Flipper Queen of Provincetown.

Mickey Finkel doesn't phone. He just shows up—a local custom.

"This place must have cost you a pretty penny," he observes, looking around. "I heard about you, that the locals took you."

I'm tongue-tied, but Mickey isn't.

"You're a member of the Art Association, aren't you?"

"Yes."

"Well, I have a ninety-nine year lease on some Provincelands. You could sell the Art Association the idea of building on it."

"I'm a new member. I haven't any voice there—and besides. . ."

"Doesn't matter. Tell them about it anyhow."

"I'm sorry about your father."

Mickey sighs deeply. "Fathers and sons! I have a son. You know what he wants to be?" I have no idea, but from the way Mickey looks, it must be awful. "He wants to be a musician, that's what!"

"What's wrong with that?"

"What do you know? An artist. You're all alike. How is the boy to get along? What's the matter with children?" It finally occurs to him. "What was it you wanted to talk to me about?"

I had almost forgotten. Flipper Dough.

"Nothing important."

Back in New York, Amy, with stars in her eyes, has been asking all my friends if they know David Rothman. She has had a crush on him ever since he peeked at her from behind the hedge our first summer in the house on Cook Street and almost hit her square in the eye with a ripe tomato.

"What shall I do about it?" I ask Roz Roose, who knows everything. I call her The Source.

"Invite David and his father for dinner."

"Who's his father?"

"Henry Rothman. The framemaker. You've met him."

I remember. There was a picnic at New Beach. In the frenzy of activity, with everybody carrying hot dogs and hamburgers, and the children sent scurrying down the beach to gather driftwood, I noticed a man sound asleep in a convertible. That's the laziest man I ever saw, I thought. He was perfectly relaxed, oblivious to everything, with his hat pulled down over his eyes to shield them from the last rays of sun. When we were driven off the beach by an onslaught of gnats, he came with all the others to our house on Cook Street. He said I made good coffee.

"But I don't really know him."

"Doesn't matter," says Roz with a certain look in her eye. "He'd love to come." I decide to take a direct approach.

"Look," I say when I phone Henry Rothman, "my daughter seems to have a crush on your son. Perhaps all she needs is to see him to get over it. Maybe she'd stop mooning and bothering my friends. I hear you're a good framemaker and I need to have some drawings done. What if I came over Saturday with them? I'll bring Amy." Henry chuckles.

"Can I go with you?" Amy asks as I wrap my drawings and tell her I am going to Henry Rothman's shop on Twenty-eighth Street. "Will David be there?"

"I don't know."

Fifty-seven West Twenty-eighth Street is a narrow building in

the heart of the wholesale flower district. I look for a sign, but there isn't any. An armed guard of gladiolus pokes stiffly out of long cardboard containers at the entrance where a tiny card glued on one of a battered row of mailboxes says HENRY ROTH-MAN. FRAMEMAKER. 4TH FLOOR.

"Up here!" a voice yells from far above our heads.

We struggle up the dusty stairway through large wooden tree trunks outside Michael Lekakis's studio and street trophies on all the other floors. The frame-shop door is open. Pinned to it are notices of art shows long gone.

Sawdust is flying from a table saw where Henry is working. His head is bald, his clothes are thick with dust. His body is masculine and stocky. He looks comfortable. Bach is emanating at a high-decibel pitch from a stereo. A young helper with a great mass of curly hair is running a soft brush through it to attract electricity and picking up quivering bits of gold leaf to fasten to the red clay of a frame he is finishing. Lengths of molding are overhead, sticking out of racks on the ceiling. On all the surfaces—on small and large chests of drawers, on architects' blueprint cabinets of marred gray steel and oak, on large furriers' cutting tables pitted where skins once were pinned—on all of them is a litter of tin cans holding brushes, paints, pictures, and frame corners.

I look around to see if David is there, but there is no young boy. When I unwrap my drawings, Henry tosses the brown paper and string into a bin where he stores them.

"I want these matted in off-white board. And simple frames."

We try on various corners and select a walnut molding.

"I'll have them in about two weeks. Would you like to see my collection of Peruvian and Coptic textiles? I live one flight up."

We fight another obstacle course through more rescued objects and on the top floor the light is filtering through a small skylight and illuminating a whole wall perfectly hung with framed fragments.

"My *shmattes*," says Henry. His rags.

"They're like Klees," I say reverently. I pick up a small pre-Columbian figure standing on a shelf. The space where it was standing is surrounded by a patina of dust.

"My mother cleans the apartment when I let her," Henry says.

I put the statue back in exactly the same spot where it was. "She lives in Brooklyn with a crazy roommate who puts a fur coat on every time she opens the refrigerator door. She says she catches cold easily. My mother likes to get away from her once in a while. But I hate things moved." I can see why. They are arranged to perfection. "Even a quarter of an inch off bothers me." I understand that. I am the same way.

In the front room facing the street, the long windows are open to the screeching sounds of the flower trucks. An ornate Franklin stove has a black pipe that disappears into the roof. On one wall is a collection of carved wooden letters, on another an African mask garnished with seashells and limp, hanging feathers glares menacingly. Fish bones, white and still smelling of the sea, are mounted like sculpture on stands. Henry opens a door to a large darkroom.

"I didn't know you were a photographer."

"I make color slides," he says modestly. "I'll show them to you sometime."

David darts in suddenly through a window on the fire escape.

"Hi!" he says to Amy.

"Hi!" she replies. And then he is gone out the front door.

Walking down to the street of flowers, Amy says, "He's not so good-looking."

"Who? Henry?"

"No. David. He's not as good-looking as I thought."

"Would you like a cup of coffee?" Henry asks when I come for the drawings. At a small restaurant nearby we discuss the difficulties of bringing up children. Henry tells me he has custody of his son, that David's mother remarried and has other children. She seldom sees him. David doesn't want to practice the clarinet, an instrument Henry dearly loves. I complain about bringing up the girls with a father they rarely see and how they resist their piano lessons.

We bump into Zero Mostel sailing down Twenty-eighth Street lightly like an air-borne blimp. He has a beret cocked jauntily on his head. Right now, Zero's engagements are few and far between. He has been blacklisted and has plenty of time to work

on his paintings. He was an artist before his career as an actor, and still is.

"I haven't seen you since you talked me into doing *shtiklach* for the Artists League Ball," Zero bellows, wringing my hand and locking his leg into mine. I back away. "You married that rich collector—Joe Hirshhorn. What are you doing with Dumbo here?"

"He made some frames for me."

"He makes grounds for me. He slaps gesso on anything and I work on it. What's happened to you?"

"I'm divorced. I have two daughters."

"How old?"

"Twelve and nine."

"Good. Perfect. We'll marry them to my sons. The rotten kids don't know what they want anyhow. Have your girls got money? Of course they have money. I'll make a deal right now," he thunders, waving his tiny hands and waltzing his large frame gracefully on his small feet. "How much is the dowry?"

Through Henry, I seem to be a member of the Twenty-eighth Street Gang, a group of artists-in-residence in lofts they are not supposed to live in. Whenever the news whizzes down the street that a building inspector is on his way, the artists bolt their doors or escape to a movie. There is the dashing Italian painter Remo Farrugio and his meltingly romantic wife, Ella. There is Ngoot Lee, a Chinese artist who canvasses all the floors of the Salvation Army as well as every thrift shop in New York for treasures. His loft is packed with them. "Z and I are going to open a restaurant. We call it 'Ju Fu,' " he says. "No. I'm going to invent a perfume," Zero counters. "Call it the simplest thing. 'Fuck Me.' Get right to the point."

There is Carter Winter, with whom Henry vies constantly for perfection. Carter is an industrial designer who sets the highest standards for himself—whether designing a chair, a houseboat, or a catalogue for a lighting company.

Herbie Kallem, Zero's closest friend, is a sculptor in metal. I join the class in his studio on Twenty-eighth Street and learn soldering. Oddly enough, Sidney Kingsley, who wrote *Men in White* is one of the students. Herbie takes me to Canal Street to

buy tools. Soldering irons. Heavy reels of lead and copper. An anvil. Findings of copper and bits of plumbing fixtures. I build my first figure on an armature. The flat piece of copper I drape from it looks like a king's robe. I top it with a mass of lead glob for a head and use the sizzling point of the soldering iron to burn an eye socket deep into it. I add an authoritative beak of a nose, and, to my surprise, when I add a faucet for a crown, it is a little full-length figure of Joe Hirshhorn. It looks just like him. A portrait. I call it "The Cold King" and make a seated companion figure—"The Hot Queen"—using the other faucet.

"Who poses the model?" I ask when I join Herbie and Zero's sketch class on Saturday morning.

"You do," Zero says.

"Sure, you do it," says Herbie.

"Do you want long or short poses?"

"Doesn't matter." Zero is setting a canvas on his easel and squeezing paint on his palette.

I see what they mean when we start. Neither of them is paying any attention to the model, a buxom young lass. Zero is working intently covering an old canvas, and Herbie is making abstract acrylic sketches, taking a line here or there from the model. Her stomach shakes with laughter from time to time as Zero makes lascivious cracks at her.

"But why do you have a model at all?" I ask when the three hours are over.

"We like company. It gets lonesome," says Zero.

Zero, who behaves like Harpo Marx in restaurants, is different in the studio when there is no audience. He has a small etching press and I bring an incised plate for us to pull a proof. It has been such a long time since either of us did any intaglio that we have difficulty remembering the process.

We soak Rives paper from Zero's collection of fine papers, remember to warm the plate, then daub ink into it with tarlatan. We run the print through the press, turning the star wheel. When it emerges from the blotters and blanket that cradle it, and we lift the paper above the plate and see that every line has registered, we are like happy children.

"It works!" says Zero. Which is more than he is allowed to do now as an actor.

The portrait I paint of Henry takes only two hours, but I think it is a good one. *Alla prima.* All at once.

"It's perfect," Zero says. "I can almost see the dust flying out of him."

Henry's head is like a Buddha. Perhaps he suggests J.B. Neumann, our maven in art, to Zero and me. J.B. was at almost every performance of *Ulysses in Nighttown* chuckling appreciatively when Zero and Carroll O'Connor jiggled on a bench as if they were moving violently on a carriage seat.

Henry courts me with anemones, my favorite flowers. I love the way the tightly closed red, purple, white and mauve blossoms burst into fullness as soon as they hit water. I love them even as they die and their petals bend backward before they fall.

Driving to the Cape for the summer, again we pass Pilgrim Lake, a deep mud-green watery turmoil ruffled with horizontal whitecaps. The long dune reclining in back of it is accented by a dark blue sky. All along the Mid-Cape Highway, the willows are the first to show spring in a haze of bitter yellow, but the buckets of gold bushes aren't out yet. The first motorboat of the season kicks up spray and a semicircular white wake as it tears noisily through the harbor. In the distance, the nets of the weirs drawn up on stakes look like the tulle of ballet dancers' skirts.

When Henry comes to Provincetown to stay again at the Nonie Bell, the little fishing shack he rents every summer, we continue our courtship at the Wellfleet dump, presided over by Andy. An unlikely cupid, he appears naked to the waist and sweating freely, with his fat slug-white stomach protruding over his tightly belted pants.

Andy is an artist. The entrance to the dump is a happening, with a funeral wreath hanging from the gate and a battered doll peeping out of it. Things Andy cannot bear to see demolished he rescues and arranges around his house in categories. Plumbing parts. Iron hardware. Torn scallop nets. Doorknobs. Copper pipes. Broken furniture. A constant yard sale. Wrecked cars

recline in a gulley where grass and foliage triumph over Fords, Chevies and even Cadillacs in their final resting place. Shattered glass windshields have masses of spidery-net crackles and living bugs ooze from ripped upholstery.

We are flattered when Andy leads us down steep steps to his secret place in the basement. Nothing is for sale there. In the dim light at the foot of the stairs, a life-sized mannequin stands guard with a black lace shawl draped over her shoulders, a faded silk red rose at her bosom, and a high black evening hat tilted rakishly over one eye. She gives me quite a turn.

On the shelves are Andy's toys. Mechanical banks, tin soldiers of long ago, Erector sets, bisque dolls, articulated cardboard figures on strings, lacy valentines, teddy bears, trains and cabooses. Andy works on them in the long winter months. He waits for their missing parts to show up at the dump and then reconstructs and repaints everything as good as new.

Andy, pleased with our reaction to his treasures, picks up a chair outside.

"Here, I want you to have this."

"We couldn't."

"Yes, I want you to have it."

Our first present. It is almost perfect. Only one rung is missing. But Henry says he can fix it.

When Andy dies, the first thing his wife does is clean up the yard. The old Paige Brothers bus that used to amble down Commercial Street that Andy had stuffed full of junk with a clutter of books goes; then the hammock that stretched from tree to tree holding incongruous objects disappears. The water-closet jugs, faucets, and parts of things vanish. Where? Maybe back to the dump where Andy found them. His wife always hated the mess.

That summer, Katie, Zero, and their two sons, Josh and Toby, come up to Provincetown. They have a huge old secondhand Cadillac without power steering that Katie maneuvers like a pro. They rent a little cottage behind the Patrician Shop with a floor tilted at such an angle that Zero complains he is seasick when he wakes up in the morning. We all go to Race Point Beach and

afterward, in the big living room of the new house, we play flamenco records.

Katie, who used to be a dancer, and Zero start a tango. Katie twirls out through the front door, picks a rose, and comes back with it in her teeth. Zero, stamping his small feet and clapping his hands above his head, makes the floor shake. He dances straight out the front door, down the steps, all around the house, comes in the beachside door and joins Katie without missing a beat while we all yell *Olé! Olé!*

While I am ironing curtains for Gus and Arnold Newman, the first tenants of my small rental house, Katie drops in and watches me for a while. I have terrible bursitis in my shoulder.

"Here," Katie says, grabbing the iron from my hand. "I love ironing. Let me do it." She finishes the curtains; I cannot make her stop. I try to express my gratitude, but she will not hear it. "*Zug garnichts,*" she says. Say nothing. She has picked up one of Zero's favorite expressions, and it sounds funny coming from her Irish lips.

Joe is coming to the Cape to see the girls, but perhaps he is also curious about the house I have remodeled. Herbie and Sally Kallem are my house guests. I find myself shaking with fear the night before his arrival. At an opening of an art show at Tirca Karlis's I start to cry. Mercifully, my guests and Henry hustle me out to the darkness of Commercial Street.

"What's the matter?"

I can't talk.

"Would you like some ice cream?" Herbie suggests.

"Swiss chocolate almond with hot fudge, nuts, and whipped cream?"

"I want to go home." I cannot stop crying. At home, I accept double Scotches.

"Maybe I'm upset because Joe is coming tomorrow," I say when I finally calm down.

"So what?" Sally says.

"So I can't stand it, that's what. It's my house. I made it, and

he'll find something wrong. I don't want him criticizing it, that's what." And I tell them about the hall light in Port Chester.

Henry realizes for the first time that I am vulnerable, and for the first time puts his arm around me.

At lunch the next day with Herbie and Sally, Joe, who has toured the whole house and found everything charming, looks up at the brass chandelier above the table.

"Don't you think it's too shiny?"

"It's perfect," says Sally belligerently.

"Couldn't be more right," Herbie says firmly.

Henry strolls by casually when Joe and I are sitting on the deck. He comes up the beach stairs and I introduce them.

"And what do you do?" Joe asks.

"I used to be on Wall Street."

"Retired?"

"Something like that."

"What on earth was that all about?" I ask Henry later.

"It was true. I *was* on Wall Street once. For about three days. Delivered messages. I hated it."

Al Leslie, painting abstractions in my little garage-studio and living in the house next door, drops in. All during his conversation with Joe the phone rings with dealers asking, "Is Joe visiting the children?" They are out playing on the beach. "Tell him to drop in. I have some nice paintings to show him."

"How do you price your paintings?" Joe asks Al Leslie, and there is a faraway look in his eye as he differentiates the artist from the businessman, putting him in some rare climate.

"By the square inch," Al answers.

"What?"

"Five dollars a square inch."

Joe looks hurt, devastated at such a cold-blooded approach, but I am enchanted.

"Yes," says Al, sticking to his guns. "That's the way I do it. By the square inch."

Pruning the rosebushes, I rush in to answer the phone. It's Joe, back in New York, or Toronto, or somewhere.

"Do you have five thousand dollars?" His voice is cheery.

Honest John, I answer, "Yes."

"I'm buying some stock for the girls. A winner. I think you should go into it."

Anxious to get back to the roses, carried away by the urgency and energy of Joe's hypnotic voice, I say yes. So I am still not impervious to Joe.

When I pick up the shears again, I wonder at myself. Snipping vengefully at the dead branches, I cannot understand myself. How can I be doing this? In New York, the superintendent of our apartment house asks me all the time what to do with the worthless stock he bought with his life savings. I take off my gardening gloves and call Joe back and do the unthinkable. I renege.

"I mustn't buy that stock. I'm not in a position to speculate."

But I speculate about greed, which seems ingrained in me as well as everybody surrounding my ex-husband.

The summer settles down. It is a happy one. Nicky Meyer, the precocious son of Buddy Meyer, a psychiatrist down the street, makes a movie which he calls *Around the World in Eighty-one Days.* I invest five dollars, as do other parents of the small thespians, the oldest of whom is fifteen, and also contribute a laundry basket to be suspended from a balloon. In the cast, bearded Joe Kaplan, an artist, becomes a crusty old sea captain and Jo Ann borrows a sheet to wrap around herself. She is one of the extras in a mass Arab scene on the dunes, which have become a desert with a whole group of kids running madly about and dying of thirst. The climax comes when they are all about to expire. There is Howard Johnson's—an oasis. They all eat ice-cream cones and are saved. I never get my laundry basket back. It was demolished in an unfortunate accident. The movie is previewed by a large group of proud mothers and fathers. Much later, Nicky Meyer goes on to write a book, *The Seven Percent Solution,* and then the movie, both of which pay off a lot better than his first effort.

Is Henry a Renaissance man or the last Bohemian? I do not know. All I know is that I enjoy seeing him and the girls are comfortable with him. His color slides are incredible and artists

glean ideas from them. Henry has an eye. He focuses in on the peeling paint of a beached boat, oily scum floating on water, a brilliant blue summer sky seen through an ordinary white deck chair, and transforms them into abstract images. He seldom does people. He finds it hard to invade their privacy. We row out to the weirs in Henry's rowboat and duck low, circling around the nets drawn up on poles as Henry snaps shots of them. We try not to get enmeshed.

But I am getting enmeshed, and it scares me. I choose flight. Flight, as in a trip to Japan. Perhaps distance will lend clarity. In any event, it will postpone a decision. At the last moment, an artist friend, Charlotte Rubenstein, joins me. We change all the reservations to a trip around the world so that she can meet Sparky, her husband, in Paris.

Nobody tells me Charlotte is accident-prone. The very first day in Tokyo, her comfortable shoes with the zigzag bottoms catch on the brass rod of the carpeted stairs in the hotel, and she falls, barely missing the crown prince, whose wedding is the next day. An international incident has just been avoided. TOURIST CRUSHES PRINCE. Headlines.

"I only wrenched my hip a little," she sighs with relief. I hover over her. We have thousands of miles to go, reservations to keep and planes to catch.

We have a letter of introduction to Tetsuo Yamada, who has a gallery on Shinmonzen Street in Kyoto. Tetsuo speaks excellent English and welcomes us warmly. Through him we meet a Japanese artist, Hidetaka Ohno, and an American poet, Cid Corman, who is a philosopher volunteering a credo which I assume is his: "To let be, to offer, to respond," rather than "To give, to sympathize, to control."

"You and Ohno are relatives in art," Tetsuo says after he looks at color slides of my paintings. We are invited to Ohno's studio. His wife kneels before a large platter on which are thin slices of meat, chrysanthemum leaves and many-colored vegetables.

Ohno speaks not one word of English, but Tetsuo tells him I would like to try his painting medium. He shows me how to mix his water, glue, and powdered pigment mixture, and I paint half of a long horizontal canvas. My Japanese relative

finishes the other half and we sign this unique work "Ohno-Harmon."

Tetsuo's wife, a schoolteacher, walks behind us in the street and observes her husband opening doors to coffeehouses for Charlotte and me.

"A geisha boy, that's what I am!" he says after lighting innumerable cigarettes for us, and he bursts out laughing. His wife smiles discreetly behind her hand.

At the Moss Gardens, there is the sound of water running through a bamboo channel. We meet a Japanese manager of a plastics factory who wants to practice his English. He spends his lunch hour in the gardens each day. When we ask him why there is a click-click in this silent place, he says, "It is to make you hear the silence."

We think Katsura is the most beautiful and serene house in the world, with its moon-viewing pavilion, the gardens planned with the interruption of a fence like a pause in music, and the stone lanterns placed near water to attract fireflies and reflect their tiny glow at night.

At a long counter, a line of cooks toss vegetables in the air and twirl their chopsticks in a ballet of cuisine. We sit in front of Tetsuo Yamada's favorite chef, who has the hypnotic appeal of the pancake flippers in long-gone white-tiled Childs' Restaurant windows. This is our farewell meal. At the gallery, an American man is browsing through some prints.

"Didn't you see him here yesterday?"

"I don't know. They all look alike to me. They're all tall and they wear glasses."

A postcard from Jo Ann.

DEAR MOMMY—I wish you didn't go this year. This year we have the Mother's Western Luncheon and I bought the paper plates and napkins. That is why I didn't want you to go to Japan. Since you went, have a wonderful, wonderful, marvelous time.

Henry writes news about Amy and Jo Ann. He phones them almost daily and drops in to see if they are OK, although Winnie

and Ann are there to take care of them. He also sees to it that my paintings are picked up for the Art USA show.

DEAR UTSUKUSHIO (means beautiful in Japanese)—I am reading in Will Grohmann's *Klee* about how anxious the old maestro was to travel every summer, and just what these trips meant to him in terms of his work. It is interesting to note that with all his interest in Oriental art and Buddhism, he never went further away than North Africa. Some other time, I'll describe to you his reaction to travel and new visual experiences. I can understand the reason for your hegira better now.

How kind Henry is to say this. Although part of my desire to see the East was motivated by an attempt to avoid a decision about him, the farther away I get, the more lonesome I am.

Seen from the air, Repulse Bay in Hong Kong is full of boats glittering in the sun like a cluster of bluebottle flies. I have a mission for Seong Moy, to visit his mother, with James Moy, his cousin, to act as interpreter. Cousins, friends, uncles, aunts, and Seong's ancient grandmother, as well as his plump and amicable mother, advance.

When I give Mrs. Moy the latest photographs of the grand-children she has never seen, her eyes fill with tears. Through James, I tell her about her son's accomplishments as an artist and teacher and what a perfect wife she sent her son. We wind up without words, hugging one another as though I could take all her love in my body and carry it around the world back to Seong and his family.

In Macao the drugstores are full of glass jars bulging with snakes, eels, frogs, and other remedies—a whole witches' brew. We try to photograph the Chinese border, but the guide frowns and makes us put away our cameras. I sketch instead and draw the bucolic scene of a gate with a red flag flying and farmers with produce going back and forth.

"Conditions are terrible over there," the guide says and the tourists nod, but it looks the same to me on both sides.

Our handbags are heavy with bronze trophies from Bangkok.
Temple birds. Small hands severed from Buddhas. Khmer fig-
ures. Bangkok was hot, but India is hotter. One hundred and
twenty-five degrees in the shade. No matter. We choose to go
south, preferring to see people rather than to be isolated from
them on a houseboat in cool Kashmir in the north. The sun
beats into the windows of the car so strongly that we festoon
them with our panties and nightgowns. We dip our handker-
chiefs into the melting ice around the Coca-Cola container that
the driver is sure all Americans love and hold them to our hot
heads.

Peacocks strut by the roadside and unfurl their tails. White
cows have eyes so iambent and black that I can understand why
no one can eat them. They look like people.

"Your elephants are on the way," says the clerk at the Ram-
baugh Palace.

"Who ordered elephants?"

"They are on the road."

"Call up some gas station and cancel them," says Charlotte.
"We're too tired. All we want is water."

"Very well, madame. Elephants come with your reservations
—but if you don't want them . . ."

"We'll pay, we'll pay."

"There is an indoor pool."

"Not for me," says Charlotte. "A bathtub will do."

A tall turbaned bearer leads me to the maharajah's pool,
strung with overhead trapezes. There is scum over the whole
surface.

The bearer motions to me to be patient and calls a small boy.
Together, they walk on either side of the pool, skimming it with
a large cheesecloth net as if it were chicken soup. I plunge in
and swim in the silence broken only by the sounds of little scur-
rying lizards.

"Doesn't this landscape remind you of something?" I ask
Charlotte as we drive from the airport in Israel to the Hotel
Accadia. It is night, and all of B'nai B'rith arrived with us.

"Truro," she says. "We've come all the way around the world to get back to the Cape."

We are permitted to stay at our hotel only three days despite our week's reservation. B'nai B'rith has swallowed up the country. We are rescued by a Sabra lady who takes us into her own home, where we recover from the diarrhea that has overcome both of us.

The trip is getting faster and faster. In Athens, the Acropolis is East Rock with a difference. Not a photograph I ever saw prepared me for the scale of the Parthenon. In Paris Sparky meets us. He and Charlotte continue on to London and I go home to my daughters and decisions, decisions, decisions.

With the three-year deadline of my separation agreement closing in, I must give up my beautiful rented apartment on Central Park West and buy a co-op. Riding up in the elevator of an apartment building on Fifth Avenue to be approved as a buyer, my heart sinks. The ambience is all wrong. The view is all sunsets in the west, and I prefer seeing the dawn and looking at reflected evening light striking small fires in the windows of the buildings across the park. I cannot imagine the elevator man exchanging a pleasant word with the children. He is positively forbidding.

So is the whole board of directors when I am ushered into a penthouse of the chairman of the co-op. It is to be an inquisition. I can see that. "Where do you bank? is the first question. Then comes, "Are you divorced?" "Do you live on alimony?" and "Where do your children go to school?"

Looking at the faded faces of the interrogators, I realize I don't want to live in this building at all. I am sure the girls will hate it. I do, already.

"Do you mind if I ask some questions, please?" Unheard of, but they will permit it. "I noticed," I say gently, but with a touch of malice, "that the windows in this building are all casement. They open out. Who paints them? The building or the tenant?" There is an angry buzz. I have struck a nerve. "May I ask another question? I see that one's not answered easily. Where do you keep the bicycles?" A fragile old lady made of porcelain

gasps, "Where does a child ride a bicycle in New York?" "Where I live, on the West Side, there's a storage area for bikes in the basement. They ride in the park, of course." I have done it. The West Side. The old lady looks as if she will faint. The temperature in the room is easily fifty below zero—less than Blind River. I have done it. I'm sure of it. Disqualified myself.

I am rejected. The dubious honor of a Fifth Avenue apartment is not to be mine. Now I confine myself to looking on the West Side. I know all the disadvantages of my apartment—that I don't have a wood-burning fireplace or fancy paneling and that the bathrooms are old-fashioned—but I love soaking in a six-foot bathtub. I know my apartment is made for two in help —a waitress to stand rolling butterballs in the serving pantry while a cook handles the cuisine far down in the kitchen—but Amy and Jo Ann love to roller-skate down the halls. I have solved the problem the way railroads did with refrigerated cars. *Put it on wheels!* I have stainless-steel hospital carts to roll the long distances.

The co-op I find on Central Park West doesn't have as good a view as mine. It doesn't overlook the free-form lake and the Japanese bridge. It has modern bathrooms and a lot of paneling. It doesn't have plaster carving up near the ceilings and I don't love it, but it is just the amount I am supposed to spend. The man from whom I bought it accepts my deposit but changes his mind. He had forgotten, in his greed, to tell his wife about it, and she doesn't want to leave. He buys it back from me. Miraculously, a few weeks later my own apartment goes co-op. The price is so cheap that I return money to Joe, and it is wonderful to live where I want to live.

Now, back in my studio, my head is full of rocks. At least that's what Mom says when she sees my new work based on Japanese gardens.

"You used to paint people, now is only rocks. . . ."

I send a watercolor show to Yamada in Kyoto. He sends me a translation of the introduction he wrote for the catalogue. The Yamada Gallery, he says, presents for its friends its freshest prejudices, and he continues:

Lily Harmon sojourned in Kyoto for about a month for her historical evidences of fine art plus what is being done by Japanese contemporary artist from her own point of view. Lately she sent to us her recent executions with the expression of images by feminine (better word I used in Japanese) colors and also beautiful tonalities which create gracefulness of harmony. She has a studio on the seaside of Provincetown where she works during the summer. One can feel a beautiful lyric poetry of the seascape from what she has done in this location yet she has a studio in New York for winter. Again those geometric construction of New York City are transformed into lovely and poetic cityscape which we can feel her own vision. "If I am not for myself, who will be for me? If I am all for myself, what am I? And if not now, when?" That's what Lily was telling me while her stay in Kyoto.

Damn! Tetsuo has attributed Hillel to me. I must be a great philosopher in Japan. "Of course," Tetsuo continues his letter, "Japanese writing is much better in a sense, so you must understand this is very poor translation. I deeply admired your being in Japan through the understanding of 'Spring Rain,' 'A River Ran Purple,' 'Reflections in a Moss Garden,' etc. But I hope you will forget about its remembrances. And do help your desire of original nature beyond the consciousness. . . ."

I guess what he means is I am not to connect my pictures in any way with reality or title them as to their sources. And he sounds rather like some of the art critics who write for the magazines now.

When Tetsuo sells some of the watercolors, I am paid off, not in yen but in Japanese modular-sized laminated sheets of rag paper. When I draw on the thick absorbent paper in sumi ink, it seems too dry. I throw a sheet into a bathtub full of water. Soaked, it is marvelous but messy. I mount it dripping on homosote board and soak up some of the moisture with blotters. The sharp edge of the sumi ink stick runs into black feathers and large gray areas. Made bold, I rip the paper into smaller sheets, peel off layers, collage it, let bursts of yellow watercolor run into it, and use it whole for life-size drawings from models. The

paper and I have a love affair, unlocking possibilities in each other.

Will Yolen, a newspaperman and head of International Kite-flyers Association, an old friend of mine from New Haven, wants to know what's new when I bump into him, and I tell him I'm divorced from Joe Hirshhorn.

"Let's see," he says. "I remember your first marriage. It was to that boy at Yale. What was his name?"

"Peter Harnden."

"And your second was to Sidney Harmon. And your third to Hirshhorn. If you do that one more time, I'll get you on 'Hobby Lobby.' Just marry one more man whose name begins with H and ends with N. Harnden, Harmon, Hirshhorn." Will ticks them off on his fingers.

And I am in love with Henry Rothman. Am I breaking the chain? Or does it augur badly that his first name begins with H and his last name ends with N?

Nevertheless, even though there is something ludicrous about getting married beyond the third time, Henry and I, whose handwriting is so alike we cannot tell the difference, do just that. And we combine households.

Henry's apartment on the fifth floor on Twenty-eighth Street becomes my studio. My studio on Central Park West becomes our bedroom and Henry hangs the walls with his framed Coptic and Peruvian textile fragments of woven shrouds, an evil omen. My bedroom becomes David's and he moves his large collection of early comic books into cellar storage. The girls love having an older brother and a bigger family.

My whole existence is altered by having two males in the house. David loves eating a large breakfast and dinner at home. He and Henry used to eat a lot of pasta in restaurants. I cannot cope with any of it. There seems to be endless laundry, endless shopping, and no more privacy. I walk around in a daze because I cannot fall asleep until David gets in, and that is sometimes at three in the morning. I resent Henry's snoring while I am wide awake worrying about his son.

I hate an outside studio. I hate getting dressed in the morning and taking the subway or bus downtown, then changing into my work clothes and changing back for the trip home at rush hour. I don't like working on the street of flowers. The light is south, the worst. I am disoriented and nothing comes of my painting. Henry's shop on the floor below spawns visitors and coffee breaks.

Perhaps I resent my new pattern as much as Henry hates being wrenched from his Bohemian existence. He isn't accustomed to working from nine to five. Sometimes he used to go to bed at five in the morning, and if he wanted to, he could start the frame shop going at noon.

Worn out with trying to fit Henry, a square plug, into the round hole I have created for him, I decide to give up—to our mutual satisfaction. As a matter of fact, his mother, a socialist type, is almost pleased when we decide to dispense with something so bourgeois as marriage.

"Now we'll have you all to ourselves," Jo Ann gloats, but Amy is angry that I have removed a half-brother from her life when I go to Mexico for the second time and divorce Henry. The day after I come back he invites me to go to a movie, and when I say yes we are off to what will be a long friendship—fourteen years —after my shortest marriage—eight months.

.

Chapter Seven
1960-1969

"APPLE MONEY!" SAYS WILBERT, drinking tea with me between chauffeuring stints for Joe. "She's into apple money." I look bewildered.

"Well," Wilbert continues, and I know he is talking about Brenda, Joe's new wife, "she orders six bottles of Coke at a time. You always ordered it by the case."

Joe couldn't bear the idea of running out of anything.

"He gives her enough and she puts it aside, that's apple money. And she doesn't let him go to the mailbox without her."

I can't help a twinge of delight that all is not perfect in the tax-free heaven of Fort Lee, New Jersey, where Joe is living with his third wife.

"She feeds him roughage," Wilbert says direly. With Joe's diverticulosis, this could be a direct path to homicide. I always fed him cooked vegetables. Never raw carrots and celery. And so I am not surprised when Joe visits and complains about his wife.

"Are you going to marry Daddy again?" the girls want to know as their father drops in for dinner after he divorces Brenda.

"Why don't you and my little chickabackas come out to Greenwich and help me look for a house?" We join Joe on safaris among many mansions. When he settles for a twenty-four-room Tudor house, he invites us to spend the night there.

On the way up to our separate bedrooms, Joe strokes my

bottom as he mounts the stairs behind me, mumbling under his breath, "That's what you like, isn't it?" Later, while we are rolling around on a towel he has placed on the cold tile of the bathroom floor, he admonishes me to be quiet. The children may hear us.

Next morning at breakfast, Joe's French cook, Louis, teaches me how to roll cold butter into croissant pastry, and I wonder what the hell I am doing. How will I be able to resist Joe's charm?

"How on earth will you find enough help to run this place?" I ask, like a concerned mother, albeit, judging from the night before, a little incestuous. I scare myself. Joe's love dropped me from a high place once before. Twice would be incredible masochism.

Joe is not discouraged. I do not know he has found an employment agency where attractive Olga Cunningham will not only supply him with couples, chauffeurs, and gardeners, but will divorce her schoolteacher husband and marry him.

I want to protect myself from Joe and also from Henry, whom I keep on seeing. "Bring anyone," people say when they invite me to a party. "Bring Henry, if you wish." And I do. But all I want is escape and to tear myself away from ex-husbands.

My favorite fantasy. To spend a whole year at the Cape where I would be safe at last. I could watch the changing seasons and paint landscapes. It would be good for the girls. Amy, at fifteen, is like a little Lolita, developed and devastating. I turn back the clock in my head and fancy that her romance with a boy in Provincetown, unlike mine at her age with Hecky, will have a happy ending. Stormy loves poetry, as she does, and plans to go to Dartmouth like his father, a sports fisherman whose *Chantey III* brings in eight- or nine-hundred-pound tuna. We kid Stormy about his job in the summer working on a scientific project for Woods Hole Oceanographic Institute and tell him we'll get him on "What's My Line?" Nobody would ever guess his occupation. He feels the reproductive organs of the huge tuna.

Jo Ann, at twelve, is not interested in boys but wants to have a horse to ride. We settle for a cat of a particular breed of Provincetown cat that has long gray fur and a white face. I daydream about how wonderful the slow pace of country living will be,

how good it will be that the girls are not in a competitive private school, and how I will have so much time to work.

Just the same, I leave a loophole by subleasing the New York apartment only for a year in case my experiment fails. I can hardly wait for the summer people to leave. I have my wish. After Labor Day the town empties as if there were a plague. The lights in the summer houses around us go out and shutters go up. Restaurants all close. Vacancy signs go up on the tourist homes. Shop windows are left with a debris of leather sandals. Only Adams Pharmacy remains open as late as seven thirty in the evening, and there are no movies.

In September, hurricanes with names ranging from Ann to Zelda threaten. We drag deck furniture inside and roll up the hoses, which can become flying missiles in hundred-mile winds and come lashing in our large windows. We lay out our supply of candles, flashlights, and kerosene lamps for power failures; we even put blankets and provisions in the car in case we have to evacuate. The Pilgrim Fathers knew what they were doing when they built their saltboxes carefully away from the water. Waves roar and splash over the decks, tossing green seaweed up to the second-floor windows. We have begun the simple life.

We are privileged townspeople now. The clamming season starts the moment the last summer visitor leaves and will go on until spring when the first arrives. In the autumn chill, Amy walks dreamily hand in hand with Stormy; and Jo Ann, who hates clams, helps me dig them. The girls seem content. Looking back over the flats toward town, crisp light turns the bending, digging figures of whole families into rice workers in a Japanese print. Phil Malicoat, an artist who has lived year round in Provincetown for a long time, shows us how to chase the burrowing bivalves. He opens my first clam, rinses it in sea water, and it slides cold and fresh as the day down my throat. Horizontal bars of color reflect in the tide pools.

As we walk away with our bucketful of clams, the sunset promises to be a flamboyant orange inexplicably streaked with green.

Jo Ann's first day at school, I had quite a turn when I saw the starched dresses of the other girls, but after that they settled for blue jeans. While the girls are off to school and I am watering

the plants, a black object catches my eye. It looks like a rock, but there aren't any on the flats except for the manmade jetties placed at regular intervals to hold in the sand. I pull on my rubber boots and run down. The object is a sad, whiskered harbor seal and a hurt one. His nose is bleeding from a gash. Ducky Perry, a retired trap fisherman, strolling on the flats, is also curious.

"They used to pay a bounty of five dollars for their noses," he says. I shudder. "They eat the fish. Looks as if someone tried to cut this one's nose off." He is compassionate. "We ought to get it back in the water." The tide has left the animal high and dry. How to get him back?

"I know, Ducky. Let's put him on wheels." I run up to the house and come back with the girls' red express wagon and a drop cloth. But when we try to put the cloth under the seal to lift him up to the cart, he snarls and edges away. Little by little, we chase him to the water, where he gives us one last resentful look and swims off.

High Noon in Provincetown. On election day I walk around Town Hall listening to the click of my heels on the pavement and keeping the appropriate number of feet away from the entrance. I shove my stickers into the hands of the voters as they approach. I get three hundred votes to be on the School Board and lose.

"I thought you told me I'd win with one hundred and fifty votes," I complain to my sponsor, Josephine Del Deo, who urged me to try when I sounded off on certain school practices.

"You put up a good fight. It would have been impossible for you to win, but you shook things up."

I was shaken up too. What kind of nut was I? I had everything against me. I was a stranger in town, a woman, an artist, Jewish, and as if that were not enough, I was four times married. At catechism, the priest told the children they were to tell their parents not to vote for the only woman running for School Board. She was a Communist.

"But that's Amy's mother they're talking about," her best girl friend reported to her. What was I to do? Sue the Catholic Church for libel? My ardent supporters, mostly teachers,

thought that was a good idea. And then what? I'd have to leave town, that's what. But Provincetown loves a loser. They named a street Harry Kemp Way after a poet who spent his last years there and who was tenderly put to bed when he had a few too many. The girls are outraged by my treatment, but proud of me for trying. Suddenly everybody calls me by my first name, from the garbage man to the checker-out at the supermarket. "They call you Lily because they like you," says Jo Ann. Which is one way of looking at it.

Confined to the beautiful big brick house, I keep thinking of Mom's favorite adage, "Little children, little troubles. Big children, big troubles." I hate to complain when Joe phones to ask about the girls, and he hates to hear anything but good news. Besides, the things that bother me are so trivial. Aren't they? Beer-drinking high school boys honk their car horns in front of the house at all hours of the night. We discontinue the club for kids in the cellar after a mattress catches fire. Roger Rilleau, the sculptor and sandalmaker down the street, phones at two in the morning to tell me both my daughters are downtown at the Wharf Restaurant. Frantic, I drive down and bring them back. Jo Ann vies to keep up with Amy's rebellion. I scold them both. After this episode I drive to New Beach at night where the boys and girls in parked cars are doing what is called "submarine watching" and try to peek unseen into the windows hoping not to find my nubile daughters.

The girls get tired of walking to school and they hitch rides. It is not long after that a boy named Costa, with whom they rode, shoots an arrow into the back of one of Jo Ann's school chums and at the scene in Truro the police discover sections of missing girls wrapped in plastic bags and buried in the ground.

Escape becomes more and more difficult. Even short stays in the tiny top-floor maid's room in New York that I hadn't rented and had left available for myself become almost impossible as the roads ice over, planes fly spasmodically, the children seem to need me more, and the weather closes in.

In November, Ron Mason phones. He was looking someone up in the H's in the New York directory and came across my

name. Phoning the number, he was given the Provincetown one. He lives in Massachusetts. His wife has just died. He would like to see me. It is thirty-one years since Paris and white violets.

"Don't be surprised," he says. "I have white hair now."

I look in the mirror. So have I.

When I open the door I see that Ron is tall, distinguished, still handsome. We have an awkward moment and then I offer him a drink. He takes it and follows it with many others. His hands shake. Maybe he is upset because of his wife's death. In the studio I insist on giving Ron some of my Japanese paper. Then I think: What am I doing? He can't draw. Not with his hands trembling like that. Ron runs out to his car and comes back with a gift, a small delicate painting of his—its subject, appropriately enough, a cemetery. It is as if we are having a memorial service for our young selves. We find no solace in one another—only tenderness and sadness. "Dear Lilith," Ron still writes. He tells me he has remarried his first wife, mother of his daughter. I am glad to hear he is no longer lonesome. He hopes to do a series of drawings on sports with the paper I gave him. Many years later the fine, familiar handwriting becomes a scrawl when he writes to say he has had a stroke. The words are almost incomprehensible but the spirit is still strong until, at last, the letters stop coming.

After the first year at the Cape, I feel we should go back to New York. I have a general feeling of malaise. But the girls love the school and the life. In a way, their living in a small town has done them good. They have, for the first time, met people who are not liberals.

In the spring, when my New York friends come back, we all go out to dinner, and I startle everyone by fainting dead away. I am sure it is from relief at being with people with whom I do not have to guard my words. Nevertheless, putting aside my fears, I sublet the New York apartment for another year, but keep the small separate maid's room for occasional escape.

Just before Christmas, before the weather closes in, I spend a few days in New York to see art shows. When I return, Amy seems pale.

"Don't you feel well?"

"I'm all right." She looks positively green. It is impossible to get her to talk.

"Let's take a ride on the dunes." There is a powdering of light snow over the hills and low shrubs. As I look at Amy's beautiful profile, like a Picasso drawing of his classical period, she seems more relaxed.

"My tongue is swelling," she says suddenly.

"What do you mean?"

"I took some pills."

"What kind of pills?"

"All kinds. Last night. Whatever you had in your medicine cabinet."

I turn around and head for home.

"Why?"

"I broke up with Stormy."

No time to go into that. I call my doctor in New York.

"She's having an allergic reaction. Get her to the nearest hospital before she chokes to death." Armed with samples of every medication, I bundle Amy into the car and burn up the Mid Cape Highway at eighty miles an hour. We get there covering the forty-four miles in record time.

While I wait in the emergency room I am angry on all counts. Angry at the secrecy of the young, angry that the lovely tranquil life of love I hoped Amy would have is messed up. At the same time, while I wait, fear that the smorgasbord of pills from aspirins to antihistamines to sleeping pills will do irreparable harm mingles with rage until the doctor comes with news that she will be all right. It is only at that point that I remember I am duty bound by my separation agreement to let her father know immediately when catastrophe strikes. I call Joe.

"Why did she do such a thing, a young beautiful girl like that?" says Joe, horrified.

"I don't know. The doctor in Hyannis recommended someone in Boston, that's the nearest place. I'll take her there. She's home now, but she's very depressed."

I have thrown out all the pills and hidden anything sharp. I am prepared.

"Get her the best. The very best," says her father.

It is snowing the morning of our appointment and the roads have a layer of black ice. The very end of the hundred and twenty miles is hopeless. Dr. Kaufman's house is on top of a long hill. The sand truck hasn't been out yet, and there's no way the car can get up without skidding.

"We're going to walk the rest of the way," I say, hoping it isn't far.

The doctor looks surprised to see us.

"I had cancellations from patients around the corner."

It is decided that Amy will see Dr. Kaufman once a week, while I see his wife, who is a psychologist. And, for good measure, Jo Ann will see a Dr. Donald Gair. This is where the simple life has led us. Every Saturday we shall have to drive a distance of two hundred and forty miles to get help. It isn't bad enough that braces for Jo Ann have to be adjusted in Plymouth by the only orthodontist deemed suitable in the area. Now this.

We struggle back down the hill, slipping and sliding. I am shaking from the cold when I call Joe from an open phone booth in the delicatessen where we are going to have lunch. I am proud that I've made it at all, proud that I've found a man who specializes in the problems of adolescents.

"Did you see any other doctors?" asks Joe. "Are you sure he's the best?"

At this, I blow my lid. I see Joe sitting smugly in front of a cozy fire in his Greenwich estate.

"Why are you so angry at Daddy?"

I cannot stop shaking, and this is the last straw. Not only does Joe treat me like a bought-and-paid-for servant, but my daughter wants me to treat her absent father like a doll and accept all the responsibility.

Aside from that, I must bow out of the project I have not yet started with an artist and filmmaker, David Young, from Orleans. We planned to make a documentary of a full year at the Cape, but none of this would happen now. Only time, a lot of time, would ease Amy's problem, and I would have to be on

tap. Reluctantly I tell him I won't be able to join the project. I can see the shots: road signs of Tar Kiln Road, Thumpertown, and Shank Painter Road. The Junior Prom. Girls in long gowns and white kid gloves up over their elbows, with gardenias pinned on the left shoulder, preparing for the high moment of their lives. The Grand Promenade. The faces of the fishermen and their wives watching proudly. Tapes and shots of Commander Donald MacMillan, Mary Heaton Vorse, and Harriet Adams, all the grand old people of Provincetown. Local characters like Phat Francis. The simple grave of John Dos Passos' wife in Truro. A car driving next to a dune and the sand blowing so fiercely that in an instant the windshield is blasted with pit marks. David Young thought the end of the film should be a car speeding down the Mid Cape Highway and squashing an animal, a symbol of Route Six bringing more people, more cars, more everything, and flattening things out. None of this would happen now, and I resent it.

In Provincetown, when I have dinner across the street with Bob Motherwell and Helen Frankenthaler, whom he has just married, she asks me kindly, "Aren't you tired of the stiff upper lip?" I didn't think anyone noticed.

With all the attention Amy needs, Jo Ann seems to have extra strength. There is not enough of me to go around. Amy was the one fearful of thunder and lightning, Jo Ann the one who could fix things and was not afraid. I lean on her. I string Christmas lights on the two Japanese black pine trees outside the front door, polish the brass eagle knocker and print two hundred black-and-white Christmas-card woodcuts I've made and tinted with watercolor. Everything must be as usual. In the deep sink of the laundry room I immerse two hanging baskets and watch water burbling into the sphaghnum moss. From behind my screen of burro's tails, kalanchoe, sedum, and sempervivum, I see Nanno de Groot, a tall, handsome Dutch painter, walking barefoot on the cold sand. What am I doing here? Looking out the window, I see the dinghy, swamped in a rough sea, as I am, fifty years old, in this lonesome place.

The quiet may kill me. I lie awake in bed. The lapping of

waves against the bulkhead means high tide. No sound at all is low tide. I listen for cars. There are none. I pray for the screaming sirens of New York, pistol shots, cars braking or backfiring —anything—but there is only the sound of the wind whistling. I have deluded myself. I am not self-sufficient, whatever that is.

I cannot complain about nature's panorama. A sprinkling of snow turns the dunes into etchings. Sunsets burn red and are more flamboyant than those of summer. An aurora borealis pulses and whitens a dark sky.

And one night I awaken to find my face is wet. Surprised, I touch my fingers to the tears I have been crying in my sleep. That is too much. I must spend no more winters in Provincetown.

An obsolete concept. Desperate because Amy has fallen in love with a drummer whose hair is so long a waitress asks, "What'll you have, miss?" and who may have a habit that requires a spoon, I settle on a Victorian solution. Absence. Absence, as in a trip to Europe.

"I don't *want* to go to Europe!" says Amy.

Jo Ann, who is younger and not in love, is willing—more willing than Amy—but even she is disconcerted by the frenzy of preparation in three days. At the passport office, it is so difficult, with passports reading Lillian Perelmutter, Lillian Harnden, Lily Harmon, and Lily Harmon Hirshhorn, that I must run to my lawyer's office and produce an affidavit to show that I am, at this moment in time, Lily Harmon.

It is August, and we have one reservation in Paris at the Hôtel Montalembert where we stay for only one night. The next day we move to the Hôtel de France et Choiseul, redolent of charm, dust, and old furniture, as well as a little courtyard and restaurant.

"I'm going to have a nervous breakdown," insists Amy, despite breakfasts of croissants and café au lait. "Send me home." Pierre Volkoff, my long-lost French cousin who showed up alive after thirty years of being missing and escaped from Russia by way of Manchuria, becomes my helper. What made me think that whisking my daughter away would solve anything? Now, with her sobbing and tears, I see how stupid I was.

"If you're having a breakdown," Pierre says, "we have some of the best clinics and hospitals in the world right here."

"I want to go home!" cries Amy.

"If you don't feel like going to a doctor in Paris, I have a better idea. I'll take your mother to a restaurant I know where we can have some bouillabaisse, and you girls can take a boat trip on the Seine and have dinner on the boat. You can go alone!"

Jo Ann is joyful about the excursion. Amy, vexed, her lips quivering, her forehead knit, settles, but a look in her eye gives me fair warning that vengeance is still in the offing.

That day is saved. Remembering Jay's courtship by food, I take the girls to all the gourmet restaurants I can, but coquilles Saint-Jacques are countered with: "Don't they have hamburger?" or "How come there's no Coke?"

In Switzerland, visiting Pierre Volkoff's daughter, Moussy, who makes us a beef fondue bourguignonne, the girls admit it is fun to dip little forks and cook their own food, but it is not until we reach the Hôtel La Réserve in Beaulieu that they succumb entirely to haute cuisine. And no wonder! The restaurant is one of the most famous in France. Watching a waiter carve a fresh fig into a flower shape is a whole performance. Daily, not having reservations at the Hôtel La Réserve, we are moved from room to room. As if by magic, our clothes and toiletries are always in place. Finally there are no more cancellations and we must leave.

In Rome, our reservations are at a hotel near the Spanish Steps, where the whores gather nightly. My plump daughters are ogled and pinched from behind. And so am I. We go on to Capri, and nimble fingers of women knit sweaters of mohair for us overnight. Looking like caterpillars, fluffy in pastel wool, we return to the United States. No problems solved.

Back in the wonderful anonymity of New York after two long years, I plan new work. I enroll in an etching class at Pratt where I realize that I must look like a menopausal artist to the students, most of them in their twenties. After all, I am in my fifties. But as I work, all differences in age seem to disappear. I learn more from them than from the teacher, watching them cut up and reassemble plates, daring all. George Miller and tickling litho

stones seem far away. But after I soak an initialed piece of paper for an experiment and it disappears from the tray, I become angry at the carelessness of the young and decide I would rather work alone in my studio. Herman Rose, who is making etchings, tells me it is possible to convert a Chinese laundry press once used to iron the separate starched collars and cuffs of gentlemen's shirts into an etching press. He has one. If I go to see his friend, Sid Hammer, he will tell me how to rig one up.

The day of my appointment with Sid, I knock and knock at his door, but there is no answer—only the sound of dogs barking angrily inside.

"I'm sorry I couldn't let you know," Sid apologizes when I finally get to his studio. "I have epilepsy and I had a seizure. I never know when one is coming, but in a way, it's wonderful. Each time I die and come to life again."

Sid shares his discoveries with me, not only the cleverly contrived press with a new bed of Formica and television clamps to hold a different turning wheel but also his method of making prints on plastic, burning the line in with tiny soldering irons, dental torches and even candle fire.

While the girls are in the throes of adolescence—Jo Ann and Amy, both bobbing in and out of boarding schools like corks—I lose myself in the cookery of etching to stay sane. Sometimes I work until two in the morning. First I draw on the copper plate, exposing a fine gold needle line on the dark brown ground. Then I submerge it in bubbling nitric acid to bite the line, and go on to the printing process. I turn the heavy roller and am rewarded with my first print—artist's proof.

Estelle Mandel, agent and mother to artists, enters my life again. She sails into a room like a frigate, a large picture hat balanced on her perfectly dyed and set blond hair. She wears high heels now. Having overcome her insecurity about her height, she flaunts it.

It is possible for me to renew my friendship with Estelle only because she is no longer married to the journalist Ray Brock. I hadn't forgotten his plying Amy with beer when she was eight years old. It was at a party and she enjoyed his attention. "She likes it! She likes it!" I could have killed him.

"There's a Mr. Aoki here from Japan," says Estelle, "and he wants you to illustrate a book."

"You know I'm not an illustrator, Estelle."

"He saw a drawing you gave me that's in my apartment."

"That's different. I did that for myself."

"He knows you're not one of my artists. He wants you to do *Buddenbrooks*. By Thomas Mann."

"I haven't read it."

"I'll send it to you. Read it and let us know. It'll do you good to try something new." How smart she is. She knows I am working until two in the morning on prints, that work is the only thing that can bring me through this period with my daughters. Driving to Amenia to face the disapproval of Jo Ann's headmaster, or to Boston for sessions about Amy with a social worker, I feel more and more like a *kochleffl*, a cooking spoon, stirring from state to state.

Reading the saga of *Buddenbrooks*, I slip pieces of paper into parts I think suitable for illustration, and when I am finished, the book is fat with them.

"I can't make a sketch, Estelle. You know that. Only finished things."

I show up at Estelle's with seven finished black-and-whites.

"At this rate you'll be done with the whole book in another week. Too fast. We'll show him one."

He approves. In fact, he wants me to illustrate stories by Sartre, Gide, and then Kafka.

"I don't understand *The Castle* at all," I tell Mr. Aoki after I read it.

"Neither do I, but it's wonderful. That's why I'm giving it to you. You can do anything you want."

"Why on earth would a Japanese publishing firm come to the United States for illustrations when they have so many good artists there?"

"I have no idea," Estelle says. "But I'm glad they did. A lot of my artists are eating now, and me too."

It is only four and a half years after Estelle's mastectomy when she begins to complain about her bad back. We planned a celebration when she hit the five-year mark.

"I have terrible spasms," she tells me at dinner in her apartment. "The other night it was so bad I couldn't have gotten up out of bed to answer the door."

"Somebody should have a key."

"My maid has one, but she lives in the Bronx."

We say goodnight.

A few hours later, Estelle calls me.

"I've had a spasm and I can't move. I've called my doctor and he says he'll meet me at the hospital, but I've got to get there and the door's locked." I curse my stupidity for not having asked for the key.

The police, whom I've called, are milling about below Estelle's lit window one flight up. The ambulance is waiting.

"Get a ladder. Break the window."

"Lady, we don't break and enter."

"You'll have to, one way or another, and that's the easiest."

"I have cancer," Estelle says in the ambulance. "All over. In my bones. Nobody knows. Just you and Clarinda Romano."

"I won't tell anyone." And I grit my teeth when Henry compares his bad back to hers saying everyone has his own method of dealing with it.

Estelle found out when she opened an envelope with some X rays she was carrying from a Boston doctor to one in New York. She read her own death sentence. Two years.

Estelle plies her doctor with bottles of his favorite brandy.

"Try anything. I don't mind being a guinea pig."

Male hormones deepen her voice. I wax the stubble from her face and cut the long dark hairs from her nostrils. "My bones are like Swiss cheese. I can't think what holds me up."

But she is already over her allotted two years. She buys a long white Lincoln Continental with a top that flips open and shut with the touch of a finger. She travels to a book fair in Frankfurt, goes to South America, starts a committee at the New York Society of Illustrators to create a museum, and never lets up.

"Get me a motel room in Provincetown. I'm coming up. Get me one with no more than three steps, that's all I can manage."

"*I've* got three steps."

"But I can't get up to the second floor."

Freehand

"You won't have to. The bedroom's coming down to the dining room."

Sylvan and Lillian Cole are staying next door at The Sign of the Mermaid. Sylvan's sons and my daughters move the furniture down from the guest bedroom and the dining table and chairs into the living room. Sylvan was Estelle's protégé at Associated American Artists and loves her as much as I do.

When Estelle arrives with her cousin Bede, she gets out of the Lincoln, breathes the good air, and says, "I can manage without the crutches."

In her improvised bedroom facing the ocean, she looks at the pleased faces of the young people. "I feel better already."

Next day, leaning on Sylvan, Estelle manages the stairs down to the beach.

"Fourteen stairs! You did fourteen stairs! I counted them," says Sylvan.

I give a lobster party for twenty-seven people in her honor. There don't seem to be any extra lobsters. Just enough.

"I could have sworn I had some extras," I mutter.

"I couldn't stand it," confesses Jo Ann. "I threw them back in the ocean."

"But they were pegged."

"I didn't want them to die. I let them go."

"It's amazing," says Estelle, the last week of her life. It was five years since she'd opened the envelope. "How much pleasure little gifts can give." Nurses skitter about her. The pain is not too bad. Hallucinating from all the drugs, Estelle asks to talk alone to Jo Ann. They had a fine friendship. Estelle's country home in Hillsdale near Jo Ann's boarding school was always open to her and her friends. Afterward we walk down the hospital corridor. Jo Ann's eyes are filled with tears.

At the Riverside Chapel a rabbi drones a dirge about Estelle. It is obvious he never met her. He talks about her sad life, her marriage that failed, the fact that she was alone. Large as life, I can hear Estelle's wrath.

"What nonsense! That wasn't it at all."

In Estelle's apartment, mirrors are draped with cloth and there are hard little chairs for the mourners. On a turquoise felt panel, her flamboyant jewelry is still hanging in proud display.

Norman Mailer covets the big house. He would like to rent it for the summer. The girls are away at camp and I am seized with a fit of economy and cannot see occupying a whole eleven-room house by myself. I have turned the little garage next door into a one-room studio with a sleeping loft and have the illusion that I can turn the clock back to Tenth Street and simplicity.

Beverly and Norman Mailer invite me to visit them in their apartment in Brooklyn Heights, where ladders go from level to level, and I study the cigarette burns and liquor stains in the coffee table before me while they ply me with brandy. Looking into Norman Mailer's incredibly blue eyes, I agree to rent them the big brick house. Norman starts to get a check to give me a hundred-dollar deposit but since his checkbook is up in a ladder area, he decides to mail it to me the next day.

Time goes by while I have nightmares about Mailer as a tenant. A friend calls to say he wants the house and will dash over immediately with half the summer's rent if I agree. I call Norman Mailer but his secretary says he cannot be disturbed. I call my lawyer, who says I have every right to rent the house to someone else. I tell Mr. Mailer's secretary, "Please tell Mr. Mailer he thinks he has a house for the summer but he doesn't. I never received his deposit and I'm renting it to someone else." Following my lawyer's instructions, I deposit my friend's check in the bank.

When Norman Mailer calls me back, he raves and rants at me. I tell my lawyer, "If I am murdered, you will know who did it." And I spend the summer in the garage, but not alone. The girls don't like camp and come back to occupy the sleeping loft, and with the three of us crowded into one room it is not quite the summer I expected.

"Is this place for rent?" I am just leaving the garage-studio.

"There's no heat in the winter," I say, "and I'm on my way to New York."

"I'm Arthur Cohen. I'm a painter."

"I know your work. If you can stand the cold, you're welcome to stay."

"How much do you want for it?"

"One small painting, I guess. You can stay as long as you like. There's a small electric heater that could take the edge off."

Arthur lasted well into October and gave me a small still life of a black skillet with a cracked white egg in it. I liked it so much that I bought another of his paintings—of Motif Number One, the wharf in the center of town with light piercing the pilings.

"I bought a painting of Arthur Cohen's," I tell Joe when he happens to call. Joe responds like a bird dog sniffing a scent.

"Who's that? I never heard of him."

"A painter I know from Provincetown."

"Is he good?"

"I have two paintings of his."

"Tell him to come to Greenwich and bring his paintings."

"He doesn't have a car. Couldn't you go to his studio in New York when he gets back there?"

A whole year goes by. Joe doesn't forget. Finally I tell Arthur that Joe wants to see his paintings.

"Good," he says. "I can use some money."

Joe is at a fever pitch. It was hard for me to arrange this meeting. One part of me wants nothing to do with Joe's buying, and the other part wants Arthur to have enough money to continue working.

"I must warn you," I tell Arthur. "Joe is used to asking the price of each painting and then offering a flat rate for a lot of paintings. Your prices are cheap enough and you don't have a dealer to protect you, so be careful."

"He bought twenty paintings," Arthur says after Joe's visit.

"Wonderful!"

"But I was hypnotized. After I finished showing him all the paintings, he took out this wad of bills and started dishing out hundred-dollar bills. . . ."

"What did he pay you?"

"Two thousand dollars."

"For twenty paintings?"

"I couldn't help it. I never saw such a performance. I know you warned me. . . ."

My daughters are dropping out, running away, driving me crazy. I cling desperately to memories of myself in Paris driving Mom crazy. It will pass, it will pass, I tell myself. Someday it will all seem funny. I'll tell jokes about it. But that day seems far off while it is all happening. Nightly, Jo Ann, back from boarding school and about to drop out of her new school in New York, takes the A train to join the parade down MacDougal Street in Greenwich Village. "Do you know where your child is tonight?" An accusing question on TV. I don't. And my imagination invents plenty. The drug scene—it doesn't seem the same to me as bathtub gin, which was bad enough. LSD comes in sugar cubes. Where is my daughter?

Henry phones from Zero's new apartment a few blocks away at the Majestic. Life is better for Zero since *Fiddler on the Roof.*

"How are you?" asks Henry.

"I'm about to jump out the window, that's how I am."

"I'll be right over."

He comes over and consoles me; but after that night I notice that he doesn't seem to be visiting Zero any more.

"What happened?" I ask Katie when I bump into her at Bloomingdale's.

"Maybe it's because of the night Henry left Z. They were hanging paintings and moving some of the pre-Columbian sculpture into a case. After he left, Z dropped one of the biggest and best pieces. It smashed into nothing and he's convinced it happened because Henry left him to do it alone."

"But I was suicidal. Henry saved my life."

"Z will get over it. It's happened before. Sometimes they don't talk for a couple of years. Maybe they talked enough already."

Way up in a dusty corner of a machine shop where I had gone to have a star wheel concocted for my second Chinese laundry press (for the Cape), I spy a large wooden form. Arthur Cohen, who also owns a laundry press, said that someday he would like to build a press all of wood like Rembrandt's. Could this be the roller for it?

"What's that?"

"Wooden pattern mold," says the mechanic. "Bought this place from my old boss. Made machines for pasta. Spaghetti machines."

"Could I look at it?"

"Been up here fifty years," he calls down as a cloud of dirt descends with the roller.

It is hollow. No good for a roller. No weight. But finely made, and beautiful.

"Do you have more of these?"

"Sure. Lots more."

He drags down wheel patterns and molds. Under the dirt I see the leather joinings and markings of deep red.

"How much do you want for these?"

"How many?"

"All," I say recklessly.

"Fifteen dollars."

"OK."

And we fill the back of the station wagon with them.

When I look at the pattern molds in the closet of the studio in Provincetown where I have hidden them I know they will make me do something. I don't know what. I must turn them into something.

I drag them down to the cellar to join all the other junk. Discarded violin cases lined with red velvet. A mass of miniature wooden airplane propellers, stencil letters and worn poker chips. A doll's eyes with fur lashes on lids that blink open and shut. A mold of a dentist's thumb, cast in silver. Broken bits of stained glass and mirrors. Wig heads, hat molds, amber marbles and watch parts. Foreign currency. An obsolete wall telephone and a child's toy typewriter. Boxes of saved keys from all the houses of my life. A collection of black and white porcelain doorknobs. I have always preferred hardware to jewelry. "My dear young lady," I can hear Professor Diedrichsen saying, "Pectorals are not doorknobs!"

I start to dismantle the huge time clock from Duane's. Piece by piece. I'm sure it's easier to take apart than it would ever be to put it together again.

There are not enough surfaces on which to assemble all the

found objects. I use the top of the Ping-Pong table and impro-
vise other tables with four-by-eight plywood on horses. I buy
electric tools and Henry teaches me how to use a quarter-inch
drill and saber saw. I learn how to join parts with glue and fasten
them with C clamps.

I make an icon out of an oval hat mold, stick watch parts into
its head, chisel lines for features, and affix two lacquered Bel-
gian wooden glove hands which raise their movable fingers in
supplication. Another hat mold turns into an African mask with
a face painted white and a crown of a rusty broken rake.

The hollow halves of one roller are arranged into two gen-
erals, their insides collaged with cigar bands, festooned with
medals, with epaulets of brass doorbells. They are mounted on
the large numbered wheel of the time clock and revolve on the
base of an old drawing table. Between them a round red rubber
ball, collaged with continents, suggests the world on its axis.

I assemble a gourmet with tight clock springs in its chest, a
faded box of Seidlitz powders, a discarded ring of a stove
burner, and, far down in its stomach cavity, four white plaster
eggs lined up like testicles in their own niche.

My mother's unplayable seven-string guitar of honey-colored
wood inlaid with mother-of-pearl becomes a life-sized figure
when its hourglass shape is mounted on black papier-mâché
mannequin legs and stands on an old breadboard of Baba's. The
lady has a clock face and a swinging red emery heart.

But nobody wants to give me a show of my constructions. I
am a painter, and I am supposed to remain a painter. People
are uncomfortable with new styles and mediums. They want the
satisfaction of recognition. It feeds their vanity.

Finally Oscar Krasner looks at my slides. "I think they're
great!" he says.

"Didn't you once tell me you went to Yale Art School with
John Canaday?" Oscar asks, the day of the opening, after the
show is set up with collages and constructions.

"Yes."

"Well, that was Canaday, the art critic of *The New York Times*,
who just went upstairs."

"It was?" That was a dignified old man. In my mind's eye, John is still a skinny blond youth playing games at the water fountain, drinking coffee at the Waldorf Cafeteria while the waitress bellows, "Is that all?" and we linger and talk; John was a fifth-year student and made wonderful drawings.

When John Canaday comes downstairs Oscar says, "She used to be Lillian Perelmutter."

"I remember you," he says. "You were Lois's best friend. Do you remember Wibbles?"

"Of course I remember Wibbles. The rebel." My eyes light up with the thought of him.

"He's dead," Canaday says with a certain relish. "Do you remember the boy who won the Prix de Rome?"

"Of course."

"Crazy. In a state asylum."

Almost everyone he recalls is either in the great beyond, sick, or in devastating trouble. We say goodbye somberly. I am depressed.

"You should never have introduced me to him again," I say to Oscar.

(Canaday did not review my show, but sent a second-string critic instead. "I don't mix sex and art criticism," was his explanation to Oscar. What on earth did he mean?)

"My Mother, the Guitar" strums herself in the window and a television studio wants to rent her for a show. They will pay a lot of money.

"But, Oscar, she's too fragile. They might break her, and I don't have time to put her together again before my show opens this afternoon. What's more, I don't want to see her as a background for some commercial."

Raphael Soyer is the first artist to appear and is distressed to see that I have forsaken the world of two dimensions.

"I haven't stopped drawing and painting, Raphael."

But he eyes me mournfully. I am a renegade.

Senator Benton shows up early and buys "The Loving Couple," which Carter Winter had designed into a small poster for the show. Later, Bill finds the wooden lovers are too wild and

relinquishes the piece to Virginia and Worth Conkle, who wired they wanted it after seeing the poster. Senator Benton buys a painting instead.

Joe Hirshhorn shows up later and buys a construction and a collage.

"Take a look at the old HIAS building down on Lafayette Street," he says. "I'm considering it for a museum for my collection." But it is Joseph Papp who buys it eventually. The press is full of Joe's flirtations with places that vie for his art. There is a rumor that Billy Rose offered Joe ten thousand dollars to take a trip to Israel hoping he would choose that country as a recipient, and Joe accepted the offer, but didn't give. Not even a tree.

Perhaps being wined and dined and courted is so delicious he may never give the art away. And now he seems to enjoy the publicity which he used to shun before he was dubbed a uranium king. His reputation is newly minted and every day he is more virtuous.

At least Joe isn't concerned about my change in identity as an artist as are so many people who find it upsetting not to recognize my work just when they had it labeled.

There is a moment after the show while Oscar is putting out the lights when I look around at my bizarre personages and take pleasure in the renewed life of my crazy objects.

The New York *Herald Tribune* says:

Miss Harmon seems obsessed by time. Her constructions invariably include timepieces or watch works. These are put to use by a witty mind and a clever hand. "Lady with Wheels in Her Head" and "My Mother, the Guitar" are but two of Miss Harmon's skilled and humorous inventions. . . .

Washington wins the sweepstakes. The press announces that Lyndon Johnson has wooed and won the Joseph Hirshhorn collection. I can imagine the courtship period with Joe frisking about merrily like a small puppy and saying, "I'm nothing but a little Hebe who never went to college," and President Johnson, equally bashful, countering with, "I'm nothing but a country boy myself."

All that and Vietnam too. I shudder to think of the fate of the whole country but I am glad the paintings and sculpture have found a home at last.

Reverberations start immediately about the condition that the name Hirshhorn must be immortalized for a museum to be built and subsidized by the American people. There are outcries from everywhere—senators digging up past indiscretions and Jack Anderson discovering an elderly widow in Florida who claimed she was ruined by Joe's stock manipulations—all to no avail.

"These are my children," Joe, surrounded by sculpture and paintings, announces to the media.

One woman journalist writes, "But Mr. Hirshhorn *has* six children."

"I wish you weren't doing those odd things," says Bill Benton. "I liked 'Strawberry Soda' better. Why don't you do things like that any more?"

"I'm different now. That was long ago."

"I'm different, too," he says, "ever since I got the flu from Hubert Humphrey in Phoenix. That blood transfusion I had was something! Gave me hepatitis. I should have had a friend as a donor, not some hippie, or whoever it was."

He is stalwart, considering that we are having dinner without any champagne—wine is forbidden now. But he is still jovial.

"Did you ever realize how hard it is to give away mink coats?"

"Never. Is it?"

"I was angry at my wife. She went shopping in Bergdorf's one day with Muriel Humphrey, and suddenly she realized that her friend didn't have a mink coat. And she bought Muriel one, then and there. I was furious when my wife told me about it at dinner."

The oddity of our relationship amuses me. I give my fish to Bill when he finds the duck he ordered not to his liking. We have managed to transcend our insane beginning.

"But I fixed her wagon," says Bill, eating my fish happily while I settle for his too-fat duck. "I called a furrier and bought twenty-two mink coats. Then I had the problem of giving them away. Do you realize how hard it is to give a mink coat as a

present? I asked my secretary first. 'Why, Mr. Benton, I couldn't accept that' she said, almost as if I were giving her syphilis. And then I asked daughters of my friends. The same reaction. Thank God, I finally managed to get rid of twenty-two mink coats. And I taught my wife a lesson, a valuable lesson. I bought all those mink coats wholesale from a furrier for much less than she paid at Bergdorf's."

"What on earth is this file doing here?" It's nine o'clock at night, and I am tired after driving back from Provincetown with my Portuguese housekeeper, Mary Browne.

"Didn't you leave it here?"

"Of course not."

We stare at each other and at the papers littering the hall floor.

Is someone in the apartment? We run wildly through it. In my bedroom, the drawers of the tiny chest holding my antique jewelry are open and empty. Bits of costume jewelry lie discarded on the rug. I look for the lover's-knot earrings of gold, the bracelets, the pin with rubies, and what Jo Ann called "The Ball Necklace," which looks like a spider web with emeralds. They are not there.

In the girls' room, the skirt of their vanity table is pushed aside and its drawer is empty. Again, costume pieces are scattered disdainfully all over the floor.

Mary Browne calls me from the cedar closet. That the burglars should have taken the children's things seems most monstrous.

"Your mink coat and stole are gone!"

A yellowing ermine jacket, a vintage Persian lamb, and the worn dog-walking otter are still there. Discriminating thieves, they'd had plenty of time to choose. A whole long weekend.

Moments after I phone the Twentieth Precinct, a large, burly policeman arrives to say it is not his province, and is joined by Detective Maline and his partner.

"What did you lose?"

My privacy, that's what. My feeling of safety. Everything has been seen, touched, and soiled. I feel dirty and violated and tired.

"My jewelry and some fur coats. I don't know what else."

"Very unusual thieves," says Detective Maline. "They don't usually take both. Jewels and furs. Two different techniques. What was it worth? Do you have bills of sale?"

"My ex-husband, Joe Hirshhorn, may have them. He bought them for me."

"It's important to have some idea of the value to know if the FBI should be called in. Over a certain amount they are."

"I have lists somewhere," I say and I start to look frantically through the ransacked file.

The doorbell keeps chiming. More men appear. A laboratory expert dusts the furniture for fingerprints and another man, no doubt a reformed burglar, shows me how he can shove a credit card into the front-door lock and open it easily.

"You should have a double lock," he says. I can see that.

"Of course," he adds, not reassuringly at all, "if they want to get in they'll find a way."

Mary and I are making coffee at midnight for what seems to be a large party and a wake all at the same time. Finally I find some lists of jewelry.

"It seems to add up to about fifty thousand dollars for the jewelry and the mink is about ten thousand," I say, surprised myself. I had never thought of them as money, only pretty things to wear.

And now newspapermen and photographers lugging lights and festooned with cameras appear. I am exhausted.

"Just do what we say, Miss Harmon. It's much better to cooperate."

I can understand anybody confessing to anything as I allow myself to pose at my easel pretending to work on a finished painting, and then sit looking disconsolately into an empty jewel box. I want them all to go away. I want to go to bed.

The next day the headlines in the *Daily News* read:

U.S. GETS MILLIONS IN ART; THIEVES GET 60 G IN LOOT

The article is all jumbled up with Joe's gift to the nation and my donation to thieves; it eliminates Jenny as Joe's first wife, claims that honor for me, and also says that paintings were

stolen by thieves crazy enough to mingle two specialties: furs *and* jewels.

I get a letter from Ron.

DEAR LILITH,
Sixty grand are a lot of frames and I sympathize with you, but I was pleased to see you still have that lithe, lissome, Lilith figure —and even in newsprint the portrait the "fotog" (*Daily News* term) had you painting looked sensitive and superior. My compliments.

"Too bad you didn't have rocks from Cartier's," says Detective Maline, who comes almost daily for coffee and no-progress reports on his search in pawnshops. "Easier to replace."

"What do you suppose they did with my things?"

"Probably took them apart."

"They were antique jewels in lovely settings."

"They don't care," says the detective, stuffing a Danish into his mouth. "They only want the stones."

My whole life is concerned with objects and I look at all my possessions with fear. They make me vulnerable. And yet there is no way to rip out my love of them.

A fringe benefit. The girls will no longer fight over who gets which of my trinkets. Nobody gets them. The Midas touch, which I seemed to have for a while when I left Joe, is gone and nothing will bring it back.

Revolting against possessions, as soon as I decide to sell the big house in Provincetown, as if in vengeance it freezes up. All the radiators burst and seventy-five pounds of water pressure come tearing through, ruining, among other things, my first purchase—the beautiful Mason & Hamlin black ebony piano with the silver feet. No matter. After the damage to the house is repaired, it goes to Bob and Abby Friedman. I keep the small shingled house next to it with only fifty feet of waterfront, remembering what it was like to lie in bed in the big house during winter storms, watching the fringe on my canopy bed shake in time to the hammering of the waves against the bulkhead which was attached to a beam in the cellar.

But the house, after I sell it, still retains its hold on me. I have to restrain myself from pruning the tamarisk, the Japanese black pines, the forsythia. I find myself pointing out the sharp yellow dandelions trying to take over the green zoysia lawn.

"But I *like* weeds," Abby says. "I think they look pretty."

It takes a long time for me to forget the greenhouse on the porch, which has been turned into a bar. It takes a long time for my former house to let go and my new house to take over.

After the jewel robbery I am as repelled by the apartment as I would be by a faithless lover. Things have let me down and I rebel against them. Despite all the new locks I look warily about when I enter. Why on earth I think a carriage house would be better, I don't know. Anything to leave the scene of the rape.

"Why is it?" asks Philip Weisman, my third and last analyst, with whom I'm trying to unravel my distress at the shenanigans of my daughters, "that when you want to buy one house, you buy three. You did it at the Cape and now you're doing it in New York. Only now it's four."

The answer seems to be that the only way I can afford this possible carriage house converted from the Marseilles Bakery is to cut away the three small stores and convert them to houses and create a mews. The owner thinks I am some kind of nut, pretending to want to live in his bakery but really interested in his business. He leaves me barrels of flour and obsolete machinery.

"These are yours now," he says, smiling and handing me a sheaf of violations. The chimney is too high and may fall down. I must have it cut down immediately. I wonder if the building will collapse as soon as the brick ovens in the cellar are removed. The architect tells me that the old brick must be hauled away. It doesn't make sense to try to save it.

Every morning at four, I wake up with a recurrent nightmare. I have just driven my car into the garage of my new carriage house. The overhead door has swung open from an electronic signal. It closes after me and I get out of the car. As I step out, a man slinks in behind me and advances. He has a switchblade in his hand. The overhead door swings down and we are locked in together. Just as he is about to stab me and go upstairs to rob the house, I wake up.

The Adrenalin subsides. I sell the Marseilles Bakery to the agent who coveted it all along. He makes a lot of money, and I don't wake up at four in the morning any more.

Zero is playing *Fiddler on the Roof* again in Westbury, Long Island. Henry and I drive out to see him. After a terrible bus accident in front of his apartment at the Belnord, Zero's leg, saved from amputation by Dr. Joseph Wilder, always pained him. In the last scene where he drags a heavy cart behind him, I wince. It must have hurt him as much as in the film *Catherine the Great,* when he picked up Peter O'Toole and carried him like a baby.

Henry and I joke about going everywhere together and say that we shall marry again when we are eighty.

"What I *really* need is a buttonhole manufacturer," I joke. "Someone who will leave me alone." I have other lovers, but Henry is secure. He knows I will always come back to him. I always have.

In Provincetown, on the land I now own, a block from the sea, the earth is rich with loam. I plant plenty of basil for Henry to make his specialty, pesto sauce, for himself. Henry's conversation about cooking always astounds me. It even impresses Michael Field, the cooking maven across the street. In the fourteen years I have known Henry, he only cooked one meal for me, when I was ill, and almost demolished me with raw garlic.

"It's Sidney Harmon—your second husband," says Amy, who has answered the telephone. A wicked look of delight is on her face. It is almost as if she had caught me in *flagrante delicto.* It is twenty-seven years since Sidney and I were divorced.

I pick up the receiver. An unfamiliar voice comes over it. How can I not have figured that time and teeth would come between us? My daughters giggle as they listen. Sidney is in Boston visiting his son Andy, one of his four children with Liz, from whom I heard he was divorced. I also heard that he was seeing someone else. I remember my young self, downing Scotch and seeking oblivion with the news of his first child—but the pain was lessened with each of the three others.

"I'm so near Provincetown," says Sidney, "I'd like to come and see you."

"Do bring Andy. Bring your son."

"You'd better both be here," I say to my daughters, who are rolling around on the couch and laughing. They wouldn't miss it for the world.

I am like a nervous eighteen-year-old the next day when Sidney and his son are expected for dinner. I used to feel that if I had my life to live over again, I wouldn't be cruel to Sidney. I would be more tolerant of Peter. I would understand Joe, and would come to terms with Henry. I would never transgress. I would be faithful. I would resist all temptation.

I tell myself Sidney is coming because he wants to take a little trip with his son Andy. And perhaps for nostalgia.

Amy and Jo Ann look me over carefully, like matchmakers.

"A little less eye shadow. More lipstick. Your slip is showing. Comb your hair again."

"He isn't coming for any romantic reason," I say. "It isn't like that at all."

When the doorbell rings, a young man is standing there. He looks like Sidney, but fuller in the face and body. Behind him is Sidney's father, looking dried out and thin. I thought he was dead. But suddenly it hits me. The young man is Sidney's son and he is his own father.

"You look wonderful," says Sidney. Do I look like my own mother to him?

I am alarmed after dinner when Sidney offers to help with the dishes. In my day, the kitchen was off limits to him. I was furious at how Sidney's father treated his mother, who danced attendance on him like a good Jewish wife.

"I heard your mother died."

"She left an inheritance. An unusual one. You remember her chicken paprikash? . . ."

"Who could forget it?"

I knew how to make it. She'd taught me. But I was afraid to serve it to Sidney and Andy for dinner and I copped out with lobster. How I loved Sidney's mother and her kindness, making a meat loaf for us from my non-Kosher chopped beef when I

was sick, while she prepared two hard-boiled eggs for herself and ate them on a glass dish. It was a sin for her to touch that meat. But she did it out of love. I could see her tiny humble form, taste her *schnecken* and feel the strength of her submission. She was the one who ran everything while Sidney's father blustered and made loud noises.

"She knew she was dying," Sidney continued, "and she had a big freezer. She packaged a year's supply of her chicken paprikash. In her will she said it was to be divided equally among her children—Marion, Bill, Sam, and me. Her legacy to us."

"She was beautiful. I loved her."

"And how are your parents?"

"Still at the store. But New Haven's become a Model City, and they've demolished Grand Avenue. It's nothing but parking lots, furniture stores, a ravioli factory, and Pop."

"How do they manage?"

"They manage. Mom sits there all day. The neighborhood has some awful new housing for blacks. The police wake Pop—he's in his eighties now—to tell him the store's been broken into again. It's hard for him to get insurance. The crooks break windows and help themselves. Sometimes he gets up at three in the morning to meet the police. He says they know who does it, but they do nothing. He still has his Polish customers coming to him. And the Italians. Even blacks come now, and he waits on them as graciously as the others. He says they don't all help themselves."

Sidney's son and my daughters are intrigued with our conversation. It could be the Middle Ages we are discussing. As the evening goes on and Sidney fascinates the girls with stories of Hollywood, I realize he is showing off and I am pleased.

It is a strange romance. The past plucks at my sleeve. Crumbs still drop, unheeded, on Sidney's jacket. He still tells stories about plots he invents as he goes along. He is still the entrepreneur, latching onto writers. But who would have thought he would be such a concerned father, when he hadn't seemed to want children? Now here he is talking about a school he started in Hollywood with Robert Ryan and others. Here he is, bringing

me a present of a small stove and a recipe for shrimp. Is this
Sidney?

Sidney reminds me of things I would rather forget, like the
episode in Hollywood.

"It hurt me a lot, that night."

And I remember. I remember a night with the brother of a
friend of Sidney's. Nobody would stop talking about him and
his prowess. The cocksman par excellence. It was inevitable that
I should succumb, out of curiosity if nothing else. But Sidney
knew about that night and forgave me. My face reddens with
the memory.

"How stupid I was! How I hurt you!"

"Let's not talk about it."

But there it was, a little cancer. Although we progress into an
affair, as time goes by, I see that I am not so different, nor is
Sidney. And I see that given life all over again, I would act the
same way. I see that all the things would get the same responses,
and somehow the knowledge at last absolves me of guilt.

We flirt with the idea of remarrying, but we know it is not to
be. We make jokes about flying to see Sidney's sister Marion in
Maryland with her *goyish* husband, Dick, whom she finally mar-
ried when her parents died.

"It was so simple to make reservations. Mr. and Mrs. Sidney
Harmon. I didn't even have to lie!"

What fun it is to introduce Sidney at parties.

"Sidney Harmon."

"Is he your brother?"

"No, my ex-husband."

To shock the people. Still a pleasure.

My romance with Sidney is doomed by geography, among
other things. I'm not interested in going to Los Angeles. The
whiz of the cars on the freeway, the gargantuan geraniums, the
sameness of the weather, the dull nights are firmly in my head.
A vast suburbia. It is over. A lot of things are over. But Sidney
and I stay friendly and even try to give up smoking together.
After long conversations we look in disgust at ashtrays full of
cigarette butts. He succeeds, but I fail. This new Sidney, a golf

player instead of a tennis nut, this new Sidney who writes me sentimental poems about the past, is someone with whom I share tenderness, but not love.

Driving to New Haven after my brother's call, "Mom has had a stroke," I think about her rubbing Young Promise into her skin, Creme Set of Harriet Hubbard Ayer into her curly white hair, and her vanity table deep in a fluff of pale pink powder. I think about her almost daily phone calls to me and her talking on and on while I have time to run to the stove, turn over the fried eggs, come back, and not miss a beat of her monologue. "*Vus tist du,* Lilinyu? Vot are you doing?" "I'm working." "On such a nice day? Vy don't you go out vile the sun is shining. Vork, vork, vork. A person needs a little play, no?" I think about Baba. After all, she was my real mother. Why, then, do I feel so badly about Mom? I love her craziness. I love her generosity. I love her dancing the cha-cha and refusing to be old. I love her optimism and her saying, when Amy was so ill, "There's nothing the matter with her. All she needs is a nice Jewish boy." Things must have been happening to the blood vessels in her brain for a long time. The last calls from her had been different.

"I don't feel so good. I can't catch my *neshumah,* my breath. You I can tell, Lilinyu, but I don't like to complain. I don't like that people should feel sorry for me."

They have rearranged New Haven. I drive around and around something called Frontage Road. I have to find the streets I know to find New Haven Hospital. Where is Harkness Pavilion? Where are the houses of my youth? I am on an alien planet with tall, unfamiliar buildings. What have they done with all the dry-goods stores? Where are the barrels of pickles on Oak Street? Pop and I used to pick up fresh bagels on Sunday morning. Why are the bagels soft now? They used to grow stale minutes away from the store. I liked them that way.

Luckily they have not dared to tamper with the New Haven Green and its churches. It nestles helplessly with a bizarre fringe from outer space.

Pop complained of a buzzing in his ears. It occurred to my brother and me simultaneously—"The buzzing in his ears is Mom," we shrieked. She never let him get a word in edgewise.

Now she lies silenced except for what sounds like "Gibba, gibba, gibba." That is all she can say now. One of her hands moves violently. The other lies motionless on her paralyzed side.

For nine terrible months, Pop visits Mom twice a day in the nursing home to which she has been sentenced. He is miserable when she frowns and happy when she smiles. I stroke her hair. She is like a pussy cat.

"I told them she must have her hair set every week, like always. And a manicure. She looks beautiful, like a queen, no?"

"She looks beautiful."

Sidney and I walk down Central Park West to visit his friends, the Robert Ryans, at the Dakota. The apartment with its fourteen-foot ceilings, a fire blazing in the fireplace, and comfortable soft couches looks like a large country house, belied only by the view of the tall buildings across the park. Jo Ann was impressed.

"Wow! You're going to meet Robert Ryan! He's handsome."

Still, she was content to spend the afternoon with a girl friend.

We are settling back with our drinks when the doorbell rings. I am surprised to see Jo Ann. For a brief moment, I think she has pursued me to meet a movie star in the flesh, but her face is so grave that I know what it is before she says it.

"Grandma's dead."

Sidney walks us home. I am so disorganized that my daughter insists on packing my suitcase for me to go to New Haven. Jo Ann remembers everything, down to the last small necessity, unlike the time she forgot her boots for a boarding school interview and wore her sneakers in the snow.

Mom is not in the living room, as Zayda was. She is at Weller's Funeral Home. She has nothing to wear. Her own clothes have become grotesquely large on her emaciated frame. I contribute a simple new gray dress of mine, but it is too big and the mortician has to pin it from behind.

My own mortality presses on me, since Mom, whittled by death, looks like me in the casket. I keep thinking of Robbie Cohn's statement when her mother died. "Now *I'm* the mommy." There are no buffers.

Sidney has come up for the funeral, and to most of the

mourners who haven't followed my life carefully, I am still married to him for the past thirty-three years. We do not disabuse them. It would all take too long and doesn't seem necessary. I am glad he is there.

After the funeral service, while friends mill about at 709 Orange Street, my brother says I must come into the den and sign something.

"Now? On the day of Mom's funeral? Can't it wait until tomorrow?"

"We need it for the probate court."

In the room where I used to neck on the loveseat while Pop announced the quarter hours loudly from around the corner, I sit with my father, sister and brother.

"I'm going to read Mom's will," says my brother.

It is short and surprising. It says that since I am amply provided for, everything is to be divided between my brother and sister. Pop is not mentioned either. Most of the estate was in Mom's name. Mom was so jealous of Pop that she would go into a tirade if he smiled at a waitress.

"I remember Mom's telling me only a few months before her stroke how she loved us all equally and would divide her estate three ways. I told Amy and Jo Ann about it, I was so touched."

"Mom was pretty crazy at the end," says my brother. "She made a lot of wills. Some of them were with me, but this last one she went to another lawyer."

Loveless and deserted, I want to run into the bathroom, shut the door, and cry.

My sister looks triumphant, my brother embarrassed, and my father confused. After all, he was left out too.

"Pop shouldn't stay in this house," says my brother. "It's too big."

"But he's lived here fifty years!"

Nobody cares.

Since I've done as I was told and signed all the papers despite my lawyer's warning never to sign anything without his approval, I am released to go again among the mourners. Rabbi Robert Goldburg, the friend who married me to Joe Hirshhorn so long ago, having paid his respects, is leaving. I walk him downstairs.

"They're rushing so, my brother and sister. They can't wait to change my father's life."

"If a boy scout wants to lead an old person across the street," says Bob, "he ought to find out first if the old person *wants* to cross."

Pop, who never cried before, cannot stop crying. His face puckers into uncontrollable tears. He wants a painting of Mom. I did only one from life. I try to please him and go against my own nature to paint one from an early photograph. Mom, about sixteen, is wearing an old-fashioned dress with a brooch, and has her hair swept into a pompadour.

"She looks too young," he says.

I have an idea for a painting of Mom, an image of her at seventy-eight, a year before her death, dancing at a wedding all by herself, a Goyaesque figure, wrinkled and light-bodied with a black lace shawl draped around her shoulders, but I know Pop would say, "She looks too old."

There is only one thing to do. I must get "The Lady in Blue" back from Upjohn. It is twenty-four years since I painted it.

After many phone calls, I find out that Mom's painting is no longer owned by Upjohn. It is at the Kalamazoo Institute of Art. I reach the director and tell him about Pop's despair and that I would like to buy the only painting from life that I did of my mother. To my dismay he says, "We won't sell it." There is a long pause, and he adds, "However, we'd be happy to exchange it for a more recent painting. We'll send the painting on immediately, and one of our board members will visit you to select another."

And so "The Lady in Blue" (IS THERE DIABETES IN YOUR FAMILY?) comes home to my father, and a Mr. David Markin not only approves the odalisque I select instead, but even purchases a small drawing for the museum.

GRAND OLD MAN IS LEAVING GRAND AVENUE, says a headline in the New Haven Register when Pop retires at eighty-six, selling the store to his sixty-six-year-old employee of forty-eight years, Mickey Rachlis. The metamorphosis of New Haven had taken its toll.

As if to take revenge, the store burns down almost immediately and is relocated in a shopping center. It still bears the name PERELMUTTER'S, and Pop drives himself there daily from his new apartment at a residence for senior citizens to talk to his fifth generation of customers like the Pomaricos.

"I don't know what else to do with myself. I never had a hobby." He is still able to care for himself, but when he comes to the Cape, he cries. "I was never here without your mother. I never went anywhere without her."

He plays pitch with Fred Thomas, who has outlived his son, Jimmy, who built my bulkhead. Fred is ninety-one to Pop's eighty-six. "It's a *goyish* game, not like pinochle," Pop complains, "but he likes it."

"Try to let Fred beat you sometimes. After all, he's older than you are."

"Highway robbery, it's highway robbery," he says when I take him with me to the supermarket. He makes me feel guilty and extravagant. His memory goes back too far. "I remember when steak was ten cents a pound. We used to pay fifteen dollars a month rent for a house big enough for seven people."

Pop has shrunk. His hands are still the strong square hands of his youth, his face is still unwrinkled, but he has a little pot belly, and although he walks as energetically as ever, his body is no longer erect.

There will never be any change in the family. My sister Gert, through eternity, will always be the first one, the one everybody bows down to, my brother, the only boy in the family, will always be sacrosanct, and I will always be the baby, lacking in authority. I do not have the arrogance of pessimism, a godlike assumption of a dire future, that my sister and father seem to have in ample supply. I shall always be regarded as an optimistic fool. All the threads were arranged in a certain way and make predetermined patterns.

Chapter Eight
1969-1979

"BUT YOU DON'T UNDERSTAND," I say to a friend of mine who is critical about the courses Amy is taking at college. "I'm glad she's alive." The hell with credits for math and science. I'm glad she loves poetry. I'm glad the phone doesn't ring any more with news that she has smashed her car into a telephone pole and a plastic surgeon is sewing up the hole in her forehead. I still live in fear that the euphoria of love is about to set her up for a nose dive. I am hostage to her ups and downs.

It is hard when Amy hates me. When she was little she was so quiet I wanted her to yell and scream and release her anger. I felt I could carry her hate. But now I am not so sure.

"I will never talk to you again," she says, when she runs away from school and I am terrified when I don't know where she is. When I find her at last, it is with the drummer with his long hair and penchant for drugs. "You know I'm not a runaway," she says. "I told you I was going." Yes, but not where.

Jo Ann begins to make herself felt. The strong one becomes weak as if to say, *Look at me. Pay attention to me. I'm here, too.* She vacillates between holding a responsible job and goofing off. She spends much of her time watching Larry, a minister's son, race down snowy slopes in competitive skiing or listening while he plays and sings with the Provincetown Jug Band. Between the girls, I feel like a Yo-Yo.

Only my art helps. Like the time I painted children when I confronted my own barrenness, this time I am obsessed with the young people of the sixties, with their wild hair and new ways, wearing outlandish clothes from other centuries, other cultures.

I am in the mood to fill great spaces and the three-by-six-feet Japanese paper mounted on a board is so big that I have to poke my head around the easel to see the model. The first person I draw is Ann Marie Merrill, a friend of Jo Ann's from Canada, who seems to be living with us. She is an exception to the other sloppy teenagers—with her mascara that never smudges, long, well-washed hair, and perfectly manicured long nails, a ring on each finger. Next I draw Jama, a revolutionary from NYU with a face surrounded by curls, with a Peruvian poncho over his shoulders and a button on his chest with a photo of a martyred boy.

Zero's son Josh poses for me, asleep on the floor with a T-shirt with 13 in large figures all over the front of it. He is acting improvisations with a group from Boston. At a *fin de siècle* show at Associated American Artists, Sylvan Cole introduces me to a young lady I spot wearing a long black velvet gown and a Juliet cap, a diadem of pearls and rhinestones on her free-flowing long hair who comes to pose for me. Her name is Carol Kane, and she played the hippie in the movie *Carnal Knowledge.* Her delicacy makes me think of Lillian Gish. Julie Garfield, fresh from a triumph as Sonya in *Uncle Vanya,* poses, as well as my favorite model, Susie Rubenstein, who always looks twelve years old and used to be a ballet dancer. Her trained body can hold any position without strain.

At a cocktail party in Truro I pick up a boy wearing ragged shorts and playing the flute who looks like a shepherd in Jerusalem. He turns out to be Conley Falk, the son of my friend Lee Falk, who draws "Mandrake the Magician."

I work from young people who lead me to other young people and I get used to the pale imprint on tired blue jeans that look like tomb rubbings or plaster casts of the bodies within. I dare a diptych, combining two sheets of paper for a family group of a young couple who pose with their Afghan hound named Hash.

"The dog seems dopey," I say as he lolls listlessly at their feet. The color of their hair is all alike.

"We tranquilized him before we came," they say. "We brought a present for you." And they give me two cigarettes. "Acapulco gold," they say. "The best."

I wind up drawing five members of the Circus Maximus— Jerry Jeff Walker in a cape like Sherlock Holmes, others in fringed suede jackets bedecked with bangles and beads, to the delight of Jo Ann and the dismay of the elevator man, who brings them up in disbelief one at a time.

After a year and a half of doing drawings in charcoal and a gray winter, I have a strong urge to see color. Henry joins me on a trip to Morocco. We start our three weeks there auspiciously enough with a dinner at Bob and Ilse Schumann's home in Casablanca. Visiting the kitchen to learn how to make couscous, I see the cook's face is tattooed fetchingly with blue spots. She is wearing a glowing gauze robe and looks like Sheherazade. With the tips of her fingers she separates the semolina, letting air flow into it.

The next day Ilse and I go shopping at a souk, while Henry goes off strung with cameras, recorders, and other paraphernalia.

"It's nothing like our supermarkets." Around us, the housewives are cloaked in long white, black, or brown robes. Their ankles clank with silver bracelets as they bargain among mounds of hot and sweet peppers, small ripe tomatoes, barrels of lemons preserved in salt, bottles of orange water and rosewater and powdered saffron piled in extravagant heaps. The smell of full green bunches of wild mint mingles with cumin, cardamom, mace, and nutmeg. Ilse selects a large crusty loaf of bread sprinkled with sesame seeds and puts it into her basket.

"What a great bread."

"Nothing like your bread I ate in the States. It's so coarse. Not like your fine white bread. What was it called?"

"Wonder Bread." I shudder.

We rent a Fiat and drive to Marrakech with Ilse. We stay at the old Mamounia but Ilse prefers the Hilton. "It's more modern," she explains. She initiates us into the rites of bargaining, which are worse than Mom's "Offer them half." And then she goes back to Casablanca with a final blessing of *In'ch Allah* (Allah

313

be with you), and we are on our own. We are claimed by a small
boy named Mohammed whom we nickname The *Gonif* (the
thief). We are on to his steering us through the labyrinth of rugs
and merchants to shops where he will get the biggest commis-
sion. "They're mine!" he boasts as he wards off other small boys,
as if he won us in a raffle.

In the Place Djema El Fna, a name that sounds like a sneeze,
fire-eaters, salesmen of teeth, and sword swallowers surround
us, and riders on Arabian steeds kick up dust. Acrobats pile up
on one another. At a café, I sketch and Henry takes photo-
graphs. In the evening we eat at an extraordinary restaurant
called Maison des Arabes run by two French sisters. We feast on
pigeon pie made of fine strudel dough with ground pigeon meat
between the layers of sprinkled cinnamon and sugar on top, and
then have soup, lemony chicken, and a dessert crusty with al-
monds. Michael Field, the food maven at the Cape, said it
was one of the five great restaurants in the world, and he was
right.

We have a memorable lunch at the home of Raïs, a guide,
bearing gifts for him and his family. His daughters dash to his
side the moment their father enters, remove his shoes, replacing
them with embroidered slippers, and put a *djellabah* over his
jacket. Raïs sits on the highest pile of pillows like a king before
the shining copper tray on a low table laden with delicacies.

Madame Raïs, straight out of a Matisse odalisque, pours mint
tea simultaneously from two pots, one in each hand, at such a
height I marvel she can hit the target of the cups. Girls pour
rosewater from ewers over our hands, sticky from the chicken
that Raïs had torn apart, offering us the choicest tidbits.

I mention kohl, remembering Anaïs Nin's description of it.
Madame Raïs beckons to one of her daughters, who goes off
and fetches a tiny bottle of shiny blue-black antimony grains.
With no mirror, Madame Raïs draws a perfect line under each
eye with the wooden back of a brush. When I try it—and they
are kind enough to give me a mirror—I wind up looking like
Theda Bara.

"Would you permit me to give your daughters lipstick?" I ask
Raïs.

"No," he says sternly. "They are not allowed to use makeup of any kind." He adds, "My daughters are not to go anywhere alone. They are not to go to the movies."

"Even with someone?"

"No. Not even with someone. They are not to do any of these things until they are married. Then they may do everything."

Our destination is Taroudant. I drive over the High Atlas mountains. I know Henry is a master of the short stop; when he drives he automatically shoves his arm out in front of a passenger to keep him from being catapulted through the windshield. As we begin our ascent on roads so narrow that an oncoming truck could squeeze us over the edge, and even the clambering sheep sometimes slip, Henry says, "You don't understand fourth gear."

"Look at the view. You have a great opportunity to look." Down below us are the Cézanne-like forms of houses nestling cubistically into hills and gray-green olive groves. "Look and don't talk. This is one lousy car. It feels as if it is going to die any minute."

Henry's cars, a series of secondhand models, always start out in pristine condition, but the moment Henry takes possession the door hangs rakishly or falls off. Rust spots develop like a pox. The motor develops asthma and only when thoroughly loaded will give one last gasp on the way to the Cape and die in Branford. Henry's way of handling this is to walk away from the corpse.

But I am a car hypochondriac detecting symptoms long before the illness. I know the Fiat is terminal. We fight about fourth gear through small boys who choose the top of a hill to flash quartz in front of us yelling, "Ame*thyst!* Ame*thyst!*" and we have no choice but to stop and buy some or knock them off the cliff.

The Fiat dies in Fez after surviving the High Atlas mountains. When a Hertz representative arrives, I think he is there to administer last rites, but no. He manages to get it going again, although I want him to give us another car, but Henry won't make a fuss, and we continue fighting about fourth gear and

getting more and more upset. In Rabat, as we are about to leave, Helen Frankenthaler is checking in.

"We're thinking of renting a car and driving up the High Atlas mountains," she says, introducing us to her companion, a French lady.

"Don't," I say and wonder why Bob Motherwell is not with her. But I am having my own troubles. The trip seems to have crystallized and clarified that despite our joking about getting married again, we never will. *"Kimt nicht heint, kimt morgen,"* Baba would say. If not today, tomorrow. Henry can wait; I can't. I'm not geared that way.

"I can't tell you how much I dreaded meeting you when Mary-Lou told me about her way-out aunt," the Irish artist Dugald Stermer from San Francisco says as he stares at my constructions. "Are these yours?"

"Yes."

"They'd be perfect for an issue on environment I'm designing for *Communication Arts* magazine. It's all about recycling."

So that's what I've been doing. Recycling. Giving old things new life.

"Send me four-by-five color slides and a letter about how you do them."

Writing to Dugald, I realize that when I was twelve I blew my life savings of three dollars on an iridescent green pitcher and six matching glasses, that I've always loved secondhand stores, dumps, attics, and prefer the windows of hardware stores to Tiffany's. People send me metal spewings or sewer lids for my birthday instead of flowers.

I delight in my accomplishment of stealing whole lengths of iron fence from an about-to-be-demolished section of Brooklyn's Williamsburg just by hiring a welder to cut it up and then taking it to the Cape in my station wagon. Clarence, the welder there, stares in horror. "You took tons of it. You could have broken every spring in your car." But I had saved it—that was the important thing.

The process of making the constructions was so exciting I rarely thought of what would happen to the work. "You get your jollies from the doing," Carter Winter observes.

When the magazine publishes the color photos, "The Gourmet" is invited to a show in West Germany called "Garbage Is Beautiful" and returns somewhat battered and wrapped in bandages. Then there is a possibility of a show of constructions in Mexico City at the Palace of Fine Arts, but, worried about their being damaged in transit, I think of sending the large drawings instead. I am illustrating Edith Wharton's *House of Mirth* for Limited Editions. Estelle's sister Bette continues her agency. And then she has a job for me to do an edition of Guy de Maupassant's short stories for Franklin Library which I cannot resist.

I receive a request from the National Academy. Is it good or bad that I have been asked to submit a painting for membership? Do I want to be chosen by the art organization I scorned in my youth? Will they want me? I think not, but to my surprise, I am elected and pay for the honor with two paintings, one of them a self-portrait. I console myself by thinking that Thomas Eakins did that too in order to get in.

As the members, many of them in their nineties, shuffle in, they make me feel like a giddy young girl. I love it. But there are new, younger artists like Aaron Shikler and David Levine. Perhaps we can change the nature of the Academy. Perhaps we can liven things up.

The mail is full of black-rimmed announcements about the death of members. One artist says he has collaged them all on a screen in his studio, perhaps to remind himself that one can pass on to greater glory and possibly higher prices.

"You can't teach it, that's what," Dean Keller says when I ask him what he learned in all his years of teaching art at Yale Art School. To my amusement, they now claim me as an alumna. My old teacher is in an obscure dark studio and paying the model himself. The school no longer cares about life classes. Upstairs in the very cubbyholes where I painted the dead fish, Josef Albers' students are busy painting bright squares of color, moving them now to the right, now to the left. I feel sure that if I were to come back in a few more years, the pendulum would swing and the students would again be painting from models.

When Joe Hirsch asks me to take over his drawing class at the

National Academy School while he goes to France for a few months, I find I like it, and the next year I accept a position to teach painting there. In the hundred and fifty years of its existence, I doubt that they had a single full-time woman teacher, and I hope to establish a precedent. The class ranges in age from an eighty-year-old retired physician to youngsters. My most original student is a lady in her fifties who paints heads so large they turn bodies below them into gnomes. I leave her alone. She has her own vision, her own humor, and her own world.

Some of the students object to not being offered panaceas or magic solutions. Some think recommending sap green will cure everything. Mostly they hate the handicap of free will. My monitor, Andy, has twenty-twenty vision and finishes inch by inch, starting at the upper left-hand corner of his canvas and exiting neatly at the lower right-hand corner with his signature. I could never in a million years work this way; he can't work any other. "I can't *wait* until tomorrow," he says when he washes his brushes. The show at year's end is so diversified that no Harmon label can go on it. That makes me happy. A fellow teacher is so anxious for his indelible stamp that he works on each canvas to guarantee it. Although the year is gratifying and a great ego trip, I decide I won't continue. Time is creeping up on me.

I slipped and fell today. Two young men leaped to my aid and picked me up, one on each side, raising me from my ignominious sprawl on the sidewalk. "When I fall, I fall like a dancer," I used to say, but I hadn't—I'd fallen like an old lady who had no right to wear platform shoes. There is a stranger in my body. Will I wind up looking like Rodin's "Old Courtesan?" In store windows, I catch glimpses of myself and am startled to see my own mother. The little brown spots on my hands look like ripe fruit and my skin seems to be wrinkling a little like an elephant's. I try not to look in mirrors. Truck drivers don't whistle any more. Once in a while, when someone makes a pass at me or flirts, I am positively grateful. The eyes of these young men are full of solicitude, as if I were their grandmother. How odd, when I feel eighteen still and my breasts haven't fallen.

"Are you all right?"

"Thank you. Yes."

And I tuck the rolling oranges back in the brown paper bag, wipe a disgusting blob of yoghurt from my pants, and even walk shakily on for a few blocks before hailing a cab. At home, to add to my turmoil, there are pigeons strutting and cooing on the wide stone window ledges. They frighten me. I keep thinking they will fly in and I will never be able to chase them out. Once one was trapped in the apartment fluttering its wings as it dashed down the hall, and I was afraid it would peck my eyes out in its frenzy. The superintendent rescued me by catching it in a cloth and releasing it to fly away. But now I take no chances and go around shutting all the windows to a small crack.

There is collecting and collecting. While Joe is readying his great gift to the nation, I pick up crushed Coca-Cola and Seven-Up cans flattened into constellations of jewellike color by car wheels. On my way to the Cape for spring planting, I cannot resist a tag sale, and I stop at an old mansion where there is a sale of a Miss Constance Hunt's possessions. Someone sits at the door taking cash, but for whom? She was the end of the line. I muse on handkerchiefs of white batiste still in their original Christmas boxes and on the contrast between well-worn flower-sprigged cotton housedresses and unworn Paris creations.

In the cellar, rows and rows of jars have moldering fruit in them. Peaches once dipped into boiling water to remove their skins and reveal their pink perfection are now brown. Plums that used to be royal purple have turned black and are probably crawling with botulism. I buy daguerreotypes of long-gone ancestors, feeling ashamed that there are no relatives to claim them.

Honey-locust trees seed themselves and drop perfumed petals like snow when I get to the Cape. I plant buttercrunch lettuce with its small tight heads like Bibb, ruby lettuce for color, and sharp arugula for its pepper bite. Then there are the snow peas to climb all around the fence that encloses the vegetable garden. For everything I plant there is a bug. I think of Zayda and

Ecclesiastes: "To everything there is a season." Now all hazards and weeds seem far away. In the herb garden outside my kitchen door a blind person could stand sniffing the fragrance by rolling aromatic balls of the leaves of French tarragon, lemon thyme, mint, parsley, and basil.

"We're not through with your car yet," Dennie says looking up from the hood of the station wagon.

"That's all right. Take your time. I'll just walk over and pick up some Portuguese bread."

Hugging the large brown paper bag bulging with breads, I see Milton Schachter walking down Commercial Street toward me. Damn. No way to avoid him. What is he doing in town so early, anyway?

"May I carry that bag for you?"

"I'm only going as far as the garage."

"Here. Let me."

"Your car isn't ready yet," says Dennie. "One of the guys is out sick. I could get someone to drive you home."

"Why don't we walk? It's a lovely day."

I sneak a sidelong glance at Milton Schachter and pick nervously at leaves of the hedges we brush on the narrow sidewalks. He is an extraordinary-looking man—ferocious with his hawk-like nose and strong scooped-out eye sockets, the sculpture of his face softened by a shock of thick white hair. Back-lit with the light of the sun streaming through it, it looks like the aureole of a round dandelion head gone to seed. He strides beside me with a long, loping pace.

"You look like Giacometti."

"Who's Jack O'Metty?"

Is he being funny or what? His wife, Elsa, who died of a cerebral hemorrhage, was a fine artist whose delicate collages I always admired at group shows.

"A sculptor. But you're not serious—you do know."

"No, I don't."

"Giacometti. A Swiss sculptor who whittles people down to their thinnest until they hardly exist."

"I'm at my thinnest." I noticed his clothes seemed to hang on

him. "I'm a formerly fat person who started out to lose three pounds and then before I knew it I'd lost thirty-five."

My previous encounter with Milton Schachter was irritating. One of the members of the cooperative apartments of which he was president asked me to tell him what to plant there. I plunged right in with suggestions about tamarisk bending with the wind and went on and on about rugosa rosebushes only to have him dismiss me with a wave of his hand. "I've hired a gardener for all that."

"What are you doing here so early anyhow?" he asks.

"I'm putting in the vegetable garden."

"Let me help you."

"If you like. I think it's warm enough to plant the string beans this afternoon."

Milton digs in the soil happily, hammers the stakes and surrounds them with beans in a neat circle. I turn on the pump for well water but it goes crazy. Torrents of water spurt from every crevice except the right one, while I rush madly around the river that is cascading down Allerton Street.

"Do something!" I scream. "Do something!"

"Where did you get the pump?" Milton asks calmly.

"Sears Roebuck in Hyannis. Do something!"

"We'll just call them up," he says as if the flood didn't exist, and we walk back to the house, where Milton phones and talks briefly to someone at Sears, then steers me back to the garden where he turns a valve and the waters subside. Grateful and impressed, I ask if he would like to share a duck dinner I am having with Robbie Cohn that night.

"I'm crazy about duck. I'll bring the wine."

At dinner, I sing his praises.

"I can't really fix anything. I'm terrible with my hands. It was a family joke."

"You fixed the pump."

"I only found out," he says. "I'm a good manager."

Two weeks later in New York when Milton calls (why did it take him so long?) I am a goner. His description of his upbringing is that he is the result of benign neglect. It gave him inde-

pendence. His mother would murmur, "Play nice, children, play nice," when they quarreled and would counter arguments with, "All right. I'm a bad mother." There was no answer to that one.

"I've been fighting guilt my whole life," I mutter. "Especially about the children." If only I was capable of benign neglect. That died with our parents' generation. Mom and Pop were first with each other. Kids came second.

"Perhaps the way to solve that would be to name all Jewish children 'Guilty.' "

"I see," I say, catching on, "I can see the classroom. 'Who's Guilty?' the teacher asks. All the kids raise their hands. Save a lot of analysis later on."

Milton was a radical fresh out of college when his father was killed by a drunken driver in an automobile accident in North Carolina. Milton's father was a furniture manufacturer who established lumber mills in the South to make parts to be assembled in New Jersey into the bedroom suites of the depression. As the eldest of four children, Milton was elected to run the family business. His mother, a lady in poor spirits and health, moved her family constantly from Brooklyn to the Bronx to Washington Heights, always in search of a higher altitude to help her aches and pains. After her husband died, she became a Christian Scientist and refused to see a doctor—it was against her religion—and she died of diabetes.

" 'Don't be poor and don't get old,' my mother advised us," says Milton. "Elsa's parents were different from mine, more Americanized. When the in-laws met the day Elsa and I were married, we were all wedged together in a taxi going to Tavern on the Green for lunch. Nobody said a word. Elsa's mother was a sweet lady who thought silence impolite. 'Have you any hobbies, Mr. Schachter?' My father's day began at six and sometimes went on to midnight. My father considered for a long time before he answered, 'Yes. On Sundays, I have my rheumatism.' "

"My father didn't have hobbies either. Not even rheumatism."

"Here I was. I thought I'd be a labor organizer and suddenly I was the mainstay of the family. I was married to Elsa and we had Meri and David. When the factory burned down, I had a choice. Rebuild or quit. I quit. And now I manage the old build-

ings, those that were left, and I built some new ones. I call it Evening Realty. Or Evening Reality. The occupation of my old age."

"You're not old. I'm sixty. I don't feel old."

"I'm fifty-eight. Elsa was two years older than me. I like older women."

How can a man who was married for thirty-five years to one woman be rash enough to fall in love with me? Our friends are making book on the chances. Edith Begner loses ten dollars. "You told me you'd never get married again," she bellyaches. "You said never never never. I was sure I had the inside track."

And so we give Bob Goldburg another chance. "After all," I say, "he was very young when he married me to Joe. Perhaps he'll do better this time." He didn't do well marrying Marilyn Monroe to Arthur Miller, either. But that was all a long time ago.

"How can I explain your getting your mail here to the elevator man?" I asked when Milton stayed over in the New York apartment. And that, we tell everyone, is why we got married.

Aside from the fact that I am startled to come upon my husband in the halls and there doesn't seem to be enough closet space, the transition from fourteen years of living alone is not traumatic. I feel secure. Milton knows nothing about art, but I feel free to pursue what I wish. He is, like me, constantly pursuing something. Right now it is bread. He wants to make a perfect French loaf. To that end he is exploring Julia Child's twenty-one-page recipe for French breads of various types in her blue book, letting the dough rise three times slowly and experimenting with bricks to release steam from a pan of water in the oven.

Milton's house in Maplewood must be sold. We have decided that we shall live in my apartment in New York. It is embarrassing for me to enter Elsa's house, to be in charge of dismantling the accumulation of thirty-five years of living, just as it had been hard at Huckleberry Hill with its memories of Jenny.

All the closets in the large house are stuffed. Elsa was a great saver. In the attic, hatboxes still hold confections created by

Lucy Stander, a milliner in Greenwich Village, one of Lionel Stander's ex-wives. Elsa never threw anything out. When she bought new curtains, she saved the old ones. *"Es kimt zu nitz,"* I could hear Baba saying. It comes in handy.

In the studio, Milton's eyes well with tears. An unfinished painting is on the easel. The paraphernalia of varnish and paints and brushes are on shelves. Carefully sorted scraps of lace and textured materials as well as fluffs of seedpods are in boxes. In an old photograph album that once held daguerreotypes, Elsa made small collages to fit each oval.

Elsa's paintings are divided among Meri, David, and Milton. I hoped that something could be done to rescue them from obscurity, but I do not have the energy it takes. I haven't energy enough to publicize and expose my own work. I am to have a show of my drawings in Mexico City at the Palace of Fine Arts and another one in Virginia of the same show, and just the correspondence with the U.S. Embassy is exhausting, to say nothing of the packing and shipping.

"I can't understand why you want to go," Milton says.

"I want to see the end," I say stubbornly, like a child at a movie.

I was surprised when we received an invitation to the opening of the Hirshhorn Museum and Sculpture Garden now to be part of the Smithsonian Institution in Washington. Will Attend. Won't Attend. What should I mark? Will you, won't you, will you, won't you, won't you join the dance? The opening on October first was the first of three. We weren't invited to the one for the "art world" as Joe called it, but to one for bigwigs— members of Congress, the Cabinet, the Diplomatic Corps—as well as family, friends, and a sprinkling of old enemies to eat their hearts out.

The children would be there, scarred and smarting from headlines like "Does a Mother Have a Favorite Child? says Donor" or "Hirshhorn Gives Away His Children." In one interview Joe said he couldn't leave his paintings to his children. They didn't want them. Of course, they'd never been offered. Joe said he wanted to keep the collection together—a worthy

thought. Joe was right after all. The children didn't want the collection. What they wanted from him was something even rarer—a little love. Why was I going? To protect them like a mother hen? Jenny was dead. Did I want to put wings over her children? I went to her funeral. Joe didn't. Over the years, the children came to see me, Robin especially, when she was bewildered by her father's behavior, and the others from time to time for the same reason. Somehow, the fact that I survived gave them courage.

Amy is not going. She is in one of her fat periods. Joe wouldn't enjoy seeing her that way. He was proud and pleased when the girls were thin and chic. "You look like a bum!" Joe said once when Gordon came with love and an unshaven face. The boy seemed to dissolve into nothingness on the oriental rug of the living room.

On their way to the opening, Jo Ann, who is living with her friend Anthony Bultman in Provincetown stops in to see us in New York. She rushes to phone her father in Greenwich. Their status bothers him.

"You can say Anthony is my fiancé." But she has done something more terrible.

"I forgot my invitation to the dinner at the Castle of the Smithsonian, Daddy. I forgot it on the kitchen table. . . ." And then, with tears welling in her eyes, "But Daddy, I can't go back and get it. It's three hundred miles each way. I know I shouldn't have forgotten it, and I'm sorry. . . ."

When she turns to me she is crushed and unhappy.

"Do you think I'll be able to get in without it? Do you?"

"Of course you will," I say. "Your name is Hirshhorn."

Now I'm glad I'm going. I rationalize that perhaps my mission is to pick up the pieces. The insecurity we all shared grated on me like an irritated oyster and produced no pearls, only tears. I am relatively unscarred.

"Well, I'm going to wear that old gold caftan I got in Morocco," I say, as if not buying a new gown for the occasion proved something. I will show off my husband of two years, who is not only kind and thoughtful but looks, at the very least, like the conductor of the Philharmonic. Milton, annoyed at the re-

quest for black tie, reminds me of Jack Levine who, when invited
to a formal party, said, "They can't tell *me* what color tie to
wear," and showed up in a flamboyant red one. Milton settled
for a black velvet bow tie with red polka dots on the concealed
side.

What reason had Joe given Olga for inviting us? I could al-
most hear him saying virtuously, "I must. After all, she's the
children's mother."

"How old is he?" Joe asked when he called to congratulate me
on my marriage. "Two years younger than me."

"Oh, really?" He sounded disappointed as if he'd hoped Mil-
ton was eighty. I had no right to find happiness with another
man after him. Jenny had never remarried. I had seen the sum-
mit, and now, by my attending the opening, he could rub my
nose in it.

On our way from the station to our hotel in Washington, we
share a taxi with a large woman who heaves a sigh as she edges
herself next to us.

"I'm his cousin, you know."

"Whose cousin?"

"Why, Joe Hirshhorn's of course," she answers as if the whole
world knew where she was going. "He brought me to this coun-
try from Latvia twenty years ago. I never set eyes on him or
heard a word from him since. And now," she says, "now, after
all that time—" she sighs—"I get an invitation to the party. For
his museum." We smile and nod goodbye when she gets off at
her hotel.

In the inner circle of Gordon Bunshaft's doughnut or bagel-
shaped Hirshhorn Museum, flags are flying and a large circular
bronze fountain is shooting water as high as the top of the build-
ing that was supposed to be marble but for economy's sake
turned out to be pink granite aggregate. Across the Mall, the
White House smiles at Joe's possessions. A Marine band is play-
ing. The altered and sunken design of the Sculpture Court or
Plaza seems to dwarf the twelve-foot "Standing Cardinal" of
Manzu and shrink Moore's "King and Queen," making them

less impressive than they were in Greenwich against a background of greenery and sky.

I wonder where all my paintings are. Probably in the cellar. They're not on the walls. How could they be? After all, there are about six thousand paintings. Lord knows how much sculpture. The galleries are splendid, the lighting superb, but with all the people milling about, it is hard to see the exhibition. I look for Earl Kerkam's studies of himself, for Kuniyoshi's "Child Frightened by Water," a no-neck ugly baby with its head on backwards. Where is Marsden Hartley's dead black crow hanging by its feet and decorated with bright ribbons? It used to hang in the Port Chester living room near my favorite golden Samoan scene of Eilshemius. Where is Kokoschka's portrait of Egon Wellesz? Walkowitz's studies of Isadora? They have all found a home at last.

"I had to move heaven and earth to get an invitation," a lady from our suburban past shrills. "I called around and around until I latched on to one. I'm here under another name," she giggles. "I wouldn't have missed it for the world."

When we move away, I say to Milton, "She couldn't stand Joe." With person after person from the past, we find the place full of hurt people.

"What are they all doing here?" wonders Milton. A good question. Why are we here?

Chairs are drawn up around a stage and the dedication ceremony is about to begin. There are no reserved seats. Milton and I are already seated when the scramble begins. I look around to find Robin and Gordon, Naomi and Gene, bewildered; there is no specially cordoned-off area for the family, who have been wined, dined, interviewed, and now forgotten. I do not see Jo Ann and Anthony. The October air is cold and chilly and I pull my cape closer around my shoulders.

On the stage Joe looks like Larry Rivers' portrait of him, a ventriloquist's dummy with one kind and one evil eye. S. Dillon Ripley, secretary of the Smithsonian, presides, welcomes the collection as an answer to a prayer, but when he speaks of Joe's "gift of his children, as he calls them," I think I may throw up. Then there are remarks by the Honorable Daniel Moynihan,

Chairman of the Smithsonian Board of Trustees, in which he mentions the "level of taste, energy," and, with an "in" smile, *chutzpah* of Joe and elicits an equally understanding smile from the audience.

Antal Dorati raises his baton and the National Symphony Orchestra strikes up a fanfare with the "Prelude for a Great Occasion" especially composed by William Schuman in honor of this evening. Modest Abram Lerner, Director of the Museum, whose own painting I admired so long ago, is next—lavish with his praise of Joe, giving him full credit for the collection, as I had, years ago. Didn't it occur to anyone that Joe's impulsive nature didn't permit him the patience of continuity and order the collection represented? Would anyone ever give his curator any credit? Surely Abram Lerner supplied a sense of history.

And now the Donor himself, Joseph H. Hirshhorn, approaches the podium. Unfortunately he is too short to be visible. There is a ripple of good-natured sympathetic laughter as he mounts a wooden Veuve Ambal champagne box. Joe smiles back, a little man who made it big, and the audience is captive.

"Is that smile real?" Milton whispers. Joe looks different, as if he had grown into a stereotype of his press image. Lyndon Johnson is not present, nor is President Ford, but Lady Bird Johnson is, and Joe begins by acknowledging her and Chief Justice Warren, as well as Friends, Honored Guests and even Loved Ones, at which I smile. Joe is Horatio Alger, giving credit to his Mama from Latvia, paying tribute to America but leaving out his courtship of Nixon, on whose list of campaign contributors Joe's name appeared. Had Joe also hedged bets by giving to McGovern, or wasn't that necessary?

"But he didn't give credit to Canada!" Franc Joubin fumes after the ceremony. He and his wife, Mary, are like orphans in the storm lost in the shuffle. "Where would he be without Canada?" For that matter, where would Joe have been without Franc, the little geologist and his big uranium find?

"And how is Marion?" I ask, remembering their daughter at fifteen spending the summer with us in Port Chester and splashing about with Amy and Jo Ann in the tiny tublike pool in the back yard.

"She was presented at Court," Mary says proudly, no longer

Freehand

the simple country wife of those days. She is chic and well-dressed. "Marion's a big girl now."

I would have liked to follow the lives brushed by Joe's—from ruined widows and businessmen to those presented to the Queen—but Franc and Mary are swallowed up in the crush of the crowd. Joe's lawyer, bursting with pride, says he's going to attend every single one of the three openings. He doesn't want to miss a moment of glory.

Like an emperor, Joe moves among his people. He has a curious expression on his face as he looks up at Milton when I introduce them. We congratulate Joe on his accomplishment, but then, hearing the dance music, he and Olga are the first on the floor, whirling around merrily like two tiny figures on a music box.

A woman with a notebook pushes her way toward me.

"You're Lily Harmon. Someone told me."

"Yes."

"You're the one who really formed the collection, aren't you?"

"No."

"But you're the artist he was married to, isn't that right?"

"Yes."

"Well, everybody knows you had a hand in it."

"I didn't."

She drifts away to find other material. The important thing is that the collection is housed. Who could figure out how it came about? Who could analyze the role of the taste-makers, the nuggets dropped by artists or dealers, or even the batting average of the mass-purchase technique?

"Elevator music!" says Milton, who likes rock and roll. "Let's get out of here!" Outside on the street, people are milling about looking for taxis. There are none. Milton takes off in a jogger's sprint down several blocks. Gene, Joe's second daughter, is with Barry Hyams, whose daughter I'd painted. "Nessa and the Blue Horse."

"Whatever happened to that painting you did of Nessa when she was a little girl?" Barry asks. I rack my brains. "When you didn't buy it, I guess I painted over it. It's under something. Canvas was expensive."

"Come with us," Milton says as he comes by triumphantly in a

329

cab. "We'll drop you." Nobody thought of limousines for the Loved Ones who appeared at the Command Performance. They had all played their roles, and no golden coach was waiting for them after the ball.

As for Joe, whose father had died when he was a year old, he was the biggest Daddy of them all. Perfect strangers wanted him for their very own.

An old lady in tennis sneakers is standing at the door in Provincetown.

"Are you Lily Harmon?"

"Yes."

"I'm from the Senior Citizens."

"What can I do for you?"

"The question is," she says, smiling, "what can we do for you?"

"For me?"

"Yes. According to the records at Town Hall, you're sixty-two."

In some file downtown I've reached the age where I'm entitled to hot lunches, home delivery, visits from someone to see if I'm still alive, trips to Boston, and God knows what else.

"I'm sixty-two," I say, feeling ridiculously young in my blue jeans, and anxious to get back to the studio, "but I still drive a car, I work, and I garden. Of course, there are some really old people in the neighborhood. There's Fred Thomas across the way. He's in his nineties, but he's in pretty good shape. He was up on the roof the other day painting his chimney." Disqualified. "There's Joe Kaplan. He has glaucoma and can't drive. Perhaps you could help him."

"Well, let us know if you need anything."

So this is how it happens. Somewhere in Town Hall, the statistics sound an alarm. And I go back to the studio to continue signing my name two thousand times on the colophon pages of *House of Mirth* that have arrived from Limited Editions. I am sick and tired of writing Lily Harmon over and over again, and in my thumb there is a little reminder of arthritis.

Intensive care. My sister is in intensive care. On my way to the hospital, the city is as unfamiliar as it was when Mom had her

stroke. I am lost again. I remember playing tennis with Gert. She wielded a powerful racket, all overhead smashes and top spin. I remember feeling outclassed, undone, as the ball kicked up dust at my feet. She would stand triumphant while I reeled from the shock of her drive.

"She looks cold," I say to her daughter Mary Lou as I stare at goose pimples on my sister's arm. Her skin behaves exactly like mine.

"See if the nurse will give you a blanket for your mother."

Gert's body has a large tube like a plastic caterpillar or a vent for a clothes dryer breathing air into her lungs. It huffs and puffs into a tube in her throat, where they have performed a tracheotomy. Under the sheet, my sister is naked. Why? Have they dehumanized her to the point where it doesn't matter? Her breast is exposed. I pull the sheet over it. An enormous computerlike machine is monitoring her. Tubes like transparent spaghetti branch out carrying nourishment in and pale yellow urine out.

The machines are alive and well, but Gert looks dead. The skin of her face is smooth, as if all the lines had been eradicated by silicone. Her fingers are puffed up like sausages and she is swollen everywhere. A little burst of light runs spasmodically across a monitor, attesting that she is still alive.

"Are you warmer now, Mother?" asks Mary-Lou as she covers Gert with a blanket. It seems to us that she nods, but we cannot be sure. Her eyes are closed, her lids sealed. This is the first time I have ever seen my sister helpless. Even though I know that were she to regain consciousness at this moment and rise from that foul tangle of machinery, she would say, "Oh. So it's you, is it? *Now* you come to see me," I wish with all my heart she would be sarcastic, make some crack, but live. Unfortunately the doctor perforated her windpipe while administering anesthesia for the routine gallbladder operation. Gert clings obstinately to life for three weeks with a virulent pneumonia that could have killed her in three days. Obviously, as the hospital said later when they settled out of court, it was an error of judgment to take forty-five minutes for a procedure that normally would take two minutes, five at the most.

Pop, who is in Miami, cannot hear of his oldest daughter's death by telephone. Milton and I go to him. I cannot say a word when I see Pop in the lobby. Tears flow from my eyes and from his. He knows. How terrible to outlive a child, his favorite child —and I, whose incurable optimism Pop finds foolish, am left to comfort him. I put my arm around my father, shrunken and fragile in his nineties.

"My mother," he sobs. "She was just like my mother who died when I was nine. She was just like Gittel. She was named after her."

And my sister had deserted him, too.

"You're getting younger as you get older," I tell Raphael Soyer at dinner at the Grosses' in Provincetown. The high studio living room has a fresh new hanging basket of fuchsia that makes a foil for Chaim's sculpture. "Your color is fresher." Raphael is seventy-seven and painting better than ever. I think of the paintings in his last show—the one of Joseph Floch, shrunken from his large self, his jacket hanging loosely; the double portrait of Sol and Dora Wilson, he in a blue jacket and she in a blue jumper, looking like an American Gothic. Raphael is painting his aging friends, as well as hippies and hookers, with love and tenderness. He paints himself, his twin brother Moses, and his brother Isaac, like shy gray mice, wraiths of observation at a large party scene where Mimi Gross Grooms, Chaim's daughter, holds her little daughter Saskia.

We are talking about collectors when I am startled by Raphael's "I paid his taxes for twenty years."

I am shocked. "I always thought that man was a good friend of yours and collected your work over all these years." He had died and some of his collection appeared at Parke-Bernet 84 in an appalling condition. Drawings uncared for. Paintings in need of restoration and in broken frames, many of them by well-known artists. Some of Raphael's drawings were among them.

"A bank handled the estate," Raphael says. "When I say I paid his taxes for twenty years, I mean he took bigger and bigger deductions when he gave my work away to charitable institutions. He bought them all for one thousand dollars. . . ."

"At once?"

"It was a long time ago when I had my first big show at Associated American Artists and nothing was sold. I was discouraged and I needed money. When that collector gave me a thousand dollars, he bought the whole show. Plus the drawings in the studio. He cleaned me out. I really didn't care—all I wanted was to keep on working."

And again, I am angry at the outrage that an artist may deduct only the cost of his materials if he donates a painting, but a collector may deduct it all. I am still angry at death taxes on artists' estates, still angry at the lowly position of the artist in our society. New organizations are springing up, but it seems to me that more attention is being paid to differentiate the artists by sex and color than to unite them in common economic causes.

"Collecting," Chaim says. "The first thing I ever collected was a power lawn mower. It was such a bargain, I couldn't resist it."

"We didn't have a house then, let alone a lawn," Renée interjects.

"By the time we had a house," Chaim continues, "we sold or swapped the lawn mower. I can't remember which."

"We kept it in our tiny apartment for a long time. It was always in the way," Renée reminisces. "The next thing you bought was a cradle, a beautiful old cradle. We didn't have a baby yet. But Yudi and Mimi used it later."

"Then we loaned it to someone who never gave it back and we didn't have it for Saskia."

Saskia, Mimi's child, and Chaim and Renée's granddaughter, is now three, the age Mimi was when I painted her.

"Mimi was such a good model. . . ."

"Models," says Raphael. "Does anyone know if Beryl is still alive?"

"She was good in her sixties," Chaim remembers. "She had a behind like a pear."

"She had skin like an electric light. It reflected color. So white, so pure."

"A darling woman," I say. "She told me she was a member of Hadassah."

"She wasn't a hooker," Raphael says. "Her modeling came

first. When she picked up a guy she would say, 'I'll do anything you want, whatever makes you happy. But you mustn't break my skin. No black and blues. No biting. No hickeys. No marks. The artists depend on me.' "

"Drawing from life," Rebekah Soyer says. "It's back in fashion."

"A toast. To Beryl." Chaim raises a glass of wine.

"To Beryl. She could hold a pose. . . ." And we all clink glasses.

At summer's end we have shared the tomatoes with the caterpillars in the vegetable garden. Some for them, some for us. As usual, the second planting of lettuce is unhappy in the August heat and tastes bitter. The eyedropperful of cod-liver oil in each silky corn tassel has not deterred the corn borers, which have nibbled a little from each ear. Perhaps the stuff attracts them. The snow peas have released their curly grip from the fence and are withering into brown vines. Bulbous butternut squash and green zucchini from pencil-thin to enormous phallic shapes are mixing it up in a tangle with the cucumbers. They have all gone crazy.

This year I'll clean it all up, put it to bed properly for the winter. In the spring, the compost heap will be lively with earthworms and tomato plants will sprout from random seeds.

On my way back from the garden, Fred Thomas is sunning himself in his yard and looking at his prize dahlias. Has he reached one hundred yet? He is almost there. It is almost time for him to be awarded the cane the town reserves for its oldest citizen, almost time for a letter of congratulation from the President of the United States.

"How you doing, Fred?"

"I'm waiting for the bell to ring."

An evening at the Fine Arts Work Center in Provincetown. My gray-haired contemporaries carry the cocoons of their adolescent selves within them and reminisce in their old disguises about their young days here.

Does anyone have anything to add? Is there an octogenarian

in the room? A few go back to Charles Hawthorne's time. Some knew Dos Passos, some Eugene O'Neill. Barbara Malicoat remembers the Paige Brothers bus called the Convenience that lumbered down Commercial Street with its running boards wide enough to jump on as it passed slowly. Great trees lined the streets then, before a big hurricane that felled them.

I do not say anything, listening and remembering the Portuguese boy I was in love with when I was sixteen who put ships in bottles.

Looking around at the masks of age my friends are wearing (and me too) I feel torn between the disparate views of Colette and Doris Lessing. The French writer admired the noble staving off with creams and lotions, artifice, dyed hair and corsets; the English writer accepts age, gray hair, and the inevitable. But even in the book by Colette, Chéri's love eventually admits she has grown old and succumbs to the delights of the table, bobbing her hair into short gray masculine stubble.

At the waterside, an artist is sketching on the flats. The tide is rising around his ankles, but he doesn't seem to notice. He looks like a many-legged beast bending toward his small easel and reflected back in the deepening water. Will he realize where he is before the incoming tide takes him and his work away? Just in time he straightens up, raises the board, and walks gingerly and carefully to shore.

A rainbow slick like peacock feathers drifts by lazily on its way to Beach Point. Thank God the boy next door has given up playing the drums and is now balancing himself on the narrow deck rail and juggling three oranges. A skinny kid is chasing minnows with a net in the shallow water. A boy with his dory filled with bluefish comes ashore and I buy a big one and clean it on the deck, scraping the mica-like scales that jump like rainbows into the sun.

The house smells of fresh bread. Milton shows off nine French baguettes. This time the loaves are perfect, their diagonal slashes crisped to brown, their bottoms encrusted with corn meal, their aroma heady as hay. The whole process was a succcess from the slow rising of the dough three times to the

steam hissing out of the brick in water to the final patent-leather glaze of egg white. Perfect.

We are going to have a big party on Labor Day for fifty people. Master of the overkill, I layer curly-edged lasagna into every baking pan I can find, alternately spooning a thick tomato-meat sauce and a fluffy ricotta cheese with squares of mozzarella in it and winding up with a final layer of mozzarella like a frosting to melt into delicious runny strands. Just as I am sprinkling the final touch of grated Parmesan, the phone rings. It is my brother Joe.

"Don't be alarmed," he says, "but Pop is at St. Raphael's hospital and he needs a prostate operation."

"What do you mean, don't be alarmed? Of course I am. I'll drive to New Haven right away."

"We'll have to cancel the party," I say to Milton.

"Don't you worry. I'll call everybody. You get going. But what are we going to do with all this?" And he points to the supply of lasagna casseroles in the kitchen.

"Freeze it. I'll take it to New York."

When I get to the hospital, Pop is understandably depressed. Who wouldn't be, at ninety-seven, face to face with the end?

"If I'm going to die, I want to die in my own bed."

"Don't forget," I say feigning optimism, "you said the same thing when you had that thing you called a 'cancerette' on top of your head."

"That was different. Only one day in the hospital and you drove me up to the Cape the same day. You bought me an ice-cream cone on the way."

"This will be the same."

He looks so frail I want to pick him up in my arms and comfort him like a child—my father, who used to be such a strong man.

"We'll be here, Joe and I. You don't have to worry."

But when I leave, he clutches my hand and says, as if he is making a deathbed pronouncement, "*Zei gesunt.* Stay healthy. Take care of yourself and Milton. Be happy." There are tears in his eyes.

"We don't operate to kill people," the doctor says testily to my brother and me in the hall. But my father is not so sure.

After the operation, Pop's face is a wonder to see. He looks around in surprise and ineffable joy to be on earth.

"Where is your other hearing aid?" I shout while I am packing his things to check him out of the hospital.

"The nurse made a mistake. She put it in a bowl of water the night before the operation. She must have thought it was a denture." My brother laughs and I do, too. Pop, who would normally be raging about such a thing, is in good humor.

"One will do for now. I hear enough and they'll get me a new one."

"I told you you'd live to be a hundred," I say.

"Your mother always said I'd live to be a hundred and twenty," he says, slyly upping the ante.

"*Alevai!*" I say. I hope.

Going back to Provincetown to close the house for the winter, I think about Pop's miraculous recovery and the summer's events. I marvel at Amy's strength. She is doing alcoholic counseling in Boston and will not touch a drop of anything with alcohol in it, not even cough medicine. She has licked obesity and is her own beautiful self, has a new boy friend, and will be doing graduate work toward her master's degree.

Why hadn't anyone told me everything would be all right in those years I was in anguish at the antics of my daughters? Probably someone had, but I didn't believe it.

And Jo Ann, who used to stuff a half-eaten dish of ravioli under her bed when I said, "Straighten your room," was now so tidy in her housekeeping with Anthony in New Orleans that she makes me look like a slob. The last week in August they come to visit with Grayson, Anthony's seven-year-old son by his previous marriage. The boy delights us and makes the house lively. The deck is again strewn with pails full of sea life, collections of periwinkles, moon shells, blue mussels, and quahogs.

I cut the last zinnias in the garden. Jackie, our young Trinidadian housekeeper, who lives with us in the summer, faces going back to New York and the subway with reluctance. "I hate

to leave," she says, looking out at the harbor and horizon as we strip the beds and fold up the blankets.

"What freezes?" I ask Bob Motherwell, who is sunning himself on his deck next door while I drain water out of long snakelike hoses over the railing and into the sand of the beach below.

"Soda pop and alkyd paint," he answers. "And Pepto-Bismol. Don't leave any Pepto-Bismol. Last year, Renata and I forgot it and it exploded pink all over the bathroom. We still can't get it out of the tiles. You don't have to worry about alcohol. That doesn't freeze."

The Boston ivy is reddening on the cedar fence between my former brick house, where Abby and Bob Friedman are staying late this year, and my weathering-gray-shingle house. The hedge is losing its leaves and thinning out. There is a chill in the air and the sunsets are becoming winter-brilliant. The house looks lonely as we pull away from it, the station wagon full.

"Are you sitting down?" Jo Ann asks when she phones in early October. We are finally settled in New York.

"I'm sitting down."

"Anthony and I have decided to get married. In Province-town, because that's where we met, and we're sentimental about it. We've told Anthony's parents already. They're still up there. Fritz is finishing some paintings and Jeanne is working on a stained-glass window. They're delighted. They'll take care of all the nitty-gritty, like finding out about the license and all that."

"But I've closed the house. The boards are up."

I remember how I had envisioned my daughters' weddings. Amy said hers would be on the flats at low tide with oriental rugs laid down. I had a picture of the tide coming in and swirling slowly up, engulfing the brilliant pattern of an Isfahan as well as the ankles of the guests, while a *chuppa* bedecked with flowers toppled over in the sand. Jo Ann didn't have such fantasies, so I thought she would have a traditional marriage and come down the stairway all in white.

"But perhaps the water hasn't been drained out of the house yet," I hasten to add. "Don't you worry about it. I'm so happy." I cannot find words to express the joy I feel that she and An-

thony are so strongly committed after six years of living to-
gether.

"Aren't you going to ask me if I'm pregnant?"

"Never occurred to me. Are you?"

"No. But Anthony says we shouldn't put the cart before the
horse."

Maybe I have a fighting chance to be a grandmother. Milton
used to say we'd be forced to make our own grandchildren.

"I'd have settled for being an illegitimate grandmother," I
murmur.

"You won't have to now. Shall I invite Daddy?"

"Of course. If he can come, I'll make reservations for him and
Olga at the White Dory Inn across the way. That's the nearest."

"Do you think he will?"

"Well," I say, having some doubt about it, "you know he had
a recent attack, it may have been his heart, and he was in a
hospital. It wasn't so long ago."

"It doesn't matter really," she says in such a small voice that I
know it does.

"I'm sure he'll come if he possibly can."

"You won't have to make the wedding dinner. Anthony's best
friend and best man is John Casas. He was a master chef at the
Ritz in Chicago. The dinner is his gift to us."

"Shall I bring lasagna? I have tons of it and I know you love
it."

"Well, maybe some."

"I promise I'll stay out of the kitchen and not compete, but I'll
do dinner the night before the wedding. We don't want to drag
everybody out to a restaurant."

As soon as I hang up, I phone the caretaker in Provincetown.
Sworn to secrecy, since Jo Ann wants a small wedding, I must
sound like some kind of nut.

"I want you to take the boards off the windows."

"But I just put them up."

"It doesn't matter. You didn't drain the house yet, did you?"

"Not yet." For once, I am pleased with a delay.

"Good. We're coming up. Please turn the heat on."

Milton goes off to the wine vault and returns with eight bottles of 1964 Château Lafite-Rothschild. I round up all the embroidered white tablecloths I can find that look like a wedding and even pack my most beautiful ironstone soup plates for the soup Jo Ann tells me will be one of the courses on John's menu.

"Have lasagna, will travel," says Milton as he helps us load the station wagon. Jackie and I drive to Provincetown and meet Jo Ann at the airport. Fritz and Jeanne are there, too, to welcome their new daughter-in-law, and that gives me pleasure. Jo Ann occupies her old room. Anthony will fly up just before the wedding.

"Is Amy happy about my getting married?"

"Of course. She and her friend Frank are driving in from Cambridge tonight and they want to take you out to dinner." I think about Jeanne asking me the same question. My sister's wedding proved to be a springboard to mess up our relationship. Was I being naive? I put the thought out of my head.

"Do you want place cards?" I ask Jo Ann after we pull out the round oak table to its full dimension, adding all its seven leaves and setting it.

"Yes. I'll write them out." And she is like a little girl playing house as she places slips of paper with names on them on each plate, separating boys from girls and speculating where they should all sit.

Amy phones to say she and Frank will be late picking up Jo Ann.

"Aren't you hungry?" I ask, having had my dinner.

"Yes, but I don't mind. I'll wait."

She is in a bride's glow. Nothing bothers her. Amy and Frank eventually show up late and the three of them go off gaily while I sit in front of the fireplace watching the flames and thinking my mother's thoughts. "*A bissel mazel. A bissel naches.*" A little luck, a little pleasure. I am having it all. Tucked into bed and dozing off, I am surprised when Jo Ann calls. A tearful voice on the phone.

"Amy's not coming to the wedding."

"You're kidding."

"I'm not. We had a fight."

"What about?"

"About the place cards. Amy wants to sit next to her boy friend."

"Let her."

"It's my wedding."

"Of course it is."

"I want to do it my way."

And I know everything is not to be all honey and roses. I sleep a troubled sleep, waking to rain streaming down the windows and the sound of an angry ocean thudding against the bulkhead. It must be high tide, I think, reaching for the phone that is ringing. It's Milton to say that he will be on the early plane. A few moments later, it rings again. This time it is Olga. Looking out the window, I am sure she is going to say that she and Joe will not be on the afternoon plane.

"We're coming," she says.

"Do you like lasagna?" I ask Olga. "I thought of having it for dinner tonight."

"I love it, it's my favorite thing," she says, "but Joe isn't allowed to have it." Will I never move that lasagna?

"I'll have fish, then. See you at the airport."

I phone Amy at the cottage where she is staying. She is adamant. Jo Ann is likewise. Into each life, I think, as I pull on my storm boots, some rain must fall.

Fritz, short and gnomelike, and Jeanne, tall and patrician, dressed alike in red slickers, are at the door armed with their whole garden which they have denuded in the pouring rain.

"Can you imagine?" says Fritz. "The forsythia went into bloom in October." He carries great branches of it into the house. "It's a good omen."

"Maybe. But Jo Ann and Amy had a fight last night and Jo Ann told Amy she didn't want her at the wedding."

"Oh, Lord," says Jeanne, arranging huge violet chrysanthemums in varying tones in all my available vases plus some of hers. "Don't worry. It will be all right." And she places succulents, great hens-and-chickens with thick leaves and tops like red velvet, next to bright marigolds. The house blossoms.

"On the other hand, Jo Ann's father is coming."

"That's good," say Fritz and Jeanne. "It will make her happy."
A young man who looks all of eighteen, but who is, I know, Anthony's age—thirty-two—arrives wearing a poncho and carrying a black bag that looks like a surgeon's kit. It is John Casas. Master Chef.

"I hope you don't mind, but I brought my own knives. And a sharpener, too."

He lays out his arsenal in the kitchen, takes out a large jar of black truffles and another one filled with saffron threads which he places reverently on the counter.

When everybody goes off on various chores, I phone Amy again.

"I'll come if she apologizes. She was nasty," Amy says bitterly.

No use to go over the whole thing again.

Jo Ann refuses to apologize.

"It's my fault for thinking of place cards," I moan.

"It's not," says Jo Ann, taking me off the hook.

"What kind of flowers do you want?" I ask, hoping that somehow all will not be ruined, hoping Jo Ann will have her own day as she wishes.

"Baby's-breath. A wreath of it for my hair. I'm going to wear it up in a chignon." She has lovely, long thick hair.

"Is that all?"

"And I want to carry a white rose. Just one white rose. Oh, yes —and white roses for the men's lapels."

The florist has no fresh baby's-breath. Only dried ones. We settle.

I grab an umbrella and rush to the airport to meet Milton.

"The Great Man is coming," I say, briefing him on the news.

"Wonderful. The kid will feel good."

"But she had a fight with Amy and told her not to come to the wedding."

"Maybe they'll make up."

"If Jo Ann apologizes, Amy says."

"Maybe she will."

"Doesn't look like it," I say.

The stock pot is simmering gently on the back burner. Jackie is slicing turnips into matchsticks and Abby Friedman is watch-

ing John in awe as he turns and flutes a mushroom. All is well.

Milton has made a suggestion, and I act on it, feeling like a fool.

"I've never asked you to do anything for me," I hear myself saying to Amy over the phone. "I'm asking you to do something for me now. Come to the wdding."

"She was nasty to me," says Amy, hurt. And that is that.

Jo Ann, Anthony, and I meet Joe and Olga. When he gets off the small shuttle plane from Boston, I am struck with Joe's careful descent of the stairs. I haven't seen him since the Museum opening. He no longer has his rolling sailor's gait but moves as if he is listening to the beat of his heart. He walks scared.

"Where's Amy?" he asks when he and Olga are in the station wagon.

There is a short silence.

"We had a fight," Jo Ann blurts out.

"I had a fight with her myself a few weeks ago," Joe says. The sky hasn't fallen. I am grateful.

"Perhaps if we talk to her . . ." Olga says.

"You could try."

When we get to the White Dory, I realize that although I have chosen the best room in the place, it is one flight up.

"Up the *stairs*?" Joe says.

"You can change it." I am chagrined at what I have done.

"Never mind. We'll just take it slowly," Olga says, using a nurse's plural.

"You've plenty of time to rest up before you come across the street to dinner."

"You mean we have to walk?" Joe wants to know.

"Phone when you're ready," Anthony offers. "I'll drive over and pick you up."

"I'm eighty, don't forget. I was eighty in August."

How could anyone forget? Two thousand people had attended a birthday party for him at the Smithsonian Institution.

"Unbelievable," I say. And, since Joe is eighty, I'm sixty-six.

"And you're no spring chicken, either," he echoes my own thoughts.

Years ago, Milton's analyst had said, "Say whatever comes into your mind." He'd never stopped.

"You're shuffling, Joe," he says when Joe and Olga come into the house. "You're walking like an old man. Straighten up. Stomach in, shoulders back. You ought to get some exercise."

"That's what his doctor says," Olga agrees. "But he won't do it."

"It's boring to walk around the block."

"Maybe you should get a physical therapist in a few times a week," Milton suggests.

"That's a good idea," Olga says.

"Do you like nectarines?" Milton asks Joe. "I hate nectarines. Lily bought some the other day. I told her she must be confusing me with Number Three. 'Remember me?' I said. 'I'm Number Five. I'm the one who loves peaches.' "

"I do, too," says Joe. "Must have been Number Four."

But I cannot remember which husband loved them. I know Sidney hated melons. They made him burp. When we were divorced, I couldn't stop eating melons.

They were all handsome, my husbands, one way or another. Peter at nineteen winding the thin dark curls behind his ears around his finger. Peter, dead at fifty-eight, leaving a Russian countess and four children. Sidney, young and tense, clenching his fist in excitement and reciting Shakespeare. And Joe, who used to look like a *yeshiva bocher,* sitting at the far end of the table in the Papa seat. Henry, the eye, still making photographs like abstract expressionism. And Milton, my present husband, who has the greatest gift—he makes me laugh.

"We spoke to Frank and he said it was unlikely that he and Amy would come to the wedding," Olga says.

"I'll apologize," Jo Ann sighs. "And I'll get rid of the place cards." She walks around the table and crumples all the papers into small wads and throws them into the wastepaper basket. Then she calls Amy. We all listen as she says she is sorry, she has thrown away the place cards, Amy may sit next to Frank or wherever she wishes. Then her face grows angry, and she hangs up in a huff.

"What happened?" we all ask.

"I give up. I got all through and she said I didn't really mean it. I wasn't sincere. She wouldn't accept my apology." And there is nothing more to say.

An atmosphere of reverence tinges the house as the guests arrive. It is the Hirshhorns' presence. Money generates its own magic. But that Joe cared enough to come despite his illness obliterates past sins. I feel as if I cannot do enough for them because they have made Jo Ann feel loved.

"What does Anthony's father do?" Joe asks, sotto voce.

"Why, he's an artist, a very good artist. He does paintings and collages and sculpture. His family is from New Orleans. They've been there a long time; they were early settlers. Anthony is the elder son." Why am I doing this? I sound like a bloody social columnist. And I remember Peter, the scion and son of a diplomat, my first husband, and my family's reaction to him. Zilch. *Plus ça change, plus c'est la même chose.*

"I haven't been in Provincetown for many years," Olga says, and I offer to take her on a tour the next morning.

I follow the usual routine, driving down Commercial Street, pointing out the former Chrysler Museum.

"Joe never met Walter Chrysler, you know. Isn't that odd?"

"It's odd."

Driving out Macmillan Wharf, I park for the best view of Provincetown and we look over the water at the little town and its church spires.

With that lovely vista in front of us, Joe's wife Olga and I talk about Brenda, the wife in between.

"I never met her, but the kids said she had a diamond as big as the Ritz."

"I can't believe that," Olga shudders. "Joe hates flashy diamonds."

"I had the most exquisite antique jewelry."

"That's all I have."

"And she had fur coats, too. I forget which kind. Lots of them."

"I can't believe it." Olga seems hurt. "Joe doesn't like mink." I know she must be cognizant of Joe's old theme—"You'd look

good in anything"—but then, what better way was there to prove one didn't care about his money than to be modest and make few demands?

"What on earth were you two doing so long?" Joe asks when we get back to the house.

"Talking about Brenda," I say.

Joe dismisses her with a wave of his hand.

Olga and I smile as we sit down to our cold lobster-salad lunch. Evidently while we were gone, Joe and Milton have been hitting it off.

"You're married to a very nice man," Joe says.

"I know," I say. "And you did all right, too."

Jo Ann and Anthony, who are with us for lunch, look bewildered at all the byplay.

"It's time," I say. And we get up from the table.

"You look beautiful," Joe says, and kisses Jo Ann. She is tall and a woman. She is not in white, but in a simple beige dress with a little pattern on it.

The sun comes out for a brief moment when we get to the Universalist Church with its Christopher Wren-like tower that Charles Demuth painted. A sign at the door says politely: NO BARE FEET, PLEASE. The Reverend Richardson Reid, a gentle man with glasses and a silver-pointed beard, greets us.

"I wasn't able to get the regular organist, but my wife will play."

And he walks away with Jo Ann, Anthony, and Joe. Stepping through scaffolding erected to facilitate restoration of the hazy gray trompe l'oeil columns and niches which remind me of vistas by Piero della Francesca, we settle ourselves in the pews.

To the sound of Mozart coming from the organ, Joe leads our tall daughter slowly down the aisle. He looks short next to her but proud and happy. Jo Ann looks shy and lovely. The circle of flowers around her chignon is like a small halo. A white rose trembles in her hand. Anthony, waiting for her, looks like Buster Brown.

Someone has uprooted a whole bush of marigolds and placed

it in a beautiful pot to blaze behind the Reverend Reid's head as he intones, "For richer, for poorer, in sickness and in health until death do us part." They slip rings on each other's fingers. They kiss. I miss the familiar Hebrew and the crunch of a wineglass under the groom's foot. Just the same, my eyes are moist with tears.

"A little something to help you restore your church," Joe says as he stuffs a hundred-dollar bill into the Reverend's hand. "You're a nice man."

Outside, we shower the bride and groom with brown health food rice.

"I couldn't find any white rice in the center of town," Jackie explains. Then we all dash back to the house, where the Bultmans have iced champagne and Jeanne baked a wedding cake so large it had to be put outside on the deck. We have a small reception and break up for a hiatus and nap to prepare ourselves for John Casas's creation of a wedding feast.

When we all come together again, we drink more champagne. Milton's son, David, a doctor who looks like a handsome rock star, and his wife, Susan, a therapist who looks like the girl in *Green Mansions* but is dressed in clothes like the twenties, arrive from Wellfleet. Fritz and Jeanne have brought their old friend Myron Stout, who is to have a show at the Whitney, and Ruth Latta, who used to be Norman Mailer's secretary and is just back from a trip.

Jackie serves the first course.

"What is this?" Joe asks.

"Sautéed veal kidneys with Marsala wine," John sings out from the kitchen.

"I love kidneys," Joe says, tasting them. "They're delicious. Nobody gives me kidneys any more. Call me Kidney Joe."

"OK, Kidney Joe," John is saying. "Prepare yourself for the next course."

Milton walks around replenishing the wineglasses and never leaving one empty. The beautiful ironstone soup plates arrive with a saffroned bisque full of plump mussels and a dark blue shell standing upright in each one. There is a round of applause.

Next comes a delicate breast of chicken garnished with snow peas and mushrooms *au jus.*

"I meant to have a sorbet to cleanse your palate at this point," John apologizes, but we all forgive him and try to drink up all the 1964 wine while we are waiting for the next course.

"But Anthony's father is an artist," I can hear Jeanne saying far down at the other end of the table. "Anthony comes by his talent as an architect naturally." Joe seems determined not to absorb the Bultman lineage.

"Who is that old man at the other end of the table?"

"That's Myron Stout. He's a famous artist who lives in Provincetown. He rarely shows, but the Whitney will be giving him a show in about a year."

"Never heard of him."

"Isn't there some work of yours at the Hirshhorn Museum, Myron?" Jeanne calls down to Myron, who is sitting next to me.

"A drawing," he answers modestly.

"Oh, of course," Joe says quickly. "I bought it myself."

Myron, who is almost blind, reaches out to pick up his wineglass but he cannot see it. It spills and a red stain seeps into the cloth. I know as well as Myron that someone else chose his drawing, but nobody contradicts Joe, least of all Myron, who is the soul of delicacy and consideration.

"I don't know if I want the stress of working for another powerhouse," Ruth Latta says in answer to Joe's saying he needs a secretary in New York. "I may do something else entirely."

And John has a crisis in the kitchen and throws out the sauce it has taken him two days to prepare, rescuing the truffles and beginning all over again. We switch to white wine.

John serves an incredible noisette of veal tenderloin, the meat tender and white, the new sauce black with rescued truffles. The plate is garnished with a whole poached tomato, matchstick turnips, a julienne of carrots, and a tiny hill of ricelike orzo pasta. After that we have a simple salad.

We are replete and happy. A warm glow is over all of us. It seems as if no more can add to our pleasure when a Floating

Island with Crème Anglaise laced with Grand Marnier appears and slides down our throats like an airy whisper.

At last John joins us at the table for coffee. We toast him. We toast the bride and groom. We toast each other. We have been at the table for four hours and we are forever friends, touched by the love that has gone into this celebration. We are reluctant to part.

"One last thing," Milton says to Fritz and Jeanne. "Repeat after me: *Machetunim.*"

"*Machetunim,*" they say. "What does it mean?"

"In-laws, only better. And you, Jeanne, are a *machetayneste.*"

"I'm a *machetayneste,*" she says in wonder. "What's that?"

"Same thing. Female gender. Now, all together—everybody." And he leads us all in what sounds like a college cheer. "*Machetunim! Machetayneste! Machetunim! Machetayneste!*"

"One last toast," says Joe. "*L'chaim.*"

"To life." We all raise our glasses.

Milton says jokingly to Joe, "I spent the whole weekend with you and you didn't give me a single stock tip."

"Didn't I?" says Joe, putting on his coat. "Wang!"

"What?"

"Buy Wang, it's the new IBM."

And he and Olga are out the door.

"Please take the lasagna," I beg Abby.

"I'd be glad to—I'm having a party."

"Good. I can't stand the thought of driving it to New York one more time."

Anthony and Jo Ann are the last to leave.

"Was it your day?" She looks radiant.

"It was my day," she says, throwing her arms around me.

We stand at the door watching Jo Ann and Anthony until they are out of sight. It is hard to go back to the empty house. Sad that Amy didn't come, I think, as I watch a fine drizzle play around the street lights, turning them into misty golden sparklers.

"Nobody minded the rain," Milton says, finally shutting the door. "The weather didn't interfere at all."

"It was wonderful. Nothing interfered." Not even my whole crazy life. And we walk around the living room, still glowing with good feeling, straightening the chairs and picking up the wineglasses.

"Maybe now," says Milton, "we'll learn how to make a grand-child."

PHOTO CREDITS